The publisher gratefully acknowledges the
generous contribution to this book provided
by the Art Book Endowment of the University
of California Press, which is supported by a
major gift form the Ahmanson Foundation.

PERFORMANCE ARTISTS TALKING IN THE EIGHTIES

sex food
money/fame
ritual/death

COMPILED BY **LINDA M. MONTANO**

University of California Press Berkeley Los Angeles London

Grateful acknowledgment is made for permission to reprint interviews with Nancy Barber, Alison Knowles, Leslie Labowitz, Suzanne Lacy, Susan Mogul, and Bonnie Sherk from "Food and Art," *High Performance* 4, no. 4 (winter 1981–82); Ana Mendieta from *Sulfur* 22 (1988); Annie Sprinkle and Veronica Vera from "Summer Saint Camp 1987," *The Drama Review* 33, no. 1 (spring 1989); Karen Finley, Mierle Laderman Ukeles, and Helene Aylon from *Binnewater Tides* (published by the Women's Studio Workshop) 8–9 (1991–92); and Carolee Schneemann from *Flue* (published by Franklin Furnace) (1987).

University of California Press Berkeley and Los Angeles, California

University of California Press, Ltd. London, England

Library of Congress Cataloging-in-Publication Data

Performance artists talking in the eighties : sex, food, money/fame, ritual/death/compiled by Linda M. Montano.
 p. cm.
"Ahmanson Murphy fine arts imprint."
Includes index.
ISBN 0-520-21021-2 (cloth : alk. paper)—
ISBN 0-520-21022-0 (pbk. : alk. paper)
 1. Performance artists—United States—Interviews.
 2. Performance art—United States. I. Montano, Linda
NX504.P465 2000
709'.2'273—dc21

 00-055966

This book is dedicated to:

Chakra 1, Security:
My creative parents, Mildred and Henry Montano

Chakra 2, Relationships: 1+1=1

Chakra 3, Courage:
All performance artists and lovers of Living Art

Chakra 4, Compassion:
My guides Dr. Aruna Mehta, Dr. A. L. Mehta,
Mother Mary Jane, and Sister Giotto

Chakra 5, Communication:
My grandmother Lena Kelly and all of my teachers

Chakra 6, Intuition:
My meditation Guru, Dr. Mishra
(Shri Brahmananda Saraswati)

Chakra 7, Joy: ★★★★★★★★ ★★★★★

contents

PART THREE money/fame

PART FOUR ritual/death

illustrations

following page 142

Sex

Paul Cotton, *Meditation of the Time Being*

Vanalyne Green, *This Is Where I Work*

Lynn Hershman, *Binge*

Laurel Klick, *Self-Portrait*

Minnette Lehmann, *Many Minnettes at Her Birthday Party*

Paul McCarthy, *Grand Pop*

Tim Miller, *My Queer Body*

Pat Oleszko, *The Padettes of P.O. Town (The Primary Colored Group)*

Carolee Schneemann, *Fresh Blood: A Dream Morphology*

Food

Jerri Allyn, *Love Novellas*

Howard Fried, *Long John Silver vs. Long John Servil*

Joan Jonas, *Double Lunar Dogs*

Alison Knowles, *Make a Soup*

Suzanne Lacy, *Know Where the Meat Comes From*

Antoni Miralda, *Liberty Engagement Gown (Honeymoon Project)*

Martha Rosler, *Watchwords of the Eighties*

preface

Food is good material for my art.

MILDRED MONTANO,
PAINTER AND MOTHER OF
LINDA MONTANO

This project began when the anthropologist Diane Rothenberg invited me to her "Anthropology of Food" class at the University of Southern California in 1979. It was then that I started to gather slides of food performances, which led to a series of ten interviews with performance artists who use food in their work. Those interviews were printed in *High Performance* in the early 1980s as part of the magazine's food issue. After food, I explored other themes: sex, money and fame, ritual and death—all things I wanted to know more about. I realized that performance artists were addressing these topics, so I talked to them, sometimes intermittently, sometimes intensely, for the next ten years.

After each artist chose one of the four topics (sex, food, money and fame, ritual and death), I asked him or her essentially the same question: How did you feel about (food, sex, money, fame, ritual, or death) as a child? It has always been my personal belief that the themes artists employ are born in childhood and that an artist's work explores, transforms, perpetuates, or makes the information from that time understandable and manageable via symbolic acts—art. Some artists I talked with are not interested in that connection and expressed this in our conversations. Some discovered it again or for the

first time. Others responded conceptually—for example, when asked about sex, Tony Labat said: "Interpret my silence."

My own childhood habit was not to speak but to silently intuit everything. By placing myself in an atmosphere of talking with artists about subjects I once thought too delicate or taboo to discuss, I have slowly untied my own tongue.

Also, I now have even more permission to unearth my personal recurrent art theme—hunger. Had I been interviewed for this book, I would have chosen to talk about food. I would have mentioned my allergic reactions to cow's milk as an infant, my childhood vomiting incidents and hospitalization; I would have mentioned the way my grandmother cooked roadkill and humorously called all of the different animals she cooked "chicken"; I would have mentioned my two years in the convent and anorexically going from 135 to 82 pounds; I would have mentioned my live chicken installations and later performances as Chicken Woman. Finally, I would have mentioned that for thirty years I have translated and transformed physical hunger into ecstatic, metaphysical longing disguised as art. Performance births Meditation!

Can Performance Artists Continue to Practice?

As I reread these interviews, some from twenty years ago, I am moved by two recurrent themes: courage and mortality. In his book *Writing as Sculpture,* the Indian philosopher Harish Johari told members of a workshop in Holland that artists are saints. I have always believed this, and had it been appropriate, I would have titled the book *Performance Art Saints Talking,* because we are not shy, but visible warrior-saints, who continue to work with outrageous content in great ephemerality, often without documentation or notice. We must be strong, because some of us have been jailed for our art (Hermann Nitsch), performances or videos have been stopped or banned (Karen Finley, Annie Sprinkle, Carolee Schneemann, Paul McCarthy), the National Endowment for the Arts has denied funding (Finley, Tim Miller), and college

and university administrators have censored our work. For example, Alex Grey remarks, "The administration and I never saw eye to eye, so I left school and painted billboards." Mierle Laderman Ukeles recalls, "This work [a painting] got me in a lot of trouble because the dean . . . said that I was obviously oversexed and that the art was pornographic." And, discussing her experience at Bard, Carolee Schneemann remembers, "There was great upset about his genitals appearing in the portrait [that I painted]." That was then! Yet even now, almost twenty years later, performance art often suffers from the same alienation, administrative censorship, marginalization, and cultural bias. Is it because high-level politicians and fundamentalist/conservative Internet users are hanging out—in privacy—in cyberporn chat rooms or on 900 phone sex lines and come out of hiding—with shame and guilt over their repressed frolics, persona changes, and technologically induced ecstasies—to implicate, in Helmsian complicity, performance artists willing to address real-life issues, in real time, using real flesh? Maybe, maybe not.

It's complicated. The avant-garde doesn't demand or expect acceptance, only a tolerant understanding and respect for its ability to aesthetically transform secrets, fears, addictions, impulses, and the shadow. In the meantime, we continue to be public and courageous—but also mortal and aging, and some of us in this book have died: Jim Pomeroy, John Cage, Ana Mendieta, Christine Tamblyn, Dick Higgins, and Hannah Wilke, as of this publication. Our bodies are our matter, our raw material, and I look forward to the incredibly profound, creative, and innovative ways that we will intelligently handle issues of time, cloning, robotics, environmental pollution, extraterrestrial life, cyborgs, weightlessness, androgyny, age reversal, gene therapy, and telepathy.

Relevance

It took over ten years to gather all the interviews for this book and another ten years to find a publisher. Much has changed in that time—

AIDS came, Soviet Communism went, the New Age tired, money as currency disappeared (replaced by credit cards and electronic payments), and sex became a dangerous activity, although Tantric sex was reborn. A book almost seems to be an antique, a pre-Internet phenomenon, an archaeological find, a relic from a time when we talked with each other, a time when we weren't held captive by fax machines, video conferences, cellular phones, caller ID, or e-mail. What was said back then was for then, and as those words came closer to being published, even though I thought the interviews were important, I worried about their current relevance until I read a quote from Margaret Mead, which said that young people needed "a good sense of the past" and urged them to read, in order to see how time has changed. If people have a sense of change, she indicated, they can project into the future, but if they think the world has always been the same, "with a TV set in the year one," they will lack imagination. I hope that *Performance Artists Talking in the Eighties* will function as an invitation to imagination and reflection, helping readers to evolve the form of performance art using their own unique perspectives. It is also meant as an archival portrait of artists working in the ephemerality of performance, allowing readers to experience these artists' humanness, the depth of their knowledge, and the way that they wrestle with life's mysteries.

Gratitude

On every level this book is a collaboration and a team effort (the interviews need the introductions, the book needs the critical writings, and all of it needs a venue in order to reach the reader).

My deepest thanks to all the artists who allowed me to talk with them; you graciously gave information, wisdom, and good suggestions for making life more artlike and art more lifelike. Little did we know that performance art would resurge and be hot again, as well as commodified and academized!

Although there are apologies to be made to the many artists who have not been included in this book for various reasons, I feel that if I added interviews now, it would disturb the book's authenticity and flavor. (Actually, for editorial reasons, about a third of the 150 interviews submitted for consideration in the original manuscript were not included in this book.) Perhaps another author will be moved to follow where I left off or react to my inclusivity or exclusivity, thereby creating a new work on this genre. If you are included in the book and we have edited, subtracted, or changed things so drastically that you can't recognize yourself, please be lenient. Accuracy was our goal, but it was difficult to maintain.

Thanks to my typist and preparer, Margaret Henkeles, and her assistant, Anita Wetzel, for transcribing every interview from my handwriting to the computer—a labor of love and mastery.

The art historian Richard Shiff introduced me to Kristine Stiles, an art historian at Duke University. Kristine then became the angel-agent who, after reading the interview manuscripts, suggested that Stephanie Fay, an editor at the University of California Press, might be interested in the book. Stephanie sent it to two anonymous readers who made helpful suggestions for revisions, which I studied carefully and implemented as closely as possible. Jane McFadden, with help from Patrick Lakey, worked again on bringing all parts of the puzzle together as the book came closer to being published, a Herculean effort and fruitful collaboration. My thanks to them and to Stephanie Fay, Ellie Hickerson, Sue Heinemann, Susan Ecklund, and Yuki Takagaki of the University of California Press for guiding the manuscript through the editing process and helping to make the work visible to the wide world.

Your Participation

From 1991 to 1998 I formally performed as a university teacher and found it to be one of my favorite personas. Therefore, the teacher in me feels free to offer my readers the following assignment:

Browse through or read the book. If there is any unfinished business in your own life on any topic—food, estate planning, enlightenment, umbrella policies, sex, money, medical care, teaching performance art at a university, irradiated meat, nursing homes for artists, antioxidants, real estate, tenure, cellulite, fame, censorship, your life's purpose, equality, the stock market, aging parents, and so on—interview someone who knows about that issue. After transcribing the interview, read it or listen to it until you feel satisfied and know what you need to know. Then teach someone else what you have found.

Linda M. Montano

introduction

SHALL WE TALK? LINDA M. MONTANO
PERFORMS AUTOBIOGRAPHICAL VOICES

ANGELIKA FESTA

"Living art was incredibly exhilarating . . ."
Contextualizing Linda Montano's Art/Life Performances:
Art Practices in the 1970s and 1980s

Art has functioned for me—it's pragmatic. LINDA MONTANO IN MARCIA TUCKER,
CHOICES: MAKING AN ART OF EVERYDAY LIFE

What is the magic of art? Of performance? It was and continues to be an
activity that allows me to speak *by making.* LINDA MONTANO, "PERFORMANCE
AS HEALING"

In *Performance Artists Talking in the Eighties* Linda Montano conducts a
talking performance using edited transcriptions of her interviews with
performance artists. With a group of artists (her peers, friends, and past
collaborators), she explores the relationship between art and childhood
experiences. She interviews each artist on one of four categories of con-
cern: food, sex, money/fame, and ritual/death. Her questions focus on
the relationships between art and life, history and memory, the individual
and society, and the potential for individual and social change. *Perfor-
mance Artists Talking* also raises questions about the methods and strategies

1

Montano herself employs as artist, researcher, interviewer, and compiler of the various texts. Why does she revisit the past? Why does she seek causal relations between an artist's life and his or her art? Why is she interested in the childhood memories of other artists?

Montano's talking performances combine the personal stories of each artist with her own performative vision. These performances are restaged in *Performance Artists Talking* as a "portable exhibition" in the form of an "artist's book" that is a significant document of an era in American cultural production as well as an addition to Montano's own work.[1]

Montano's performance raises complex issues concerning performance as art and as language. These issues include an emphasis on the vernacular and everyday; an insistence on the integral relationship between art and life; a displacement of linear structure through repetition, serialization of narration, and the indexing of events and concepts; a dissolution of the author's "voice" into the text and the reader; the use of personae as a way of problematizing issues of identity within performer-audience relationships; and the practice of art as an exploration and critique of the conventions of daily life, rather than as virtuosity and mastery.

While her collection of interviews is shaped by the legacy of several traditions, Montano extends genres and conventions such as devotional literature, the psychoanalytic case study, ethnography, and verbal art forms employed by the historical avant-garde and by popular culture. Most important, she extends the genres of autobiographical writing and contributes to the debate on issues of authorship. *Performance Artists Talking* raises questions about the autobiographical voice. Do the artists' voices speak truth or fiction? Are their voices singular or multiple? Are the interviews documents of expression, resistance, or critique?

Performing the autobiographical "voice" is among the more challenging explorations that have shaped the history of American concep-

tual and performance art since the 1960s. From the beginning, the challenge has been to represent a voice with an agenda, to confront expressively and critically not only the audience, as its roots in the strategies of the avant-garde would imply, but also a range of issues. A partial list of these issues includes autobiography as political activism, confession, self-transcendence, self-revelation, nihilistic self-effacement, parodic self-reflection, and resistance.

One extreme point along the representational continuum of performance art practices has been the modernist claim to the autobiographical voice as socially and psychically integrative. In this largely Anglo-American tradition, speaking is privileged over writing because the voice is assumed to possess vital immediacy or "presence"—the presence of the speaker. Writing is perceived as an alienating practice that disrupts this presence and pushes it into "absence." An alternative approach, inspired by the skeptical nature of recent French theory, has been the postmodernist interrogation and displacement of the power invested in that sense of presence, in the institution of authorship and the written text. In this view, the autobiographical voice is antagonistic. It challenges or resists concepts of singular and individualized authorship, and frustrates the drive toward narrative unity and self-identity. This tradition proposes dissolution of the myth of the author by the subjectivities of multiple readers.[2]

In *Performance Artists Talking* Montano incorporates representations of the autobiographical voice from confession to the talking cure and issues of authorship from ethnographic authority to the poststructuralist "death of the author." More important, she performs her own voice through the work of the artists she interviews by drawing on various traditions and histories, including the history of talking performances.

Artists' talking performances use language (speech, writing, and reading) as a medium for expression, construction of identity, and social change. These performances seek to empower disenfranchised

groups and to educate and incite dispassionate audiences. As autobiographical gestures, these talking performances are informed by the manifesto tradition that surfaced at the turn of the twentieth century with verbal challenges staged by cabaret, Dada, and Surrealist performers and writers. Talking performances are also informed by the language experiments produced by such neo-avant-gardist groups as Gutai, Situationist International, the Nouveaux Réalistes, Art and Language, Fluxus, and the American oral poetics movement. In the late 1960s talking performances were energized and politicized by popular-culture genres such as television talk shows and newscasts, and by the "witnessing" and "consciousness-raising" strategies of civil rights organizers and women's groups.

Landmark talking performances in the history of American performance art include Faith Wilding's early feminist performance *Waiting* (1972); Vito Acconci's confrontational language acts and stream-of-consciousness monologues, such as *Claim* (1971) and *Seedbed* (1972); David Antin's talking performances or "talk-poems," later published as books (since 1972); Carolee Schneemann's *Interior Scroll* (1975); *Ablutions* (1972), a psychosociological performance organized and performed by Judy Chicago, Suzanne Lacy, Sandra Orgel, and Aviva Rahmani; *Whisper, the Waves, the Wind* (1984), a performance on concerns of aging for one hundred fifty women aged sixty to ninety-nine, organized by Suzanne Lacy; Adrian Piper's *Funk Lessons* (1982–84), a pedagogically pitched talking and dancing performance against racial and cultural discrimination; and the Guerrilla Girls' catchy posters and anonymously delivered lectures on sexism and racism in the art world (since 1985).

Linked to the concept of talking as a performance genre is the tradition of "art/life." Montano's *Performance Artists Talking* is based on an aesthetic of everyday life in which she frames life as art.[3] As a talking performer, Montano explores with the artists how language constructs individual and social identity, how it guides memory and re-presents

history. In the process, Montano practices her art/life performance strategy by switching roles and shifting voices, exchanging questions with answers, and "writing through" the texts of others. During the interviews, Montano's own process of art making—her returning to the past as a way of understanding the present—emerges as highly prescriptive, guiding the artists' reflections on their own artwork. This raises questions about the power of confession and about causal relations between childhood memories and adult artwork. It also raises questions about the dynamic of talking and Montano's role as interviewer. What is Montano's authority as originator of this talking performance, as researcher of her own community of artists, and as interviewer of its members? And do all sources for ideas, ultimately, reflect childhood experiences?

Since Bertha Pappenheim's invention of the "talking cure" (Anna O.'s term for the cathartic effect of verbalizing her physical paralysis and speech disorders) and Freud's theories of seduction, transference, and countertransference, we know that in the context of psychoanalytic dialogue as in daily life, talking is not neutral; it reveals complex social conditions and power relations. We also know that confessions reveal simultaneously more and less than the truth—that they have truth-value as well as fiction-potential. In addition, the politics of talking and writing about personal matters in the analytic encounter, as Freud's case study of Anna O. demonstrates, yields a narrative that is complicated by the interpreting, recording, and translating authority. But what can we say about Montano's *Performance Artists Talking,* driven as it is by not only a confessional impulse but also a paradoxical power-sharing ideology that respects the integrity of the individual artists' voices while incorporating them into her own voice?

In her short essay "Performance: A Hidden History," Roselee Goldberg emphasizes three of the main formal and theoretical elements that define performance art: its emphasis on the "body," its interest in the

paradoxical relation between art and everyday life, and its use of auto-biographical material: "The terms that have sprung up in the 1970s to describe various aspects of performance—*body art, living sculpture, auto-biography*—are an indication of the very different approaches to the medium taken by contemporary artists." Goldberg, like many artists and historians, sees performance art as providing a special lens through which to review art history and serving "as a vital catalyst for the culture of the future."[4]

Critics like Lucy Lippard and Moira Roth, who track the development of activist art in the United States, have commented on the primarily political content and the critical intent of performance art strategies. Roth writes that "personal history was being ransacked, analyzed, displayed and reinvented by one woman performer after another."[5] Lippard also identifies the tendency toward self as subject matter for performance art and goes on to explore role-playing as a form of self-exploration, self-transformation, and political action in the works of a number of artists. She writes that "some chose an autobiographical method; many chose to concentrate on a self that was not outwardly apparent, a self that challenged or exposed the roles they had been playing. By means of costumes, disguises, and fantasies, they detailed the self-transformation that now seemed possible."[6] Lippard also remarks on the framing of life as art by activist artists:

> There is an increasing number of artists working all over the world who are devoting themselves to an ongoing, high structured art conceived not as an aesthetic amenity but as a consciousness-raising or organizing tool, media manipulation, or "life-frame" (to use Bonnie Sherk's phrase). Their work is a long-term exchange with an active rather than a passive audience. It concerns itself with systems critically, from within, not just as reactive commentaries on them.[7]

Marcia Tucker comments on contemporary applications of conventions and historical precedents. In her essay for the exhibition *Choices:*

Making an Art of Everyday Life, she writes about artists who, like Montano, emphasize a shift away from traditional practices of making art:

> The exhibition, by forcing attention away from specific works of art and particular aesthetic guidelines, hopes to address such issues as the distinction between art and non-art, commodity and gift, art and religious practice, theater and art activity, intentionality and accident, audience and unwitting participation, artistic discipline and obsessive behavior, and the question of morality as a function of art making—all of which may help to redefine, for the public, the nature and parameters of artistic endeavor in general.[8]

Darlene Tong and Carl Loeffler assert in their *Performance Anthology* that "performance art as a contemporary visual art form emerged fully during the 1970s, and has come to be recognized as a major new art expression of the 1980s."[9] As performance art continued to shift and change throughout the 1980s, it combined elements from the visual, verbal, and performing arts, popular culture, and daily life and used these to introduce the artist's body and voice as formal art mediums, as ideological constructions, and as political agents.[10]

In her essay "Rehearsals for Zero Hour: Performance in the Eighties," C. Carr reflects on the cultural changes that transformed Dada performances into the activist performances of the 1960s and 1970s and, more recently, into performances by "border artists," as Guillermo Gómez-Peña has described those who inhabit more than one world and are most easily identified as "Other." Otherness here charts the slippery space between geographic and metaphoric worlds and worlds marked by different languages and meanings. In the end, Carr summarizes:

> [A] sense of apocalypse had developed as we entered the fin-de-millennium: a time of panic, transgression, speed, the hyperreal, a fascination with images. As always, the artists who mattered pushed themselves into dangerous territory, but in a manner less connected with

"personal growth" than the practices of the seventies. . . . Most were more engaged with their audiences, even if it just meant entertaining them. And many were more engaged with the world, taking note of the damage, addressing the loss. Some faced censorship. A few faced even death. But no one would shut up.[11]

"I decided that I wanted to learn how to talk."
Linda Montano's Talking Performances

I sat in front of the video camera for a year without the intention to make a video. The intention was to cure myself. . . . I knew I needed to learn to talk.
LINDA MONTANO, IN LYN BLUMENTHAL, "ON ART AND ARTISTS: LINDA MONTANO"

Montano dates the scholarly beginnings of her research for *Performance Artists Talking* to her 1979 slide presentation for an anthropology class at the University of Southern California on performance artists' exploration of food as a theme for art making. She traces the emotional beginnings of the project to a childhood memory of her father telling her not to speak with others about family matters such as the cost of fixing a leaky roof.[12] Prompted by this memory and compelled by her desire to engage in dialogue with others rather than submit to silence, Montano began a journey that took her more than ten years to complete. In her effort to come to terms with her father's interdiction and to talk with others anyway, Montano created an art/life talking performance. She transformed a childhood event that threatened to silence her into a research project that exceeds the limits of paternal authority. As she brings this project to completion in this collection of interviews, she reflects on the process: "I have fixed that personal story, rescued my curiosity and legitimized my interest in others. Thanks, Dad; you helped me be an artist."[13]

Montano recalls another childhood trauma that she transformed into an art/life performance. At the age of seven, in response to distress over classmates stepping on her coat in the cloakroom at her school, Montano vomited every morning and was eventually hospitalized. She was fine in the hospital, but the vomiting resumed when she returned to school. She stopped getting sick when she was able to talk to her parents about the cause of her distress, and afterward was given her own private coat rack.[14]

The trauma of convulsions lingered and was reactivated at the age of eighteen when Montano became a novitiate in a missionary order. Though she dedicated herself to the required devotional rituals of prayer, silence, restricted social interaction, and introspection, she did not eat normal amounts of food and did not reveal this in her scheduled confessions. After two years of pre–Vatican II convent life and suffering silently from her own willfulness, and from the passion and the folly of extreme Christian asceticism, she chose to leave the order. Her weight was down to eighty-two pounds. "I left because my body was wasting away. I wasn't speaking verbally. . . . I disobeyed convent regulations by not eating properly and because I was not able to discuss this with my novice mistress, I handled the problem alone. . . . (That was an 'imperfection' and against a rule in this order.)"[15] What hungers were satisfied, or perhaps created, by her fasting and her silence? As she linked language to food, to the construction of power and autonomy, speech became for Montano the object of her desire. In her own words, she "closely associated suffering with sanctity" and engaged in silence and fasting with near-fatal intensity.[16] For her, the two years in the convent were filled with "ecstasy from hardship and silence and loneliness. I loved it. . . . I was playing this incredible control game with myself, my body, and, I regret to say, with authority, because I lacked communication skills."[17]

The emotional charge of Montano's eating disorder, her desire for autonomy, and her need for verbal or nonverbal communication

prompted her to write, make videotapes, and stage performances. As her book *Art in Everyday Life* (1981) documents, these activities enabled her to explore in private as well as with live audiences not only the therapeutic function of art, but also a way of making an art of everyday life. Montano's titles for her artworks demonstrate her interest in life framed as art and in living artfully.[18] They suggest to her audiences that her concerns about food, sex, money, fame, and death may also be their—or, rather, our—concerns.

The reflexive capabilities of performance art and video technology enabled Montano to do in "art" what she felt unsure of doing in "life." Performance and video provided her with options. She could talk or write, revise her words, adjust her voice and actions, perform privately and also publicly. Watching her recorded image on the video screen and listening intently to her voice on the sound track, Montano acquired insights and learned behaviors that she then applied to daily living. In this process, she discovered that art was a practice for creation, self-exploration, and self-transformation. She realized, "I didn't have to be depressed. I didn't have to be Linda."[19] By inventing and performing characters such as the French poet Lamar Breton, the country western singer Linda Lee, the karate champion Hilda Mahler, and others, Montano created fictions closely linked to truth that helped her to meet the challenges and overcome the apparent limitations of her daily life.

Summarizing this evolution, Montano notes, "My work from 1969 to 1976 was primarily visual, silent, sculptural. These performances included my body. In 1976 I decided that I wanted to learn how to talk so I sat in front of a video camera for a year and practiced talking. Out of this experiment emerged the characters in this tape, *Characters: Learning to Talk*."[20] "I was including sound and dialogue in order to work on an old fear of not being able to talk."[21] Her intention was to recover the lost, mute, and hidden interior selves and to reincorporate them into her consciousness.

When her ex-husband, Mitchell Payne, died suddenly and tragically, Montano used writing, video, and performance to deal with the trauma

of loss. Beginning with journal notes and two live performances, Montano created the videotape *Mitchell's Death* to mourn his death in "art." She describes the process of making this tape as:

> . . . an attempt to make sense of the death, to repeat the death over and over, to concentrate on it using my work. . . . I immediately ran to art for comfort. I made audio tapes telling the story. Somehow along the way I heard that, if you verbally repeat things over and over, they diffuse. I knew that the internal combustion would begin to lessen if I talked about it. Actually, after his death, I first wrote. I wrote my whole history with him, the whole story, seven years worth of information.[22]

In the early 1980s Montano developed performances she called "art/life counseling" to formalize her desire for dialogue and her interest in other people's lives. She describes these performances as involving a client and a counselor talking about "life, opinions, problems, difficulties, etc." With such questions as "What do you want?" Montano engaged her clients in conversations about their lives and art and in simple mind-focusing exercises based on disciplines she had studied: "EST, gestalt, TM, polarity, acupuncture, therapy, palm reading, yoga, mind dynamics, structural integration, Vipassana, karate, etc."[23] The "art/life cards" she gave to people during these encounters documented the client's commitment to his or her own way of living artfully. The card read, "I, _____, am making art of everyday life in my own way," and was signed and dated by the art/life client.

Art/life counseling was an important component of *Seven Years of Living Art* (1984–91), a performance that Montano staged largely in life and outside art institutions, although she held monthly art/life counseling sessions with visitors to the New Museum in New York City. To friends and many artists like myself, she was also available informally, willing to listen and eager to talk at any time.

In her counseling performances, Montano employs the conventions of religious introspection and confession, the psychoanalytic talking

cure, shamanic healing rituals, and the popular advice industry. She also plays the social roles of teacher and trusted friend. Envisioning herself drawing out harmful blockage and repressed guilt, and retrieving lost passions and forgotten pleasures, Montano's intention is to guide the client toward artful living marked by clarity of mind, heightened self-awareness, and fulfilled dreams.

Like the syndicated talk show hostess Oprah Winfrey, Montano also endears herself to her audience by revealing her own flaws and weaknesses and by speaking openly about such topics as her eating disorder, her hunger for attention, and her need for love. In an interview from 1989, Montano states:

> It seems like [my pieces/performances] get subtler as time goes on and more about intention. I almost feel like I am not doing anything, and I'm not sure if that's good or bad. I almost need a confessor or a whip or something. I need a critic to come and beat me up or something because it's become more philosophy and less action. I feel very free but I feel very guilty, which is one of my favorite feelings. Because this is so easy. I'm not having to mold or meld or confront the studio or the artistic process; it's more about confronting life day to day and that's the studio. There's less formal performance and there's more mental performance. It's more about knowing what's happening and not making anything happen. I'm still very hungry for performance and there are times when I structure in a stand-up performance, so to speak, or a place where I'm receiving attention or energy and giving it back in order to just be loved that way. And there are enough chances to communicate my ideas so that there's a sense of audience.[24]

Assessing her counseling efforts, Montano remarks, "I find that I like leading people through the process that I have created and believe that the results are quite effective."[25]

Montano's talking performances and art/life counseling inform *Performance Artists Talking*. She encourages the artists to talk about their lives and their art by prompting them to see connections between their

remembered experiences and their work. She acknowledges the value of the artists' experiences and asserts the power of their voices. In the process, she documents how the private becomes public and the personal becomes political.

"How did you feel about sex as a child?"
Artists on Sex, Food, Money/Fame, and Ritual/Death

I'm trying to demythologize the great issues in life, food, sex, death, money, to detach from the emotional obscurations. . . . As I get older, it looks like there's more detachment, and more humor. LINDA MONTANO IN LYN BLUMENTHAL, "ON ART AND ARTISTS: LINDA MONTANO"

Sex, food, money, fame, and death are concerns close to Montano's heart and central to her life as an artist. While she has explored these issues in many performances, the interviews in this collection reveal how other performance artists respond to these concerns. In my brief discussion of each of these issues, I bring together examples from Montano's art/life and excerpts from interviews with John Cage, Jerri Allyn, Vito Acconci, Karen Finley, Martha Wilson, Allan Kaprow, Adrian Piper, and Kim Jones. I have selected these eight artists because they explore the relationship between art and life in ways that are particularly compelling to me.

Montano's interviews with Cage, Kaprow, and Wilson intrigue me in part because of what they say about the relation between their lives and art making and because of their influence on contemporary art and artists. Their commitment to art as process and inquiry and their experimentation with sound, language, imagery, and daily living have in many ways shaped the discourse on performance art and fostered the community of artists. I have selected excerpts from Montano's interviews with Acconci, Finley, Allyn, Piper, and Jones in part because of my affinity with their

work and the issues it raises, such as the performativity of language, the representation of violence, and the construction of identity.

In response to Montano's questions, the artists attempt to make explicit the links between their childhood memories, their staged performances, and the details of their lives. In the process, they translate the official interpretations of their public artworks into the languages of intimate experience and private fantasy. According to psychoanalytic theory, the energy that emanates from forgotten experiences or repressed emotions informs all conscious actions, including the artistic process. From this perspective, Montano's interviews suggest that childhood experiences shape adult art making, and that recalling and reflecting on the past and talking confessionally promote the construction and performance of identity.

Montano's continuous return to nearly forgotten and repressed childhood memories is an effort to construct—really, to restore and reclaim—an autobiographical voice that is at once expressive, reflective, and critical. Through this effort, she aims to integrate the contradictory voices of her good girl, bad girl, artist, researcher, guilt-riddled sinner, and saint personae into a voice with a single affirming purpose. That purpose is to prompt the verbally resistant underside of performance art to make explicit links between art and life. Ideally, it also produces a shift in consciousness that relates to the moments of heightened awareness produced in religious confession, legal proceedings, and psychoanalytic dialogue.

Sex

In *Art/Life: One Year Performance* (1983–84) Montano responded to the conceptual artist Tehching Hsieh's idea of being tied to another artist with an eight-foot rope at the waist. He proposed that he and another artist live together in this umbilical connectedness for 365 days—never touching. Montano agreed to do the experiment with Hsieh, and al-

though each artist held a different vision of the piece, from the outside it appeared to be a performance about the intimate relations between people, about childhood memories and fetal fantasies, about sex and death. Although the artists were "unsexed" by a contractual renunciation of physical contact, contact ironically figured intensely in the piece by its absence. (They "touched" each other accidentally one hundred times.) Like a common artery in the shape of a potential death trap, the rope suggested an externalized inner organ and also a flamboyant S&M public signaling device, which aroused the scrutiny of audiences everywhere due to its erotic references.

Vito Acconci responded to Montano's question about sex as a child by acknowledging the mysterious power of sex and sexual attraction:

> As a child, sex had the same kind of mystification that religion had. It was something very much there. And by there, I mean out there. . . . And it's true, I have used sex throughout. . . . I use sex as a metaphor for some kind of power . . . a sign of power in an intimate relationship, and then, in turn, male power.

Acconci is known for his performative use of language and the exploration of such dialectical relationships as performer and spectator, private and public, secrecy and disclosure, speech and vision, passivity and aggression, trust and violation. *Seedbed* (1971), his most notorious performance from the 1970s, emphasized the erotic relation between himself and his audience. Hiding from the public under the gallery's raised floor, Acconci masturbated while responding with exhortations to the sounds of gallery visitors walking on the platform above him. In this performance the spectators' desire to see the performer was provoked yet frustrated by the elusive presence of the performer, who was audible yet remained invisible and inaccessible to his audience.

Sensing that his reputation as a confrontational performer distracted some audiences from the content of his work, Acconci turned in the late 1970s to making more accessible sculptures and installations, and to

working with architects on the design of public gathering spaces. With such pieces as *Gang-Bang* (1980), *Instant House* (1980), and *Adjustable Wall Bra* (1990–91), he invited the audience's more willing participation and active engagement without sacrificing his commentary on "the politics of the body" and the erotics of public and private spaces.[26]

When asked how she felt about sex as a child, Karen Finley recalls, "It never really was a major issue. I never had repressions and wasn't overly dramatic about sex. I guess you'd say that I was average." Although Finley and Acconci answer Montano's question very differently, they share some performance practices that have given them similar notoriety: poetic, strong and profane language and a confrontational use of their bodies with an emphasis on physicality and sexuality. Similarly to Acconci's challenging the spectator's subliminal erotic desire, Finley confronts the mean streak embedded in stereotyping and in the sexually charged relationship between performers and spectators. Exploiting both sacred and profane language and alternately posing as victim and victimizer, she critiques the intentionally abusive and thoughtless sexual politics between men and women in public and domestic life, state officials and ordinary citizens, doctors and patients, and others in unequal power relations. In performances such as *The Constant State of Desire* (1988), *The Theory of Total Blame (*1988), and *We Keep Our Victims Ready* (1989), Finley engaged audiences as a good little girl, a harried house-mother, a successful porn goddess, and a revival preacher. To dramatize her messages, she linked social conditions to the politics of sex, desire, and consumption. She decorated her seminude body with such food items as chocolate, raw eggs, and sprouts, or such products as Christmas tinsel and tiny American flags. As Finley notes in the interview, this process of combining verbal information with visual and tactile material turns her body into a work of art: "What I do is build up a situation and then turn it around so that it's sexual. All of the time I am working consciously with pattern and form. The content

comes from my own life because I am a woman and I deal with availability and the problems of fucking to get places."

Food

The subject of food is central to Montano's art/life performances and to her ongoing exploration of speech and silence. In the interviews collected here, she talks about food as a childhood preoccupation and as a driving force in art. To the question, "How did you feel about food as a child?" Montano responds, "I was allergic to my formula and had to switch from cow's to goat's milk, so from infancy I imagine that I had a strange relationship with food." Further probing reveals that Montano links food to Chicken Woman, the persona she began to develop for *The Chicken Show* (1969): "The Chicken Woman sat in the streets of Rochester, N.Y., for three hours on nine different days, experimenting with stillness and availability. So in some ways I moved from the chicken as live animal and potential food to myself as a Chicken Woman, a non-potential food!!!!"[27]

Montano continued to explore her relationships to food and eating by incorporating those concerns as conceptual, verbal, or visual elements into many of her performances. In *Lying in a Crib, Listening to My Mother Talk about Me* (1974), she placed a partially filled baby's bottle next to her in the crib. In *Astral Travel to Bud's from San Diego* (1976), she traveled from San Diego to San Francisco by visualizing herself meeting friends at Bud's ice cream store. In her text for *Mitchell's Death* (1976), food emerged as an important element in grieving loss: "Pauline brings in some tuna salad and brown bread. Can't eat, then eat. So hungry, yet not hungry at all. Feels paradoxical. Eating and mourning. Tears and tuna fish."[28]

In interviewing John Cage, Montano encourages him to speak about food. A mushroom lover, an aficionado of macrobiotic cooking,

the son of an inventor, and a Duchamp-inspired composer and poet, Cage devoted much of his creativity to exploring art in everyday life. By using chance operations and indeterminacy as primary compositional methods in his sound performances and his writings, Cage left a legacy that emphasizes mindfulness and the sounds of silence within an aesthetic of everyday life. He is perhaps best known for *Untitled Event* (1952), a now-legendary performance with Robert Rauschenberg, David Tudor, Charles Olson, M. C. Richards, and Merce Cunningham at Black Mountain College in North Carolina. This performance became the prototype for later Happenings and an inspiration for performance artists in the 1970s and 1980s.

Cage's aesthetic of indeterminacy can be interpreted as noncausal and therefore countering Montano's game of determinacy, in which childhood experiences inform, if not determine, adult art. In spite of this apparent difference, Cage responds to Montano's question on his feelings about food as a child by remembering, "As a child I was raised on meat and potatoes, salads and Jell-O . . . [Food] was an imposition. I was obliged to eat everything put in front of me, and I couldn't have the dessert until I ate the vegetable."

When, in the late 1970s, Cage suffered from arthritis, he began to rethink his eating and drinking habits by aligning his preparation and consumption of food with certain Zen practices and a good measure of common sense and humor. "Eat when you're hungry and drink when you're thirsty" was the advice of his macrobiotic healer, Shizuku Yamamoto. These words of wisdom brought everything together for Cage: art, music, poetry, and food.

Jerri Allyn responds to Montano's question about her childhood memories of food by recalling her mother's concern for good nutrition and her gift for occasional pleasure. She remembers, "We always had balanced meals three times a day, because that was supposed to be good for you. . . . Once a year my mother would make this phenomenal cheesecake she called Dream Cheese Pie."

While Allyn learned from her mother about food as sustenance, she learned from her extended family about food as a social signifier and a marker of class. Some of her relatives who had experienced economic hardship in the past were horrified when Allyn turned vegetarian: to them, eating meat meant that you were doing well economically and socially, and a meatless diet meant abject poverty.

Allyn brings to food and performance art a feminist and multicultural perspective. Feminist art, as Arlene Raven has defined the term, is "that which raises questions, invites dialogue, and ultimately transforms culture."[29] Like Finley, who uses food to critique the circumscribed value of the female body and women's work within America's male-dominated capitalist culture, Allyn has made food and eating performances since the 1970s. In works such as *One Year Art/Life Prostitute* (1975), *Ready to Order?* (1978), and *American Dining: A Working Woman's Moment* (1987), she explored serving food as a way to earn a living wage and raise social consciousness. For example, in *One Year Art/Life Prostitute,* she examined serving food as an invitation for exploitation and sexual harassment.

To explore women's roles in relation to food in greater depth, Allyn cofounded "The Waitresses" (1977–85), a performance group that emerged from the Feminist Studio Workshop program at the Woman's Building in Los Angeles. The performances they staged in galleries, restaurants, at labor conferences and in the street were really ethnographic studies of women's place in society. As Allyn recalls, "We located four issues we thought were important and analogous to the position of women in the world—women and work, women and money, sexual harassment, and stereotypes of women, that is, waitress as prostitute, servant, and slave."

These performances provided Allyn with the information, the support, and the courage she needed to change. Understanding the power relations between the one who serves and the one who is served, she recognized the waitress role in everyday life as fantasized nurturer and

sex object for male desire. As a performance art project, waitressing of-
fered an opportunity to raise women's consciousness and create social
change. As Allyn recalls, "what happened after so much work and anal-
ysis is that we went back into the waitress situation, and our jobs, feel-
ing powerful. In fact, from that time on, I have had a different relation-
ship to it."

Money/Fame

Money and fame are two concerns that sum up the dilemma of the
contemporary artist living and working within a capitalist society. To
explore this dilemma of the committed artist earning money and mak-
ing a living, Montano created several performances with those themes.
In *Odd Jobs . . . Artfully Done* (1973), *Becoming a Bell Ringer* (1974), and
Garage Talk (1974), her wish to fully participate in society was compli-
cated by her desire to be an artist and maintain the detachment of an
observer. In these performances she questioned the value of her art and
the social function of her art practice: "Was I really working like ev-
eryone else? Earning my keep in the world? Was I a valuable profes-
sional person?"[30]

Young artists searching for their visions and social validation con-
tinue to pose questions similar to Montano's. In addressing those ques-
tions, few artists have been as committed to applauding and sustaining
other artists and their work as well as educating the public about the
value and social functions of art as Martha Wilson and Allan Kaprow.

Wilson is founder and director of Franklin Furnace in New York
City, an exhibition and performance space and a public archive for
artist's books. A performance artist since the early 1970s, she has ex-
plored various constructions of identity, including beauty and fame,
and other psychosocial states of femininity. She has examined women's
private roles in performances such as *Captivating a Man* (1972) and *Pos-*

turing: Male Impersonator (1973), and has explored women's public roles by performing as America's "First Lady."

Each of Wilson's First Lady performances—beginning (ironically) with the construction of "Ronald Reagan" (1983), followed by "Nancy Reagan" (1984–88), "Barbara Bush" (1988–92), and "Tipper Gore" (since 1992)—is a parodic presentation of reality. In her effort to link politics and art through these roles, she employs postmodern strategies such as parody and personae. As critics of postmodern art and culture have argued, parody's dual reality (the visible and the hidden, the real and the fictive) is occasionally funny, but its more important function is pedagogical and critical.[31]

By performing at public events, Wilson acquired a measure of fame and a supportive following. As she imitates mannerisms, adopts rhetorical devices, and dons wigs, clothes, and accessories in the colors and styles we associate with the presidents' wives, Wilson exploits both her fame and notoriety to heighten public awareness and raise money for causes and issues close to her heart.[32]

Keeping in mind Wilson's commitment to education, experimental art, storytelling, and role-playing, it is not surprising to learn that she spent part of her childhood in a Skinner box. Isolated, temperature-controlled, and soundproofed, she was expected by well-intentioned adults to grow in a "natural way." As the solo performer on the lonely but well-maintained "stage" of the box, she performed the daily life of an infant in this psychosocial experiment.

From this perspective, her early experience of staged isolation has not only influenced her art practice, but, as Wilson speculates in her conversation with Montano, also served her well in the complex world of contemporary arts administration. Imagining an "absent" world, as she learned to do as an infant, enables her to remain focused in a world that is intensely present. Visions of an imagined reality may also enable her First Ladies to speak with aplomb to an audience of strangers.

In contrast to Wilson, with her performances of famous women, Allan Kaprow has become nearly unidentifiable as an artist in his performances of anonymous roles. Both Wilson and Kaprow share, however, in addition to an art/life aesthetic, an aesthetic of self-removal, renunciation, and self-control that recalls Montano's work—her spiritual practices at the convent, her meditation and practice of attention.

For over thirty years, Allan Kaprow has explored the relationship between art and life. In the 1950s he gained public recognition by developing Happenings—usually large and extravagant events in which he explored such states as risk and fear through a roughly sketched-out series of chance operations, often involving many participants in public places. In the late 1960s Kaprow began complicating his celebrity status, acquired in part through his earlier spectacular performances, by staging various nontheatrical activities. His increasing fascination with ingenuous and often solitary actions led him to the concept of the "unartist" and to his theoretical distinctions between "artlike art" and "lifelike art." Lifelike art, he argued, is "the shift of art away from its familiar contexts, the studio, museums, concert halls, theaters, etc. to anywhere else in the real world . . . continuous with that life, inflecting, probing, testing, and even suffering it, but always attentively."[33]

According to Kaprow, the impulse toward lifelike art—an unspectacular art form when compared to Happenings or other artlike art such as action painting—dominated the vanguard of the late 1950s and 1960s.[34] Since the early 1970s, lifelike art has been the focus of Kaprow's art practice and theory. His lifelike performances are often private events, performed by himself or by others and later discussed and shared with other audiences in narrative or visual form. As Kaprow describes it, *Another Spit Piece,* in which he cleaned a kitchen floor with Q-Tips and spit, was such an action: "It was an interesting process, very intense work on my knees," he commented. "I got to see, at close-up range, crumbs, dead flies, pieces of hair that I'd never no-

ticed. . . . I told people about this cleaning activity and they said, 'What! You used dirty spit to clean the floor?' "[35]

Prompted by Montano to reflect on childhood experiences that influenced his life as an artist, Kaprow recalls his identification with television's Lone Ranger. Sent by his family for an extended period to a better climate for his health, Kaprow felt alone and abandoned in his new environment. Too young to fully understand this move away from home, Kaprow felt exiled and attempted to atone for "an undisclosed but apparently very, very disagreeable past." Imitating the spirit of the Lone Ranger, his anonymous hero, his atonement consisted of his "doing deeds in the world but never accepting praise for them." He admits,

> I engineered my career right from the beginning to enforce whatever craziness I had about the Lone Ranger complex—I'm sure of that. I made it so special, so radically different from what the art world needs that it couldn't possibly be rewarding to the art world. . . . I designed an art form which allowed me to leave the art world. . . . My fame, if I was famous, would never be collected on. . . . I secretly said to myself, "You see, you can do it. You did it. But it's nothing. It doesn't feel good."

Kaprow's early experiences of exile, atonement, and anonymity have shaped not only his life, but also his art and his influential art theories.

Ritual/Death

Under the heading "Ritual/Death," Montano talks with the artists about their early childhood memories that may have encouraged them to work with risk, fear, or death imagery. Ritual, the artists argue, is one of the many ways to face fear and anger in an attempt to overcome them. Ritual is also a drama that stages social transgression and ideally facilitates communal reintegration.

To explore the fear and experience of death in her own work, Montano created *Alive* (1976), an art/life performance about overcoming

the fear of death, and two years later, *Mitchell's Death,* a set of works including a haunting videotape, which she describes as "an attempt to make sense out of a death." For the mail-art piece *Alive,* Montano sent out commemorative picture postcards of her grandmother Lena Kelly as a young woman. The postcard announced *Alive,* a three-day performance taking place three days before Montano's thirty-fifth birthday. The back of the card read, "When I was young, I thought that I would die when I was 34." By using her grandmother's youthful image to announce her *Alive* performance, Montano announced her fear of death.

In 1984 Montano summed up her thoughts on death as a major theme in her work:

> Because I wanted so badly to be a saint, I took on romantic concepts of death as ways to achieve sainthood. I've also been in near-death experiences and my life has been rather dramatic. I am trying to be more realistic about death. I think Ram Dass said death is highly overrated and sex is highly overrated. . . . Death has always been in my work.[36]

A different perspective on fear and death is offered by Adrian Piper. Known for her bold political stance against racism and gender discrimination, she is one of many performance artists who question the political constructions of identity. As a black woman who can pass for "white" in American society, Piper argues that identity is a political yet personal decision that manifests itself aesthetically and ethically in daily life. Her theoretical perspectives and her art activism on racism and identity in the United States are documented in her two-volume book *Out of Order, Out of Sight* (1997) and go as far back as her *Catalysis* series (1970–71). This is how Piper describes one of her early catalyzing, consciousness-raising, attention-getting performances: "I saturated a set of clothing in a mixture of vinegar, eggs, milk and cod liver oil for a week then wore them on the D train during evening rush hour, then while browsing in the Marboro bookstore on Saturday night."[37]

For Montano, these socially disruptive performances were shocking, but they also made her laugh. She comments, "I was able to feel an 'ah-

ha!' and a comical cure for myself through her art."[38] Piper's intention was to do just that and more: to shock the audience and cause them and herself to think. She was especially intrigued by the sociopolitical implications and the philosophical questions about perceived reality—about the stereotype of a one-dimensional world. How do one's actions within different social contexts define the limits of one's identity? How do implicit power relations between the performer and spectator, such as those based on race, gender, or class, drive the meaning of a performance?

Piper responds to Montano's questions about fear and taking risks in her *Catalysis* series by acknowledging: "It was the compulsion to assert and express my own, changing perceptions of social realities and my own relation to them, in the face of a set of art world conventions and practices that seemed to me completely unresponsive, unrealistic, and insignificant, that motivated me to do the *Catalysis* series."

Finally, Montano wonders whether the little daily fears of our lives are not practice sessions for the "big fear, that of death." She asks, "Is your work a way of cutting through these obstacles to clarity?" "Yes, definitely," Piper responds. "It's a way of mastering the unknown and forcing it to reveal itself to me, thereby making it manageable (that is, intelligible) to me. My goal is to understand everything that happens to me. That way I won't be afraid to die."

In contrast to Piper's desire to understand, Kim Jones, an artist who spent three years in the U.S. Marine Corps, seems to accept his confusion: "I'm really confused about the death imagery. I think it's really my personality and don't think that [being in] Vietnam had that much to do with it. . . . I'm pretty accepting of it, but I want to live." Since 1972 Jones, also known as the Mudman, has done performances in which he covers his seminude body with mud, wears a hoodlike headdress, and carries on his back a huge handmade stick structure. In *Rat Piece* (1976) Jones burned three rats. The inflamed public response brought Jones to trial, charged with cruelty to animals. This case between the art world, the legal system, and animal lovers was resolved

when Jones's attorney argued that the Los Angeles Department of Sanitation routinely destroys rats for hygienic reasons.[39]

In 1990 Jones published all the documentation pertaining to the controversy surrounding this performance as an artist's book. *Rat Piece: February 17, 1976* examines the volatile relationship between performer, spectator, and the media, as well as the competing discourses within performance art as a medium for self-reflection and social change. The book highlights the dynamic relationship between destruction and creation, which such post–World War II, post-Holocaust, and post-Hiroshima artists as the Gutai Group, Wolf Vostell, and Raphael Montañez Ortiz used in their efforts to bring art theories and practices closer to life. In short, *Rat Piece* was a performance about not only infamy and the murderous contradictions within acts of ritual cleansing, but also the politics of survival in a world devoted to producing more and more complex forms of destruction and waste.

In his reflections on childhood experiences, Jones recalls his struggles with a bone disease that kept him in braces, on crutches, and in a wheelchair from age seven to age ten. "The traction, braces, and sticks somewhat relate to my present images." Although he was a boy and still growing, he was told he would never walk again. Rather than accept this verdict and internalize it as a kind of death sentence, Jones used his imagination to create a rich fantasy life. "I couldn't go out and run around," he remembers, "so I ran around in my mind. I made up my own friends. . . . I drew sexy women. I drew trees. I drew animals. And I drew . . . extremely violent cartoon characters tearing each other apart."

As Montano had done in her postcard piece *Alive,* Jones resorts to art and to the power of his imagination. In "Flying" (1987) Piper describes a similar use of that power to evade her pursuers in a recurring dream. She flies to rooftops, lampposts, and other high places where "they won't catch up with me and drag me to the ground."[40] Jones's draw-

ing, Piper's flying, and Montano's practices of paying attention, visualizing, conceptualizing, or inducing out-of-body experiences are ways of confronting the unknown, including the fear of death.

"Do you have anything to add?"
Linda Montano's Power-Sharing Games

. . . the interview belongs, to put it casually, to an inescapable social game.
ROLAND BARTHES, IN *THE GRAIN OF THE VOICE: INTERVIEWS 1962–1980*

Montano is the originator and central organizing force for *Performance Artists Talking,* and an ethnographer of her own community of performance artists. The artists collaborate with her on constructing this talking performance as she elicits their stories and documents their fictions. This process raises questions about whose story is recorded, whose voice is created, performed, and documented.

The creative authority of the speaking subject is a topic of debate among performance artists and literary and cultural theorists. The central issue is the construction of identity and the "voice" in the arts, in historical research, and in the para-ethnographic genres of oral history, autobiographical fiction, artists' texts, and art documentation. What does it mean to be the author of a text that is spoken or written as well as the author of one's life?

While Montano's conceptual and directorial role is clear, the construction of her autobiographical voice through her composite role as collaborator, participant-spectator, friend, and colleague to more than one hundred performance artists is more complex. *Performance Artists Talking* is a power-sharing performance that draws upon the representational conventions of the voice in confession, the psychoanalytic dialogue, the ethnographic interview, and other social games.

The literary critic Gerald L. Bruns has examined texts like *Performance Artists Talking* in which authorship is complicated by reliance on existing texts. By citing Cage's work *Writing through 'Howl'* (1984), a stochastic text extracted from Allen Ginsberg's famous poem, using the letters in Ginsberg's name as keys, Bruns reflects on the already written and on writing through the work "of others"—a writing strategy that evokes Montano's employment of other artists' voices to shape her own ideas. Bruns notes, "To write is to intervene in what has already been written; it is to work 'between the lines' of antecedent texts, there to gloss, to embellish, to build inventions upon invention. All writing is essentially amplification of discourse; it consists of doing something to (or with) other texts."[41]

The cultural theorist James Clifford addresses the production of voice in his examination of the politics of ethnographic writing, literature, and art. He argues that in an ethnographic situation, researchers and informants create, but can also break down, hierarchical relationships that in the past have guided ethnographic practice toward the monological voice. In his words:

> The developments of ethnographic science cannot ultimately be understood in isolation from more general political-epistemological debates about writing and the representation of otherness. . . . A discursive model of ethnographic practice brings into prominence the intersubjectivity of all speech, along with its immediate performative context.[42]

Clifford's study seeks to privilege the power and authority available to informants. In the end, he envisions ethnographic texts not as interpretive ventures produced in isolation and away from the subject of study, but as dialogue and collaboration between two individuals or two cultures.

Montano is an ethnographer, researcher, and writer in these terms. She asks questions to which the artists respond, but then relinquishes control by asking, "Do you have anything to add?" She transcribes the

recorded interviews, but then opens the text for revision, offering the artists an opportunity to rethink the content of their interviews without her narrative intervention. Through these power-sharing gestures, she diffuses the "ethnographic authority" in both the interviews and their written transcription. The artists are invited to join with her in the creation of the work.

Notes

I thank Linda Novak for dialogue and sharing her insights into this work. I thank Hubert Hohn for contributing to this essay with his computer help and editing suggestions, and for talks about these artists' performances.

The first two quotations before the headings come from Linda Montano, "Living Art: A Complex Theory Which States That Life Can Be Art, December 1975," in *Art in Everyday Life* (Los Angeles: Astro Artz, 1981), and Linda Montano, program for performance with screenings of *Mitchell's Death* and *Characters: Learning to Talk,* at Film in the Cities, St. Paul, Minnesota, 1980 (Montano Art/Life Institute Archive). The last two quotations are from her interviews in this book.

The full citations for the epigraphs following the headings are, sequentially: Linda Montano in Marcia Tucker, *Choices: Making an Art of Everyday Life* (New York: New Museum of Contemporary Art [catalog], 1986), 90; Linda Montano, "Performance as Healing," in *Doc-u-men-tia*, edited by F-Stop Fitzgerald (San Francisco/New York/Los Angeles: Last Gasp/Post Contemporary Productions/Astro Artz, 1987); Linda Montano in Lyn Blumenthal, "On Art and Artists: Linda Montano," *Profile* 4, no. 6 (December 1984): 12, 25; Roland Barthes, "Roland Barthes on Roland Barthes," in *The Grain of the Voice: Interviews, 1962–1980,* translated by Linda Cloverdale (Berkeley: University of California Press, 1991), 322.

1. Lucy R. Lippard writes that the "artist's book," as it has taken shape since the 1960s, is a kind of activism, a crossover form that mixes politics and aesthetics, conveys ideas visually and verbally, and appears as a "serial work or a series of closely related ideas and/or images—a portable exhibition" (Lippard, "The Artist's Book Goes Public," in her *Get the Message? A Decade of Art for Social Change* [New York: E. P. Dutton, 1984], 48–52). For more information on this genre, see Johanna Drucker's history, *A Century of Artists' Books* (New York: Granary Books, 1997), and Kristine Stiles and Peter Selz's edited volume *Theories and Documents of Contemporary Art: A Sourcebook of Artists' Writings* (Berkeley: University of California Press, 1996).

2. Roland Barthes, "The Death of the Author," in his *Image/Music/Text,* translated by Stephen Heath (New York: Noonday Press, 1977), 142–48; Michel Foucault, "What Is an Author?" in *Language, Counter-Memory, Practice: Selected Essays and Interviews,* edited by Donald F. Bouchard, translated by Donald F. Bouchard and Sherry Simon (Ithaca, N.Y.: Cornell University Press, 1988), 113–38; Jacques Derrida, "The Roundtable on Autobiography," *The Ear of the Other: Texts and Discussions with Jacques Derrida,* edited by Christie McDonald and Claude Levesque, translated by Avital Ronell and Peggy Kamuf (Lincoln: University of Nebraska Press, 1985), 41–89.

3. Montano emphasizes in this talking performance, as in all of her conceptual and performance art work, an aesthetic in which she frames everyday life as art. Her aesthetic is an engaged practice of paying close attention to daily life, examining its forms and processes in detail, and addressing the questions it raises without insisting on simple resolutions. To underscore the integral relationship between art and life, Montano calls her work "living art" or "art/life." In her book *Art in Everyday Life,* she defines "living art" as a complex theory that states "life can be art," an aesthetic that enables her to live more fully, more truthfully, and more spontaneously.

Art/life opens up the categories of art by dissolving conceptual, social, and economic boundaries that tend to limit conventional art forms and artistic expressions. Although Montano's ideal art/life artist is not required to master a prescribed set of tools and techniques, but only to live life artfully, she admits that this aesthetic is not always easy to practice. Commenting on her 1975 four-day *Living Art* performance with Pauline Oliveros and Nina Wise, she remembers, "Instead of feeling creative, human, and spontaneous, I felt like a harried hostess during this event probably because the complexities and paradoxes of relating were too problematic—I decided to go back to life" (*Art in Everyday Life*).

Montano's art/life aesthetic is rooted in the anti-aesthetic impulse that emerged among the avant-garde in Europe at the turn of the twentieth century and became prominent again in the arts activism of the late 1960s and 1970s. Disgusted by the commercialism and bourgeois ideals of the fin de siècle and deeply shaken by the effects of World War I, artists such as Alfred Jarry, Hugo Ball, Marcel Duchamp, and André Breton turned to ethnography, psychoanalysis, mystical philosophies, and new image-making technologies such as photography and film. Abandoning the Western fine arts traditions, they used media and methods from daily life and from non-Western cultures to blur the distinction between art and life.

Marcel Duchamp, perhaps the most influential of that group, brought the status of fine art to the commonplace in a series of texts, objects, actions, and ideas that he called "readymades." His readymades include New York's Woolworth Building, his playing games of chess, his self-dramatization as *Rrose Sélavy*, and his provocative submission of *Fountain*, a commercially made porcelain urinal, to the first exhibition of the American Society of Independent Artists.

In the late 1950s John Cage, Allan Kaprow, Claes Oldenburg, La Monte Young, and others were inspired by non-Western ideas and the experiments of early avant-garde artists such as Duchamp. Incorporating elements of their daily lives into their work, their art became self-reflective, dialogical, and socially responsive. By the 1960s and 1970s terms such as "art/life" and "living art" had become popular among artists, but the problem of recognizing and evaluating art that appeared to be identical to life remained unresolved for many audiences and critics.

Kaprow envisioned a kind of "nonart" produced by "un-artists" that would make art continuous with life. He developed this idea in his writings by distinguishing between "artlike art" and "lifelike art." Lifelike art is always contextual and therefore rarely fits into traditional art institutions. It can include such events as moving furniture when changing apartments or cleaning up the sewage problem in a community. In 1966 Kaprow announced, "Once the task of the artist was to make good art; now it is to avoid making art of any kind," and in 1990 he restated this aesthetic ideal: "The experimental artist of today is the un-artist." After all, as Kaprow argued in his essay on the legacy of Marcel Duchamp, the point of any art theory or practice was "to discover art where art wasn't." (See Kaprow, *Essays on the Blurring of Art and Life,* edited by Jeff Kelley [Berkeley: University of California Press, 1993], 81, 97–109, 110–11, 128, 201–18, 229.)

4. Roselee Goldberg, "Performance: A Hidden History," in *The Art of Performance: A Critical Anthology,* edited by Gregory Battcock and Robert Nickas (New York: E. P. Dutton, 1984), 24–36.

5. Moira Roth, "The Amazing Decade," in *The Amazing Decade: Women and Performance Art in America, 1979–1980,* edited by Moira Roth (Los Angeles: Astro Artz, 1983), 18.

6. Lucy R. Lippard, "Making Up: Role-Playing and Transformation in Women's Art," in *From the Center: Feminist Essays on Women's Art* (New York: E. P. Dutton, 1976), 103–104.

7. Lucy R. Lippard, "Long-Term Planning: Notes toward an Activist Performance Art," in *Get the Message?,* 318.

8. Tucker, *Choices,* 17–18.

9. Darlene Tong and Carl Loeffler, eds., *Performance Anthology: Source Book of California Performance Art* (San Francisco: Last Gasp Press and Contemporary Arts Press, 1989), vi.

10. Angelika Festa, "Performance Art," in *Cambridge Guide to American Theatre,* edited by Don B. Wilmeth and Tice L. Miller (Cambridge: Cambridge University Press, 1993), 370.

11. C. Carr, "Rehearsals for Zero Hour: Performance in the Eighties," in *The Decade Show: Frameworks of Identity in the 1980s* (New York: New Museum of Contemporary Art, Museum of Contemporary Hispanic Art, and the Studio Museum in Harlem [catalog], 1990), 207.

12. Linda Montano, "Talking Artists" (unpublished artist's preface, Montano Art/Life Institute Archive, Kingston, N.Y., 1981), 2.

13. Ibid.

14. Linda Montano, "Food and Art," *High Performance* 4, no. 4 (winter 1981–82), 50–51.

15. The first and last parts of this quotation are from Blumenthal, "On Art and Artists: Montano," 4; the middle quotation is from a telephone conversation between Linda Montano and Angelika Festa, September 17, 1997.

16. Montano, "Performance as Healing."

17. Quoted in Blumenthal, "On Art and Artists: Montano," 4.

18. Talking performances with such titles are *Lying in a Crib for Three Hours Listening to My Mother Talk about Me as an Infant* (1974), *The Story of My Life* (1974), *Garage Talk* (1974), *Talking about Sex While under Hypnosis* (1975), *The Screaming Nun* (1975), *Listening to My Heart . . . A Congenital Murmur* (1975), *Hypnosis, Dream, Sleep* (1975), *Erasing the Past* (1977), *Characters: Learning to Talk* (1978), *Mitchell's Death* (1977), *Listening to the Eighties* (1980), *Anorexia Nervosa: Five Stories* (1981), and her ongoing practice of "art/life counseling."

19. Quoted in Blumenthal, "On Art and Artists: Montano," 13.

20. Montano, program for performance with screenings of *Mitchell's Death* and *Chartacters.*

21. Montano, "Art in Everyday Life," in *Art in Everyday Life.*

22. Quoted in Blumenthal, "On Art and Artists: Montano," 20.

23. Linda Montano, "Linda Montano: Art/Life Counseling," *High Performance* 4, no. 2 (summer 1981): 53.

24. Linda Montano, "Interview," *Satori* 1, no. 3 (winter 1989): 16–17.

25. Montano, "Linda Montano: Art/Life Counseling," 53.

26. Vito Acconci, "Some Notes on Illegality in Art," *Art Journal* 50, no. 3 (fall 1991): 72.

27. Montano, "Food and Art."

28. Linda Montano, "Mitchell's Death," in *Art in Everyday Life.*

29. Cited in Jerri Allyn, "A Waitress Movement," in *Reimagining America: The Arts of Social Change,* edited by Mark O'Brien and Craig Little (Philadelphia: New Society Publishers, 1990), 255.

30. Montano, "Garage Talk," in *Art in Everyday Life.*

31. Linda Hutcheon, *The Theory of Parody: Teachings of Twentieth-Century Art Forms* (New York: Methuen, 1985), 32.

32. Wilson has appeared in New York City as Nancy Reagan at Artist's Call Against U.S. Intervention in Central America, Taller Latino Americano (1984); as Barbara Bush at ArtTable (1991); and as Tipper Gore at the New School (1992).

33. Allan Kaprow, "The Real Experiment," *Artforum* 22, no. 4 (December 1983): 39.

34. Kaprow, *Blurring of Art and Life,* 219–22.

35. Allan Kaprow, "Art Which Can't Be Art," *The Act* 1, no. 3 (winter/spring 1988–89): 27–29. Other references to spit pieces can be found in Kaprow, *Blurring of Art and Life,* 239, 240.

In his teaching, writings, and public talks, Kaprow again and again refers to certain lifelike art activities such as brushing teeth or cleaning floors with Q-Tips and spit. (The first time I heard Kaprow tell about cleaning a friend's kitchen floor with a Q-Tip and spit was at a talk about his work at the Banff Center of Art in Canada in the winter of 1984.) In his repeated telling, these activities seem to be exemplary rather than discrete art events. I interpret this repetition as his effort to elaborate insights that might have escaped him (or his audience) at earlier tellings, or it may be because he enjoys recalling these life-like art activities.

36. Quoted in Blumenthal, "On Art and Artists: Montano," 25.

37. Quoted in Lucy R. Lippard, "*Catalysis:* An Interview with Adrian Piper," *The Drama Review* 16, no. 1 (March 1972): 76.

38. Montano, "Performance as Healing."

39. Kim Jones, *Rat Piece: February 17, 1976* (self-published, 1990), 104–5, 107.

40. Adrian Piper, "Flying," in *Out of Order, Out of Sight,* vol. 1 (Cambridge, Mass.: MIT Press, 1996), 223.

41. Gerald L. Bruns, *Inventions: Writing, Textuality, and Understanding in Literary History* (New Haven: Yale University Press, 1982), 52–53.

42. James Clifford, "On Ethnographic Authority," in his *The Predicament of Culture: Twentieth-Century Ethnography, Literature, and Art* (Cambridge, Mass.: Harvard University Press, 1988), 24, 41.

sex

introduction

CHRISTINE TAMBLYN

These interviews about sex are an outgrowth of Linda Montano's ongoing project to make art from and in everyday life. Although she has used many different mediums, from painting and sculpture to performance and video, Montano's real medium has always been the raw material of daily experience. Not only is her work derived from the quotidian; it is also returned to the arena of the everyday. Montano often devises innovative contexts in which to present or implement her projects outside the usual art institutions of galleries, museums, and theaters.

By asking people to discuss their feelings about sex, Montano broaches a topic that is still considered taboo in our repressive Judeo-Christian patriarchal culture. Although sex is endlessly debated on television talk shows, gossiped about in glossy magazines, and analyzed in academic journals, these discussions are invariably impersonal or theoretical. The topic is often obfuscated under the rhetoric of medical or moralistic control and regulation. Encouraging people to talk intimately about the role sex plays in their lives, as Montano has done, is thus equally risky and revelatory.

The insights Montano's subjects provide are suffused with particular nuances and universal relevance. Because sex is such a powerful force

in human existence, any attempt to address it ensnares the speaker in a welter of paradoxes. Sexual expression is both the key to personal identity and the primary means of bonding with others. The manifestations of sexual communication are infinitely varied and disarmingly simple. Sex can be ecstatic, terrifying, or banal. It can function to objectify or to affirm others. Often it's funny. Sometimes it's sad. No theoretical system has sufficiently encompassed the variety of motives people have for engaging in sexual contact.

It is difficult to generalize about the comments made in the interviews because of the volatility of the topic under consideration. The questions Montano asked ranged from queries about childhood sexual experiences to opinions about how sexual behavior has changed since the onset of AIDS. Although some of the artists she interviewed responded by elaborating in explicit confessional detail about their experiences, others were more guarded and distant. And it should be noted that when the interviews were conducted, AIDS had not yet touched quite so many lives directly; people's remarks on this subject must be regarded as an artifact of a particular era.

As I read the interviews, I particularly enjoyed monitoring how conversations developed. The respondents sometimes began with a superficial or conventional mode of discourse that later deepened and became more idiosyncratic as they focused on their introspective memories and sensations. The interviews thus became vehicles for meditative contemplation. In all of her work, Montano has searched for new ways to induce contemplative states in audiences. She has transformed rituals like funeral eulogies and palm reading into occasions for spiritual growth and transcendence.

The mundane journalistic conceits of an interview take on an altered significance when Montano employs this format to induce her subjects to elaborate on the role sex plays in their work. Artists usually love to talk about their art, and the scope of the art endeavors they describe here

is remarkable. For example, Barbara Smith discusses *Feed Me,* a performance in which she received visitors to a gallery in the nude, inviting them to interact with her. Pat Oleszko narrates her exploits as "The Hippie Strippie" in a Toledo striptease joint. By asking questions in a certain way, Montano has encouraged the people she interviewed to frame aspects of their daily lives as art in the same fashion that she does.

This collection of interviews is provocative and engrossing, just as sex itself is. The honesty and integrity Montano and her subjects bring to the process prevent it from ever becoming prurient or exploitative. In an era when censorship and puritanical moralism seem endemic, this book serves as a refreshing alternative by reminding us how important the principle of freedom of speech is. Providing contexts for individuals to bear witness to all dimensions of their experiences is crucial work.

VITO ACCONCI

Montano: The first comment, which leads to a question, is this—I would like to ask you about sex because your work reflects that theme, even though you indicated that you didn't want to be identified that way. Can we talk about it just the same?

Acconci: At least we can start. Sure.

Montano: How did you feel about sex as a child?

Acconci: I don't know. I'm just not sure what relevance this has to my work. Do I really want to present myself as: "This is the person Vito Acconci?" People know me from my work. I'm not sure what my particular feelings before work or around work have to do with an image that's publicly presented. It might be of interest to people I know, but I'm not sure what it would mean to others. In other words, most people didn't know me as a child. People know the work; I don't know why they should know about my childhood.

Montano: Because in your work you're trying to know yourself. In your work you're presenting yourself as you, and you were a child at one time.

Acconci: Yes, but what I've revealed in my work is available. I'm not sure if anything else should be. If I wanted to write an autobiography, fine. I probably wouldn't. It just seems that if I'm asking questions like that, that I'd be presenting myself as Vito Acconci, as the work presented. I guess I've never felt that. If someone knew something about me as a child, I wouldn't try to block that. But if I wasn't going to deal with it in a piece, I'd feel that it's unnecessary to deal with it otherwise.

Montano: Often personal imagery is used in your work, some of it sexual. What motivates your sexual imagery?

Acconci: Obviously, there are themes that have meant something to me, that are important to use. But I wonder if in early pieces that dealt directly with my own person, did I deal with those things that came

from my personal background? I'm not sure if I know. I'm not sure if
I'm sure. I was more concerned with notions of art—relation of person
as artist, relation of person as viewer. I'm not sure if any of that work
came from innermost fears, desires, et cetera, although I might possibly
be trying to block something out.

Montano: So the content was merely content and was not talking
about your life?

Acconci: So far as I can tell, it was that.

Montano: Were you raised Catholic?

Acconci: Italian Catholic. I went to Catholic schools until I was
twenty-three. A lot of that early work could be interpreted: "Oh,
many of those pieces take place in closed rooms; therefore, they are
about confessional chambers, the confessional box." That's a possible
explanation and comes from my Catholic background. But again, it
was the end of the sixties, a time of meditation chambers. The pieces
are obviously analogous to something like a meditation chamber. I'm
not sure which came first.

Montano: Did you take Catholicism seriously as a seven-year-old?

Acconci: As a seven-year-old, I'm not sure. Somewhere around high
school, I know that I didn't take it seriously. I mean that I didn't be-
lieve, but I took it seriously in the sense that I realized that I no longer
believed it, but was afraid not to go through the motions. In other
words, it was a kind of Pascal's wager: What if they're right? If they're
right, I have a lot to lose; therefore, I'll act as if they're right, though
not quite believing they're right.

Montano: How else did you rebel?

Acconci: My first act of rebellion against my family was to reject my
Italianism. I went to the Irish Catholic school, rather than the Italian
Catholic school—a small rebellion, maybe, but I introduced an Irish
Catholic guilt to my probably non-guilt-ridden family. I introduced
notions of confession to my family, and that had meant nothing to

them. To my family, Catholicism meant you went to church on Christmas and on Palm Sunday because you got something—you got palms. I introduced a much more rigid structure. I took the structure and the rules very seriously, but I'm not sure what Catholicism meant to me.

Montano: Afterward did you go through a period of anger at what seemed to be repression of your natural inclinations because of what you had believed?

Acconci: I was tremendously repressed; I acted as if I believed in Catholicism but didn't believe. As a result, there were millions of things that I didn't do that I knew that other people did. I guess I assumed, "Well, I haven't done it but there's time to do it. Now that I don't believe, there's time." I felt that maybe there was a way to use that repression, a way to make use of all of that, if I wanted to think of it as lost time. In other words, there's this traditional lapsed Catholic way of thinking: "Oh well, at least Catholicism gives you something to resist. At least it gives you something to fight, a kind of measure to fight against." I don't think that I ever felt angry about it, though. In fact, there were a lot of things that fascinated me about Catholicism. Thomas Aquinas was my introduction to structuralism. I liked that way of thinking. I liked breaking things down into categories. Again, I may not have liked the categories, but at least that system's way of thinking was still valuable to me, even though I may have rejected the content of the system. I guess that I could be angry and still like a lot of it at the same time, so I couldn't be totally angry.

Now that we've gotten an atmosphere of talking, we can go back to that first question. As a child, sex had the same kind of mystification that religion had. It was something very much there. And by there, I mean out there. It wasn't part of my life. I'm not sure when I started resenting that it wasn't part of my life. I almost assumed that it wasn't part of my life. And it's true, I have used sex throughout, even in more

recent pieces that haven't been involved so much with people. It seems in a lot of ways, I use sex as a metaphor for some kind of power. In earlier pieces it was a sign of power in an intimate relationship and then, in turn, male power. In more recent pieces sex has been about cultural power.

The notion of maleness has always interested me. It's something that I hoped to tear apart, that mystification of maleness. Although I know a lot of my earlier pieces have been seen as sexist, I hope they were the opposite. I hope that the way I was using sex was to break apart that notion of male power rather than affirm it. But what I learned, I'm not sure. Maybe through my work I started to learn how sex is used by a male. Because again, I started doing pieces at a time when things like feminism became very important to me; I'm not sure if I can claim that my work helped me to clarify those issues, because they'd already started to be very much in the air for me. At the end of the sixties, feminism seemed almost more important than any antiwar movement. And it was exactly at that time that pieces of mine started to appear, so that way of thinking coincided.

But I am still a male, and I know that I think like a male. No matter how conscious I might have been trying to make myself of certain things, I am still confined in that maleness. With my Italian Catholic background, maybe I am totally solidified. I mean, my father never got a drink of water for himself. We lived in a small three-room apartment in the Bronx, and if my father was in the kitchen and my mother was in the living room, my father would still ask my mother for a glass of water, as if it were a normal thing. And she, even more as if it were normal, would get it. Obviously, I grew up as if it were normal, too. I don't think that I got rid of that stuff right away. I'm probably conscious of it now, but you just can't lose those things that quickly. Being conscious of it isn't quite enough. Unfortunately, consciousness doesn't mean change. Hopefully it can lead to it.

PHILIP CORNER

Montano: What was sexual about your childhood?

Corner: Nothing. I have no memories at all, although I vaguely remember an atmosphere of repression, a nonsensual atmosphere where I was not free with my body. I want to be fair to my mother and don't want to say that she ever told me not to touch myself if she didn't, but I somehow feel that there was an aura of restraint. I remember being struck by the image of corsets, girdles, brassieres, and things like that hanging to dry in the bathroom. They always struck me as disgusting. I always had a sense of the beauty, or maybe it wouldn't be too much to say a yearning for nakedness or wanting to see the body in a free and uninhibited way, which is the way I felt deep down. I remember seeing the reproduction of the painting by David called *The Rape of the Sabines*—no, it was the one where the women come between the men to stop them from fighting—and there were a lot of heroic bodies lightly draped, carrying a sword or shield or wearing a helmet just for modesty's sake. And I remember the comment went like this, "Why is everyone naked?" And my mother's answer was, "In those days the artists thought that human bodies were beautiful."

Around the age which was prepubescent, when it was cute to have a girlfriend, I remember being shamed by the attitude of my family, which was a kind of sniggling. Not repressive, but not a positive attitude either. I remember my aunts saying something like, "Do you have a little girlfriend? Hee, hee, hee, hee, hee." That always made me feel that it was not the kind of thing to have. That comment went deeper than I knew consciously and left a sense that having a girlfriend was an all-too-human weakness that I would never let myself fall into, but at the same time it also got to me that I didn't have one—a girlfriend.

Montano: What is either sensual or sexual about your work?

Corner: It's sexual because it's sensual. I have never allowed the immediate qualities to be subjected to formal systems. Not that I don't use formal systems, but there is always a sense in which the system doesn't impose itself. I associate sensuality with immediate presence and apprehension of the quality of sound, and to obtain that, the work has a minimum of manufactured qualities. I have problems with electronic music and have hardly done any because that kind of purity and refinement of sound strikes me as being antisensual, and I can't use it except occasionally as a trip to the monastery of abstract essences. I do use electronics to magnify small, natural sounds—rock sounds, metal sounds—and have done that a lot because I like the complexity, richness, and immediate sensuality of natural substances. I use the microphone as an approximate ear, which can then be amplified so that scratching and rubbing seems to happen very close to or even in the listener's ear. That physical proximity is sensual.

When *Metal Meditations* was done as an installation, the audience went physically close to the sound source, but in other pieces I have carried sounds to the audience and played them close to people. There is nothing inherently sexual about that aspect of the work, except that sensuality and sexuality are related to each other. Another thing: my music has never been bereft of pulsations. I come from a time when the avant-garde was Stockhausen, Boulez, and the like, so of course my work was moving toward that, but I eventually rejected it precisely because of the sterility of it and the sense that you had to sacrifice everything to the intellectual ordering. My liberation came from Cage, who combined the irrational texture and great richness of sound, which I saw as sensual but sensual in a detached way, in the Zen or ascetic way that you look at a rock. But it's not sexual. There's no tactility in it aside from the sense that visual things can be sensual at a distance with their substance imagined. That kind of cool awareness comes from the absence of pulsations, which are the essence of a life pulse.

All the life processes like the heartbeat, pulse, and sex are an extension of that pulsation. Pulsation is the hallmark of organic entity. In my work the sine qua non for having that aspect of sensuality which is related to an organism, and therefore can express sexuality, is to have some sense of pulse. Even in my early music in the fifties there was some way in which pulses came in. They might come in and disappear, but they were never totally absent. That reflects my interest and my own inner processes. I don't just look out but feel from within. Eventually, that became paradoxically abstracted into one of the elementals in a totally systematic search for the limits of interest, so that I finally got down to a single, unbroken, regular pulse. I found that the beat, although it's just a single pulse, allows you to get carried away so that you start identifying with your own heart, and sometimes listeners consider the possibility of expressing themselves in explicitly sexual movements. That happens even when I am performing a single, unvaried pulse. By going to the simplest element, the pulse, I have been able to clear myself of a whole lot of stylistic debris.

Just around that time I coincidentally started working with the gamelan, and one of the things that did was to bring me into more measured and regular things—simpler rhythms, coordinated rhythms, and things that suggest those simple pulses and, by extension, the possibility of music that makes you move physically and suggests sexuality the way pop music does. I think a lot of my more recent music does express that very explicitly. For the first time in my life, I have been able to write successful marches, which move the body physically! Structure is something that helps me get back into the world. It is at best a formal device, never to be seen, but allowing so much irrational and sensual overplay that you sometimes can't even hear the structure anymore. In most cases there is a kind of balance, and several times the music has been called orgiastic. As a matter of fact, last year when I was doing a piano piece at a party in Verona, one lady said, "Quel orgasmo musicale!" When my music provokes that kind of response, I'm pleased.

Montano: Is sex your muse? Is sex music? Does your personal life feed your music?

Corner: I write words. I also make designs, drawings, calligraphy. All of that comes out of my music, and I see it as word music, visual music. In that sense I don't presume to write literature. My scores don't have notes; they have words. But I also do erotic writing, and in that I express the inexpressible, the sensual, the details and finesse of ephemeral experience. Language is about generalizations that objectify and distance phenomena. To express sexuality in words is really to fight against language itself. That's why most pornography is so awful. It doesn't bridge the gap between what it looks like and what it feels like, and in sex it's crucial to express feeling. In erotic pornography, people are shown humping away and exposing the plumbing of the erotic experience, but that is at odds with the true nature of sex, at odds with the depth and richness of sex.

The thing that disappears when you are lost in sensuality is distance, because everything gets magnified. Language is incapable of dealing with that magnification, but music relates to the specifics of experience in a way that is similar to an erotic one. Music is moment to moment and produces that same magnification that sex produces, so you have the same problem describing music as you do sex: neither can be reduced to generalizations. To adequately speak about the unspeakable, the language has to be music itself. The language of writing has to transform itself, so when I write erotica, I fracture the language/grammar, destroy the syntax of words, and get into something less gross than "they fucked," when that could mean thirty-six hours of experience. (That number came up spontaneously. I wouldn't want to give an exaggerated impression. The longest, unbroken embrace for me was more like twenty hours.) Or even if it were one minute of touching fingers together, words are paltry compared to what that experience is.

Montano: Do you think that you are drawn to this way of working because you are a twin and have known the sensuality of closeness that way?

Corner: That's possible, but I do know that sex inspires and charges me. Erotic experiences get into me, transform themselves into words that want to be written down. I see it as a perpetuation—the writing, that is. Traditional morality is repressive. It talks about the wages of sin, indulgence, dissipation, and "What do you do when it is all over?" I find that a cowardly response to something that is ephemeral, ungraspable—maybe a fear of that space. My erotic writing externalizes the ephemeral. It validates it and values it by turning it into something permanent which is as true to it as it can be. That's the underlying motive. When I have had an erotic experience, it stays in my mind, plays around, creates the word and wants to be written down. Now I have hundreds of pages of writing.

Montano: Anything to add?

Corner: Not only is writing about sex and music, art; but sex itself, making love is itself an art, a corporeal music. The nature of that art is not pornographic, nor can it be defined as getting you off, but it is erotic and properly erotic by contrast. And sex intentionally has its purpose for you not to come or be brought to orgasms unless as a fecundation of the inner mind.

PAUL COTTON

Montano: Is Paul Cotton your real name?

Cotton: Yes, and I'm happy that you see that this is remarkable. I think it is remarkable, too. The most obvious reason for asking, I assume, is because of the rabbit imagery in my work and the worldwide celebrity of one of my totem ancestors, Peter Cottontail. A thread that weaves itself cross-gender-ally through the creation hymn of the Astral-Naught-Bride-Groom is a womb-to-tomb/birth-mother-to-Earth-Mother rite called "Mrs. Cotton's Petertale." I was born Jewish

in Fitchberg at the beginning of World War II, 1939, in the Chinese Year of the Rabbit. My sister's name is Bunny. In 1966, during the act of lovemaking, I had a Tantric vision of Love's Body in which I first *heard my Calling* from my Creator and I first Glimpsed a divine purpose for my eternal spirit's choice to be reborn through my particular parents as a sculptor/poet in this Time's apocalypse. I then re-membered that every one, and every thing is Divine. My inner guide appeared to me then as Hermes in the form of a rabbit to guide me through passages in my life/art journey; through countless ego deaths, rebirths, and at-one-ments with Creator and creation. In the late sixties Eye (I am that Eye am) created painting/sculptures that material-eyes'd the Empty Zen Mirror. In 1970 I "wrote" *The Word Made Flesh,* as a living audiovisual book in the form of a man-animal sculpture/spaceperson/rabbit (Zippily Boo-Duh). He was originally born (out of The Peoples' Prick) with a live penis (mine, painted white), which was eventually "cut off" in a primal battle (father-son/brother-brother) at the crossroads with Norman O. Brown (*The Second Norman Invasion,* 1976). A broadcasting vagina with a miked eunuch-horn resurrected itself on the gravesite of the castration. Sew it came to pass that the *Word Made Flesh* now elect-trick-ally broadcasts hir seed on line in real time from the Uni-Verse-All-Joint.

Rabbit tracks also lead to the Hare-in-the-Moon's appearance as the first astral-naught of the art world to launch a *Dionysian Space Project* to grounding the *first man and woman* on the Earth in the Eternal Present.

The Easter Bunny became the Wester Bunny on many Wester Sun-Days renewing pagan rites of Spring, the bringing of the cosmic eeg [*sic*] and celebrating the resurrection of god hear and now in all manifest forms. Last, but certainly not least, Eye pays tribute to those old trickster folks Br'er Rabbit and Bugs Bunny for their Hermes wisdom and quick wit.

Montano: How did you feel about sex as a child?

Cotton: Confused. When I was eight years old my mother came to visit me at overnight summer camp. We were walking hand in hand on a path through a sunny meadow when she asked me what I knew about sex. I was clueless and embarrassed and didn't know what to say. I think I said, "I know what I know, but I don't know what I don't know." She didn't say anything else. The next week she sent me two white rabbits in a cage. It was years later when I figured out the connection between her question and the rabbits, although I never witnessed any physical or sexual interest between the two.

I have another vivid memory of being sent out into the hall by my second-grade teacher, Miss McManus, as punishment for trying to kiss Suzanne Kinzer. I remember running after that twinkly blue-eye'd pudgy blond, tackling her around her naked thighs as I planted a solid kiss on the skirt covering her butt. Mr. Bigley, the principal, happened to pass by and saw me standing quietly nursing my humiliation near the closed classroom door. "Kissing the girls again, Paul?" he asked with a voice that reminded me that this was not the first time. He towered above me as he gazed down at me through his glasses with undisguised amusement and thinly veiled appreciation of my budding interest in the opposite sex. I loved Mr. Bigley. (I also loved Miss McManus.) I remember my face being directly in front of his fly as he almost touched my nose with his extended right index finger, which was softly and rhythmically being stroked by the index finger of his left hand. "Shame, shame, shame," he said tauntingly, with that lilting singsong taunting music that we all know in the recesses of our collective memory.

Many years later, in 1980, Eye was invited to the Venice Biennale at the time of the first revival of Mardi Gras in Venice. The Biennale's theme was "Transgression and Transformation." I remember being in the office with Maurizio to plan the times and nature of my "performances." I don't know how many times he extended his right index fin-

ger and pretended to snip it with scissors made of the index and third finger of the other hand as he said in Italian: "The pope, the pope" (i.e., the pope will cut your penis off if you get an erection, or if you transgress too far from innocence). I am very conscious of the violence civil-eye-zation imposes upon innocent, primary, preliterate vision. My work reflects upon some of these issues: the fall, the castration, exile, excommunication, being put out in the hall.

KAREN FINLEY

Montano: I am very interested in your work and would like to know why you use sex as content. How did you feel about sex as a child, growing up in Chicago?

Finley: It never really was a major issue. I never had repressions and wasn't overly dramatic about sex. I guess you'd say that I was average. I grew up with several different religions. My father was into Buddhism, and I went to a Catholic school for a couple of years, but it wasn't really very strict or sexually repressive. More important, I was raised with occult influences—card reading, spells to take away sickness, and things like that. My mother and gypsy grandmother practiced those gifts. My father was a musician, and my parents were liberal about sex. I don't remember being upset about seeing people naked, including my parents. That wasn't traumatic. There were some drugs then, but my father started getting a little straighter as more kids came along. It wasn't only jazz that affected me; my mother was into politics, and I was affected by her.

Sometimes when you talk with people, you find that they had strongly repressed childhoods. In some homes they couldn't even talk about sex. That wasn't the way it was with me, so that's why I'm so outspoken when I perform. I think that it comes from having been

sexually open rather than sexually repressed. I'm into sex, not because of my childhood, but because I got older and a lot of crises began happening in my life. My father committed suicide, my family suffered from poverty—crises like that.

I use it because I feel that many times people do things for ulterior motives. For example, going to a performance. Someone may be going to a performance, but actually they're getting all dressed up and are really thinking about who they are going to meet and who they are going to pick up. I'm very aware of the undercurrents and the other patterns that lie beneath the surface. There is surface pattern in everyday life and then there is what lies beneath that. This usually involves trying to find a sexual partner. I expose motives. I deal with taboos by presenting them in a normal situation. For example, maybe a woman goes to a bar and has a drink. This is part of one of my performances. A man tries to pick her up. They're just talking, and all of a sudden things change. She orders a cream drink, and he immediately assumes that it is a pussy drink. What I do is build up a situation and then turn it around so that it's sexual. All of the time I am working consciously with pattern and form. The content comes from my own life because I am a woman and I deal with availability and the problems of fucking to get places.

Montano: When did you start using sexual imagery in your work? Was it gradual?

Finley: The first time was a performance I did when I was seventeen. I used my body and presented myself as sexual and alluring, but I made a definite decision about the content when I was in Howard Fried's class in San Francisco. Once we were asked to use food in our work. I put melons in my bra and referred to my breasts as melons. I ate out of the fruit and jogged with them in my bra, because I've always felt that jogging is a severe problem for women who have anything over a B cup. Even if you get a strong jogging bra, it just doesn't work.

My content also comes from fantasies. For example, sometimes you see regular, ordinary people, sometimes about fifty-five, prim and

proper—and you begin to have sexual fantasies about them. One fantasy I have is wanting to see Nancy Reagan take out her tit and squeeze her nipple—something out of the ordinary. Or if your neighbor is just standing there and squeezes his dick or something. Sometimes I walk down the street and imagine things like that. In the last performance there was a staircase, and I thought, "Of course, I could slide down the banister with lots of Vaseline on it." I try to take the fantasy and give the audience an outrageous vision so that they can realize that what they do or think in private is actually very harmless. It's just a joke. I try to ease it, to ease the tension of sex, and so I bring sex—and sexual fantasies—to the conscious level so that it can be humorous.

Montano: It seems that you are performing the function of an outrageous sex therapist because you are communicating your ease and good humor about sexually charged issues and images.

Finley: Yes, I feel very comfortable with that. Many people who have seen my work, seen my performances, consider them obscene and rude, but I see them as natural, what I am supposed to be doing. When I'm doing it, I don't feel that I'm unleashing guilt from myself.

Montano: You go into very highly charged trance states. Can you talk about that?

Finley: I do use trance, and I don't know how it happened originally, but I think that anyone who is creative goes into that hypnotic state. It happens even when you're painting. I learn all of my material ahead of time, but when I'm performing it, I'm there. I'm conscious, although it feels like something else is leading me. It's definitely an entirely different state. It's different from theatrical performance. It's a place that I can't wait to get to all the time. It's different from a sexual, orgasmic state because I feel it much more above my eyes and it feels like an incredible wave of energy. There are elements of control in this experience; if I'm doing something physically dangerous in a performance, I feel as if I'm protected. I'm so focused on the activity and so intent on giving it out to the people in the audience that I produce this trance

and never get hurt. Sometimes I feel as if I'm on the brink of losing it, because I could take this kind of energy and freak out with it and just not return, but I'm conscious when I'm doing it, so that never happens. I feel the time when it is supposed to end. As soon as it gets to a certain energy, I take it down as if it were a kind of music.

Montano: The obvious jazz influences that you had are apparent in your work, because you know how to use your voice. You know about rhythm, timing, you know that culture from you father's influence, and you sing intense sexual skat. And, of course, there is your mother's psychic, political influence.

Finley: There are these two influences, but I'm also interested in layers of meaning. I try to show that sex is a motivation behind all things, that sex overlays everything, but there are other issues like jobs, work, or the issue of children locked in closets and never spoken of. I expose and explore areas that have been locked up and haven't been discussed. I think that we are becoming more open about sexual situations than we are about people who have been born deformed or who are handicapped in some way. Those issues are more closed than sex, and I like to show the contrast between these levels of awareness.

Montano: How has working with sex as content changed your life?

Finley: It hasn't changed my life at all, because I use sex the way a painter uses color. It's just a device for understanding people's motivations. It's a device that is easy and accessible to me. It's my information and material. I am a performer. I bring in personal issues. I can slide peaches in my pussy, scrub my butt with chocolate, apply champagne douches, give dwarves head, and make tit sandwiches on stage. So what! That's my role. My personal sexual needs are average—boring by comparison. I have orgasms, enjoy penises, hairy balls, enjoy a one-to-one fuck. The world won't end if you don't get a mouthful of tit and a throbbing cock in the kitchen.

Montano: What would you say to someone who wants sexual freedom?

Finley: Work in a strip joint. When you see tits and ass all the time, it's like looking at ears and fingers. After a while the repression removes itself. I worked there for economic reasons. With a dead father, my family poor, going to school, I had no choice but to do it for the money. I would, of course, have preferred to have had money handed to me or to make it in another way, because I would never wish that job on anyone. You're subject to drugs, perverts, Hell's Angels, et cetera. I acted as if I liked my job—that's how anyone survives. If I didn't, I couldn't have paid for my education. I don't believe that a prostitute enjoys her job. It's economics in most cases.

Getting back to advice. I'd say, don't unleash the repressions; work with them and use them. Show the repression and where you're at. Show how it came about. Some people have some really good repressed sex stories. I wish that I did. There are some really amazing childhoods. Use that, and don't try to be something else.

Montano: Do you have anything to add?

Finley: I feel disappointed that I am seen as a performer who uses sex exclusively. I use sex, but I deal more with taboos. My performances aren't sexy because I'm not getting sexually turned on by them. It's all energy. If I weren't performing, I don't know what I'd do with my energy.

VANALYNE GREEN

Montano: I know of your work from California, and it seems that some of the major themes have been sexual. How did you feel about sex as a child?

Green: I was on a ship for six weeks going to Taiwan, where my father was stationed as a professional soldier for two years. I was four years old and in bed the whole trip. That's when I first discovered

masturbation and recognized physical pleasure, sexual pleasure. I also used to touch myself erotically with a pencil. I don't remember thinking that it was bad, but a secret I shouldn't tell anyone.

Montano: Were your parents permissive about your sexual needs?

Green: No, not at all. My mother was unusual because she had two abortions between marriages. This was a message to me that she probably liked making love enough to risk the consequences that went along with that era. It was also clear to me that she wanted to spare me from that misery—that's why she wasn't permissive about sex. I was the last hope in the family, the one who was supposed to keep the morality together. When I started living with my boyfriend, my parents were really upset and called me a tramp. They got in the car once with a rifle to come and kill my boyfriend.

Montano: Is there a connection between your sensual trip to Taiwan and your bed performances? Why did you start using sex in your work?

Green: Sex had been a big topic for me in therapy, although now I don't talk about it as much. During my first year in Judy Chicago's program [at the California Institute of the Arts], I was dealing with what it means to be a woman, which to me is deeply tied to one's feelings about sexuality. For example, what about women who enjoy sex? My first sexual relationship was very positive and powerful. I loved it. I loved the sex. I felt very close to my lover, and compared to the other women in Judy's program who experienced negative things, I felt very lucky. But when I did those first drawings in class, they were of women with their legs spread open, pushing some invisible things away from them. In the lower half of the woman's body was this open, splayed passivity, and on the top was rejection. I honestly couldn't think of where that came from, because I wasn't conscious of wanting to push my sexual partner away. In therapy I'm aware of the fact that I sometimes feel a sense of impending sexual danger and possible violation. Usually the only way to feel safe is to re-create the parental relationship with the sexual partner.

My first piece came out of a deep frustration that I had after I read [Wilhelm] Reich and Dorothy Dinnerstein's book *The Mermaid and the Minotaur*. I decided that if you can't be sexual, you're deprived of an incredible kind of authority about yourself. Sexual repression is powerlessness. I had to go through the painful process of meeting someone, enduring all kinds of trials, tribulations, and tests, and only then would I allow myself sexual pleasure. I felt such a deep regret and sadness that I was living in a culture where I felt profound shame about my body, so I decided to do a piece about that. To prepare, I read books for pre-orgasmic women that give sensual exercises. The piece was based on these issues.

Montano: Did you use these techniques in your life?

Green: Yes, they were hilarious. I learned that some things were great but didn't produce deep internal change. But the things I actually did were wonderful. I looked at myself closely in a mirror the way a lover would, and so I had to move past stereotypes of what I thought I should look like. It was as if I were making love to an image of myself. There were other exercises, like tasting my vaginal secretion every day for a couple of weeks, touching myself and not orgasming, and so on. I also asked various friends to teach me how to flirt!

Tender Me resulted from that research. It was about my feelings concerning men. The piece began with a couple walking into the performance space to sexy background music. The scene read as if this were a one-night stand and they don't know each other that well. They take their clothes off and start making love while putting their clothes back on at the same time. It really looks stupid and awkward. On the audiotape I talk about the sexual dilemma of not being able to have sexual feelings with lovers unless I know them well, comparing it to sitting down to a meal and not being able to eat the food. That seemed profoundly sad and unnecessary to me.

Montano: How did you feel about making love publicly in that piece?

Green: I felt powerful because I thought the piece showed images of women's sexuality that were different from and contradictory to those we know. For example, I show slides of preorgasmic exercises in the piece and also a slide of me making love to a straw man until he disintegrates. The disintegration was about lack of solidity, change, and the death of an older image.

Montano: How do audiences react to sex in that event?

Green: Most people have so much hurt and moralism attached to sex that I think it's hard for them to know what to trust. After I did *Tender Me* on the East Coast, people in the left community wanted to know what it really meant—was it an ode to heterosexuality? An ode to homosexuality? I felt that they were unwilling to experience it, whereas the women in the community where I came from in California understood it and didn't need to analyze it. Audiences respond complexly to material about sex.

Sex entered my work in another piece, *Gender Vacations,* which is about a clerical worker, a union organizer, and a manager. I used consciousness-raising with them in the beginning because some of them had never been exposed to that method of relating. I started by talking about my life and asked them to do likewise. I was going through this phase of sleeping with men again after not having done so for some years. We talked about sex. The central image that I used was my bed, seen as a sexual highway, a crossroads. Before anyone can be politicized, there has to be openness and vulnerability. The project worked because we felt comfortable on a personal level and could therefore explore things that turned out to be political, although we didn't begin that way.

We met once a week for three months. The union organizer knew the clerical worker, and I knew the manager. When I formed the group, I was curious to see if the union organizer, who was a socialist feminist, would feel antagonistic being with a manager who was clearly

out to make money. There were all kinds of possibilities: Would they find a bond of communality and connection because they were women? Would there be class friction?

We found that we were incredibly close. Tremendous growth happened. One woman confessed that she had never had a sexual relationship and had never told anyone that. Another talked about her isolation. The two women with the most power—the organizer and manager—were the most lonely and deeply troubled, because they were struggling with things they didn't know how to get through. I had a chance to see that people making sixty thousand dollars a year, people with some privilege, people who had conceptualized a certain kind of ambition, still struggled with horrible childhoods, success pressures, and the like. They were raised with as many contradictions and crunches as any of us were. Despite all that, they had a kind of mastery in the world.

The piece that resulted was a monologue with slides. I photographed each woman's home, the contents of her medicine cabinet and her purse, her coffee cup. I met each one separately, and we talked about the books that she liked to read. For example, the organizer comes from a Catholic background and had all of her socialist posters set up as altars in her home.

Montano: Has this work changed or transformed your life?

Green: Judy Chicago said that if you work on things that are going on in your life, you'll transform your life. I actually haven't found that to be true in the areas that I thought it would be true. My life has transformed because I know that I can communicate images that other people receive powerfully. Therefore, I have a feeling of competence and know that I can create change. But I think the thing that I set out to do—to transform my life by working on sexual material—got very confused. After I made *Tender Me* and people liked it, I thought that I was changed sexually and I wasn't. It was the opposite. By focusing so

much on my sexuality, it almost intensified the problem. Of course, now I feel a sense of mastery in the world, more autonomy, and less dependence on male approval. But work hasn't completely cured me of sexual problems.

Montano: Do you have advice to anyone wanting to do performances about sex?

Green: Don't think of what you think you should do or make. Especially don't do that only because I tend to get involved in what's politically correct. Some questions that usually go around in my head are: Can you do something that doesn't smack of being feminist? What about doing something that reads like a duplication of one's own oppression? Is showing a nude woman politically bad? There are other issues—these are some that I think about. Getting back to advice—show close friends your work. Do something for them. Feel your way. Don't put a limitation on it in the beginning. Material that has to do with sexuality can be so powerful that when one thinks of what it should be, it's never that powerful. I never know what's true for me until it's there.

[handwritten note: Think about this more !!!]

Montano: What about someone expecting to be changed?

Green: At best she'll acquire a knowledge about herself, a knowledge of what she does well, of what's true for her. I'm learning slowly that I make my best work about men and sex. I don't want that to be true. God forbid that my best work is about men—but unfortunately, it's true.

LYNN HERSHMAN

Montano: I would like to ask you questions, not specifically about sex, but about gender and about some issues specific to women artists. In the early seventies you created a persona (in fact, became her)— Roberta. She was a woman, not like you, but one who had her own life, likes, and identity. Can you trace that impetus to create a persona

and work things out that way to anything that happened in your childhood?

Hershman: I was an unhappy child who often retreated into fantasy, to the creation of characters in order to survive the deprived reality of my own world. Roberta was that deprived aspect of myself that I didn't let many people know about. She was the reverse of my public, polished image. Many people assumed that I was Roberta. In retrospect, I feel that we were linked, though I denied it at the time. Roberta represented my underside—a dark, shadowy, animus cadaver that is the gnawing decay of our bodies, the sustaining growth of death within us that we try with pathetic illusion to camouflage through life. At a cultural level, she personified the underbelly of San Francisco. To me, she was my own flippant effigy—my physical opposite, my psychological traps. As can be inferred from the records of both of us, her life infected mine. Closure and transformation of her life meant my own personal individuation as well.

Montano: How were you supported by your parents when you were young?

Hershman: I would say that my parents' support came from an environment nourishing in intellectual life but lacking in emotional strength or love. Surviving my childhood took courage. Adult life was easy. After my first breakdown, when I was about fourteen, I had intense, frequent psychological analytic treatment for about four years. It was during that time that I formed the link of art to life and feel indeed that it was art that saved my life. I still, to this day, need to do art to feel I can breathe. Were it not for that association, I doubt that I would have continued to live.

There is a story that I remember from that time that may have contributed to my understanding of how to solve life problems. When I was seven, my mother bought me a reversible skirt. It was maroon on one side, turquoise on the other. I believe that this garment made me

understand that fragments could be complete in themselves, part of a whole. And that most things could be turned inside out.

Montano: Were you aware of oppression at an early age?

Hershman: Oppression—yes; female oppression—not until I was about thirty.

Montano: Since Roberta was a classically oppressed victim, did she become an opportunity for you to exorcise female oppression?

Hershman: Absolutely. All knowledge is firmly based upon mystical insight obtained through personal experience. Watching, rather than thinking, looking inside oneself, is the foundation of Buddhist philosophy. As the Taoist notion of dynamic interplay shows us, opposites are united. Polarities are joined by dint of their essences. For example, cold things warm themselves—easy things give rise to difficult ones, and in the flow toward change, there is a cycle. Roberta's evolution from temporary victim to eternal victor was intended as an aesthetic conversion that transcended values—good and/or evil—or gender definitions. The transformation was away from an alienating experience of life in contemporary society to an androgynous cycle of sublime introspection.

Montano: Were you able to move out of uncomfortable places in yourself by acting out the extreme limitation in her?

Hershman: Without a doubt. Her limitation was only mild. I know of others in our culture who are much more extreme and sadly are unwittingly living that tragic reality.

Montano: Who is Roberta? What does she look like? How long was she alive?

Hershman: Roberta Breitmore is a portrait of a woman in San Francisco, a collage of a person experiencing her environment. She is a contemporary heroine fashioned from real life in real time. Her social identities—checkbook, license, handwriting, and speech mannerisms—are textures and testimonies to her credibility. This is a description of her taken from the psychiatrist's case history:

Appearance: deeply affected posture that quite often puts her into slumped position. Heavy makeup conceals her features. During observation she appeared both passive and eager to please. Prefers to lie down (dramatizing her helplessness). A line is beginning to form between her eyes. Modest signs of dysphasia. Her knees are stiff and feet contracted. Decreasing flexibility of legs. Can curl toes under in prehensile manner. Under the superficial softness, one could palpitate tension in deep muscles of the skull. Tensions cut off the flow of blood and energy; thus, skin appears tender and dry. Voice is nearly always inaudible. No spontaneity of gesture.

She faced life's realities like everyone else. Her savings dwindled. She would have to learn to survive by finding a job. She hopes to cut expenses by having a roommate. She places ads in papers, meets prospective roommates, takes temporary jobs, and participates in the subculture she hears about through her adventures. She tries therapy. She tries diets. All of her pursuits mirror the invisible side of life she hopes to not face. As she turns inward to her silent inner space, her thoughts focus on self-destruction.

Montano: What was the most memorable experience she had?

Hershman: Ever? Or with Roberta? Ever—walking in clear air in Los Angeles in 1968 after having been hospitalized for two years with heart failure and being told that I would never walk again. With Roberta—the transformation. As well, her pursuit in the San Diego Zoo by would-be prostitution rings. To escape I turned into Lynn in a public rest room and left the zoo undetected. Roberta was conceived in 1973, and in 1978 one of the Roberta multiples—there were four—symbolically exorcised Roberta by burning her portrait in Lucrezia Borgia's crypt in Ferrara, Italy. After Roberta's exorcism, my personal life seemed to decompose. I returned from Italy determined to end *The Floating Museum* and dedicate myself to my own life, my marriage, and my own interiors. I was deeply in debt, and the strain of my marriage was not reconcilable. My daughter had bitter resentment toward me

for traveling so much with my work. My husband viewed my projects as wasteful indulgences. Critics viewed my work as neither serious nor art and voiced their views loudly in the press. I was exhausted and depressed.

On November 25, 1978, my husband left home and never returned. It was his fortieth birthday. In a way I never expected, I was to become autonomous. The terror of those days/weeks/months was so intense, I still remember the feeling; it was like being a burn victim. A razor seemed to slice thin strips of my skin and peel it off. I was raw and exposed and bleeding. For nearly two years I hardly left my home and would answer neither the phone nor the door. I threw out all my mail unopened. My brain went into a synapse, so that I could not write or finish a thought. Each hour was an exhausting struggle through which suicide would have been a comfort to the pain. The same week my husband left, my mother died unexpectedly. My daughter's resentments and anger were aimed at me, and in her suffering she left school and temporarily ran away. Eighteen years of marriage and dependency evaporated into the ash that was to begin my new life. Like Roberta, destiny forced me to change and reform like the phoenix.

Montano: How are you transforming now?

Hershman: I am now more interested in transformation on a mass scale through the media. I am still concerned with culturally imposed limitations presented by boundaries of society, particularly to disadvantaged individuals. The work that I do now has more to do with survival than with victimization, with restoring, preserving, and celebrating creative achievements. I am doing a project as Lorna, a woman suffering from agoraphobia—fear of open spaces. She hides in her apartment and relates to the world through objects that ironically exacerbate her neurosis: television, wallet, phone. I work with her by manipulating media. For example, viewers can access different channels and in so doing determine Lorna's fate: suicide, continued existence as an agora-

phobic, or leaving her apartment and flying to a new state, starting a new life. I guess that the omnipotent media is like our society's brutalizing parent. My last tape was about a woman's struggle against alcoholism that resulted from being a battered child. I guess that basic instinct to react to our past never leaves us.

Montano: Do you think that women artists are more insistent on using art to transform themselves than male artists are?

Hershman: No, but I think that women in general are more flexible than men, and I think that has to do with all the interruptions in life and work that we face more than men. We are less linear, more willing to see many perspectives. Male artists are probably as flexible as women artists. It is the artist side of the psyche that allows intuitive analysis.

Montano: If you were to envision another self now, what would she/he/it be?

Hershman: I keep inventing characters. Every year a new one, it seems. Last year it was Lorna, forty, who confronted the fears the media imposed and had the option of freeing herself from the self-exile in her own home. Then it was Rebecca. This year it is going to be Iris, a woman artist who is struggling to survive with lobotomization from the pressures of society. Survival means remaining an artist with creative vitality despite the problems of earning a living and being considered difficult and eccentric. And who knows what's next? The fun is that they skit into my brain when I least expect them and enter like a community of friends. I guess that I have my own collective here.

Montano: What is the art of the future?

Hershman: The art of the future will not be more mental than visual but rather more transmental than mental. The media of the future will be less and less visible. The art of the future will involve perceptual shifts that dynamically transform the way one sees. It will be a harnessing and intensifying of awareness, achieved through minimal means. It is a reductive and subtractive process whereby taking elements away, a

situation is intensified and made more visible. Electronic projection can easily be core media in dealing with time and space.

DICK HIGGINS

Montano: What was your childhood like in terms of sex?

Higgins: When I was about six, I had extreme nightmares, and as a result, I was put under psychiatric care. I'm now forty-four, and I've been on partial psychiatric care off and on since six. I was taken to a place that specialized in juvenile psychology in Boston, where they gave me various tests and told my mother that I seemed to have some difficulty with gender identity. Now this I can understand, since later when I went away to school at eight years old, one of the things that I liked best happened after I discovered the school's supply of theater costumes. Often I used to dress up in a blond wig, and I became a woman, carrying a violin around with me. I called myself "Madame Stradivarius."

Actually, I never really identified exclusively with either men or women, but had a bisexual element in my personality. And it's never given me any trouble because even then it was understood that it was part of me. My mother was sympathetic, and my entire family was quite open about sex. As a result, I never had a lot of problems that other people had as a result of their inhibitions.

This boarding school was a little bit like Summerhill, and people were encouraged to experiment sexually. I learned about gay sex the first night that I arrived at the school because my two roommates slept together. I've been learning about it ever since, as well as about other aspects of intersexual relationship. Back at that school, I remember we were given a candy allowance, and I used to give away my candy in order to get fellow students to model nude so I could sketch them. We

also had mutual masturbation jerk-off circles that happen among teenage boys and are part of growing up. I belonged to one called the "Cow Club."

Montano: How early were your sexual works?

Higgins: I've never written pornography because that has a different objective from art, but there has often been a sexual element in my work, starting with the sex poems that I wrote when I was a teenager. Sex was included because I wanted to include all aspects of myself, including the sexual.

Montano: How do you differentiate between erotic and pornographic in your work?

Higgins: Erotic has subject matter which relates to eros, love, including lovemaking. Pornography has the specific purpose of arousing sexual excitement in the viewer, reader, or hearer. I may be old-fashioned, but I consider pornography a perfectly valid form of art. I do not disapprove of works which stimulate the erotic appetites and abilities of those who experience them. But two problems arise with this: One, how is this stimulation to be dealt with? That's the social problem. And two, what does the work imply for the people who are included in it? This is the political and psychological problem. These are complex questions to answer, but as I am aware of the dangers in pornography, at the same time I accept it as a potentially valuable genre. I know that even silly, commercial porno relaxes me when I'm traveling alone. I don't go out and rape people; I just read and enjoy having my fantasies stimulated. My favorite bedtime reading when I travel is the three "P's"—poetry, philosophy, and pornography. I always bring along one of each. However, to refer to the question: the difference between pornography and other erotic art is one of purpose, that is, the intended or actual function. Pornography is oriented specifically toward stimulation, while erotic art derives its character from its subject matter and may have any number of purposes.

Montano: What specific pieces deal with sex?

Higgins: Early pieces were in the *Twenty-seven Episodes* (1957), which was my first published work. There are a couple of small things in there that have sexual undercurrents—nothing very explicit. Also some pieces from the Fluxus days that are to be performed in the nude. Although nudity doesn't necessarily have to do with sex, in my pieces it often does.

There is a piece called *Nude Game* in my book *Jefferson's Birthday* (1964), which has erotic elements as well as nude elements. I've always liked the idea of people performing in the nude, but I've also thought that it was too bad to entirely desexualize the nude body, which is an objective of official nudism, where you sit around among strangers playing bridge in the nude and eating in the cafeteria in the nude. Never, but never, may the conversation turn to sex except in a very clinical way: "John/Joan has herpes, did you hear?" Never, "I love the base of your spine, may I turn you on to a back rub?" Even the nude in fine art is a little that way. One doesn't sleep with one's models. One talks maturely about what fine lines he or she has, never about what cute tits or what a finely modeled cock.

Montano: You say that your parents did not make you feel guilt. Did any church?

Higgins: I'm of a religious temperament and have been in the Episcopal church all my life. It is an understanding institution but is not necessarily encouraging. I have had occasional guilt, particularly in early years, when I was also celibate for a while. Celibacy turned out not to be a good idea for me because it created great tension. Guilt was not natural to me. The reason that I stopped being celibate was that I felt that I ought to know more about sex and to have as much of it as possible, which turned out not to be a great deal. Why? Because I was left emotionally unsatisfied by purely recreational sex, but I made a conscious effort to have the sexual communication level clearly de-

fined. I felt that it was a lack in my life that I ought to deal with as a human being. What I learned was that for myself I had a sense of completion and wholeness after having sex that was not possible for me otherwise. If I don't have sex, I tend to get not so much horny as ingrown and tense. I felt that I was in communication with the real world after sex. And since, as I've said, I have a somewhat neurotic personality and have had psychiatric care all of my life, it is a great danger with me—that I will become too ingrown, withdrawn. Having sex is one of the best ways of keeping me in touch with real people. That's a very cold-blooded way to put it, but in terms of my own personal balance, it is part of the proper way of handling it for me. Not the whole game, but part of it.

Montano: What other artworks have sexual themes?

Higgins: There's an early unpublished novel called *Orpheus Snorts,* which deals with bisexuals finding a relationship together. And also, there is a large theater piece, which has been published but never produced, called *The Ladder to the Moon.* It's the climax of all my early happenings. A lesbian is one of the main characters, and the main female character is bisexual. This is part of the whole balance.

I find people who participate in only one kind of sexual activity for the course of their entire lives somehow don't seem as complete to me as those who have known both sides of the coin. *The Ladder to the Moon* is my best statement of that belief. The sex it proposes is lyrical and poetic communication. It's not just climax oriented and not oriented toward an exclusively one-to-one coitus involvement for the woman. If I had to point to any of my works as having a message, that would be it.

Montano: How was your family sexually open?

Higgins: Well, I always knew the facts of life, and we were not particularly covert about our bodies. We went skinny-dipping together, we talked about sexuality, and so on. It was never particularly a problem in my family. My mother was not the typical artist's mother who

doesn't understand her child. She was sympathetic, always, and continues to be. I have no problem at all with my mother, with bringing her around my artist friends. She belonged to a milieu like mine herself.

Montano: How has working with sex as content changed you or your ideas about sex?

Higgins: I don't think that has caused any particular change in my ideas. It's just been present as part of my message, part of my subject matter, part of what I use. It's never caused any particular dramatic change in me. I was never out to shock people by using sex. The sex is simply there. You take it or you leave it. So there was no change assumed. I like scandal, but I'm not out to cause it in my own work. That's for Tomas Schmit or Nam June Paik, to name just two Fluxus friends and artists.

Montano: How have others reacted to your work about sex?

Higgins: It has been embarrassing to people who were involved with me to see my personal relationship used as part of my subject matter. But I somewhat fictionalize sex that comes from my own life so that I can create a purer model. I refine it and simplify it so that the relationships, as I present them in my works, are not always exactly the way the relationships are in real life. They are made archetypal, not just to protect the individuals—although I do think of that—but also to allow the viewer to see them as examples of something rather than as something that happened to me, Dick Higgins. Although the information is drawn from my life, it is transformed autobiography.

Montano: So early permission to use sexual material and a so-called problem with sexuality have become food and material for work?

Higgins: That's right. It's food and material. We think about our sex lives—we care about our sex lives as human beings—and it seems a shame to rule out any area that we think and care about in the work that we do, so long as it is, to some extent, objectivized or made more archetypal than it would be in a case history. I repeat, I want viewers to see themselves in my work, not me.

Montano: Has any work caused you discomfort?

Higgins: The principal work of mine that has worked on a sexual problem is called *Of Celebration of Morning* and deals with an ingrown and definitely not "out" older man and his rather obsessive relationship with a young man called Justin. People who have known me and the model with whom I was involved have made somewhat of an error in assuming that I am the narrator or that he is the young man. In fact, he is much more open than the young man in the book, and I am a great deal more open than the older figure. Nor was our relationship obsessive in any way. By obsession, I mean preoccupation.

The older man, the narrator, is obsessed, so that the worst appears to be a pedophile's notebook or scrapbook in which he has pictures of his young friend. The whole book tropes that identity, as a matter of fact. It's pasted up as a book, off square, the way a scrapbook is apt to be. It's not neat and orderly. It is filled with questions that, if I said them, would sound totally naive or trivial. If my young model friend had said them aloud, they would also seem naive. But in the context of the characters in that book, they're not particularly naive, because these are the kinds of things that Justin would say, even if the model would not say them. This book is probably the most extreme example of my fictionalizing from autobiographical material. In fact, the older man gives nothing to the younger man—all he does is celebrate his looks, his body. As a result, the young man, who desperately needs some guidance and encouragement, drifts off into drugs and eventually dies of an overdose of heroin. At the same time that it is a celebration of morning, the morning of your life and the glories of being beautiful; it is also of mourning for the young man and the old, in a way. And it is a warning for the way these relationships should not be handled. I have been involved in relationships with people much younger than I, and definitely there is a responsibility of the older person to help the younger one fulfill himself. I think anyone would agree to that. This is precisely what the narrator in that particular work does not do, so it is as much a warning as it is anything else.

Montano: Are you tempted to write an autobiography?

Higgins: I've written one. It's called *A Life,* and it's unpublished. I've also done a second and third autobiography. One is purely visual, in the form of a movie. In the third autobiography I deal with my artistic activity, and that is out in the form of a deluxe edition in Italy, published by Francesco Conz.

Montano: Is it true?

Higgins: I hope so. It's not fictionalized at all, nor have I presented myself as a mask. I've shown as much of my personality as seemed appropriate.

Montano: Sex keeps you well and grounded. You are comfortable with your sexual needs; you incorporate sex in some of your works so that you can complete the portrait of your humanness. Do you have anything else to add?

Higgins: Just that there are other areas of my sexuality that I have not explored, which I definitely intend to do before I'm through. I want to make a comparison of the various people I have been close with over the years, not from any point of view of embarrassing them, but to make a stage work in which I present the people with whom I have had a relationship as archetypes in a pageant format, titled *A Pageant of Lovers.* Since they're being presented as sexual beings, this may or may not be an event that can be performed without someone calling the police.

Montano: What is your advice to people wanting to use sexual material in their work?

Higgins: For the performance artist it may or may not be relevant to explore one's sexual side, but it certainly should not be rejected just because of the traditional taboos. If a person is exploring his or her overall personality, generalizing from his or her personal experience, then definitely it would seem artificial to have a work that did not deal frankly and openly with sexuality as part of the whole human being.

Otherwise you could conclude that the person was essentially asexual. Of course, some people are.

Montano: Do you feel that sex is highly overrated?

Higgins: Sex is just not terribly central to the types of communication some people set up for themselves. I don't think that everybody is given the same sexual drive or the same sexual needs or the same sexual emphasis in their lives. We each have a way of finding our own balance. I think that I'm a little more sexual than most people, but not necessarily a great deal more. There are other people I know who are much more sexual than I am.

LAUREL KLICK

Montano: Your work has sexuality as one of its themes. How did you feel about sex as a child?

Klick: I think that before I reached puberty it was something not to be thought about at all. After puberty it was a burden because I found that I was totally defined by my sexuality. In other words, my sex was what I had to offer the world.

Montano: Was your family supportive, encouraging, or educating?

Klick: No, none of the above. I would say that they were initially more frightened of my budding sexuality than I was. My own fears and ambivalence came from them. When I was quite young, a friend and I were playing make-believe childbirth by putting our Betsy Wetsy dolls under our skirts and groaning. My mother was horrified and immediately stopped the game. This was a very innocent act—it wasn't even as precocious as playing doctor.

Montano: How did you move from sex being uncomfortable to being able to incorporate it into your life? When did you make it public in your work?

Klick: The transition came naturally. I was thinking about it and so began talking about it in my work. Also in the feminist art tradition, we were encouraged to make work about what was happening in our lives, so it was only natural that sex became a theme. It was only when I started working with the Feminist Art Program that I used the material consciously. Before that the theme was covert and hidden in my drawings and other artwork. The first work I did with overt sexual content came about because I was working in a porno theater as a projectionist. When I first started working on the piece, I had many images but was unclear about what any of them meant. I brought the material to Arlene Raven, and after seeing it she asked me to just tell her how I felt about the images. I found I was repulsed by and at the same time identified with the images. I began dealing with that dichotomy and with the fact that I saw myself as a virgin/whore. It seemed important to admit to that paradox.

Montano: Did you have to change your job eventually?

Klick: I didn't quit because of the images, but if the job hadn't ended when it did, I would have eventually had to leave that negative environment. Once I discovered that I really identified with the whore, I no longer felt the attraction of porn movies. The experience gave me permission to be that taboo image—the whore.

Montano: And feminism supported your exploration of the image?

Klick: Yes. I can't imagine getting that kind of support in another context. I think somewhere else I would have been perceived as just sort of sick. I mean, I did show myself in slides doing cheesecake, naked.

Montano: What did that lead to, once you learned what you had to learn from the whore?

Klick: I moved into the character of Cat Woman, who is a very sexual being but isn't a whore. She's naturally sexual, she's comfortable, she's an animal.

Montano: Did it take time to get comfortable with primitive sexuality?

Klick: It took a couple of years because, as I recall, it took about that long for her to fully evolve. The last piece I did with her really worked, and it worked because I had finally incorporated Cat Woman into me.

Montano: Is there anyone now, after Cat Woman and the whore, those two big archetypes?

Klick: I'm still working with animals, more things with dogs. I see dogs as more needy, much more dependent. Right now the work is more playful, more fun. I see it getting much more serious. Feeling dependent and needy is not always fun or funny.

Montano: How has working with sex as art affected your daily life and your sexuality?

Klick: I don't know which comes from which. I'm not sure if working with it in my art affects my life, or if talking and thinking about it in my life dictates that I make art about it. I do know that there are parallel developments. Life and art happen at the same time, and being open about sex in my art has changed my personal life. It's one of the reasons I can live with a lover. Of course, it's still an issue, but on different levels, like sex and love and relationships. Now that's a real can of worms! Politically there is always work to do. The same negative images are still out there. Women are still defined solely by their sex. We are still seen as commodities. We are still defined as the two-dimensional virgin/whore.

Montano: How would you advise a young woman artist to work on her own sexuality?

Klick: No matter how outrageous her material or images are, she should still explore them. It may be shocking or beautiful or ugly, but I think we should put those images out in public. We are still much too well behaved in most of our work. Also, I think a certain supportive environment is necessary for producing this type of work.

STEVEN KOLPAN

Montano: One of the prevalent qualities of your video work is its erotic sensuality. Can you trace this sensuality to your childhood? Was the source of that theme there?

Kolpan: When I was a child, I was very aware of my father as a sexual being. He told World War II stories, which included references to being with English, French, and Icelandic women. I remember being embarrassed by the stories because of my mother, but I was also intrigued by these tales.

When I was in the second grade, I was actually married to one of my classmates. We had a little ceremony at her house, in the garage. The other kids from the second grade attended. Her name was Wilma Greenberg. She had terrible problems with asthma and actually died from asthmatic complications. I remember thinking that her mother and father wanted to kill her, because they moved the Greenberg family to London, a city that I thought had to be the asthma capital of the world, with its fog and dampness.

When I was sixteen years old, I read Wilma Greenberg's obituary in our local newspaper—she died from an asthma attack—and remembered that I was married to her in the second grade. I think that this childhood experience, this juvenile marriage, coupled with the death of my bride at the hands of her parents, and my own inevitable comparisons between myself and my father and his exploits, whether apocryphal or true to life, made me very interested in sex and the rituals that accompany it. I have never married as an adult.

My mother can be a very nurturing being, and it is partially a sensual experience to be nurtured by her. I was tremendously shy and quiet as a child and did not speak until I was four years old. She encouraged me to be in the world, to be outgoing, to have a commanding presence, to not shy away from people. She showed me things about the world.

When I was eight she took me to see *Sundays and Cybele,* which at the time was a controversial French film. It was the first art film I had ever seen—a story of a relationship between an older man and a young girl. I guess it was important to my mother that I see that there are things like that in the world. She encouraged me to see movies and to read important literature. This was a time when people were yelling and screaming about the film *I Am Curious Yellow,* a film from Sweden that I also saw with my mother, and the book *Catcher in the Rye,* which both my mother and I read.

Maybe all of this literary and cinematic exposure by my mother was a replacement for talking frankly to me about sex. I remember my mother told me that when she asked her own mother about sex, her mother, a Russian immigrant who was very involved in civic affairs, who counted Eleanor Roosevelt and Albert Schweitzer among her friends, slapped my mother across the face. My mother was about thirteen at the time. My mother tried to make sure, by indirect gesture if not by direct conversation, that I felt comfortable with my own sexuality and sexuality as a part of the lives of other people.

I have two brothers, and until I was sixteen my family had money, a big house, and a classic Jaguar, which I drove to school. My brothers and I all had our own bedrooms. When my father had a very bad car accident, we sold the house, the car, and moved to a small apartment, where my younger and older brother shared a room. Since I showed the most academic promise and didn't really get along with either of my brothers, who got along with each other pretty well, I got my own room. That was a very sensual time for me, because I had privacy during adolescence and my brothers didn't. For example, I had the private space to fantasize if I wanted to, and I wanted to very much. Now I wonder how my brothers worked that out. I think that by the very nature of their physical setup, their sexual fantasies were probably arrested, whereas mine were given fairly free rein. My brothers are both

married with children. I'm not married and have never had a child with anyone. I don't know if this is at all connected to the adolescent situation, but I think that in many ways I don't fully understand it's possible.

Montano: The family was not pleasure-negative.

Kolpan: No. In fact, if anything, pleasure within the family was very much encouraged. My mother left information about sex, clinical stuff really, around the house. There was a lot of swimming, tennis, singing, eating for pleasure, and pleasure in seeing my paternal grandmother. Both grandfathers were dead, and my maternal grandmother really didn't like me, because I reminded her of my mother—her daughter— whom she didn't understand.

Visiting with my father's mother was one of the important events of my youth. She would tell me many stories about my father in his youth. He was a bad boy in these stories, kind of a lovable wild animal, always cutting school, disappearing for days at a time, bringing home the worst kinds of friends. The stories were very funny and always included the fact that the girls in this old Jewish neighborhood in the Bronx would swoon over my father, who really was good-looking, I guess. Between my grandmother's stories and my father's war stories, my father took on a certain fantasy aura. I could only laugh, because I was a serious, studious, unhappy kid, nothing like my father. My mother was a serious, studious, unhappy kid in her own youth.

I remember seeing old photographs of my grandmother, an immigrant from Franz Joseph's Austria-Hungary, who came to this country when she was thirteen and was married at sixteen. In these photographs she was perhaps the most beautiful woman I had ever seen, and I always kept this image of this beautiful young woman in my mind, even when I saw her as an older woman who had been through a lot. She died when I was seventeen, while my father was in the hospital, recovering from his auto accident.

Montano: How did you translate this pull toward the erotic into your work?

Kolpan: I find nature to be highly erotic, and so I began to make videotapes of, for want of a better word, nature—animals, water, leaves, sky. I find it all very tactile and sensual, and although I didn't and don't approach my work with the sensual in mind, it always seems to surface. It is seen more quickly by other people than it is by me. Like the tape *Sheep* is quite sensual, but that was not what the tape was about at the time that I was making it. It just happens that many people think watching sheep running, mounting, colliding in slow motion is very textural and sensual. The videotape *Yellow Rose Ceremony* has been interpreted as highly erotic, and it is a kind of meditation on deflowering, but eroticism was not my conscious intent. The tape is a visual commentary on an essay by D. T. Suzuki in the book *Zen Buddhism and Psychoanalysis,* about the art of life and contemporary neurosis. We pick a flower to appreciate it, killing it in the process. But only I, and now you, know my reference for this tape.

Montano: Would you call your life an erotic performance?

Kolpan: Up until recently my life could be looked at that way, but right now I find myself questioning the value of the erotic life. I've had many erotic experiences, and these do find their way into my work. But when I actually formalize that aspect of life into performance, it is then that the sensuality seems to slip away. However, when I make work that goes beyond that intention, the first thing that seems to surface is the sensual aspect, a kind of erotic tension.

In my daily life I perform on different levels, and sensuality does surface. It causes many problems, however, with increasingly diminished benefits. Some of the problems have been a broken heart, jealousies, possession, secret relationships, and relationships frowned upon by my family. In the past I have been incapable of doing anything else but responding to sensuality—I felt there were no coincidences. No, I do not

trust fate too much. Although my relationships with people still have a sensual edge to them, I explore this edge less and less, more and more selectively.

Although it has allowed me to appreciate certain pleasures—images, words, wine, textures, curves, the feel of something, the touch of another—I can feel myself changing. I'm departing from the erotic performance. Sometimes we can be swept away by the senses, eroticism, sexuality, and find that beyond and behind the pleasure there is little, if anything, else. So I am looking for a balance between my most radical impulses and my most conservative thoughts. Between wild abandon and learned behaviors. I think my erotic life and performance have been what Kushi or Oshawa in the macrobiotic literature would call *sanpaku*. I need to balance myself, but with the help of others.

Montano: What performance or videotape do you feel epitomizes this past strength or your new direction?

Kolpan: Both are incorporated in *He/She*, a very long work in progress. It talks about eroticism and also talks about paying for it. It deals with a long-term relationship that, at its core, was based on some erotic fantasies, not only on my part, but on the part of the other people. The pain that this life attitude causes is dealt with kind of obliquely, but as the tape progresses, it will become more prevalent because I have great pain and an unhealthy measure of guilt for the way I have conducted my life. The tape deals with an obsession over two issues—past performance and the issues that this past performance raises and the kind of changes it brings. It's a kind of sobering that has overtaken my life, although I still have glimpses of life as an erotic performance.

Montano: You are currently involved with an intimate affair/performance with your own body—intending to lose weight performatively.

Kolpan: I'm in the thirtieth day of a juice fast. I plan to do it for one hundred days. I'm very involved with and have been involved with my

own body. I have acupuncture every week and have done so for the past year and a half. It has restored me to health. I have made video-tapes of my own body and of myself undergoing various physical activities. Now I am planning to lose one half of my body, and I'm beginning to sense that this will bring about a cathartic change in my life. Even if there is no easily perceptible change, just the weight loss and the process by which the weight is lost will prove to be a catharsis. I can sense now that a lot of things happening around me are different. My own day-to-day functioning is different. For example, when you fast for a long time, in order to shit, you have to use enemas. Just this aspect of time spent on this activity, formerly taken for granted, makes me very conscious of the attention that must be paid to every part of my life. Fasting has made me keenly aware of the function of food and eating in my life and the lives of others. Believe me, it has almost nothing to do with hunger—it is a social ritual, oftentimes a positive one and, just as often, a negative ritual.

I'm thirty-seven and have been overweight all my life. I can't say that I enjoy fasting, but just as you are in the midst of a seven-year performance and are committed to doing that, I'm committed to losing half my weight. Unlike yourself, however, when I attain this goal, I will celebrate in the most outrageous way. An excessive celebration, bordering on dangerous, harmful. I will do something on that day that will make a marked difference in my life, so that I will be able to remember that day and the entire process in a substantive way.

JILL KROESEN

Montano: How did you feel about sex as a child?

Kroesen: My first sexual fantasies were about machines. One would get on a conveyer belt, and various things would be done to your

body. I was born in 1949, at a time when you weren't supposed to have sex until you were married. From the time I was about twelve, I had boyfriends whom I made out with constantly—lots of heavy petting—but I never had the urge to have intercourse at all. At seventeen I finally did it when I was talked into it by my boyfriend at the time, the cutest boy in Oakland, who was going away to the marines. It didn't feel very sexy—he was in me for what seemed like many painful hours. I did think that it was very sweet, though, to have someone inside your body. I felt different afterward, and my period lightened up. It wasn't until I was nineteen that I discovered that orgasms and boys had anything to do with each other. Before that, when I had sex, I would end up wandering around feeling frustrated. Sometimes I would even go for long rides or walks late at night without having any idea what was wrong.

Montano: What is there about sex in your work?

Kroesen: There is a lot about sex and sex roles in my work. I played male characters mostly, and often men would play female characters. Many of my plays were born out of sex fantasies, but by the time the work reaches the public, most of the porn is gone. Two songs contain some explicit sex, "The Original Lou and Walter Story," which is an explicit gay male S&M song, and "Penis Envy Blues." Both songs embarrass me a lot to sing now, although they didn't used to.

Montano: Did you experiment with gender changes in your life, or was it just an artistic vehicle?

Kroesen: There was a time when I thought that I would really rather be a male, although I never considered having an operation or anything like that. I wore butch clothes for years and even wore a mustache that I drew on with a pen in daily life for a few years. Then one day I was thinking about transsexuals and transvestites and thought about how these men wish they could be a woman, and here I was one—maybe I should enjoy it. After that I slowly adopted traditional female ways of

looking. At first I would only go to places where no one knew me to wear a dress. I felt like I was in drag, and I really felt guilty. I started taking ballet, which made me feel very feminine and beautiful and exhilarated. For some mysterious reason, I didn't feel like I deserved to feel in those ways, and I injured myself and couldn't dance for eight years. Actually, the wearing of female clothes made me feel vulnerable. My defenses started to melt, and I really fell apart completely. Those damn dresses!

Montano: When did you start using your voice? Do you consider that your medium?

Kroesen: I always sang along with records, but I started to sing by myself in college. I developed my low voice to express my frustration over Tom, whom I had a crush on and who liked me but took six months to let me know. This voice has basically served to express deep, dark, excruciating pain and terror. I suppose I can use it to express other feelings, but when I hear it now, it embarrasses me because I associate it with those feelings. I am very confused about it now. The way I act and look does not match the way my voice sounds—that makes me feel like a freak. I'd rather have access to a high voice that sounds like a girl. I'm trying to work on it. We'll see what happens.

Montano: What do you consider your art of live performance to be?

Kroesen: I make portraits of systems. My interest is in the dynamics of relationships. It's like studying the way matter and energy relate in physics. I often portray groups as individuals. For example, *Excuse Me, I Feel Like Multiplying* is about the relationship between Russia and the United States, with the two superpowers being portrayed as individuals fighting over the underdeveloped country as a love object. In another play, *Fay Shism in the Home,* Hitler and the Third Reich are portrayed as a femme fatale, with the SS as her eager boyfriends and the persecuted people as her roommate.

Montano: How do you feel about sex now?

Kroesen: It feels forbidden, scary, and rare and precious. Though I have great permission to think anything I want and let my work go anywhere it seems to want to go, I still feel guilty to have sex fantasies about men. That is the only thing that I won't allow myself to think about, though they slip out once in a while. I'm totally confused about sex and love and feel like a person from another planet. Excuse me, while I make an appointment with a psychiatrist.

ROBERT KUSHNER

Montano: How did you feel about sex as a child?

Kushner: It was something mysterious and a little scary. I didn't understand it at all and had the misconception that it was necessary but not connected to pleasure. That idea changed after I was in college and became an active and practicing sexual person.

Montano: Were other things pleasurable in childhood?

Kushner: Yes, gardening and hanging out in my mother's studio. I would watch her paint with her friends or do my own art work, which was extremely satisfying. For the most part, I was very lonely as a child and have many memories of being isolated, so the pleasures were very personal and private, rather than social and interactive. My father and I were distant when I was a child. He wanted to be close to me, but he and I were temperamentally very different although we had a bond. We only started getting close to each other when I was an adult. He had a difficult life because he couldn't find a profession in which he could really excel. He was a very angry man and was also ill a lot of the time with heart trouble, and that made him very resentful of life. When I left home and went to college, we had more space between us, and that made him a little happier and gave us a chance to get to know each other. When I was growing up, he was trying to be a businessman and

was selling real estate, doing all of those things, which didn't interest me because I wasn't interested in money, even then. He also liked politics, not on a candidate level but as a real lefty, interested in world events, political analysis, and the motivations behind seemingly arbitrary political action.

Montano: There is a sensual energy that permeates your performances. What is the origin of it?

Kushner: In college I wanted to make art seriously and in the way that I thought that I should make it, and that meant exploring things from my childhood. And to do that we have to get back to talking about my father, who was a furrier. Although he eventually stopped working that way, some of his friends were furriers, so I had access to fur and would make little boxes filled with scraps. Also, my grandmother lived near us, and she would make her own hats to wear to service every Saturday morning, so she had boxes of feathers, silk flowers, and rhinestone buttons. All of those things were sources of intense fascination and real pleasure. This peculiarly precious yet slightly tacky material was beautiful in the eyes of a six-year-old child. When I later started to make costumes, I wanted to incorporate all of these things because they were beautiful reminders of my past. By using them I was taking stock of who I was. I conceived of this work as "sissy consciousness," because I had been a sissy as a child or was considered so by my friends, and I guess also by myself. But also it was a real way of trying to react to the macho art materials that you were expected to use.

I was always interested in blurring stereotypes of sexuality, which doesn't mean that I was specifically interested in making a transvestite statement, but I was asking the question, "Why do we associate certain garments and certain attitudes with one's sex—specifically, with women?" I always have been very jealous of the range of clothing that they have available, because men are traditionally given a very narrow range to choose from. In my day-to-day life of going to the bank or

grocery store, I was not interested in challenging those stereotypes, but performance let me do it in a formal way. It became a rhetorical question rather than a lifestyle question. People used to ask me why I didn't wear the costumes that I made on the street, but I was more interested in the costume reflecting my deep thoughts, not my daily life thoughts. The costumes were always my art, not my daily life.

Montano: What happened to you as a result of those performances?

Kushner: The early performances were about directing large groups of people, while in the later ones, I was more interested in doing solo or duet work. Then I became more responsible for maintaining the mood. The two moods that I worked with were joy and sadness, and occasionally I would go into these very deep emotional states where I was able to maintain and portray a poignant sadness. That became a challenge—Romantic sadness.

Montano: That sounds like a Japanese aesthetic.

Kushner: Yes, it is. In fact, they have a special word for that specific condition of sadness, although I knew nothing about it at that time. Quite often that mood would not happen. I can remember one section of a very long striptease when I was taking off layers of white, cream-colored silk and rearranging it by taking it from my waist and putting it around my head, ten or fifteen layers. I always thought of that as peeling an onion, revealing more and more and more until finally I was naked and there was nothing left to peel away from the outside. In fact, I sometimes would enter a state where I felt that I was stripping for God, that God was my audience, and that I was revealing what God already knew was there. When that would happen, it was wonderful. But like all performers, I faced times when it was not happening, and I vividly remember a time when I went through this whole thing, and I had realized that the audience was getting something, but I was totally distracted. I was into the movement and the choreography of it, but my mind kept saying, "You're faking it." It was a very strange feeling

because performance had up until then been a high experience. The point is that it was not always a positively cathartic experience.

Montano: Is that why you stopped performing?

Kushner: I've often asked myself that question, and I came up with three ideas. It was a combination of having gone through a lot of basic variations on the theme that I had started exploring and the question was, "How does what we wear affect everything else about us?" To answer that, I worked through a series of fashion shows and hat shows as solos and groups. By doing that work, I satisfactorily answered the question for myself. The second reason I stopped performing is because after I worked through that question, I was devoid of ideas. That's always a good reason to change, plus I wasn't getting support for my work from anyplace. And the third reason I stopped is because I was getting tired of performing. I solved that by training four people to do this one piece, and that was satisfying, but then I just stopped. The energy had left, and I was becoming more engrossed in the problems of painting and two-dimensional composition.

Montano: What is the pleasure now? What is the catharsis?

Kushner: It's my studio. The artistic charge that I used to get from performance comes from less time-oriented activity. There is frankly still a lot of performance in my studio work because I do almost all of my drawings from models, and I do them in real time. I don't do a drawing and then fudge it afterward, because whatever I've drawn, I stick with; so I am still working in time as I did then, but it is studio time. Now I fall in love with the painting and the process of painting, the same as I used to fall in love with the experience of performing in time with an audience.

But the joy and catharsis come from other aspects of my life right now. My family and certainly my spiritual practice are very important to me. The way that I used to perform always had an element of exhibitionism to it that doesn't seem to be necessary to me in my life right

now. People used to talk with me about that exhibitionistic quality when I would perform nude, but I would always deny it while I was doing it. Now when I look back, I see that there was a need to show myself or flaunt myself or reveal myself that I just don't feel anymore. The pressures that come from doing a performance, I really don't relish. Then it was fun and a stimulus, but I don't want that kind of pressure now.

Montano: What is the responsibility of the artist?

Kushner: To oneself? To society? The main responsibility is to honesty. The artist wants to see. For example, very often I am working on something in the studio where it has reached an impasse and I know that it looks okay, I know that it may even be able to be sold, that someone would like it, but I also know that I could learn more from it and I have to risk wrecking it. I have often wrecked paintings, which may or may not come back from wherever they have gone. There is a dishonesty in letting myself off the hook, and I will not do that because it is then easy to slip into a kind of laziness and lack of discipline. So that is my responsibility to myself. To the public? I think that we have to give people pleasure rather than stir them up or show them things about the world that they may have overlooked. Many artists tend to do that and do it much better than I can. They show the boredom, frustration, and difficulty of the time that we live in. I would like to think that I have the gift to give pleasure and enjoyment.

MINNETTE LEHMANN

Montano: How did you feel about sex as a child?

Lehmann: She remembered lying in her crib in the empty room, the early morning sun coming under the shade, picking her nose, tasting the salt. Later, when she was three, one evening in the Madestone

Apartments, there was quarreling behind the Chinese screen. That started endless nightmares connected by the theme inside/out. A year later she looked up to see her mother's eyes glowing yellow-green as she screamed at her and Johnny, who were lying on the bed with their pants off, investigating the difference. She wished them all dead because no matter how hard she tried, she couldn't say no to playing doctor under the sheets strung up on the clothesline in the backyard. Mrs. Rown, the baby-sitter, put Ivory soap in her mouth because some word offended her. She attempted to leave, taking her doll and buggy over to Clunie Park, but they brought her back for more punishment. Between the stucco bungalows on Twenty-third and E Streets, a patch of lawn about four feet wide was the scene of many pleasant days with Doreen and her Pekinese dog. She and Doreen played sophisticated games of Doctor and Teacher, where they took turns being in charge. She always wanted to have it done to her. Sexual discourse has animated her life; the ability to enter another, to affect another, to forget herself in another, to put off mortality. It's all about how you get into someone or how they do it to you. All the apertures count. Certainly the ivory-coated words coming off a page can tickle everything between your legs. Powerful words can also travel up to inscribe you in this backward civilization with its dead institutions. Or the ideas can allow you to laugh together, really together, joined at the hips, laughing at dead rules.

Montano: Who are your influences?

Lehmann: For me, right now, it is the discourse of such people as Jane Gallop, Kaja Silverman, Yvonne Rainer, Linda Nochlin, and Rosalind Krauss articulating the ancient ideas, twisted for women, playing between the row of houses.

Montano: Anything to add?

Lehmann: I remember when we met and went to a stranger's over-stuffed apartment in the Haight. We sat in a circle talking of this and

that. I remember being startled by feeling a warm embrace although no one was actually touching me. I looked around the dimly lit room and located the source. It was coming from you, and my body and mind opened to you.

LYDIA LUNCH

Montano: How did you feel about sex as a young person living in Rochester, New York?

Lunch: By young, what do you mean? Six? Twelve? Sixteen?

Montano: All of them.

Lunch: At six, sex was an invasion. It was hell! And pain and guilt. However, at that age you don't know what you are feeling or why you are subjected to those things because you can't reason it out or say no. By the time I was twelve, I had become stronger and could say no. Then sex was an obsessive preoccupation, and I decided it could be used for enjoyment because of a black-haired hot-rod racer a few blocks away who fucked everything that walked. Then I was able to manipulate it. I was doing the sexual invasion. For six years, I used sex as a weapon, a tool of infinite power. So by the time I was a reasoning person and educated by necessity and thirst and hunger—I began viewing sex in a more scientific way, although I can't say I didn't enjoy it physically also. I don't know how I was able to enjoy it mentally at that time because I didn't have the distance to say, "You are doing exactly what has been done to you." Until you've made your mistakes and fortified your bad habits, you can't reflect—until you decide to alter the pattern, you will not know what you are doing.

By the time that I was eighteen, however, I decided to maybe experiment in a different format. Up until that time all the manipulations

and power of sex were really mental games more than physical games, because mental games hurt more. When I was ready for something else, I decided to experiment with sex in a more physically devastating manner. I could then accept and reciprocate in a more violently physically intoxicating experiment. The perfect man then equaled asshole, big dick, or idiot. That ended a few years ago, and we'll all know the results of these experiments with my new book, *My Father's Daughter,* which is about how one person, given a set of circumstances, eventually arrives at this—I hate to say conclusion, because I haven't concluded—ends up feeling, thinking, and acting the way that I have.

Now, I'm not an example by which we can judge the rest of the world, but I'm not unique. I'm female. Universal female phenomena have occurred in my life, and I've noticed, as I say, that with maturity I see the same things happening to other women. I'm not claiming to speak for everyone, just for people who have suffered the consequences but have not been buried by them. I kick and bite and scream and yell for everything I believe in, stand for, and mean. I guess that's my message. It doesn't matter what has happened to you. Who cares? Okay, I care. I'm very interested. But it's happened to all of us in one form or another. As I say, "It's all about getting fucked!" That's what it's all about, Linda. "GETTING FUCKED UP, FUCKED OVER, FUCKED AROUND, FUCKED WITH, OR JUST PLAIN GOOD OLD-FASHIONED FUCKED." But it doesn't stop there. It's for you to take it from there.

Two years ago a cycle ended. I was saturated with this experiment or a certain phase in the experimentation, although I hate to use the word "experiment" because it sounds totally impersonal. I haven't done everything as some sort of pseudo-sociopsychological-analytical capitalization on the exploitation of women, although it may appear like that. Two years ago I decided that I wanted to understand what the patterns are, how the circle comes around, how you translate your disadvantages or abuses into advantages. No one can escape disadvantages,

either personal ones or those society imposes on you so that you think you aren't beautiful enough, tall enough, rich enough, intelligent enough, blond enough, sexy enough, or don't live in the right neighborhood.

But I wanted to break out of my habit as a child. I had made myself physically sick and tortured, reading the Bible and living with a card-playing, horse-racing, drinking door-to-door salesman who just happened to be my wonderful father—living in a black ghetto until I was thirteen. I mean, you just have to decide that either you sit in the corner, crying your eyes out for the rest of your life, or do something about it, which in my case was to read half-pulp psychology or whatever Freud or Jung I could get my hands on to figure out why I was fucked up.

I knew that was not normal. You know it's not normal by the time you're nine or ten or eleven. You know that everyone is not being tortured with the vision of hell twenty-four hours a day because of guilt, fear, and terror. Why are you being tortured? I'm not a martyr. If I was put on this earth to suffer, okay, I can accept that, but I'm not going to just sit there and take it. You have to be able to turn your disadvantages into advantages. The key to success is not falling into patterns, which I see almost every human being falling into. It's very important for me to progress, to mature, and to fucking get over it. That's what I'm trying to do. And I think I'm almost successful.

Montano: And you've made an art of that process.

Lunch: Exactly. It didn't strike me until recently that what I am, in my incredible generosity, is a public exhibitionist of my most tortured, personal feelings. That's what I've done since day one, when I started screaming and yelling, and I've been screaming ever since. That's one thing I would not like to get over, but once I understand this and understand that I'm trying to correct my problems as I recognize them, then hopefully my art, which is my life, will progress, so that I will al-

ways be screaming at people for however they irritate me. I could be screaming until I'm ninety-nine years old and be justified. But, progression.

My new thing is running against the president. Not running for president. Lydia Lunch is not running for president, don't worry. I am running against the president. My new speeches are politically oriented. My beef has always been a one-woman war, a one-man gang of me-versus-you. Now I'm getting a little bit more specific, and it's just going to be me versus Reagan! So Reagan has become my big fucking father, the father of my country, the man that fucks the whole world! It's all about getting fucked, and he's the biggest dick I can think of. If he wants to compete, I can be the biggest cunt. We can see eye to eye on a lot of things. That's my hope for 1988. It is default, the big coming. The second coming, and this time I want to be the one doing the coming. He can swallow it. No free Lunch. I don't care. That's it. That's exactly it.

Montano: How did you get so smart?

Lunch: I dropped out of school at fifteen—that's how I got smart. I dropped out so I could get an education under the tutelage of my English teacher, who suggested that I leave Rochester, New York, for New York City. I came here when I was fourteen to escape and because things were happening, and then I moved here when I was sixteen and lived in the Chelsea district, begging with hippies for money. But look where I am today—I'm on 109th Street, Spanish Harlem. Born in a ghetto, died in a ghetto. I mean, it doesn't matter. As long as I don't have the slum mentality, I don't care. As long as I am not out on the street buying or selling crack, I'm fine. I don't care if I have to live here. That doesn't matter to me—109th Street, Soho, or Beverly Hills—because I'm living among shit, and that doesn't impress me. Expensive shit, cheap shit, it doesn't matter.

Montano: What did you learn on the street that you couldn't have learned in school?

Lunch: Facts. The facts of life, survival techniques, and strength—not taking kicks in the teeth, which is not to say be a hard-faced, hard-assed, coldhearted bitch. It's more about personal pride, being or doing the best I can do. That's not what everyone on the street practices, but if you reduced survival to basics, that's what it is. People have to learn to take care of themselves. Now for some that means ripping off the first guy who comes along, but that's not how all street people do it. A lot of them are looking after themselves in a way that is not strictly selfish. They are surviving, and they have pride in themselves.

Human animals, like most animals, only want to do what it takes to survive—go to work, do their thing, get paid. They love the ritual, they love the routine, because it's much easier. It's simple. When you slip into a routine, you don't have to think about what to do or what to think or how to be. It's all set up for you. I have avoided that. I haven't had a job in almost ten years. When the day comes for reality to really settle in, we'll see how smart I am.

Montano: How do you pay rent?

Lunch: I perform. But very rarely. I don't have any expensive habits or an expensive lifestyle, so I can support myself easily by my performances. I've also set up my own record label to put out my own products and a few other people's. My records don't sell a lot. Neither do the other ones I put out, but it gets the products where they are wanted.

Montano: How do you feel about sex now?

Lunch: Sex in the eighties is very disturbing to me. I've altered my sexual patterns and habits; I have progressed. Now I am with the same man and have been with him for three years. I am monogamous now, not by moral or personal choice but for health reasons, because I think sex in the eighties is dangerous. Although I believe sex and death are very closely related, I don't feel that a sexual plague should destroy my life. Now I'm very sexually satisfied, almost, because it's a more personal thing to me, without too much of the game or experimentation

or analysis. I've already figured out my problems and my interest, and I know that you can actually experiment just so long before you actually die, which I'm not ready to do now, no matter how prepared I was in the past. I would not like to be thirteen or fourteen now and as sexually voracious as I was because you can't be. You are insane if you are, absolutely insane.

But we are all paying for our liberation, either with the spread of venereal infection that everyone I know has, females especially, or just fear of disease. It is a very stifling time, and anyone who hasn't had a steady partner and one that is sexually satisfying—I'm sorry for you, I really am. I am so happy that I had the time that I did, which I consider a safe time, never getting any disease that was incredibly disastrous, either in physical damage or irreparable infection. I feel very lucky, I really do.

Montano: Do you relate with your partner differently because you want to stay in the relationship?

Lunch: I have chosen to be with a man who is my equal, as opposed to someone I could outsmart or someone I wasn't learning from or educating myself with. The person I am with now is my first equal, and this is the first time I have ever been interested in a man who was my equal. In the past we would use each other for mutual stimulation; I lived out a fetishism, and I got reciprocated. Now I have a relationship with my best friend, and although sex is a very important part, it is by no means the basis of it. I knew this man for quite a while before sex came into it. And I'll know him quite a while after sex goes out of it.

Montano: What do you think that people are doing with their sexual energy since it cannot be spread around so much?

Lunch: I think that they are transferring that energy into making money because money is a substitute for sex. My generation was more sex-oriented and did all the things that go along with sex, including drugs. I think people now are more ambitious, certainly, than I am. I

am perfectly happy to continue at the rate of progress I am, which means that I'm not looking for any great alteration in my financial situation. People now want more—more money, position, power, authority. Good luck. It's an empty and lonely thing at the end of the day. I'm not saying that you should be after what I am after or should live your life like me, but I have been rewarded with experience and knowledge I couldn't have had if I had gone to school for ten more years and pursued one line of work. The school of life I have gone to takes a lot of time. It takes years with one person and with many people on the sidelines to get the information.

You can't figure these things out in one night. The number of friends I have is very limited because I insist on giving everything I have and getting everything you have in mutual exchange. That is too demanding for most people. They don't have time. They are busy on the phone, being businessmen and businesswomen. To give and get everything from each other, you have to trust and respect, allowing people total freedom without being petty, jealous, or greedy. I believe in mutual exchange.

PAUL McCARTHY

Montano: I'm doing interviews with artists on the topics food, sex, money/fame, ritual/death, and I would like to interview you about sex.

McCarthy: You can ask me questions about sex if you want, but I'm concerned with more than that.

Montano: Okay. Sex it is. I'm looking for connections between your personal history and sexual imagery, and so the first question is about your past. What was your early childhood like as far as sex was concerned?

McCarthy: I came from a pretty repressed sexual environment. It was religious and isolated. I didn't know what sex was. It was a taboo subject. I grew up not talking about it. It was a Mormon community. My grandfather was Irish Catholic. My parents weren't particularly religious, but the environment was. The whole community was Mormon. I went to a Mormon church. The church was very youth-oriented. It was a town outside Salt Lake City, a kind of rural farm environment. They were beginning to build suburbs and tract houses, and now it's just like the San Fernando Valley—all tract houses.

Montano: When did you start using sexual imagery in your work?

McCarthy: The paintings that I did in 1966 had sexual imagery. They were triptychs with a machine beast or a tree beast in the center, surrounded on both sides by nude females. Their arms and legs looked like ropes. I usually wrote down the center. The writing was short slang and referred to power. I also started painting with my hands. The paintings were laid flat on the ground. The act of painting itself was sexual, was a sensual act. The last one was almost all black, no figures. This was in 1968. I always lit the paintings on fire. I poured gasoline on them and threw a match. I let them burn until they became charred. The last one was like a doorway to me. I became aware of Allan Kaprow, Yves Klein, and Yoko Ono in 1966–67. One of my first performances was in 1966. It was a kind of homage to Yves Klein. I jumped from a second-floor window in the art department. I didn't know that he had painted with fire until years later. I started the performances with food in 1972.

Montano: Why do you think that you were using such powerful imagery?

McCarthy: One reason was that I was obsessed with what had been repressed. Nothing new, probably. In performances I coated my thighs with ketchup and bent over with my face between my legs and sucked on bottle caps. My motivation seems physical. My head up my rectum. It was about body sensations, physical sensations.

Montano: Have you traced that to anything?

McCarthy: You mean to a trauma? I was a breech birth. I came out ass first and bent over. It was a difficult delivery. Maybe I have physical memories of it. I have done a series of performances that involve the act of being bent over grabbing my toes. I asked my mother about being breech birth. She made light of it, made some joke. They'd put her to sleep anyway. Using sex in my work has a lot to do with anxiety. For the most part, it's directed at myself and objects. I was an old woman for a while in performances, and that came from a repulsion. When I was a kid I remember two or three women in particular squeezing me. I was not able to get away, so it was about those women, not all women. When I write about it now, I write about my memories and certain types of women and my relationship with them—aunts, a step-grandmother, a neighbor. Then I started doing males—old men, power figures, political leaders. I bought a mask in Hollywood, and later I realized that it looked like my grandfather. I started being animals— a monkey and a pig. In the beginning I made noises, but lately I've been doing a lot of talking. Talking started with the first *Death Ship,* where I am a sea captain. The images I use are ketchup for the blood, packing my ass closed with hamburger so it's stopped up, stuffing my mouth, sticking my face in ketchup. The last ones have been funny. At the San Francisco Art Institute, I felt that the audience was out to get me. At the end it got really nuts. I got people to laugh.

Montano: What effect does your work have on your everyday life?

McCarthy: I don't usually make art consciously, directly, or literally about myself or my life. It's more metaphorical. I think it's more like a dream. My actions surprise me. Sometimes it's like waking up in the morning. I rely on my physical responses or the way things occur by chance or the way something becomes something else in my imagination during the performance. I couldn't predetermine these things, although I often know where to start or have chosen an image to begin

with. I do repeat specific actions from past performances. They become starting points.

Montano: Physical sensation is your motivation for performing. What is the source of that?

McCarthy: Physical sensation is not my complete motivation for my performances. There are physical sensations during the performances. I might feel like lying down or rubbing against something. Sometimes I feel strongly about becoming something or that I have become something. There are physical sensations that are not part of the performances. They occur just prior to sleep when I am completely relaxed. One night I was lying in bed and felt my arms becoming huge and heavy. I sensed that if I could see them, they would be concrete. I had them on my chest, and it felt like they were sinking through my chest and I couldn't lift them. I couldn't breathe. I write all of my sensations down. I have a list of them. I would lie down, and for a split second I would become someone else. The realization that I had been someone else only occurred after the sensation left. A lot of times, I became old people. Sometimes I grow larger until I fill the room. Sometimes in conversations with people, I all of a sudden feel as if I am looking out of my stomach.

In the *Death Ship,* I am the captain. It is the ship of death. The audience is seated in the shape of a ship, and they wear little white sailor hats to identify them as the crew. In the piece I talk about two contrasting cultures. I call one the Aryans—the ones who invented cars, radios, TVs—the vain ones. I call the other ones the Little Brown People, the so-called primitives, aborigines, tribes in Africa and South America, people who remain near the original or basic state. I tell the crew that the Aryan ship is going in and out of little coves, capturing Little Brown People. I carry a saw blade, a circular blade that I call the Aryan wheel.

I had been thinking a lot about cultures and the way that they develop. During the performance I told the audience—the crew—that

we needed a pure baby, born of imperfection, and that it must be born on the ship, and that I would be the mother and that the crew must fuck me. But they wouldn't do it, so I pretended that they were doing it with a pepper shaker. I had the baby on the ship, on top of a table. I held up the baby and called it the Aryan baby. They all clapped and sang "Rock-a-Bye Baby." The thing that was weird is that all along I was telling them that they were Aryan racists and that we were on a death ship. That was okay with them. They drank ketchup. I asked them to drink the blood of the sea, and they did.

TIM MILLER

Montano: How did you feel about sex as a child?

Miller: That's a funny question because we just did a Phil Donahue show for his miniseries, and the section that we did was on sex and homosexuality, but I don't have a lot of memories actually. No repertory of "Oh, I remember this or that." The main theme was one of intense feelings that I would have for male friends. But sex itself was confusing and tawdry in the way early sixties concepts of sex were—naked women and that whole thing.

Montano: When did you start performance, and why?

Miller: I performed in plays when I was seven or eight, and we did our version of *Hamlet*. My early interest was in normal theater, and when I reached high school, I tapped into another historical perspective—new forms—and started dancing, which helped me break out of the text/theater thing. It was then that the pieces started coming from my autobiography and observations.

Montano: Is your work thematically about homosexuality?

Miller: One piece is—the one that I'm doing with my boyfriend, Douglas, is about a relationship and also about adolescent flashbacks

and young adulthood flashbacks. But this is the first piece that I've made in a couple of years that has focused on sex, love, being gay—it comes after a period of making big, big pieces where I went out into the world and interviewed people, surveyed them, and had a different perspective. Three years ago I did a piece at the Kitchen called *Cost of Living,* and for that I researched human happiness all over the country. My pieces got bigger and bigger politically and theatrically, which has its problems. With this current one it was sort of nice just to come back to the unit that I live my life in and to work with that. And it is strong material, especially since we have lived together for many years in a tiny apartment on Mulberry Street. That was a fact of life, and it is what I am most interested in, since I wasn't inspired to make big pieces about democracy. It was just a natural kind of return.

Montano: Because of the pressure of AIDS, do you have a function as a gay performance artist?

Miller: Oh, yes. That's a natural assumption. I founded and ran P.S. 122 in the East Village and kept that going for years. The first thing I coordinated in 1979 was a big gay performance art festival, so that's been an ongoing concern, although I haven't limited myself to that palette. Conversely, I definitely have not ignored it, especially since the art world of the preceding generation was so closeted. And then there was the post–New Wave, late-seventies work, which irritated me because all of those famous fag artists would never go to bat and were always so discreet. They wouldn't put it on the line in terms of gay political stuff, and there were times when it would have been helpful if they had been public, straightforward, and not afraid to potentially put their international, historical art world reputations on that line. They were not there and supportive when it was time to rally around the flag or when there was one assault or another on gay people. Part of that is a generational thing, because people twenty years older don't do things that way. But also there is sometimes a desire to

preserve power in the whole complex of the art world. Money comes into the picture, too.

So yes, the current crisis has drawn me back to working on gay sex—and one good thing about the piece is that it isn't specifically about the health crisis, even though a lot of the material refers obliquely to it. I use my dog to talk about the issues, because I feel that dogs are really spiritual beings, child replacements, and entities who need energy. And the piece equates that kind of care and continuity to the same kind of attention that we need to give to a person. It's about issues of monogamy, continuity, plugging away, and it gives helpful hints on "How do you actually manage to get along with another person with all of this complicated stuff going on?" I think that, in a way, that kind of terrain was real helpful rather than specifically addressing the health crisis, because, obviously, staying with one person and not sleeping around is politically and medically correct now. And to do that you have to train yourself, the way you train a dog—*Come, Stay, Heel!* It's time now to tame yourself in the big libidinal search. Sit! There's a very funny piece of music in it called "Sit, Stay, Come," with synthesized dog barks. Rruff, rruff, rruff. Training yourself—training yourself to sit, training your dog to sit and not just go nuts. For gay men right now, the metaphor is clear.

Montano: Especially since, ten years ago, the conditioning was to not train yourself. It was imperative to run around and change Victorian repressions and stereotypes.

Miller: Things were definitely encouraged back then.

Montano: What are your training devices?

Miller: I'm twenty-eight now, getting a little bit older, and am not the new kid on the block or in the East Village, and even though the apartment is extremely narrow, I value my home time. For those reasons, it's easier now, but as my eye wanders, and interest or commitment to my partner begins to dissipate, I bring it back. I breathe and I

say, "There I am, there I go again." Also, I've had to find w
maintain my attention span a little bit better in the relationship, and we
do that by talking about stuff—we don't avoid issues, we confront
things, and make it fresh again.

Montano: All of this is going to lead to a men's movement just as
there was a women's movement. And gay men will have incredibly
strong relationships as a result of the AIDS scare.

Miller: Maybe. We are going through a very particularly intense time
right now, and it should have interesting results.

Montano: Is this typical of all gay men?

Miller: I think more of us are thinking this way. A death threat cer-
tainly improves your meditation! And if the situation changed, things
would go back in ten minutes to the former freedoms. I'm sure of that,
because people are people. But this has been a positive byproduct of
this whole terrible thing. People have been learning to take the com-
mitment of energy and make it a continuous thing and not just when it
is fun and in its first flush. So new terrains are being discovered. But is
it worth it? Why does it take twenty or thirty thousand people dying to
wake up?

I have friends who have AIDS, surprisingly few for living in New
York, where things are so bad. At this point, no one I know has died,
which is definitely odd. And so unusual. No real close friend has died.
Unfortunately, that will probably change in a year or so.

Montano: Did you have your own period of AIDS phobia? How did
you deal with that?

Miller: It comes and goes. I've been in a monogamous relationship
for almost five years, so whatever was done in the past was done. What
can I do? If I were sleeping around, I'd probably have recurrent pho-
bias, which I think is a real pattern a lot of people get into—sleeping
around, then feeling spooked and guilty—then not fooling around for
a while, then getting horny, then fooling around again.

Montano: Is it time to be a lesbian? Either that or monogamous? Celibate?

Miller: Yes, and for some reason or another there is a big lesbian scene at P.S. 122, and it's a new thing. A lot of them are really young, from eighteen to twenty-five, and they are interesting new creatures, different from lesbian friends I have had in the past. They are wildly sexualized, all sleeping with each other, somewhat like gay men of seven or eight years ago. Their intrigues are complicated; they are constantly changing their partners, and it is kind of a tribal thing. But at this point they quite sensibly totally stay within the group and deal within their own community, and men are not included. In fact, if a woman is sleeping with men, too, she doesn't get to join the club. That way everything is kept proscribed.

Montano: Anything to add?

Miller: These are hard days for sex now because of the political situation and the various health crises. The Reagan years have meant a general retrenchment and a conservative cultural tide. People are falling all over themselves, retreating from the sexual revolution and the social experimentation of the last twenty years. That makes sex a wild card, especially in this city, which is so sexualized. Even the art world is sexualized—art is sexy, so are artists, and you are around them so much here. It is still a thrilling terrain, but it is simpler now. It's a source of pleasure and fun and not so much about tension, worry, or anxiety, except for occasional AIDS phobia stuff. Before it seemed that there were more relationship problems—for example, not having a boyfriend or being stuck with somebody that you don't like or "How do I get out of this relationship?" I don't have those hassles now, and since Douglas and I work very closely, it is a team effort. That's how I feel now, but life can throw lots of surprises at you and says, "You think that you know what you are doing—well, you just wait, wait until next year and see what that will bring."

My straight men and women friends are all a little bit spooked, too. Aside from how hard it is to connect with anyone, on top of everything else to have all of these AIDS worries is like, "As if it wasn't difficult enough already!" I have a number of friends choosing to become monks and nuns, at least for a while.

FRANK MOORE AND LINDA MAC

Montano: Paul McCarthy told me that you deal with intimacy in your performances, Frank.

Moore: Yes, that's true.

Montano: How do you deal with intimacy?

Moore: That is a big question.

Montano: What are your performances like?

Moore: They vary, they vary. What I like most is spending forty-eight hours with a person and creating around them.

Montano: What do you mean, creating around them?

Moore: An intimate situation.

Montano: So you work forty-eight hours with someone creating an intimate situation. What happens in that intimate situation?

Moore: That depends. I like to have freedom to do anything except violence and sex. But sex needs to be defined.

Montano: How do you define sex?

Moore: It is the intent to have an orgasm.

Montano: Is there something other than sex?

Moore: Yes, but there are no words for it in the English language. I like kids. Kids are very physical, but it is not sex, not sexual. But we have lost that possibility. We need it, but we mix it up with sex and think sex is what we want, but it's really being close that we want. We need sex, too, but the two are different—being physical and sex.

We go after sex so intensely because we confuse the one with the other.

Montano: When you are together with someone for forty-eight hours, what is the intimacy like?

Moore: It's very concrete, not abstract. It's hard to get the forty-eight hours because people think that's a very long time.

Montano: Can you explain one event where you spent forty-eight hours with someone?

Moore: It was like this. I'll explain what I did when I did it as a growth thing, as a counselor. I had the person write a list of goals that they wanted in life. They paid me five hundred dollars and agreed to follow my directions. I said that by doing that, they would get their goals. Then I created a situation where they got their goals. But I did not like that formality. It limited what I could do. I had to get them their goals if I told them that I would.

Montano: Do you do things differently now?

Moore: This is my sign [a typed paper on the front of the wheelchair]:

> I would like to shoot you for the film that I am doing for my master's thesis at the San Francisco Art Institute. I am asking people who I find attractive, although maybe not in Hollywood's concept of attractiveness, beauty, sexiness. Then I and my wife, Linda [Mac], shoot these people, almost like in paintings, in different poses, different clothes (sometimes nude when the person feels comfortable with that), focusing on different parts of the body as abstract forms. Then I will edit these pieces into a series of collage shorts, which will be funny but will hopefully expand the concept of beauty. One of these shorts will show people just playing and having fun. Another will show the different types of bodies, but they will poke fun at the pinup concept of beauty. I have been dealing with this same subject in my oil paintings and plays and especially in my rock comedy *The Outrageous Beauty Revue,* which ran four or five years in San Francisco, and in my film *Fairy Tales Can Come True,* which will be used in special education classes. I've been shooting all kinds of people from little babies to old people. If you will pose, write down your name and phone number for me. Linda will

call you to set up a time for us to get together. It usually takes two sessions. The first time usually takes between one and two hours. We will just play around and talk about ideas for us to film with costumes and poses and, in general, have fun. And the second session, which is usually between one and three hours, we will video you. Frank Moore.

I go up to people on the street, show them my sign, and have them write their names down here on the paper. It is amazing how many people want to do it. Even uptight people change and become like children when they see the costumes. Do you see that red dress? A woman with polio wore it in the film. Since then I have everyone wear that dress, men and women both. The men like it. Then they play with everything else in there. Some show parts of themselves and their bodies because they don't have any other place where they can play where it is not sleazy. My work is not about sex but about play.

Montano: Do you use music?

Moore: Sounds of laughter. I use video because people trust that more than performance. We have shot sixty people on video. I would rather not use equipment, but most people have not heard about performance.

Montano: How do you think that people who are not handicapped can be more intimate?

Moore: By not being romantic. It puts everything in a sexual context. It makes people not enjoy being turned on.

Montano: How do you define love?

Moore: I don't.

[Each word "said" by Moore in this interview was pointed to, sometimes letter by letter, on a communication board that is attached to his wheelchair. Moore points with a long rod on a harness worn on his forehead.]

Montano: Linda, can you talk about your collaboration with Frank Moore?

Mac: Do you mean in life or in art?

Montano: Life and art.

Mac: We've been together for seven or eight years, and I mainly just hang out with Frank and do whatever there is to do that's fun. That's the way I look at what we do. And so when he comes up with a new idea for a project, for example, *The Outrageous Beauty Revue,* I get into doing that. I never go into it as art or looking at myself as an artist.

Montano: What about your work with video?

Mac: I had never used a camera before, so it was interesting playing with it. Frank's attitude toward things is not perfectionistic at all. If I were left on my own, I'd probably tend to be more of a perfectionist, but doing it with him is different. He doesn't care—we just have a good time. I get into playing with the camera, playing with people, and that is the main thing that's been going on in this video project. We meet a lot of new people, and we are with them in what is not really a social way, which I tend to shy away from in general. It's a situation that provides immediate intimacy just because of the way it's set up. I like that.

Montano: How have you redefined conventional sexuality, being with Frank?

Mac: My idea of what sex is is not as rigid as it once was. I think for most of my life I thought that if you were physical with a person, that meant it was a lead-in to having a sexual relationship with that person. I don't think that's true anymore. And I don't think it's necessarily easy for that not to be true. Now it's possible for me to play and be physical with someone and know that it's not going to lead to sex. It can simply express a way to play with that person. If that idea is clear, then that's all that it will be. I never thought that this was possible in my life. Mainly I don't think that my work has given me another option, but my relationship with Frank and the other people I live with gives me that option. The way that I relate to the people I live with defines the

way I relate to the people I don't live with, because it wouldn't work for me to have superficial social relationships outside of my primary relationships. Everything I do is affected by this kind of life.

VERNITA NEMEC

Montano: Your performances are primarily about sex. How did you feel about sex as a young person?

Nemec: My performances are about sex and romance and sex with love, as I say in *Private Places,* a performance about teenage sexuality. In this work I've explored my reactions to sex and have discovered the universality of experience through revealing my own secrets from adolescence.

I didn't do sex when I was young, but I was a flirt in the fifties way of smiling at boys, being coy, and asking boys for help when I didn't necessarily need it. *Private Places* confesses the embarrassments of adolescence, things that were a turn-on to me, pre-intercourse, pre-petting. Reading books that I thought were dirty like *Peyton Place, Marjorie Morningstar, Forever Amber,* and *Gone with the Wind,* which I would hide under my mattress when my mother yelled that I should be outside in the sun instead of hiding in my bedroom. I also made very graphic drawings of people making love in unusual positions. I hid the drawings in my dresser drawer underneath my underwear, where my mother eventually found them. My mother remembers none of this, but for me, the memory of that experience was the initial impulse to create the *Private Places* performance and to re-create the dresser, complete with an audiotape and little flashing lights illuminating the drawer. The dresser was included in a show about feminist pornography at Franklin Furnace, and the performance was presented there and at the Woman's Building in Los Angeles in 1985. The performance included the story of the dirty

drawings and other things I did then, like looking up words in the dictionary like "cock" and "intercourse." It included scrapbooks I kept of the Maidenform bra ads and other pictures of models in underwear—all of the mysteries of adolescence. For me it represented the secret side of love and romance.

My mother and father talked about how much they were in love and were openly affectionate, but there was a sense of propriety. I never saw my father in underwear, and I wasn't allowed to walk around in a slip. I came from an artistic family and saw many art books with nudes and issues of *National Geographic* with bare-breasted natives that were a turn-on, but acceptable, although I was forbidden trashy magazines, and sneaked looks at them with a girl next door. I remember my mother's little mother-daughter talk about becoming a woman and not going all the way or kissing until I was sixteen, using the symbol of the snow before footprints mar its pure white surface, and I believed in all that. I didn't want to go all the way, and I didn't pet in high school. The guys thought I did more than I did because I was such a flirt, or maybe they just got off on trying. I was pretty naive, really.

At twenty I was still saving my virginity and met a man who wanted to be a writer, who wanted to come to New York. I fell madly in love with him because his dreams matched mine. I guess he was shocked when he discovered I was still a virgin, and I was shocked that he was shocked, that he didn't believe me. Finally making love was a disappointment and hurt—the foreplay was more exciting—but we got married and stayed together for six years. I was a visual artist then, painting and drawing my frustrations and fantasies.

My work has always been about my life, and the themes most important to me were romantic and sexual. My love life or lack of love life was what concerned me until more recently. My emotional state was sexually connected. Men have always been my friends as well as

lovers, and it wasn't until after my divorce that I began to feel more comfortable with women and trust them more.

My first performance, in 1978, was called *Humorette* and was about my relationships with men, starting with my father. It was about the quest for my father, never feeling that he loved me enough and having these father feelings about him and these lover feelings about him. I remember my father once commenting on how womanly a friend of mine was becoming. I felt he rejected me by noticing her and did not see my womanliness. In *Humorette* I mix up the male symbols of father/lover/husband by recalling experiences I had with men in all those roles in a stream-of-consciousness fashion with the intention of merging the relationships. Now, because the man I am with is someone I can communicate with well, I have resolved a lot of those feelings and needs. In fact, his voice and certain looks of his remind me of my father. He plays my father when I need a daddy and reassures me in a way my father was never able to. It's curious to finally have those daddy-daughter needs satisfied.

Montano: Which sex performance satisfied your art/life needs?

Nemec: All of my performances, whether or not they deal with sex, satisfy my art/life needs. I was involved in a car accident in Greece in which we were all seriously hurt. When I woke up eight hours later, my first reaction was to ask a hospital attendant, "Will I ever be able to make love again?" because my leg and hip were broken and my whole body was numb. When I first saw that my face was scarred, I couldn't imagine that any man would ever want me, and if he did, what would I do? As part of my recovery, I developed an infatuation with my physical therapist, who showed me that it was still possible to make love by visiting me in my hotel soon after I had checked out of the hospital. I really wasn't healed for over a year, not only in my body, but in my mind. I was like a crazy person and able to function only because my survival instincts were so strong and I wanted so badly to be well again.

Out of that experience and the anger I felt, I did a performance about revenge called *My Name Is Nemesis*. In this piece I am a Victorian invalid secretly in love with her doctor. In slides she imagines their affair and a rivalry with her best friend, whom she murders. The action is the reality of the doctor caring for his patient with a sound track of her thoughts and the slide projections of her fantasies. The performance was healing for me. I was angry about the real-life injuries I had suffered, the scars, the cane I used for a year. Portraying an insane and murderous invalid was an exaggeration of that reality, but it vented some of my anger.

Montano: How do you feel about sex now after working on it as art?

Nemec: My last two performances have not been so much about sex really. For the moment, they've become more tongue-in-cheek; perhaps I've worked it out. I'm not searching for love now—I have it. I can focus on other aspects of being a woman, for instance, a woman in the art world. I've begun to include other people in my performances. At the end of last year I created *The Floating Performance* to produce and present not only my own work but also interesting work of other performers who might not be seen. For each event I find a different space, and I am also creating a slide archive of performance art. I'm becoming concerned more with getting older. I've always played the starring role myself, and I don't know yet how that will be when I'm middle-aged and beyond.

My performance work has been therapy at times, and I've worked out problems through it. Therapeutic methods of exploring experience in depth are very connected to performance. Now that I am more peaceful about myself, the focus of my material goes outside myself more. I'm not saying that I've stopped dealing with sexual themes, but I can comment on the larger world, on feminism and other political issues. Right now I don't feel such a need to confess, nor do I need so much affirmation from others—some, but not so much.

Montano: What advice would you give to a woman artist?

Nemec: Art is the perfect place to work on the things that are bothering you because it gives you freedom by its being called art and not having to be true. It might be true, but you don't have to face the consequences of reality because the problem has become your art. You can say it's not really true, it's something you made up for art. Art gives you a shelter in which to confess and examine yourself and universalize feelings. I want to use performance to clarify life for both myself and the audience. The learning process one goes through preparing for a performance and looking for the meanings one's own experiences might have for others is life-affecting. I did a performance in 1982 called *The Last Confession,* which was just that. Be honest if you need to and, if not, lie. Be honest and say you were lying, or lie and tell them you were being honest. It's your art.

PAT OLESZKO

Montano: How did you feel about sex as a child?

Oleszko: I thought that it was the most exciting thing that I could imagine. I always read a lot and had dreams filled with exotic, erotic, nude people. I come from a Victorian background—my mother is German, my father, Polish, and sex was never mentioned in the house, although reproduction was explained scientifically. I was big and very, very energetic, like one of the guys who talked big, talked fast, talked dirty. When the changes came in puberty, the other girls became womanly, but I was still much taller than everybody, and there was no way that guys my age would respond to me. It was horrifying. I spent from twelve to eighteen trying to get through life without having the physical attention of men.

I continued to have this terrifying fireball energy all through junior high and high school and was constantly getting thrown out of class for talking back to the teacher and for being loud. When I got to college at the University of Michigan, I burst open and splattered everywhere. I had six dates the first week, just like my mother said I would. But it took me a long, long time to get over the fact that I had been ignored for so long.

Performance began almost immediately and evolved from a school project. We were supposed to design a Christmas gift for the teacher, and it had to be wrapped in the same style as the gift. I drew the TA's name, not the teacher's. He was a motorcycle freak, so I built this Hell's Angels belt, put his name on it in studs, buried it in a coffin, and he had to unearth it to get it. It was the first time that I correlated what people wore to what they thought. After that I didn't turn back. I wanted to make big sculptures, but the school had three times as many kids as it was designed for. Because of space limitations and because I was humiliated that I couldn't make an armature that stood up, I figured, "I'll hang my sculptures on myself. I'm a big sculpture." I knew that I wouldn't fall down.

The work I am doing now began in my second semester of college, and as I was doing it, I found that I was solving all of these enormous problems that I had developed as a kid. By wearing these costumes and making myself up as a pedestrian sculpture, I was creating an armor that would not only bring people to me by its interesting character but also hide me. I could create all of these characters to compete against the memories and the contemporary rejection of men that I was still feeling. I was still trying to make myself happy about myself, to not care that men thought I was weird and therefore wouldn't get close to me.

This went on. For twenty-four years I thought I wasn't sexually attractive. I had an enormous sex drive that wasn't being fulfilled. In my sculptures I worked through many different stereotypes of women,

making nude bodies that were caricatures of the types I was portraying. There was a fish woman, a Playboy bunny, and in all of them I concentrated pretty heavily on the genitals for the basic hyperbole and then built out from there. That was a therapeutic way of dealing with that crossed energy. Then something happened. I was dating a famous neurosurgeon, a guy who went out with all the fancy chicks. He had been married to a stripper and was actually a closet homosexual. He asked me if I would accompany him to the amateur striptease contest at the Empire Burlesque in Toledo, Ohio, and I said, "Great," got all dressed up, and we went. The club was crammed to the rafters with people. Ten women, volunteers from the audience, stripped. Afterward he introduced me to Rose La Rose, who was the owner of the theater. And when she saw me, she acted as if she were discovering America, because there I was, dressed to kill, but in a completely different way than they were. I was barefoot, rings on my fingers, bells on my toes, and adorned! Anyway, Rose took me downstairs to meet the girls, and we all gaped at one another, and in the course of twenty-four hours she called me, trying to convince me to come down and volunteer from the audience, which I did. The other volunteer was a telephone operator from Flint who was dressed in black, was real skinny, and had a beehive hairdo. The audience booed me as I went up to the stage because I looked so weird. Then they put the music on, and I literally danced circles around this woman. I did it easily, probably because I had been using my body so long either athletically or as art, and I never felt modest about it, although I've always felt fat and have felt that way since I was five years old. But I wasn't particularly inhibited. The naked body is just another costume. Another thing that you play with. It didn't bother me at all to take off my clothes in front of these people. And at the end of the show they were standing on their chairs, screaming with appreciation.

After that I worked weekends at the striphouse and got my name, "Pat the Hippie Strippie," from the chief of police, who was Rose's

boyfriend. It was the most amazing experience—to know transsexuals, hairless strippers, serious S&M people, transvestites with families in tow, plus entertaining on the last legs of vaudeville. It was illuminating for this suburban kid.

I couldn't present myself seriously as a sex queen. It had a lot to do with my size. Being sexy was something that other women might be, but not me. My act was lively and bizarre but rarely sexy. Then one time I was the headliner, and Rose told me that I had to do a slow number, dry humping the pillows and everything. As I was having a problem with this, she told me about "Sally the Shape," a woman she discovered in a bar in Detroit. At her lowest, Sally weighed in at 170, but on stage could make everyone think that she was a sex kitten. Well, it didn't help me—the slow part was always my laugh sequence.

Montano: When did you formalize your work in public spaces other than the burlesque theater?

Oleszko: I always considered stripping art and never separated that from it. I was even writing a paper about it for school. It was art in that context. And the costumes that I designed were radically different from the ones that the other strippers used.

Montano: Have there been nuances and subtleties over the years?

Oleszko: When I started doing it, women presented stereotypes that explored expectations and sexual connotations particular to that era. Gradually the massive attack and hitting the audience over the head changed, so images that I made in 1971 of ten different female stereotypes delivered in the *Outrageous Female Body* didn't apply anymore. Then, I could wear those costumes on the street and shock everybody. There are movies of me dressed as a "sexretary" walking on the street, being followed by hundreds of people. Now the culture has worked through that stereotype's problem. Currently I am using the body as another material. It's not shocking to me in any way, and if I am using my pussy or ass as characters that sing, it's just a lighthearted tweaking

of people's sedentary and religious values, which they still maintain to validate themselves.

My mother hadn't seen me perform until two weeks ago. That's not entirely true. When I was eighteen she saw something, and I don't know what her other comments were, but she said then, "Your gloves were sloppy." A knife in the heart! Then when [my parents] got wind of this stripping thing; they didn't want to hear anything about it, so there was an enormous amount of time when they knew nothing about my work. When they moved back to this country, my mother kept saying, "I'd like to see her work before I die." I had to go to a shrink to be able to deal with the fact that she might come and say something about my sloppy gloves again. I knew that I would be destroyed if she did.

The whole family said, "Don't worry, she gets amnesia if things get too difficult." But the family was really worried. She loved it! I had the faces painted on my ass and pussy and tits, and she still said that she loved the show and she wants to go to all of my gigs. Besides, the place in Boston put us up in a real fancy hotel, and that impressed her. When I took her to the bus, she asked me how I got the face painted on my bottom, and I said that I did it. And she said, "Gee, I can't even get my own makeup on straight." Her acceptance is the most amazing thing that I can imagine.

Montano: How do you feel about sex now?

Oleszko: I think that we're kind of cooled out, me and my libido. I use sex in my work offhandedly now, and besides I have a hard time staying thin, so I can't use my body as freely in performance as I once did. I have started to have to enclose my body and use parts of it because I don't want everybody to see the whole thing.

Montano: How do you feel about aging?

Oleszko: I feel myself as half man and half woman, and that seems more of an issue than aging. I'm the man as much as I'm the woman in

my work. And people on the streets regard me frequently as a man, and that's been a real problem in my life.

When I first got to New York, I moved to the Lower East Side. I had bleached blond hair and looked like a traveling circus. Anybody as big as that who looked like that was taken for a female impersonator. I was harassed all the time, treated as if I didn't know if I was a man or a woman. So I went to Way Bandy, the fellow who did the cover for *Cosmopolitan* and billed himself as the most beautiful man in the world, and said to him, "Make me into a woman. If you can't, nobody can." And he took away my eyebrows and put a 1972 face on me, and I exited with that baby-doll face on this big body and looked more like a drag queen than ever. I have masculine features, and you don't make them look feminine. They can be womanly, but not feminine.

Montano: In other cultures, in India for example, you would be revered as the perfect being, a saint, because you are so androgynous and balanced. Your inner Shiva (male) and Shakti (female) energies have united!

Oleszko: When I go to Europe I don't have so many problems. Here it's so puritan. When a woman is aggressive and/or takes care of herself or is interested in sex, it is not acceptable. But I just can't believe that I'm that different from other women who have acknowledged appetites.

CAROLEE SCHNEEMANN

Montano: The street that led to your loft is flower-strewn, exotic, and seems like an appropriate, sensual environment and entrance to your world in New York City.

Schneemann: Let me get you around the corner. I live on the fur street—Twenty-ninth Street is where the furs begin. My loft formerly

belonged to fur cutters. When I first got here in 1962, it was covered in a patina of fur, which made it primitive, dark, mysterious. The street is also strewn with garbage, and no matter how disoriented I am, I turn the corner, and there will be something satisfying about the detritus, the basic spillage and leakage that's all over the street—flowers, furs, piles of the litter—and the Empire State Building illuminated out my front window.

Montano: How did you feel about sex as a child?

Schneemann: Drawing and masturbating were the first sacred experiences that I remember. Both activities began when I was about four years old. Exquisite sensations produced in my body and images that I made on paper tangled with language, religion, everything that I was taught. As a result I thought that the genital was where God lived. He took the form of a kind of Santa Claus and inhabited me. Santa Claus was the good version of Christ, because something awful had happened to Christ, and I didn't want that to embody me. Having Santa Claus in my body gave me a sense of effulgence, gifts, mystery, and renewal— down the chimney, into the house, up the chimney. Christianity and Christmas were two cards that led the pack, and I felt that by choosing Santa Claus over Christ, I made the pleasurable choice and was therefore able to deflect the other possibility, which was more painful, confusing.

Montano: Were your parents liberal in giving you sexual or bodily permission?

Schneemann: They weren't prohibiting. I remember their sexual pleasure with each other was all-pervasive, and I was part of that. We'd all lie in bed on Sunday mornings. They would teach me to read comics. More than any other prohibition, I remember the deep intimacy, sensuousness, and delight. I built my own erotic fantasy life with various invisible animal and human lovers inhabiting my sheets, bed, influencing common objects.

By the time I was five or six, I was playing kissing games and blind-man's bluff in the fields with the Catholic boy across the road, who was afraid when I grabbed him. Growing up in the country was very important. The animals were sexual creatures, and I identified that part of my nature with them. Nudity was also clear and direct. We turned hay as adolescents. In the afternoon, after working, we would take off our work clothes to swim naked in the river.

Montano: Your parents and environment supported your naturalness. Were there any other supports?

Schneemann: Yes, my father, as a rural physician, took care of the body—the living body, the dying body. People would come to the house with bloody limbs in their arms, and we were trained to sit them down, put a towel around something that was bleeding, and then run and get him. I would also peek through the keyhole of his office, because it was on our side of the house. Sometimes I'd see a woman's foot sticking off the edge of the examining table and I'd crouch there listening to him say strange things. For example, he asked one woman when she had menstruated, and she asked, "What's that?" and I heard him say, "Bleed." I had *Gray's Anatomy* to look at, and it gave me a peculiar sense, an inside/out visual vocabulary.

Montano: Did that kind of relationship with naturalness and the body continue? Did you direct those experiences into art at a certain point?

Schneemann: I knew that I could locate that naturalness by making images and by loving. When I was young I was called a mad pantheist by older friends. I didn't know what that was about (I hoped it was a female panther) but was told that a pantheist is a nature worshiper. I had elaborate ritual places to go and lie at certain times of day or night. There were special trees that I had to be in contact with, and I would hide in a well that my mother had filled in with flowers. I did this at dusk, because I found the transition from day to night uncertain and painful. I would get dizzy listening to the birds, smelling night aromas. That was what I had to do.

Montano: You never lost this way of exploring, and your work attests to that.

Schneemann: When sex negativity and the ordinary sexual abuse and depersonalization that females experience in our culture intruded, I tried to judge it, sort it out, not internalize it. I suppose that not internalizing prohibitions gave me some messianic sense that I was going to have to confront or go against erotic denial fragmentations.

Montano: When did you start using sexual themes in your work? What form did these take?

Schneemann: There are different strands. One theme emerged when I was four or five and I did visual dramas on prescription tablets. The tablets were thick, and so I made a sequence of drawings, not just one on a page. It would take fifteen pages for an image to emerge. These primitive drawings were filled with sexual implication.

Montano: You were making movies?

Schneemann: Yes, they were about making visual dramas (even before I had seen a movie). They were all projected, weird erotic events between male and female figurations. The second theme became clear in college. I posed for my boyfriend because we didn't have nude models at Bard. He would do studies of me but not include my head, so I thought that I would do him, only I would include his head and actually work from his head to his feet. There was great upset about his genitals appearing in the portrait. Then I did a self-portrait and sat open-legged, including my entire body and exposed genitals. The painting was glowing red and dense. I got indirect reports that this was improper. The female was the constant preoccupation of the male imagination, but when I wanted to examine it fully myself and have actual parts depicted, I was accused of breaking essential aesthetic boundaries. I remember feeling that I would have to keep my eyes on that—that I was myself both an idealization and a center of intense taboo. I didn't want to feel that taboo projected onto me. I was later temporarily kicked out of Bard for "moral turpitude" because they had seen my

boyfriend and me doing something obscene under a tree. They didn't kick him out for moral turpitude.

Montano: Was your work a continuation of and a way of maintaining this freedom that you've always had?

Schneemann: No, not quite. In the mid-sixties, when I began my film *Fuses* and the performance *Meat Joy,* I was thinking about eroticizing my guilty culture. I saw a cultural task combined with a personal dilemma. My work was dependent on my sexuality, its satisfaction, integrity. I couldn't work without a coherent sexual relationship that fueled my imagination, my energies. My mind works out of the knowledge of the body. An erotic sensibility is inevitably going to experience conflicting messages in a masculinist culture that is basically divisive, sex-negative—one that traditionally controls female expressiveness, our imaginative domain, our creative will, our desire.

Montano: Did you have any models in this work?

Schneemann: In the early sixties, my personal relationships, lovers, and friends were sustaining, as well as the writings of Wilhelm Reich and Simone de Beauvoir. Researching the "lost" paintings and writing of women artists was very important, and I also did research in obscure books in Dutch, German, French, just to discover unacknowledged women as precedents.

Montano: You were a pioneer in a time when there wasn't that much support for what you were doing.

Schneemann: It was a lonely, stroke-by-stroke position. I had to resist, analyze, and reposition sexual/cultural attitudes.

Montano: Did you suffer from guilt yourself?

Schneemann: I might feel guilty if too many sexual events pile up close to each other, but it's worse for me to judge or deny sexual feelings or experience. I've only really regretted the times when I felt that I wanted to be with someone and there was something socially or interpersonally uncertain about the situation and I said "no."

Montano: You had guilt in reverse?

Schneemann: There are levels of reversal here.

Montano: Have you ever thought of writing a handbook for the sexually guilty?

Schneemann: I wrote one in 1970 for the sexually curious: *The Sexual Parameters Survey.* It's in the form of a chart collating all aspects of lovemaking. I was alone after having been in an equitable, loving relationship for more than ten years. I began to encounter areas of sex negativity in relationships I assumed would be spontaneous, whole, passionate, even temporary. At times my body seemed to be a battleground of projected taboos, contradictions. I posited a range of analysis, the sexual parameters to which three women friends contributed their personal data. It was exhibited as a five-foot-long chart in a London gallery and was printed in my book *Parts of a Body House* (1971).

Montano: Has the message of your performances changed over the years?

Schneemann: Two recent performances, *Dirty Pictures* and *Fresh Blood,* develop movement and slide imagery from texts that unravel specific erotic information as metaphor.

DIRTY PICTURES:
Erotic close-up images of body parts of myself and my lover . . . contrasted with body images that register ambiguities between sensuality, eroticism, pornography . . . images from anatomy books, mutilated bodies, X-rays, baby shit . . . the texts structure a series of "interrogations" about actual sexual experiences . . . the interrogated and the interrogator share the same secret knowledge . . . answers evaded, diverted, then stated. This knowledge centers on a female basis of sexuality. The performers' physical actions concretize aspects of the surrounding slide images . . . these juxtapositions are often comic, releasing tensions between image and text, between the public and private knowledge.

FRESH BLOOD:
. . . the visual analysis and association of two simple dream objects (an umbrella and a bouquet of dried flowers) produces a matrix embracing elements of architecture, chemistry, crystal physics, alchemy, goddess

worship, etymology. This morphology re-enters its source in the dreamer's body.

Montano: Your work has been celebratory and didactic. It's been for others, and in that sense, how has it helped you?

Schneemann: It's made me concentrate on formal structures. My work presents particular difficulties because its source and its forms examine eroticism, but that can also be used against it. The content can be used to trivialize the formal complexity. Recent audiences and critics are doing somewhat better. It seems that feminist analysis has deepened perceptions for the process of the work.

BARBARA SMITH

Montano: Your work with sexuality is as memorable as your work with food. But let's talk about sex. How did you feel about sex as a child?

Smith: As a child I don't think that I was terribly aware one way or another. I was stimulated but didn't know it. I remember being in the bathtub with my brother and being very curious about his penis, and seeing my father nude and being curious about his penis, and seeing my mother nude. I also had escapades with the neighbor boy—we showed ourselves to each other and were caught by my mother. I can also remember masturbatory things when I was a toddler. Once I was under the dining room table when my mother was ironing, and she told me not to touch myself. My mother was the more antisexual one in the family. I felt angry at her for telling me that, and I wondered why she did it. Basically, I think that I was naturally curious, joyful, and energized by sex.

Montano: Were there times when you felt guilty because of your interest in sex?

Smith: Only when my mother told me those things, and then I would try not to touch myself because I thought that it was bad. I was more angry at her than guilty at what I had done.

Montano: You worked with sex publicly in two of your pieces, *Feed Me* and *Birth Daze. Feed Me* was a pivotal and very important event for all of us. Why did you do that piece?

Smith: A lot of it had to do with fortune and timing, because circumstances conspired to make it happen. The idea came out of my own anger and confusion, anger at the way I always seemed to be treated by men. Their interest in relationships was always sexual and temporary. With few exceptions, men in the art world had no manners—they had no complexity—they seemed tired of having to go through courting rituals, tired of getting permission from women to become intimate. I felt that they didn't know the process of getting to know a woman in gradual stages. They didn't understand that all aspects of relating are sexual. The ways that men treated me were one-dimensional and overbearing. I was mad, and in the piece I was saying, "Don't you know anything else?"

I happened to see Tom Marioni at a conference, and he asked me what I was doing, and I said that I was just then thinking of doing that piece. He responded immediately, thought it was an incredible idea, and said that I could do it at his place. So I did it at MOCA [Museum of Conceptual Art] for a show called *All Night Sculptures.* It was a night of installations and performances that lasted from dusk to dawn. People came all night to see the different events. My performance was in a room that had been the women's rest room. It was an empty, bare, brick space. I put a mattress on the floor in the center of the room and covered it and the rest of the floor with rugs. I sat on the bed nude, and all around me were vehicles for interaction. Those vehicles suggested other ways that men could interact with me if they could see the subtle complexity that I was presenting. There were many things in that

room, a lot to choose from—books, wine, fruit, champagne, cheese, body oils, beads, shawls, perfumes, tea, music, a record player. And a tape recorder with a tape loop played continuously. It said, "Feed me. Feed me. Feed me." Over and over.

When a man or a woman came into the room, one at a time, I only said, "Hello," and then they would begin to explore the room, try to talk and find out what was going on. I responded to them and also took some initiative as well. Most people came in with a preconceived notion that they were going to make love with me, because a rumor had gone around about the piece. The event was definitely addressing the question and issue of the woman as object and sexually available. Most people were nervous but would finally understand what was being asked and find something that they wanted to share with me. They'd say, "Oh, I get it. Maybe you'd like some tea?" I'd say, "Sure." I spent a half hour or more with each person and found out that men might be a little bit one-dimensional, but if the woman guides the circumstances, she can have it pretty much the way she wants it.

Montano: Your performances seem didactic. They have sex as content, but you seem to be teaching others new responses to intimacy.

Smith: I realize that they are, and I even think that performance is a form of cultural teaching, but if I were just sitting there presuming to know everything and then grandly telling others what I know, it would be too presumptuous. I am taking a terrible risk when I do my work. For example, I'd never been in sexual union in front of an audience before, although I had previously created Tantric rituals in private. I am always on untried ground in my work, and anything can happen. What I do is offer a value, something to try, an alternative, but I never say, "You ought to do this!" I am enlisting cultural approval, witness, and consideration. I am a searcher and a researcher coming back with findings to share in my performances.

Montano: In *Birth Daze* you talk about two ways of relating sexually: a conventional way and a Tantric way. Why did you do that piece?

Smith: Actually there were three ways of relating represented. The first part represented my prissy attempts to keep clean, protected, and pure so that I could avoid the marauding boogeymen, Paul McCarthy and Kim Jones. This represented my very protected upbringing and attempts not to have to get involved with anything outside conventionality. It's not unusual for many people to deny whole worlds of reality by only addressing themselves to experiences within the norm. Had I stayed married, this would have been my life. The second part with Dick Kilgroe and Allan Kaprow was about my getting involved, and so I was metaphorically speaking about the power dynamics of this culture and the things that keep everything endlessly the same. Those conditions usually lead to war, territoriality, et cetera. The third part of the piece was the new possibility, the Tantric way, the chance to go beyond all of that, because most sexuality functions on the same basic power structure as that of the culture.

I was dramatizing the fact that I was drawn to two different types of men and would always be pulled by the drama that I would get into with that. The style came from my early sexual patterns of relating with my father, mother, and brother, because I would tend to meet replicas of these energies in the males I related with. For example, I would tend to meet a guiding father figure whose energy was not as powerfully sexual because he would be intellectually centered. Or else I would meet a powerfully sexual person whose energy was in his first chakra but who was not focused mentally. I could love both of them but not feel complete with just one.

As time went on, I found that by working with several spiritual techniques I could begin to experience Tantric possibilities instead. That is, I began looking at my situation differently and saw that the problem was not with the types of people I was relating to. Instead, I understood that it was a problem I was having with energy and naming. I found that when I let energy flow between me and my partner, I could experience sex differently. I began to have very, very powerful experiences

with men after I made this discovery. It was seemingly outrageous. At times, when I was in that state, in that consciousness, there was no way the person I was with could resist me. I was irresistible and encounter was inevitable. I would become the guide in this sexual experience, and it would become an incredible event. My body began speaking for itself. It was almost a cellular vibration. Soon after this discovery that I made on my own, I began studying Tantric rituals with a couple in LA. We were working experimentally and without an extended study of traditional techniques. It came directly out of our experiences, although it directly parallels all the things that I've read about Tantric practices in other countries.

One of the private rituals I've done consists of setting up a space with a meditation area on the floor. Two pillows are opposite each other. Between the pillows is an object, usually a candle, a flower, or a crystal. Stones, incense, and music are part of the environment. The man I am to do the ritual with comes to the house. I have just showered. He showers when he gets here so that our bodies are ionized the same. Then he sits opposite me and we meditate. Then I balance his energies, sending the energy of my hands over his chakra centers, encouraging his energy flow between them. We meditate again, eat a sea food (shrimp), an earth food (meat), a grain (rice), wine, water, and cardamom seeds. As this ritual proceeds, it becomes more and more intimate. Feeding each other is first sensuous, then erotic. Soon it becomes sexual. Eventually I sit in his lap, he penetrates me, and we hold that position without orgasm. In fact, neither of us has a genital orgasm during the ritual, and in that way it's possible to learn how to handle energy and let it go up and rise to another level. Then it becomes something more than just a genital experience, and it teaches men that they are not possessed by women. They possess themselves. It's a power they've gotten, and they're no longer trapped. They don't have to fear women anymore.

Tantra comes from an energetic level of consciousness, and in some rituals there are shuddering experiences, past-life memories, and feelings that you're dying. The more free the person, the more they can experience. Often there's a release of heart energy so that every touch is charged. It's like touching on a nonphysical plane. You aren't touching a body or a muscle on that level. It's really two energies touching. Hands become contact points that cause energy experiences to happen.

Montano: I saw your performance *Birth Daze* in LA. Was it difficult to find a man to do a public Tantric ritual with you?

Smith: I talked to two different men about doing it. One was Vic Henderson, and the other, Lewis MacAdams. Both of them had performance experience. Both have a spiritual understanding. Both of them said yes. I worked with Vic because Lewis had no time to prepare, and also Vic was going through a big change in his life, so he was ready to do something quite unusual to further initiate the change and keep it going. As a result, we had time to spend together. We went away to the desert, lived together for a week, fasted, and did energy work with Jack Zimmerman and Jacqueline McCandless.

Montano: How do you feel about sex now?

Smith: I'm in a place where I've been very asexual. I'm going to leave the house where I'm living, and I'm ready to go back out into the erotic world. I've come to a new sexual level, and I'd like any relationship that I now have to reflect that change.

Montano: Anything to add?

Smith: Yes. I had said that I wanted to bring into Tantra more of the deep, primal, sexual energy that I am aware of. I haven't done that in the rituals because they have been on a very "nice" level, but I believe that all levels of sexuality can be brought into it if we learn how. I don't mean dirty sex or lusty sex, which connotes something bad. It amazes me that we've been taught by the top half of our bodies that the bottom half is bad, and then we say that the top half is insipid and sexless.

That split affects our lifestyles, and we feel that we have to choose one or the other. It is all just energy. Naming makes it wrong and right. We need to learn energy integration and self-containment and management so that we can incorporate and express it fully without so much destructive violence.

ANNIE SPRINKLE AND VERONICA VERA

Montano: The circumstances of this interview are very different because we are sitting here, having spent many hours collaborating together in upstate New York, working on chakras during the Summer Saint Camp that you are both attending at the Kingston "convent." But getting to the question—you both, collaboratively and singly, have worked with sex, so the first question is how did you feel about sex as a child?

Vera: With my fingers! It felt very good and gushy. When my fingers got slapped, it started feeling bad and good at the same time, so that became confusing. My mother slapped me, but she was motivated by religion, so I guess I can say that the church slapped my hand. But I didn't go looking for that spot—God made it and then let me find it. My mother spanked me with my father's belt, and I've thought and written about that at length. The fact that the pants were in the bedroom, that mysterious place closed off to me—that's another element in the drama. She took the belt from their bedroom, spanked my fingers and bottom, keeping me warm where I had touched myself. The belt was a good friend because it made me a good girl again. I was lovable. Suffering made me lovable. What a bunch of baloney!

Sprinkle: I didn't feel much of anything about sex as a young person— I wasn't a sexual child. My parents never said it was bad. I heard a little about it at school on the playground. I was a very shy child, and the

only sexual memory I have is the one of waking up in the morning, needing to pee really badly, and at the same time, I would actually be having an orgasm. So I had nothing to do with sex at all until I was seventeen, when I lost my virginity. Then it snowballed. My first experience was positive—it was with an older guy, and now I see that guys my age were a turnoff. When I met a twenty-six-year-old guy with a hippie coffee shop and motorcycle, I got interested. Maybe it was the motorcycle vibrating between my legs. After I lost my virginity, I immediately dove right in. I thought that it was the greatest, so great that I left him so that I could try every other guy in town. I knew in my heart that sex felt so good—I knew in my heart that it was going to lead me to something, and I had to know everything about sex. I had to do it with everybody, in every combination, with as many or as few people as possible. I had to try everything and know everything about this exciting subject. I knew in my heart that it wasn't a bad thing, although sex itself is not always a positive experience. I knew that I had to do it, so I became a hooker, a porn star, and everything but a swinger. Swingers' clubs turned me off, although I tried that, too. As far as sex is concerned, there are three things that I have never tried in fifteen years of having sex—I never fucked a horse, never did it with a dead person, and I never ate shit—and that's it! The rest, I've done. Sounds like I'm bragging? I guess I am!

Vera: Sex was linked to Prince Charming. The first time I had it, I wanted to have sex all the time, wanted to get married—it was hooked up to all of that right away. I was shocked when it didn't happen. My first lover only wanted to get into my pants and then he left me. I bet he's sorry now!

Sprinkle: I've come up with a new theory about sex. There is a scale, and at one end is absolutely total ecstasy and sheer enlightenment; on the other end is abuse, pain, suffering, rape, power tripping—everything negative about sex. I guess boring, routine sex would be in the

middle. I've traveled virtually the entire line, made a stop at every single point. I've experienced everything bad about it, from something I've done or something done to me. And I've experienced incredible ecstasy and beauty, love, and peace through sex. Miraculously, I was never raped or violently assaulted or anything real scary. It's like I walked on hot coals and was totally unscathed. I went into hooking with a heart of gold. I went into it all the way. No one forced me. I loved it. It was wonderful for me, and I benefited from it in countless ways. My heart of gold got wounded toward the end because sometimes I got ripped off for my money or a guy would be too rough or unappreciative. Numerous other little hurts. I try not to put myself in a negative situation anymore. I don't need to experience lousy sex. I've done that. There's a lot of stuff that I don't need to do, but I did need to go to that negative extreme so that I could find out what the other side was all about.

Vera: We each go through our own evolution. I went from no, no, no to sex to yes, yes, yes to sex. Now I'm in the middle, and I insist on being conscious during sex—and I insist that it's very intimate. Even if it's with a stranger, there's an intimacy going on.

Sprinkle: There was one point for about a year into my sexual evolution where I went to a kinky sex club. I would be in the center of the room, surrounded by twelve guys on their knees, jerking off. Then I'd go get fist-fucked by an amputee without a fist, then have a dog eat Crisco off my pussy. Then I'd fist-fuck a guy up the ass, piss on someone—all in one night. It was the most liberating, mind-boggling, fabulous, fantastic time in my life. But today you couldn't get me to do that if you paid me—or at least paid me a lot! So if I see somebody who's into dumb, stupid S&M, I try not to judge it because at one time something that's a turnoff to me now was once the most exciting, liberating turn-on in the world!

Montano: There's one theory that states that by following something through to the end, you gain a nonjudgmental mind. Do you believe that?

Vera: Yes, definitely. Everything taken in its total context makes sense. Plus sex feels good. Having your pussy eaten by a dog feels good. Now I wouldn't do it, but all these things really feel good. Sometimes people are afraid to try things, so they lay trips on each other, but so many sex rules that don't make sense keep people from experiencing good feelings.

Montano: People are afraid of feeling and sex.

Vera: That's okay. Not everyone travels the same route.

Sprinkle: Not everyone needs to do what I did. I was curious about sex, that's why I did it. And then I would think about what I had learned—make magazines about it, take pictures of it, talk to other people about it, interview people. So it was a constant study. I would meet a foot fetishist and would want to know what that was about, so he would show me his whole trip. Veronica and I once had this experience with a great foot fetishist. Veronica, didn't he work as a pedicurist?

Vera: At one time he did, and then he was found out.

Sprinkle: He did Brooke Shields's toes, Cheryl Tiegs's, celebrities' toes.

Vera: He had watched our cable TV sex show, wrote a letter to us, telling us what our exact shoe size was, and volunteered himself to do anything we wanted. So we invited him over to our house and made a videotape.

Sprinkle: He put chopsticks between our toes, tied the chopsticks together and when he pulled the string, the chopsticks would tighten. It was called the Chinese pedicure. Then we got the hairbrush on the bottom of the foot. It was a whole lot of fun. Very creative. And, of course, what we learned, we could use on other people.

Vera: We used the Chinese technique recently on the director of a performance art festival and made our way into the festival!

Sprinkle: That's right, we did.

Montano: What are fetishes about?

Sprinkle: Didn't we fuck him?

Vera: No, that was another foot fetishist. He jerked off. If he hadn't offered to pedicure us, we probably wouldn't have invited him over.

Sprinkle: That's like Frank Moore talking about painting nudes. He's got cerebral palsy, and he's in a wheelchair and wanted to see people naked. He couldn't say, "Will you come over to my house and take your clothes off?" But he could say, "Could you come over to my house so that I can paint you nude?" I bought one of his paintings. It's wonderful—like de Kooning.

Adding cameras, video, lights, and costumes to sex allows things to go much further. You get that camera out, and it changes people. I did things for the camera that I definitely wouldn't have done otherwise! Money is a nice incentive, too. I often say that the two reasons I got involved in the sex business were fantasy fulfillment and money. I never did it for the money. I used the money as an excuse to do what I wanted to do. For example, if I needed to pay my rent, I'd go to work in an S&M house. I wouldn't have gone to work there if the money hadn't been there, but I think I wanted to work in an S&M house to see what it was about.

Montano: You have to be brave and curious to do this.

Sprinkle: The only hard part was hurting my parents. Lately I've heard something I really like: "Everyone is doing the best they can with what they know and where they came from." And I really like that because it helps me not feel guilty about some of the stupid shit I did, because at the time I did it I didn't think it was stupid shit. To whip someone now doesn't appeal to me, because I somehow feel that it hurts them deep down, even though I whipped people with love. I'm in a softer mode now. I'd like to take somebody who wanted to be whipped and show them what more pure, direct love is like. And Tantra is the image I have for that.

Vera: Being spanked while having sex brought pain and guilt and sex together. Now I don't want to associate pain with sex anymore. I don't want to perpetuate that feeling in other people who get off on it the way I used to get off on it. I don't want that idea to stay in the world.

Sprinkle: My motivation was to collect experiences and to have fun.

Vera: I can remember one particular orgy that was quantity sex, not quality sex.

Sprinkle: I had to experience quantity sex before I could experience quality.

Vera: From not being intimate you learn what intimacy is all about.

Sprinkle: What I'm exploring in sex now is psychic sex—what's invisible. I feel as if I'm going to be dealing with sex for the rest of my life. I'm totally obsessed with it. I walk down the street and that's almost all that I think about. Or if I'm going to make something, a drawing or a photo, it's always about sex.

Montano: The art world is very excited that you decided to join it. What's happening when you do your thing for that audience?

Sprinkle: First of all I want to share that you baptized Veronica and me as artists yesterday. That's important to put in here. The difference between the art world and the porn world is being able to have the freedom to express what I really feel instead of worrying about what they want. Usually I think they need to have an orgasm, so I'd better write this or photograph that, so it can turn them on, although it doesn't turn me on. Now I want to share my work with my peers who think the way I do. The only place that is open enough for someone like me is the art world. But it's scary. Not many people think the way I do, and I might not make a living at it like I can in porn.

Vera: Being in the art world as opposed to the sex world is about taking sex out of a hidden place, out of a ghetto, hidden from the rest of the world. The art world is more open. Now I can feel that I can bring sex out in the open. This means more a change in attitude than anything else.

Sprinkle: And yes, there is the exciting new challenge of trying to turn on the art world. I mean, I've done it all in porn. There's nowhere else to go. I really need a new audience.

Vera: We love a great dog and pony act!!!

Montano: What is AIDS doing to or for your evolution?

Sprinkle: It changes things because society is jumping on the band-wagon and saying, "See, it was wrong and now you're paying the price." There's a lot of going back into the closet. Negative thoughts and feelings about sex are around, but I'm seeing more intimate and spiritual sex evolving. There's more love in the air. It's not just about cocks going into assholes and pussies anymore.

Montano: What about all of the people who missed out and didn't get enough and now feel they can't because of the health crisis?

Sprinkle: That's really a sad thing, but we can show them what it was like. I have pictures and stories.

Vera: Safe sex is okay. Sex with rubbers can still be good sex. Every-thing has its pluses and minuses—sexual freedom does, sexual absti-nence does, jerking off does. We are all still left with a treasure chest of possibilities.

Sprinkle: Tantra can be safe. Maybe kids today are going to be hap-pier in a monogamous situation than I was fucking half the world. Maybe they will experience something that I could never experience just because they have that limitation. My limitation was that I had to fuck the whole world, because there was birth control and the freedom to do that. I never got to see what it was like to be with one person for fourteen years straight.

Montano: What will they do to stay monogamous?

Vera: Acknowledge commitment to one another. Acknowledge that times have changed. We are getting very fifties, very into not having as much sex. Everything has a season, and it's not great the way this sea-son has come about. It comes from a plague, but we have to be hum-bled by the fact that it exists and that we are part of it. We may not un-derstand all the reasons for it. Hard as it feels sometimes, there is joy in being part of the cosmos.

Sprinkle: Before, if I wanted to get to know someone, the best way was to just fuck, and then you knew each other quite well. I fucked

everyone I met. Now that I'm not fucking everyone I meet, I still want that intimacy. I want to know them—so I'm having to find other ways.

Working together is very sexual. We've been here at your house for three days, haven't had sex, and yet I feel we've gotten very deep, very intense, whereas if we were just hanging out, it wouldn't be the same. The way we are together allows me to learn, concentrate, experiment, perform, create.

Montano: What piece of yours linked sex, life, and art?

Vera: Going on a trip around the world. I went to fifteen different cities in eighty days. In all of those places, especially India, I got into the feeling of being a woman from that place. In India I wore heavy makeup, dressed in garters, stockings and a leather skirt, a corset, come-fuck-me pumps and flashed in front of the Taj Mahal and all the national monuments. It was a chance to take this image of myself around the world and to imagine myself as a woman from foreign places. I had intense sexual experiences as me/them, with the added bonus of taking photos and writing about it afterward. It was complete, unique, and made me happy with myself.

Sprinkle: This week with you has been a highlight.

Vera: We've done something here that's been good for our friendship, and then we get the added bonus of you, so thank you for reaching out and being accessible.

HANNAH WILKE

Montano: You have a choice—food, sex, money/fame, or ritual/death.

Wilke: What I really want to talk about is women in society, not just about myself. It is important to me to elevate the status of women as well as to elevate my art. I'm interested in the creation of an unmistakably female, genital art, and that includes performance art as well as

sculpture, photography, video, and other media. The performances
came partly out of a desire to overcome the alienation I felt was caused
by my own physical presence, to overcome the kind of visual preju-
dice that also attends racial, cultural, and gender differences. Schwit-
ters's face was too bourgeois for the Dadaists; mine was too pretty for
the feminists. Women, above all, need to support each other and
shouldn't fight over the way they wear their hats or sip their tea. We
have to come together and find strength in our physical and mental
rapport.

I created myself as goddess, as angel, as a female crucified so that I
could expropriate the symbols that were made by men of women and
then give women a new status, a new formal language. I particularly
wanted to reaffirm the body's physicality, which seems to have become
more alien than ever in the world of deconstruction. Women have al-
ways served as man's ideal and creative spirit. For me to create my own
images as the artist and the object was important because I was really
objecting to being the object. I made myself the object to idealize
woman in the same way men often did in order to give her back her
own body. I took back my own body instead of giving it to someone
else "to create."

Performance gave me back my body, especially in *Hannah Wilke,
through the Large Glass as the Bride Stripped Bare by Her Bachelors, Even*. In
that video-film-performance, I was the bride stripped bare but also the
bride as artist making the artwork, so that Duchamp's *Large Glass* be-
came, all of a sudden, just a dead symbol, a prop for a moving, live
woman. It didn't matter if I was a work of art or not. I moved and
didn't allow the cameraman to move. He stayed still (still life). The
filmstrip was a pun; I stripped myself bare, but I stripped myself of the
veil of woman being just the model for the man. I was now the model
of the creative spirit, as the artist of my own ideology.

Montano: How long did it take to move from muse to creator?

Wilke: For me they were always one and the same. I guess the use of myself began as a kid, when I was fourteen or so, in nude photographs and paintings. The abstract sexual images are extensions of myself; literally that way in the gestural ceramic and chewing gum female genital sculptures. In 1970 in California, when I was living with [Claes] Oldenburg, I did film performances behind fish tanks, in which snails seem to mark my face like scarification wounds. They signified the emotional, psychic wounds of myself and of women in general—cultural scars. These wounds were then transformed into a series of vaginal chewing-gum sculptures on my body, which fused my art and myself. Later I created the *Ray Gun* series of photographs, objects, and a video-performance when Claes and I split up. This was called *So Help Me Hannah,* but he didn't. I had collected these "guns" for him and yet only received recognition in the catalog for the show as "Group H" when he exhibited the ray guns at the Whitney Museum and elsewhere. I again took back what was mine; to preserve my sanity and selfhood, I made myself into a work of art. That gave me back my control as well as dignity. I always used art that way. When my brother-in-law died, I set up the video camera in Claes's studio, and I touched myself, felt myself, molded my face, and stroked myself until I got back my body at a time when I felt emotionally lost.

I feel that I have to preserve my body in order to preserve womanhood and to create a religious ideal. All of Christianity, Buddhism, Judaism are male religions. I wanted to create a female religion honoring the body because the body re-creates life. We can't be sure that God exists, but we do know that life exists through the body of woman. To create myself as goddess/angel, female/Christ was really to take away that which was questionable—religion. We women create life. We are the ones who should be honored. Life is more important than art or performance or whatever. Life. Feminism at times upsets me because it

seems to be generally about economics, and it sometimes denies the fact of the necessity of the regeneration of the species.

Montano: Does the fact that life is more important than art make you not want to do art? Is life enough?

Wilke: My entire life is the work of art. I feel that I needed to do performance to confront visual prejudice. I used my nude body to reveal something about humanity. Nudity is synonymous with universality. All of my pieces had to do with real moments in time and space that could have been translated historically into anybody's moment.

The main thread that wove itself through my art was my mother's life and death. Most of my work had something about my mother in it. *Intercourse With* (telephone messages saved over five years and collaged together from 1970 to 1975) had twelve messages from her of the sixty or so that I extrapolated. She has always been the real constant figure in my life. It was always *mother,* it wasn't *cunt.* I was never thought of as "Earth Mother." I was always thought of as "Sex Goddess." I think they are the same thing. The sculptures were circles that, when folded, became three-dimensional objects. They are about oneness, about cell division. Where one cell becomes hundreds of cells that ultimately comprise a life. The art begins as a minimal, geometric form, which is then transformed gesturally into singular symbols for life itself. Later they also became symbols of the cell division that may consume us— cancer. (Regeneration. Degeneration.)

After the memorial exhibition I made for my mother, *Support-Foundation-Comfort,* I didn't make very much art. Last night I went to a conference given by Donald Kuspit on psychology and art, and there was no mention of sexuality, but they did talk about artists and death. One of the speakers stated that some artists in crisis have created frontal self-portraits, although this has happened rarely in art. I realized that what I had done in the last few days, because I had been quite depressed, was to make gestural layered watercolors of only my face in

which I took away my hair, creating circular patterns. But these portraits really became portraits of my mother, who had lost all of her hair from chemotherapy. I guess I was fusing myself into her because I am her. She created me, and I am bringing her back to life by being me. I guess that I can finally accept the fact that she died, knowing that she lives inside me. Although she lost her breast with the cancer that finally ate up her body, she knew what it was like to live. She was a woman of wisdom, courage, and love. She gave me spirit, mind, and also my body.

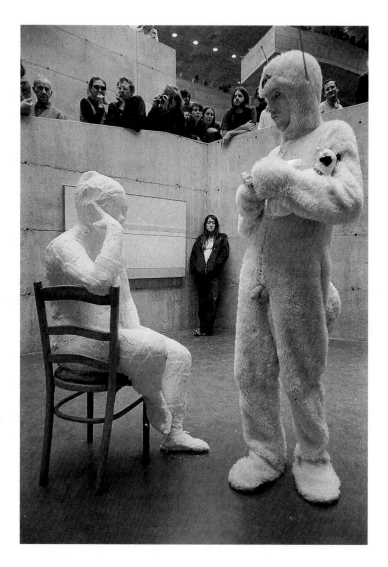

PAUL COTTON
Meditation of the Time Being, 1970
(photo: Charles Stepkin)

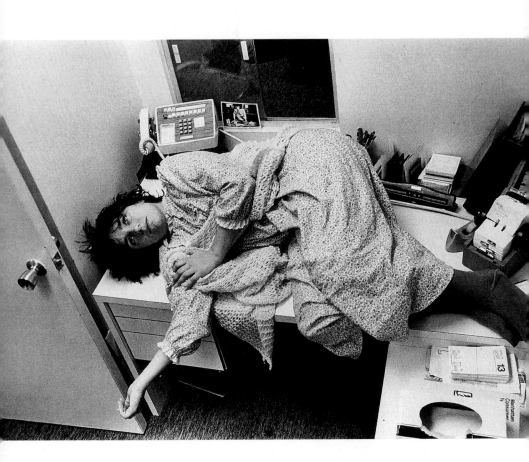

VANALYNE GREEN
This Is Where I Work, 1981,
image from super-8 sequence
(photo: Vanalyne Green)

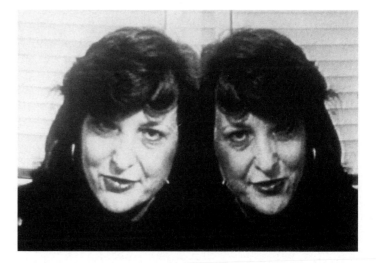

LYNN HERSHMAN
Binge, 1986, videotape
(photo: Lynn Hershman)

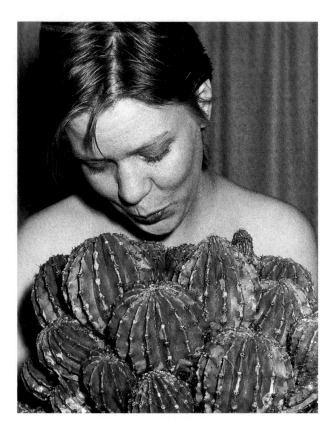

LAUREL KLICK
Self-Portrait, 1983
(photo: Susan Mogul;
originally in *High Performance* 5, no. 4 [1983])

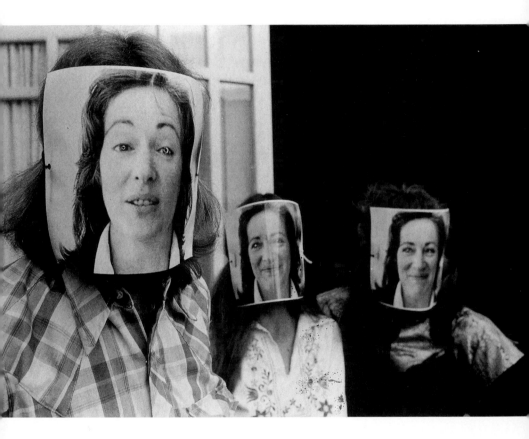

MINNETTE LEHMANN
Many Minnettes at Her Birthday Party, 1972
(photo: Mitchell Payne)

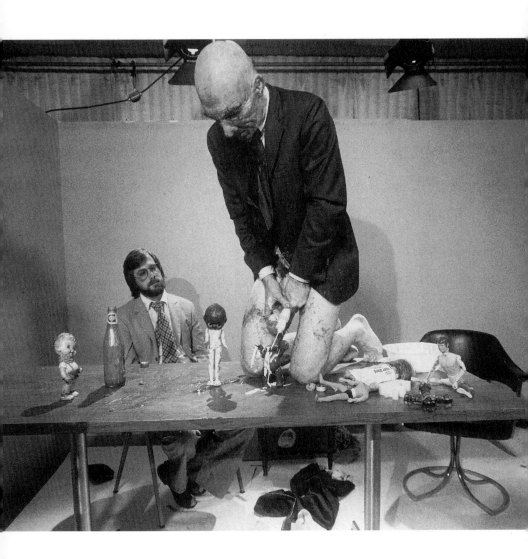

PAUL MCCARTHY
Grand Pop, 1977
(photo: Tom Keller)

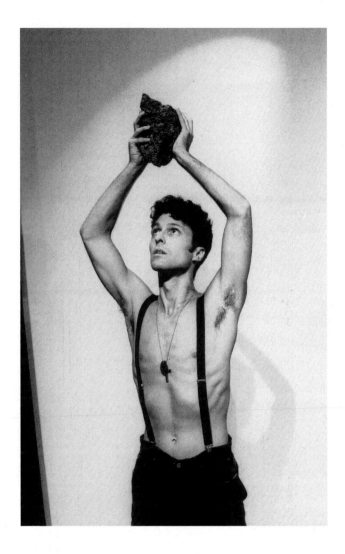

TIM MILLER
My Queer Body, 1992
(photo: Chuck Stallard)

PAT OLESZKO
The Padettes of P.O. Town
(*The Primary Colored Group*), 1976
(photo: Paula Gillen)

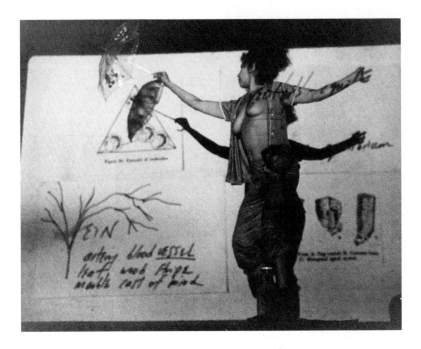

CAROLEE SCHNEEMANN
Fresh Blood: A Dream Morphology, 1983
(photo: Ginerva Portlock)

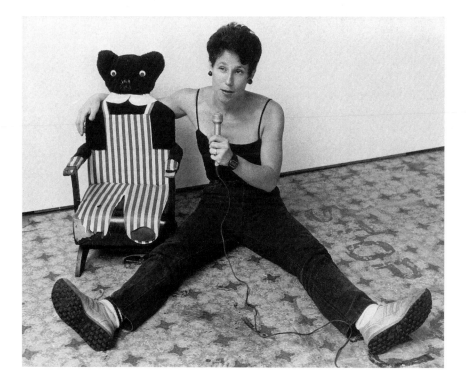

JERRI ALLYN
Love Novellas, © 1983
(photo: Herb Perr)

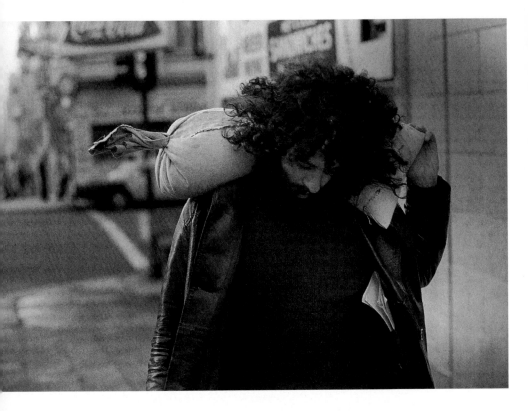

HOWARD FRIED
Long John Silver vs. Long John Servil, 1972
(photo: Larry Fox)

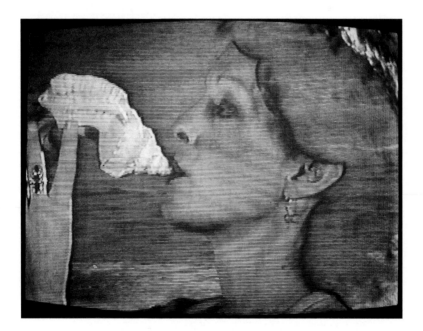

JOAN JONAS
Double Lunar Dogs, 1984, videotape
(photo: Gwenn Thomas)

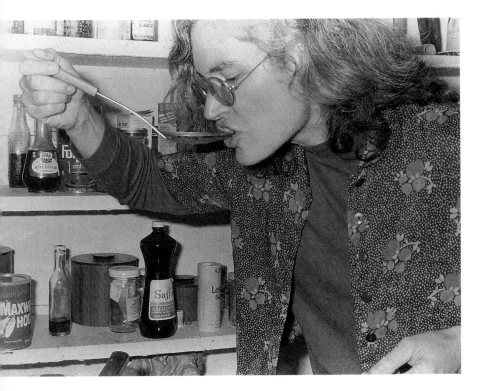

ALISON KNOWLES
Make a Soup, 1976
(photo: Elaine Hartnett)

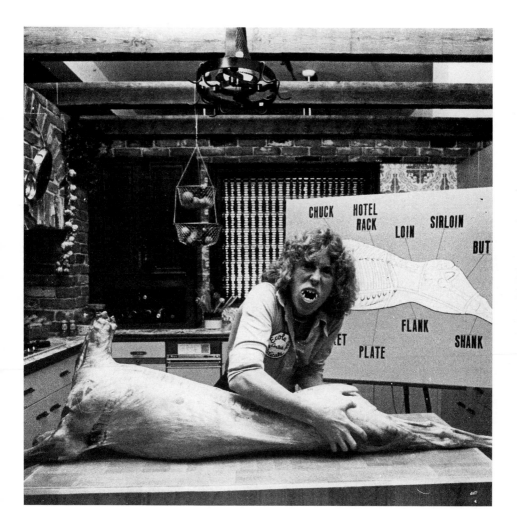

SUZANNE LACY
Know Where the Meat Comes From, 1976
(photo: Raul Vega)

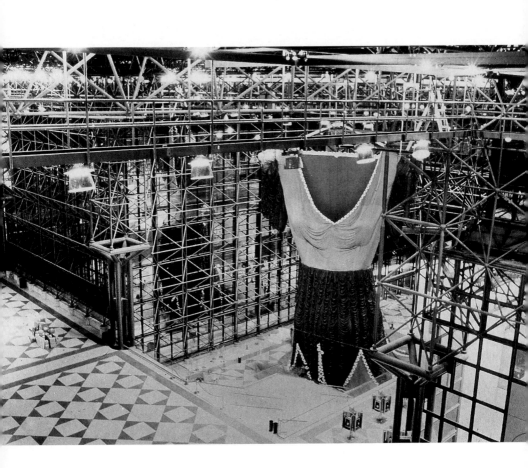

ANTONI MIRALDA
Liberty Engagement Gown (Honeymoon Project), 1986
(photo: Marta Jentis)

MARTHA ROSLER
Watchwords of the Eighties, 1981
(photo: Richard Baron)

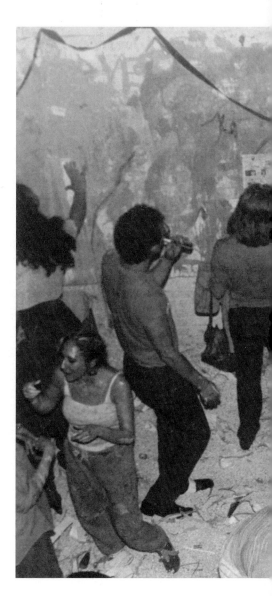

BOB AND BOB
Forget Everything You Know,
December 31, 1979 – January 1, 1980
(photo: Diane Sherry)

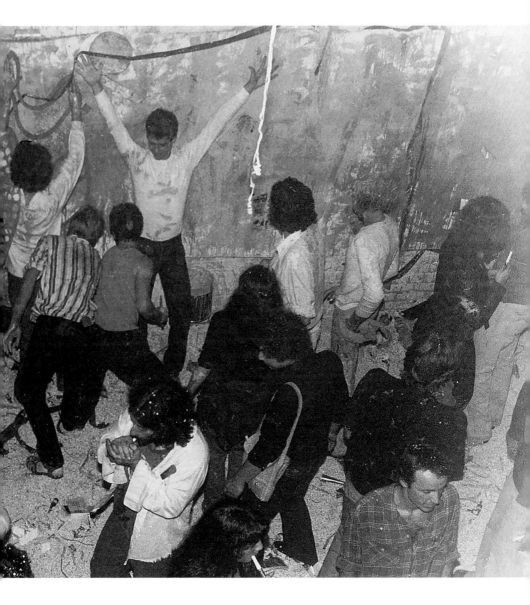

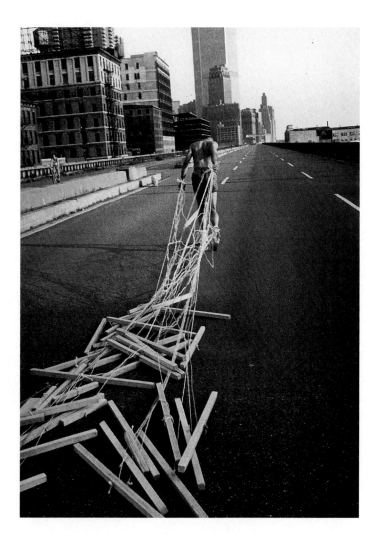

PAPO COLO
Superman 51, 1976
(photo: Pico Harden)

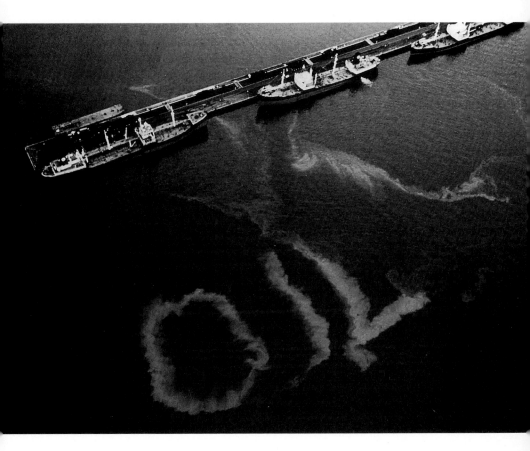

MEL HENDERSON
Oil, 1969
(photo: Robert Campbell)

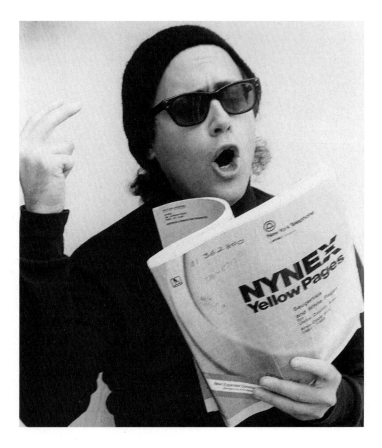

MIKHAIL HOROWITZ
Dramatic Reading from NYNEX Phone Directory, 1985
(photo: Carol Zaloom)

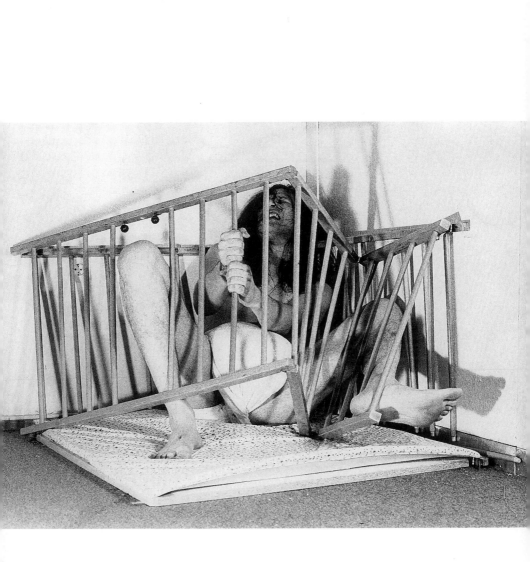

WILLOUGHBY SHARP
Saskia, 1974, video performance
(photo: Kirsten Bates, © 1997 Willoughby Sharp)

PING CHONG
Humbolt's Current, 1977
(photo: Toby Sanford)

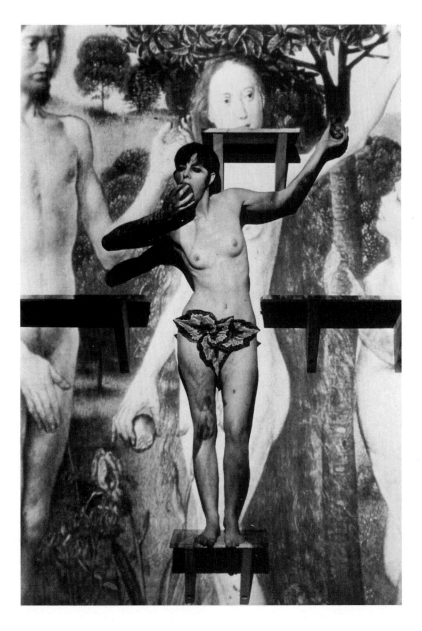

CHERI GAULKE
This Is My Body, 1982
(photo: Sheila Ruth)

ALISTAIR MCLENNAN
If Underhand, 1985,
a forty-eight-hour nonstop actuation
(photo courtesy of Antonia Reeve Photography)

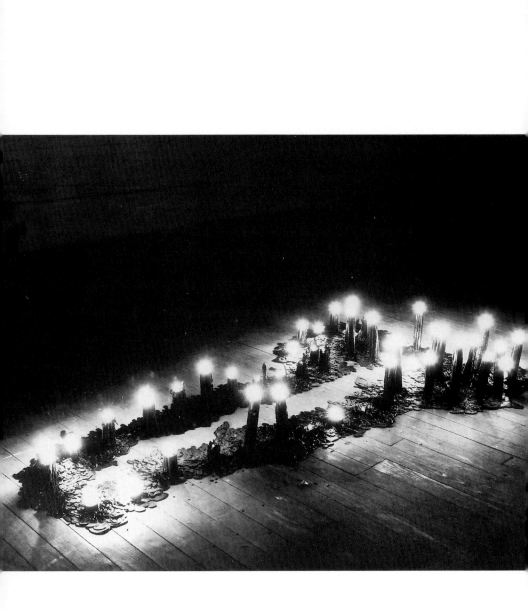

ANA MENDIETA
The Burial of the Nañigo, 1976,
silueta with candles (photo courtesy of
Ana Mendieta Trust, Galerie LeLong)

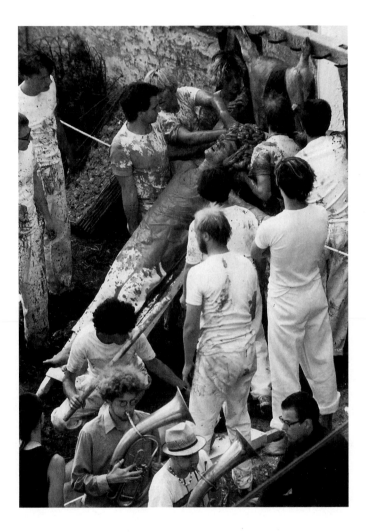

HERMANN NITSCH
80.Action ("Three-Day Play"), 1984
(photo: Archiv Cibulua)

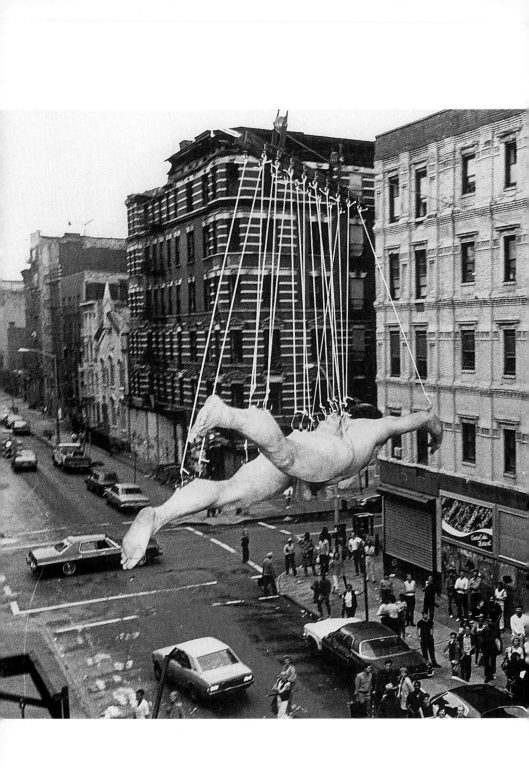

STELARC
Street Suspension, 1984,
on East Eleventh Street, New York City
(photo: Nina Kuo, © 1984 Stelarc)

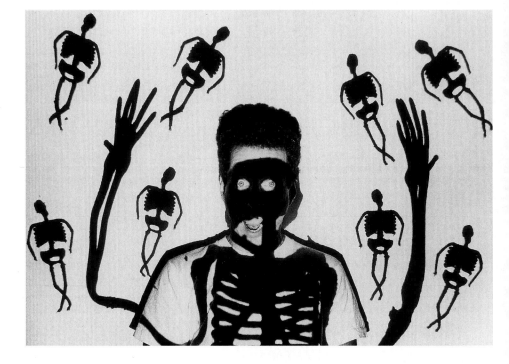

PAUL ZALOOM
Sick But True, 1990
(photo: © 1990 Jim Moore)

food

introduction

MOIRA ROTH

In memory of Christine Tamblyn

Prelude: Nostalgia

Artists have used food as political statement (Martha Rosler, The Waitresses, Nancy Buchanan, Suzanne Lacy), as conceptual device (Eleanor Antin, Bonnie Sherk, Vito Acconci), as life principle (Tom Marioni, Les Levine), as sculptural material (Paul McCarthy, Joseph Beuys, Kipper Kids, Terry Fox, Carolee Schneemann, Motion, Bob & Bob), for nurturance and ritual (Barbara Smith), for props and irony (Allan Kaprow), as a scare tactic (Hermann Nitsch), in autobiography (Rachel Rosenthal), as feminist statement (Suzanne Lacy, Judy Chicago, Womanhouse), in humor (Susan Mogul), for survival (Leslie Labowitz). LINDA MONTANO, "FOOD AND ART"

Linda Montano lists this array of artists' attitudes in her introduction to "Food and Art" (an article in *High Performance* that consists of ten interviews with women performance artists, including a self-interview, and is accompanied by an artist's portfolio of food pieces).* On the magazine's

* Linda Montano, "Food and Art," *High Performance* 4, no. 4 (winter 1981–82): 45–54. Her interviews are with Nancy Barber, Alison Knowles, Leslie Labowitz, Suzanne Lacy, Joan Yushin Loori, Susan Mogul, Mildred Montano, Bonnie Sherk, and Barbara Smith, as well as herself. Six of these interviews appear in this section of *Performance Artists Talking in the Eighties.*

cover Rachel Rosenthal appears seated by a food-laden table, her head tilted back, as she intently consumes food suspended from a fork. The Waitresses adorn the back cover; demurely costumed and wearing dark glasses, they assume giddy poses with wildly outstretched arms and legs on what appears to be a flying carpet (in actuality, a tilted tabletop), with an explosion of clouds behind them.

These interviews and photographs evoke so many memories for me: lending Barbara Smith pillows and a rug for her performance *Feed Me* at the Museum of Conceptual Art in San Francisco (1973); attending Suzanne Lacy's giant ERA-inspired potluck for five hundred women in New Orleans (1980); participating in a weeklong exchange between Los Angeles and London women artists and critics, held in New York's Franklin Furnace gallery, surrounded by shelves of Leslie Labowitz's luscious blooming sprouts (1981). They recall, too, legendary events that I never saw: most notably, *Ablutions* (1972), a collaborative performance by Judy Chicago, Suzanne Lacy, Sandra Orgel, and Aviva Rahmani, with its tubs of blood and clay and a thousand raw eggs into which three performers were immersed.

But most of all, as almost twenty years later I turn the pages of this *High Performance* issue, I am consumed by nostalgia and regret.* I deeply miss that earlier art/life performance blending of food, ritual, and activism, one that I find hard to locate these days. For me, so many of the acts of creating community in the seventies took place around food. I recall conversations with friends, including artists and critics—conversations about ideas and politics, exchanges of confidences, and evenings of plotting and strategizing, all leading to the creation of precious, fragile communities, and so often occurring in the

* Sadly, *High Performance* stopped publication in the mid-1990s, and with it a most important site of performance records, history, and criticism disappeared.

context of cooking and eating. There were the weekly visits to the Southern California home of Diane and Jerome Rothenberg, where writers, artists, and scholars gathered around Diane's dazzlingly imaginative food, which contributed to (inspired?) the richness of our ideas. The sensible meals and extravagant conversations at the home of Eleanor and David Antin. And the ceremonious dinners that I myself used to give.

But certainly, Montano did not gather the remarkable interviews about food in this book merely to provoke my personal memories. Although I do suspect that one of the fascinating aspects of this book will be that Montano's other readers, like me, will be led inexorably to examine not only the artists' but also their own relationships to and experiences around food—just as with the book's other three main themes.

Childhood Food and Adult Art

Montano tells us in her preface that she has always believed that "the themes artists employ are born in childhood," and that, if interviewed, she would have chosen the topic of food. Recently she wrote to me that "our first performative actions as infants are [often] suckling at our mothers' breast . . . and a little later we use the kitchen table as a proscenium stage where we practice narrative skills and strategies for the delight or disapproval of our first audience, our families."

The interviews of this section address a wide range of childhood relationships to food: diets, structures and functions of meals, and both the historical, public and the private, individual food connotations for each artist. For some, their childhood is associated with comfortable memories (though inevitably tinged with psychological complexities). Bonnie Sherk's mother was "a wonderful cook, and my sister and I learned the art of cooking at an early age. Food was always overly plentiful, and I always enjoyed eating. I still do." Nancy Barber recalls her mother making yeast dough: "I loved the magic of the rising and the softness." For Suzanne Lacy, "food was accompanied with a great deal

of pleasure because we could do whatever we wanted at the table. . . . I'd make chocolate scrambled eggs." For Faith Ringgold, food was associated with both childhood allergies (asthma) and a devoted mother, one who fed her "a kind of health food diet of steamed vegetables, fresh fruits, cornmeal gruel, oatmeal." For Antoni Miralda in Spain after the civil war, "food was tied to a celebration . . . all mixed with images of street events, family gatherings, costume, ritual elements, church, and incense."

Yet, for most, there is some level of ambivalence—during childhood or later, or both. It is a theme succinctly and wittily explored by Howard Fried in his hilarious video *Sea Sell Sea Sick,* which plays out psychological indecision in an ambience of privilege. Fried and a waiter are both seated on swings as Fried toys for fifty minutes with menu after menu, addressing questions about each item to the increasingly impatient, finally enraged waiter. But for the most part ambivalence is not spelled out in such a straightforward, farcical way. In the wealthy prewar world of Rachel Rosenthal, for example, "food was an art because we had a Cordon Bleu cook and, as a result, were renowned as one of the best gastronomical houses in Paris." Yet, simultaneously, Rosenthal associated "being loved with being thin. That created a lifelong problem and an eating disorder." The theme of food haunts her early work: in *Charm,* a performance about the secret traumas of this glamorous Parisian childhood, she greedily stuffs masses of pastries into her mouth; in *Grand Canyon,* she materializes into the Fat Vampire, a character who returns as her "demon" in *The Death Show.*

For other artists, associations with food are fraught with specific historical, as well as individual circumstances. Angelika Festa moved from household to household in bleak postwar Germany: in her early years, "food [was] part of my concern for basic survival." In Ireland during World War II, Les Levine remembers eating "banana sandwiches, made from stewed turnips," and this and other experiences of hunger then ruled out for him forever what he sees as a "North American [no-

tion] of food, as something defining taste and defining a certain social experience where there is variety and choice."* As for Linda Montano, who was at one time anorexic, "I was always upset that eating meant sitting at the table and talking." And interestingly, Linda's own mother, Mildred Montano, "ate because my mother made me. Food was something I ate to keep alive."**

Survival . . . celebration . . . pleasure . . . hunger . . . eating disorders . . . ambivalence . . . family attitudes to food and meals . . . complex associations between food and love, control and punishment. As these children grew and became artists, some drew directly from childhood experiences, recognizing consciously metaphoric links between food, eating, and art in the performance genre that Allan Kaprow has named "art/life." Joan Jonas, who loved food as a child and cooked diligently for years, sees parallels between cooking and art making: "mixing elements in an alchemical way. Mix two things and come up with a third." Alison Knowles, who also basically enjoyed childhood food and cooking, tells Montano, "When I perform *Make a Salad* in a concert hall for one hundred people, it's the same as making a salad in my own home kitchen because food preparation has always been a meditation for me." Suzanne Lacy speculates that she brings people together for huge potluck events "because it's a metaphor for nurturing each other."

Selecting food is, for several artists, an act of great deliberation, sometimes part of the creation of a private aesthetic of display. John Cage shifted from a childhood fare of meat and potatoes, salads and Jell-O, to a stringent macrobiotic diet (and became renowned for his legendary and elegant mushroom hunting). In their joint interview,

* This quotation comes from a part of the interview not included in this section.

** The quotations from Linda and Mildred Montano are from the *High Performance* article.

Jackson Mac Low and Anne Tardos discuss their choice of vegetarianism, and Tardos observes a link between his focus on consciousness in his work "and what you are doing with the rest of your life and the food you eat."* Rachel Rosenthal became a deeply committed vegetarian and argues, in private and public life, that "eating the flesh of animals that are rendered mad by confinement, pain, isolation, tortures . . . cannot be very conducive to building sane and healthy human bodies."

Weight swings, overeating, anorexia, and diet preoccupy several artists and, on occasion, are expressed in performances—witness Eleanor Antin's *Carving,* a meticulous photographic documentation of her nude body over ten days of dieting. One of the most sustained, inventive, poignant, and wry artistic documentations about dieting is by Faith Ringgold. In 1986 she undertook an elaborate weight-loss program that lasted for over a year; at its successful conclusion she created a story quilt (together with a performance), *Change: Over 100 Pounds Weight Loss,* made out of photo etchings on silk and cotton canvas, with printed and pieced fabrics, containing images and texts dramatically describing her private and political relationship to food in each decade of her life. She continued this saga in *Change 2* (1988) and *Change 3* (1989).**

* This quotation comes from a part of the interview not included in this section.

** Montano's interview with Ringgold was conducted during this yearlong weight loss, and therefore Ringgold does not discuss the results, the actual weight loss plus the creation of a story quilt and a performance about the experience. The text and photography of *Change: Faith Ringgold's over 100 Pound Weight Loss Performance Story Quilt* was published in *Faith Ringgold, Change: Painted Story Quilts* (New York: Bernice Steinbaum Gallery, 1997), 18–21. The texts for her two later performances, *Change 2* and *Change 3,* can be found in *We Flew over the Bridge: The Memoirs of Faith Ringgold* (Boston: Little, Brown, 1995), 242–49.

Women artists have also addressed the topic of women and food, removing it from the realm of the merely personal in order to analyze the subject in societal and economic terms. Martha Rosler, for whom "food was often a burden," tells Montano that only when she was in her mid-twenties, with a small child, did she fully realize the impact of consumerism and the notion of food as capitalist spectacle, and generally the "contradictory demands on women in relation to food." In her interview, Jerri Allyn discusses food in the context of issues around women and work, commenting that "the waitress was and still is a metaphor for women's position in the world." As a member of the Waitresses, she experienced this firsthand on the job, and then later she and other members of the collective critiqued it through performances, locating "four issues . . . women and work, women and money, sexual harassment, and stereotypes of women, that is, waitress as prostitute, servant, and slave." In a very different manner, Leslie Labowitz, who recalls considerable ambivalence over food as a child, explored the subject of women, economics, and power in a most concrete way by becoming a woman entrepreneur. In 1980 she created what proved to be not only a very profitable sprout business (still going strong two decades later) but also—after years of performance about women's oppression and rape—offered tranquil experiences of "quiet attention, color awareness, playing with seeds, and mixing seeds." Bonnie Sherk, too, had to contend with business practices and local bureaucracy when she set up *The Farm,* an alternative space that existed for years in the middle of San Francisco. For Sherk, *The Farm* was "a form that brings together a lot of the ideas that I had been working on previously which include food, growth, life, and the human, plant, animal relationships."

For the most part, the artists in this section were born in the United States or at least reside here now. The United States has a notoriously public history of ambivalence toward food. It is a hugely wealthy country that has many living below the poverty level, and thus hunger is a

very real part of American life. It has an enormous range of food cultures, developing out of the varied ethnic, class, and local food traditions. It is also a country obsessed with dieting and weight, and attitudes still respond, all too frequently, to a dominant media set of limited images—of young white beauty and the tantalizing mirage of the "perfect" body. In reading the interviews with these artists, we must remember this larger American context. For surely it shapes us, as much as the individual psychological and familial circumstances of our childhoods do.

Postscript: Christine Tamblyn, 1951–1998

Surrounded by friends and family, ritual and food (I and others brought food to her in San Francisco's Mount Zion Hospital), the artist-critic-theorist Christine Tamblyn died on January 1, 1998, having exhausted all available treatment for breast cancer. At her memorial at the Lab in San Francisco on March 7, 1998, knowing this would have pleased her, we served chocolate-dipped strawberries, champagne, and Perrier water.

During the various events held in her memory (which included Linda Montano's *Seven Chakras for Kathy Acker and Christine Tamblyn*), friends and family spoke of Tamblyn's many overlapping passions—for her art and the art of others, for sensuality in its many forms, and for community. Tamblyn's contribution to *Performance Artists Talking in the Eighties* was her introduction to the section on sex, yet she could have easily made insightful comments on the other three sections of this book. In 1966, at age sixteen, Tamblyn wrote in her diary (which she kept throughout her life): "I must experience things not in categories, but rather seeing into the soul of them." This haunting statement by the young Tamblyn aptly expresses Montano's own intentions for this book. For certainly Montano understands that the four subjects (food, sex, money and fame, ritual and death), which she selected for artists to comment on, are impossible to confine within their separate categories—if we are to see within the soul of things.

JERRI ALLYN

Montano: You were a member of the Waitresses, a group of women artists in California who did performances and consciousness-raising about food. To trace things back even further, how did you feel about food as a child?

Allyn: We always had balanced meals three times a day, because that was supposed to be good for you—sausages, or kielbasy for breakfast or cereal. For nine years in a row I had bologna sandwiches for lunch, and my mother always made them on Pepperidge Farm bread. Actually she was very health conscious, and it wasn't known then so publicly that meat was bad for you. Her family came from Spain and a life of tremendous poverty, so eating meat meant that you were doing well. When I became a vegetarian at nineteen, that side of my family was horrified, and they still grab my ribs to see if I'm fat enough. At dinner we would have a salad, vegetable, and meat again. We hardly ever had sweets; we had to be near death to stay home from school, and on Christmas and holidays or when we were sick, we could have ginger ale. Once a year my mother would make this phenomenal cheesecake she called Dream Cheese Pie. Sometimes we would have ice cream, but mostly pretzels and fruit.

Montano: Before you cofounded the Waitresses, did you use food in your work?

Allyn: No, I didn't use food. The group was founded when Anne Gauldin of the Feminist Studio Workshop did this completely macabre performance. She blackened her eyes, served cocktails, and wanted to convey that cocktails were poisonous, and the whole job was poisonous. I don't remember any more details, but I do know that I connected to it very deeply, since I had been a waitress for seven years. We got together, some other women joined us, and we decided to do one performance about waitressing. We located four issues we thought were important and analogous to the position of women in the

world—women and work, women and money, sexual harassment, and stereotypes of women, that is, waitress as prostitute, servant, and slave. We exposed and explained these issues by doing performance vignettes about them. The group always had about six of us, and I was with them for five years. The current group is Chutney Gunderson, Denise Yarfitz, and Anne Gauldin.

Waitresses have been traditionally seen as sex objects, slaves, whores, and women who perform a service. People also mix up getting food with their mothers. Often they come to restaurants and want everything instantaneously—they want that instant gratification they used to get at home. Maybe that's why fast-food restaurants are so popular. When people want it, they want it, and they can't wait. I've worked in restaurants where people have to wait awhile, even if they are getting better food, and I've noticed they can't bear it and leave.

The other stereotype is the prostitute, because you get tips, and that indicates payment for service. For a while, when I first started performance, I did a yearlong character as a prostitute, because I was cocktail waitressing and it was so disturbing that I had to do this work. As a result, I finally got whole hog into the character and dressed sexier, adopted a cheerful attitude, played up to the men. Then I made more money at my waitressing job. It was such a direct correlation—it was phenomenal.

Our group actually found statistics to verify this. One of the airports had their cocktail lounge waitresses wear little miniskirts, and the airline pilots' wives complained so heavily and protested so badly that they got the skirts dropped to below the knee. After that there was a sixty percent decline in tips. It's documented everywhere that men pay for skin, and there's something real debilitating about that, because they don't really know who you are. You enter into a fantasy with them, make them feel good, boost their ego, let yourself be looked at or fucked, and they know nothing about you and give you money for that. It's very weird.

Montano: You said that you wanted to waitress for one week as a performance. Did you? When you did the job as performance versus doing it as a job, what was the mental frame like then?

Allyn: We did a weeklong event as job/art, but there was so much material uncovered that we worked for years on just that. The waitress was and still is a metaphor for women's position in the world. Basically, what happened after so much work and analysis is that we went back into the waitress situation, and our jobs, feeling powerful. In fact, from that time on, I had a different relationship to it. First of all, it became a job. There were things that I had to do on the job, and I somehow backed off from all the other emotional things that customers, bosses, and staff projected onto me, because there's always one sexual innuendo after another, which gets boring and stupid. After the work that we did, I was a step removed from it all. I guess that's what powerful means—understanding the entire setup and choosing. I chose to waitress again because it was quick money. I also knew that it wasn't permanent, and I guess that I would have a different relationship to it if I knew that it was forever.

I've thought about forever a lot in terms of quality of work and lifers who are permanent. The best of them, and I mean that in all ways— waitresses who consider themselves professionals and are excellent at what they do—are stable and have their heads screwed on. They are multijob people, although lifers don't always see that. For example, all of my waitressing prepared me for doing administrative work, which is basically about having to handle five hundred details at one time. Waitressing is great training for that. The best of them can anticipate customers' needs on top of taking care of what they've asked for, and you can't always maintain that that is the job. You're literally in service to the public. You are supposed to serve that public, and you are supposed to do it pleasantly. No nasty attitudes. If you have them, you should get into another line of work. Also, you become a psychologist. We interviewed waitresses about that, and found they had become really

skilled—a composite of psychologist and diplomat. They are able to skirt any potentially dangerous situation that could get out of hand. In drinking situations, things can get physically dangerous and violent. Aside from drinking, people can get unbelievably infuriated if something's wrong with their food or if it's the wrong dish. A lot of cocktail waitresses have fantasies about dumping entire drink trays on customers or heaving drinks at the bartender or just flinging every glass across the room and smashing it. Someone in the group actually did quit like that. She had a whole tray of drinks, threw them on the floor, and stomped out—every cocktail waitress's fantasy.

Another weird thing that would happen is that I'd look out at people eating, and they would look awful. They'd be stuffing themselves, and it just looked disgusting—there was something about these people. They looked obsessed and out of control.

Montano: Did working with food as a waitress change your relationship to food?

Allyn: Sometimes I couldn't eat. I'd literally feel nauseous. Everything is the double edge. I hate the fact that serving someone makes you a slave—or a lot of people think that you are at their beck and call, and there is no respect for you in any way, shape, or form.

But I ultimately believe the highest thing that we can do as human beings on this planet is to serve and to serve out of love. In any way. In any job. If you do the job to the best of your ability, that is serving, and if you can do that in love—that sounds so hokey—but I think that's what life is all about.

When a restaurant is working perfectly—this sounds completely out there and shows how I got about restaurants and food—it demands that the entire team work like a smooth-running machine to get the job done. Sometimes it flipped into that other edge, and I felt only like a machine, putting out tons of food without having human contact. Other times the well-oiled machine was working and human and be-

came a metaphor for the world working. I got into fantasies like that. If one part messes up, grinds to a halt, then all of the other parts are affected. At my last job, my entire goal and challenge was to never get upset. No matter what happened, I would try to remain calm. In fact, that's still my goal in life—that no matter what goes down, I remain calm enough to handle whatever—effectively and creatively. I got really good at pulling it off in the restaurant because I got so detached. When I'm a little too close to something, it's harder. The trick is caring and stepping back at the same time. And to keep it all together, I'd go to the club for a good workout and steam. That helps!

NANCY BARBER

Montano: What was your relationship to food as a child?

Barber: I generally liked it. My mother died when I was very young, and I only have a few memories of her. They are all cooking memories—of her making buns and rolls and putting raisins and cinnamon in dough. That was a real image for us—making bread, putting it in a warm place, and watching it rise. I loved the magic of the rising and the softness.

Montano: How old were you when she died?

Barber: I had just turned five. Yeah, I remember that and the kitchen table—we had big breakfasts at the kitchen table with her. Afterward, I was raised by my grandmother, and we had big breakfasts with every kind of food imaginable—pancakes, toast, hot and cold cereal—that's how we were raised for about five years. And then we went through a terrible period with the stepmother, and I experienced a terrible way of eating. It was the meat here, and the frozen vegetables there, and the potatoes and honey wheat bread or something in the basket—and then the salad with the Jell-O and mayonnaise on the Jell-O and the iceberg lettuce. Those were my high school years.

Montano: Did you always enjoy eating?

Barber: Yes, I always enjoyed eating, but I was a bit of a snob because whenever I was exposed to anything that was good, I thought that the person who made it was great, and the information about it was even better. I would take the recipe back to the house and try to duplicate it.

Montano: When did you include food in your art?

Barber: I started doing video about eight or nine years ago because I wanted to earn my living by dealing with food and talking about it. I had been writing before that and was also the art historian for a jigsaw puzzle company. I was sick of that, so I started doing documentaries about food. The first one was about myself, but I wasn't about to be Julia Child, so I did videos of twenty-five people cooking in their homes and they put them on Channel C, cable TV.

Montano: Why do you think that food appeared in your work?

Barber: Because it was an opportunity to talk to people and be in their houses, not for aesthetic reasons, but for the bigger experience.

Montano: What happened to you as a result of that work?

Barber: I got totally engrossed in the video process, and everyone and everything that I came in contact with became material for the stories that would unfold. I was amazed that you could focus the camera, and fantastic things would happen. I wanted to continue, but I moved downtown and got a loft together. That was so debilitating financially that I stopped working that way.

Montano: Did that working with food and video affect your relationship to food?

Barber: It expanded and relaxed it, and I found out more about food and food preparation. It gave me knowledge and accelerated the process of finding out that food didn't matter. I like the interaction with people much better.

Montano: Do you see food meditatively?

Barber: Sure, it's the cutting and chopping—it's good raw material for meditation.

Montano: What other food work have you done?

Barber: After that I wrote about people cooking and eating and getting together for the *Soho News*. It was about whoever came into my life or asked me over for dinner or came here to do food things. I would write about all of the other extenuating circumstances around food. Then I took food pictures.

When I got pregnant with Tony, I really didn't like to eat, and then when he was born, I was so absorbed with him that it changed my cooking process. So what I've done is make a child's book with the alphabet made out of different foods. It also contains essays written from his point of view about what it's like to eat apples, bananas, and doughnuts. So, that brings me up to now. Recently, I've done some catering.

Montano: Have you done that as art?

Barber: No, mostly it's love and a way to loosen things up. For example, we were talking with people in the city government about artists' rights as tenants, and then three people came from City Hall. Lynn Wilens and I decided to make food so that it would be a softer environment, and people would talk longer. Her chocolate cake was great, and they loved the fish that I made. As a result of the meeting, four hundred thousand dollars has been allocated to investigate the situation of rents and artists' lofts. So, you see, it's an education—a big eight-dollar fish from Canal Street pushed things along.

Montano: Do you think that being a woman influences your use of food?

Barber: I think that nurturing and mothering figure into the final process, and women approach food as something that nourishes, not as a perfect product. That was evident in the videotapes that I made—women were functioning on many different levels while they were putting their stews together. Their goal wasn't a perfect presentation of food but nourishment.

Montano: Has working with food in your art changed your relationship to food in your life?

Barber: No, because food for me is about people. It's also like a big mix. In life, I also like the raw and cooked together. I really welcome change and variety. I'm eclectic with food and with life.

JOHN CAGE

Montano: I am compiling a book of interviews with performance artists. The topics are food, sex, money/fame, and ritual/death. Do you feel comfortable talking about one of these?

Cage: Would you repeat those categories?

Montano: Food, sex, money/fame, ritual/death. Do you like one over the other?

Cage: Of those?

Montano: Yes.

Cage: No.

Montano: Then let's talk about food. How did you feel about food as a young person?

Cage: It was an imposition. I was obliged to eat everything put in front of me, and I couldn't have the dessert until I ate the vegetable, and so forth. I think, from my present point of view, there's been very little good thinking about food in the course of my life. And only recently, in the past fifteen years, did I begin following a macrobiotic diet, which I think is a good diet. As a child I was raised on meat and potatoes, salads and Jell-O.

Montano: And Wonder Bread and condensed milk.

Cage: Exactly. Peanut butter!

Montano: And fried bologna.

Cage: Right.

Montano: Did you notice a change in your work or thinking when you changed your diet to macrobiotics?

Cage: My thinking had already changed through Suzuki and the philosophies of Zen Buddhism. But I had the mistaken notion that the spirit is separate from the body. Then my body began to revolt. It took the form of arthritis, and my wrists were very swollen. Through a series of fortunate circumstances, I finally came to Shizuku Yamamoto. The first thing that she said to me was "Eat when you're hungry. And drink when you're thirsty." And that sounded very much like "Shiver in winter, perspire in summer." And it came to me that I had finally gotten to the point where everything worked together.

Montano: What could you invite in terms of more thinking about food?

Cage: It's not so much a question of thinking as it is following some discipline. The one that I've chosen to follow is one of avoiding animal fat in all its various forms—dairy products included. And then finding a balance that suits you—in vegetables, grains.

Montano: This is very good for me to hear. Food is important.

Cage: I think so.

ANGELIKA FESTA

Montano: I wanted to ask you about food, especially since you did a three-day piece in upstate New York with fish tied to different parts of your body—you also made bread every day and then handed out the bread at the end of the three days. And now you have been going out for an hour every day for three months and holding a loaf of bread in each palm, offering the food to passersby. The fact that you are wearing papier-mâché rabbit ears also ties in to the food image. How did you feel about food as a child?

Festa: Food was always part of an emotional and material economy. Food preparation and communal eating rituals were always emotionally

conflicted events. Feelings of despair and violence were in the air. The dinner table was the stage where feelings about ourselves and others were revealed, yet much was nonverbal. I was raised in postwar Germany. My biological parents were devastated by the war. So I grew up eating in different situations, with different parents, different mothers, and a series of different temporary homes where I lived with total or semi-strangers. I also experienced many live-in housekeepers and cooks. For a while, an elderly maiden aunt cooked for my invalid and drinking father, my brother, and me. So, my feelings about food were complex. At age fourteen, I was adopted by a fairly well-to-do German-Canadian couple, and my feelings about food changed radically because food was now plentiful. Before that food had been part of my concern for basic survival, although I don't remember ever being hungry in a starving kind of way.

Montano: What kind of food did you eat?

Festa: I ate a great variety of foods because I lived with so many different people in so many different situations. I had to adapt to different culinary practices and attitudes about food and eating. Some of my good food memories from my childhood in southern Germany are about eating raw vegetables that I picked in our garden (sweet peas and carrots were my favorites), and wild mushrooms and berries that I picked along the river bank and in the nearby forest. Other favorite food memories from early childhood are fresh fish and homemade sausages that my father smoked in a big barrel in the backyard. I also shall never forget the two apricot trees in our California backyard that produced abundantly the biggest and sweetest apricots in the world. Less favorite food memories are about awful-looking and terrible-tasting bread soup made from the week's leftovers in one institutional setting run by Catholic nuns; overcooked and tasteless vegetables in one family setting; a lot of fried red meat and a lot of rich cake in another.

Montano: What kind of activity was eating?

Festa: Eating was an activity that went way beyond ingesting nutrients required for normal growth. It was an emotional event and symbolic of the relationships with family members or significant others. In hindsight, most striking to me is the use of food as a manipulative tool. For example, when I was about eight years old, I burned the potatoes that were meant for dinner. I was supposed to watch them boil while my older brother and I were doing homework and my mother was doing the washing in the basement. I got distracted from my chore of attending the potatoes and let them burn dry. When the smell of burned potatoes summoned mother from the basement, she lashed out and beat me for a long time, breaking the wooden laundry spoon over my back. She continued to slap me around until she fell into a heap, suffering a minor heart attack. When she turned blue, I both feared and wished I had killed her.

A few years later, my not eating enough prompted another mother to flush all the food from the dinner table down the toilet! It took me a long time to figure out just what food meant and what kind of an activity eating was in these cases.

Reflecting as an adult on the complexity of emotions that surfaced in both these food events helped me to understand better my own misuse of food as manipulation. For example, when I was ten or eleven years old, I repeatedly mocked my elderly and ailing aunt when the cakes she tried to bake in our wood stove collapsed. Rather than admire her heroic effort to meet the challenges of housekeeping in poverty, I cruelly misused the occasion of Tante Mia's limited success at baking to empower myself.

Montano: How did you use food in your art and life after you left your different families?

Festa: When I started to live alone at twenty or so, my exploration with food was quite wonderful. Food was just food to eat and enjoy. I ate a lot of raw vegetables, yogurt, fruit, and nuts. I made wonderful

salads with tunafish in them. Sometimes I boiled a pot of rice or made a cheese and mushroom omelet. I became an expert salad maker, and I loved it. I had Iranian housemates who expanded my tastes and attitudes toward food to include lamb stew as a form of seduction! Food became complicated again when, in a few years, I returned to struggling with close and familial relationships.

Montano: How did you start using food in your work? When? What happened?

Festa: What in hindsight I call making art is a process by which I try to nourish myself. I use food as an art medium to create conditions for survival. I have been practicing this kind of art since childhood by living most powerfully in the imagination. Ordering, analyzing, and reshaping my world was my way of creating a relationship to what seemed like an inhospitable world. I am still trying to do that. Working this way as a child led me from collecting rocks and leaves to digging holes in sandpiles, to studying literature, to photographically documenting what I saw and imagined, and to making dishes and cloth for everyday use. Finally, it led me to the work I am now doing—performing with fish, bread, and rabbits.

Montano: What do fish, bread, and rabbits signify in your work?

Festa: Fish, bread, and rabbits carry specific meanings defined by organized religions such as Christianity. Rabbits are symbolic of fertility, the moon, meekness, cycles of birth, death, and so on. But I am not interested in the Easter bunny, nor in sorting out the mystery of transubstantiation. Instead, I want to know how power works, how it is misused, gained, and lost.

In the performance that I am doing now, I stand on the streets in New York holding out small loaves of bread as a kind of offering. The bread provides an opportunity for all sorts of interaction and analysis on my part. I study my own responses and attend to what else happens around me. People sometimes tear a piece off or take both loaves.

Some just walk on or leave small sums of money in my coat pocket. Others think I am advertising for a bakery and inquire about the good-looking bread. They are disappointed when I don't respond to give them an address. I was terrified when two strange men pushed me around on the sidewalk and began to drag me into their car. These incidents of potential violence shocked me into recognizing my performance on the street as others might see it—outrageous, recklessly naive, and maybe stupid.

Montano: How does the offering differ from sitting down at a meal with your families?

Festa: In this performance I confront myself and others. It is like asking a question to which there are many answers. In this way it is similar to sitting with my families at dinner. It is tense, unknown, and potentially violent. Anything can happen as I stand on Broadway and Eighth Street at high noon wearing huge red rabbit ears and red clothing, holding out loaves of bread without speaking for an hour. I have set a stage for many things to happen. I feel as vulnerable as a small child.

Montano: How has working with food this way changed things for you?

Festa: I now think that I have learned a lot from working with food about communication as nourishment, especially about the language of desire and rejection. I can evaluate more effectively different ways of responding. I mean, I understand the dynamic between giving and receiving better than I did before this piece and am quicker at determining what I want or need and what I can offer. I have also learned a bit about how I create boundaries, how I share or withhold myself from others—as in the gesture with the bread as both offering and demand, a scream and also a joke. And I have learned a bit about distancing myself from difficult interactions by paradoxically being very much located inside them. New York is a good place for practicing that, I think.

Montano: You put yourself into a potentially volatile situation so that you can cure yourself of past fears. You incur situations that train you

out of old responses. How many days will you be offering food in the street?

Festa: Three.

Montano: Will you have a big dinner after that? A celebration?

Festa: Yes.

Montano: Do you have any bread that we can eat?

Festa: Yes.

HOWARD FRIED

Montano: How did you feel about food as a child?

Fried: I liked food. I ate fried chicken on vacations. My mom cooked roast beef for us once a week. I liked hamburgers, although I liked hot dogs better if they were cooked out in the backyard. I drank a lot of milk shakes. Now, theoretically, I don't eat red meat, but I've been slipping a lot recently. I've also been gaining weight. The amount of red meat I eat is probably insignificant in that regard, but I ate some last night. I'm just eating a lot generally. I may be eating too much spicy stuff. My cousin, who's a plastic surgeon, put that in my head. I like spicy stuff. I like vegetables.

Montano: As a teacher you are always nourishing. Do you have any comments on that?

Fried: No.

Montano: How are food and art correlated?

Fried: I've used food a lot in pieces. I did the *Sea Saw* piece using different menus and different waiters—that's where I tried to order food for an hour. I did a piece called *Museum Reaction Piece,* which is structured around fourteen lunches. There's a lot of decision making in that one also. All of the participants are museum employees. There are two hosts who, for one thing, decide what they are going to make for lunch

the next day when they will again be entertaining a lunch guest. They have a different museum employee guest every day. These decisions are part of a metaphorical pattern of tasks. Their significance differs from one host to the other because of the specific placement of the "What's for lunch?" decision in the order of the rest of what they have to do. This order is not the same for the two hosts. The preliminary text for the whole piece was written like a recipe. I was inspired by the form and structure of the recipes in *The Joy of Cooking*. Another part of this piece that we haven't talked about, the *Host's Host* episodes, was inspired by restaurant reviews, one of my favorite forms of literature at that time.

Montano: Do you still cook on a camp stove?

Fried: No, I got a regular stove eight years ago. It's much better.

Montano: Why do you use food?

Fried: I can be a compulsive eater unless I'm focusing on not doing that. My work can get pretty compulsive, too, but besides that I like food a lot. Maybe that's an entirely sensual thing. I don't know. I like to see it. I like to smell it. I like to taste it, but just as much as I like to taste it, I like to feel it going down—and I like to push it.

Once I went on an intense diet, and that was definitely the peak of my abilities to taste food. I only ate when I was running out of energy, and I ate slowly. I didn't eat a lot, and I appreciated everything. Now I just slap it in.

Montano: Anything to add?

Fried: Not really. I completely forgot that I was talking to somebody who didn't like to eat! In 1984 I did a piece called *Pattern Maker*. A lot of rows of chairs were placed in a space—like auditorium seating— except that there were no aisles. The chairs were side to side and wall to wall. There was a buffet table in the front of the room with chafing dishes on it. Someday I want to redo this piece and put attractive food in the chafing dishes. As it was, the food that I used wasn't much more

than symbolic food—instant chicken noodle soup—something that smelled, but didn't smell that great. The situation, more than the food, was the inducement to disturb the chairs and go to the front of the room, kind of a challenge. I made a time-lapse film of the situation every day. At night it was transferred to tape and then played back the next day in the foyer of the gallery, where the situation continued. It was like the news. When someone penetrates a situation on the news, it induces others to do likewise. It legitimizes penetration. If the food were better, it would change the character of the piece—it would deemphasize the role of the video feedback. It would be less revolutionary.

Another interesting thing that is happening to me is that I am teaching a graduate seminar, and the students have really gotten into refreshments. They didn't used to do that. There is wonderful food every time we meet. We don't meet until 10:00 P.M., so I always fall asleep after eating, but they take care of everything. It's very good.

JOAN JONAS

Montano: How did you feel about food as a child?

Jonas: I loved it. My father was a very good cook, and I enjoyed eating immensely. Food is one way parents express love for their children. They feed them. Sometimes I ate too much rich food and got sick. They often worried that I didn't eat enough. Someone put a clock on the table once and said, "Eat your coleslaw. Finish or else."

I am a mixture of Welsh, Irish, French, Scotch, Dutch, Italian, but the food we ate had nothing to do with this melting pot—it was a hodgepodge by people who used many cookbooks, traveled, and ate in restaurants—there was no fear or guilt connected with food.

Meals, however, were dramatic events because my stepfather, who was an amateur magician and jazz musician, performed à la Eugene

O'Neill. He did soliloquies—interior monologues aloud—consisting of funny commentaries on other members of the family. When I saw *Who's Afraid of Virginia Woolf?* I wasn't surprised. My brother and I mostly giggled, sometimes cried. Often I simply watched.

My favorite foods are salmon with egg sauce, delicious curry, black bean soup, and so on. I remember many delicious dishes—chicken tetrazzini, popovers, hot chile.

Montano: Do you make a correlation between food and art?

Jonas: I was married at twenty-two, focused on cooking, and thought about the meal I would cook from the time I woke up in the morning. I never made the same meal twice—for five years. When I began to spend more time on my art, my dishes got very simple and sometimes burned.

And I do connect the two. I like to work with my hands. Cooking involves taste and sight and smell and sometimes touch. Now I can cook and make art, but the focus is on the art. Also, as a woman, I was really trained to cook for a man, as a duty. I still have this in me, but I began to resent it fifteen years ago because I had become a skilled worker in the kitchen. Now I can get a fairly good meal on the table rather quickly. I try not to waste time. I still love to eat good food, but not spending two days on a dish. Things are more in balance than when I was a young bride and thought people would like me if I served a delicious meal. They did.

Montano: What is the similar creative process?

Jonas: Mixing elements in an alchemical way. Mix two things and come up with a third. Just the way an image is constructed. Two adds up to a third. Or mixes. You lay it out on the table and you combine it.

My method of cooking is the same as my method of working. Intuitive. Cook to taste. I never follow cookbooks, but I do refer to them. I go to museums. I look and I taste. I combine different elements. A little of this, a little of that. Use what is at hand. Also, cooking for me has

to do with getting people together, one or more, and communicating. In performance I also gather a crowd.

Montano: Do you feel drawn to do performance?

Jonas: Yes. For a while, recently, I retreated, but now I am going back out there. I miss it, and I like it. In the seventies, the situation was more intimate. There was a core of people who came to see everything, and they were friends. We all went to each other's works. Now people are busy. The audience is big and often composed of people you don't know. This can be inspiring also. The meals have become catered events. So my little transition is over.

Montano: Have you gone back to cooking?

Jonas: I cooked for a while almost every night until the mid-seventies. Then I lived alone and stopped. Now I am cooking again. It gives me pleasure and satisfaction that I don't get in my work. I like to stir the pot again.

Montano: Do you ever literally use food in your work?

Jonas: I haven't used food, but I included a beef heart in my performance *Double Lunar Dogs*. Every night we cut it open and looked inside. Before that I drew an anatomical heart to signify the Way of the Heart and also as a method to look at feeling and to indicate a kind of earthy ritual in the context of a spaceship where nothing is natural and feelings are. People commented and found it odd, but I used to cook hearts a long time ago and enjoyed going to the butcher, so it didn't disgust me to touch this raw heart.

I enjoy shopping for foods. I like markets, marketplaces. I never cook in my work, but I did a tape about the markets in Budapest, and it showed all the different kinds of food and the people who sell it. That's the only time that I really used food in a piece.

Montano: You are lucky to have that positive beginning and association of food with love.

Jonas: I guess so. I never thought of that exactly, but I probably didn't get love in other ways, and this was a substitute. But I also use it

as a way of communication. For instance, if I have people over for dinner, and I don't know what to say to them, at least if I get the food on the table and it's good, I'm saying something.

Montano: Have you ever experienced a silent, formal meal in a Zen monastery?

Jonas: No, but perhaps I will someday. I have always been drawn to ritual and have witnessed quite a few in which food plays a part. Observing the rituals of the Hopi Indians and the Tibetans, for instance, is one reason I was drawn to performance.

Montano: What is the concern of your work now?

Jonas: I have just gone through a quiet reassessment. Storytelling. My new work is based on an Icelandic saga. I went to Iceland to do some research, to record in video and film, and to see what the place is like—so besides telling a story in abstract form, I want to convey something of my experience when I travel. Ghosts in the landscape are called "hiding people" in Iceland. So I am going back to what I have always done, translating ideas into visual elements and large video projects. I want to make images with layers of references. In particular, landscapes interest me because unspoiled nature as we know it is slowly disappearing from the earth. It interests me to mix technology with nature.

Montano: How did you get into performance?

Jonas: I was a sculptor before and wasn't really happy with the work I was doing, but then I saw some Judson pieces, and that's how I became interested in performance. I saw artists make visually interesting works in time—called Happenings. Also, dancers were using a language of movement and gesture—acting as they felt. That struck something in me. It just struck a chord, and I wanted to do it, so that's how I got interested in performance. Also, I worked in the Greene Gallery for six months with Dick Bellamy.

Montano: What do you think the art of the future will be?

Jonas: I'm involved with media and video, so I think that if there is not a major catastrophe, that more and more will be done with video.

And I also think that movies like *Blade Runner* and *Road Warrior* are interesting because they show a kind of chaotic future—things are broken down and at the same time they are very technological. So maybe it's all going to be outdoors and back to strange rituals again.

Montano: Anything to add?

Jonas: Actually, this interview might have inspired me to think in different ways about food and art. In *Volcano Saga* I use a big hunk of bread dough. We performed the piece ten times in New York, and for each performance we made fresh dough. And I used it as dough but also as a claylike, elastic substance to refer to a woman's activities in the ninth century.

ALISON KNOWLES

Montano: How did you feel about food as a child?

Knowles: I wasn't breast-fed and ate the usual baby food. I do remember one experience concerning fruit, because many of my female relatives canned fruit. My mother left me in the hot sun with a dish of pitted prunes, in a high chair. I somehow got my shoes off and my feet into the prune dish, where I must have had a happy time squidging around. Really, the idea of getting something into your mouth is a great task for a child. It's such a messy process that lots of people form negative patterns from the agony of learning how to do it. It's hard to find that hole in your face that you can't see, and it's even harder to try and hit it with a spoon.

Montano: Did you always enjoy eating?

Knowles: Yes, certainly more than the other communal activities like talking, dancing, and so on. These things made me uncomfortable when I was growing up. My mother cooked religiously and well, and our family group managed to gather and eat together at the end of the day.

Montano: Was it pleasant?

Knowles: Generally speaking, yes, although somewhat quiet and overformal. My father at the head, mother at the other end, and children at either side. We read stories after dinner and finished the whole of *David Copperfield* by passing the book around. It took a year or so.

After her thirties, my mother became uninterested in baking desserts and all of the yummy things in general, as she began to watch her weight. Suddenly, she stopped serious cooking, and with that our attitude at the table changed. We all felt we should get done quickly with dinner. She did take off the weight. It was one of her most assertive acts and probably a good thing, but at some expense to group enjoyment.

Montano: Why did food appear in your work?

Knowles: I usually offer people food and drink when they come into my space. These are good things, things we can all agree on. Also, I love to cook. I've always used real things in my work, real objects. For me the real world is the right place to start from, whether you are making art, a performance, music, or dinner. You put the right things in and pay attention to the cooking. Time and attention.

Montano: What event was memorable?

Knowles: *Make a Salad* was first done in Denmark for three hundred people. It's an event from the early sixties. It turned out to be a very rebellious piece, because it was performed at a concert funded by the music conservatory. The audience was really offended. We dragged in bushel basket bags of carrots and other vegetables to make a huge salad. I was the only woman in the original Fluxus group, so the piece had a dynamic feminist twist as well. Some of the audience stayed around for the hour of washing, chopping, and tossing the ingredients in the barrel, which had been donated by the Crosse and Blackwell Marmalade Company. But they all came back mysteriously when the salad was finished. We even managed a cheese dressing. Some carrots were thrown back at us, but other than that the piece was a great success. It was the

first one of mine that the Fluxus group performed, and it has been done many times since then in turned-over kettledrums, with acoustic mikes at musical concerts. Personally, I prefer it straight, just getting out there and making a salad for people. Participation is guaranteed.

That's what is unique about the event form in performance art— once it starts, everyone essentially knows what will happen, and it just follows through until it is done, maybe minimally, maybe not.

Montano: The work that I have seen of yours has been meditative and about a very simple and quiet presence that happens in the space. How do you connect this with food?

Knowles: Food is a substance that nourishes. When we see it being used as art, we examine it more intensely. We enrich our lives because we encounter this food again in life. The nonverbal energy that happens when I perform with food interests me.

Montano: When did the bean image appear in your work, and why?

Knowles: Beans have always been one of my favorite foods; besides, George Maciunas called me and said, "If you are going to do a book, decide overnight." I did a bean book, and it was called *Canned Bean Rolls,* published by Fluxus as long scrolls, which are read from top to bottom. The information on the rolls is a compendium of bean stories and proverbs, which I collected from friends and from library research. In the can, along with the rolls, were real beans, which people did plant, and some of them grew.

After meeting Daniel Spoerri, the French artist interested in eggs, I decided that the two foods, beans and eggs, were the most ubiquitous, the most ancient, the most mysterious foods in the world. Corn, eggs, and beans are the great triumvirate, but I also feel that corn can't match the majesty of eggs and beans. So, I made those early performances as real experiences, which weren't disguised as anything else. I wasn't making a salad to glorify a concept or eating a sandwich in the *Identical Lunch* to make music. It was merely the experience itself that interested me, although I did it to happen in the context of a concert hall.

Montano: Have you ever been uncomfortable eating?

Knowles: If I'm uncomfortable eating, I don't eat. In fact, if I'm in a situation that disturbs me that much, I can't eat. But I do eat more when I'm traveling because I need that comfort.

Montano: Has food in your art affected your relationship to food in your life?

Knowles: It hasn't. I don't go from art to life, I go from daily life to art. When I perform *Make a Salad* in a concert hall for one hundred people, it's the same as making a salad in my own home kitchen because food preparation has always been a meditation for me, and I really don't know why it has that quality.

Montano: The fact that your family ate together and then read *David Copperfield* could possibly explain your relationship of food to art, because your work feels like a reenactment of that childhood memory.

Knowles: I never thought of that before. I guess that I regard food as very close to home.

LESLIE LABOWITZ

Montano: How did you feel about food as a child?

Labowitz: I had a love-hate relationship with food as a child. I hated it because I always thought that it would make me fat. And yet I loved all of the breads and cookies that my mother would bake. My family was European and cooked in that style, which embarrassed me because all of my friends were eating hamburgers. Both my brother and I told my mother that we wanted plain, skinny hamburgers like everyone else. We basically trained her in the American way and demanded soft, white bread.

Montano: Did you always enjoy eating?

Labowitz: No, I really didn't like to eat because my mother watched what I ate so that I wouldn't get fat. As a result, I could never just freely

eat and enjoy it. But I particularly liked to eat when I was alone in the night, when no one was watching.

Montano: When did food first appear in your work?

Labowitz: Just last year [1980], when I started growing sprouts and selling them as a business. It naturally evolved that the sprout business became an art activity.

Montano: Why did you choose sprouts as a business?

Labowitz: The art of growing sprouts was passed on to me by a woman I met who was growing them for the co-op. I said that I was real desperate for money and didn't know what I was going to do, and she said I should become her partner in the sprout business. So I saw her greenhouse and fell in love with it. I worked with her, and eventually she passed on the business to me because she wanted the right person to do it.

Montano: How do you connect sprout growing and art?

Labowitz: Sprout growers, in general, operate like artists. For example, the other sprout grower in the canyon has a greenhouse that is very sculptural. Their businesses are not your typical technological food-processing centers either, but rather seem more personally designed. The growing methods are unique to each grower.

The process takes a lot of quiet, attention, color awareness, playing with seeds, and mixing seeds. I designed my greenhouse that I work in to be a functional, sculptural space.

Montano: Has the sprout business given you a new persona?

Labowitz: Yes. When I walk into stores with different-colored beans, people open up and are happy to see me. They call me the "Sprout Lady," and I'm sure that it's because people have a positive attraction to life and sprouts radiate consciousness. They're the alivest forms that are. In the beginning I used to think that it was bizarre that I would walk into stores and everyone would react to me, tell sprout jokes, and be joyful around sprouts. Now I see why.

Even the people who work for me are special. They are here because they want to be doing something physical. They like growing things, and all of them are artists. Sprouts like that mentality.

Montano: What has happened to you as a result of your work with food?

Labowitz: It changed my life, or at least was a part of that life change. I feel that everything that I am doing and the way that I am eating is rejuvenating me—my skin has changed, my colon has relaxed, chronic conditions have cleared up, and I feel that I am regenerating my soul and every part of my body. My eyes are literally becoming greener.

Montano: What were your past art concerns and your present ones?

Labowitz: One's art is about one's life, and for many years I was attracted to death, destruction, rape, violence, and heavy topics, which led me to work for five years on events concerning women and violence. The preoccupation began in Germany, where I did an abortion piece that used Catholic symbols, pagan imagery, and large hats with pointed heads. Then I came to the United States and worked with Suzanne Lacy on some events—a rape project, a large float in the porno district of San Francisco, and another on issues of violence against women in the media. The last event was an incest project on child abuse. I'm not attracted to that work anymore and am drawn to lighter topics and things that bring joy and pleasure. Sprouts have been part of the reason that I have changed, because they have given me new life, which I can now give to my work. So I have a deep, positive, and personal relationship to this subject matter.

Montano: What is the relationship of art to business?

Labowitz: I think that the act of starting a business as my art has been another growth process. Most businesses start because they have a product that's needed and they want to make money on the product. I started the business to buy myself time and designed it so that I could put in the least amount of time working. That way, I could have the

greatest amount of time off for myself. The artist must make steps toward personal independence and survival.

For the future I plan to design a solar studio-greenhouse system so that I can maintain my economic, creative, and spiritual balance. Hopefully this structure will become a model for other artists.

SUZANNE LACY

Montano: How did you feel about food as a child?

Lacy: We used food as a game—my brother and I would be kept at the table until we finished our dinner. This way we were out of my mother's hair. We didn't really have to finish the food, and we would play dinosaurs, cavemen, et cetera, with it. Later I started a series of play restaurants because my mother worked all the time and we had free access to the kitchen. I'd make chocolate scrambled eggs, eggs with salad oil, brownies without a recipe, and other things like that. My parents were permissive, and so we could eat white bread with alternating layers of honey, sugar, jelly, butter. For snacks we ate white bread with mustard and sugar. Consequently, when we were five our teeth were falling out of our heads. I think that food was accompanied with a great deal of pleasure, because we could do whatever we wanted at the table. Also, I remember that we used to read at the table.

Montano: Did you always enjoy eating?

Lacy: Yes, but now I have a feeling that there isn't going to be enough to eat, and I think that it's because when I was younger I ate such crappy foods that I developed a kind of hypoglycemia or feeling of starvation. When I don't have enough money, the first thing I worry about is not having enough food.

Montano: Why did food appear in your work?

Lacy: Probably because of teaching. I've done lots of things at the Woman's Building in performance classes, and food becomes a simple

way of moving into performance situations. It also serves as a bridge between private rituals and social issues. In one piece we invited older women from the Jewish Community Center to the class and arranged ourselves so that an older woman sat next to a younger one. We chopped vegetables, told stories of our lives, cooked the food, then ate it. I like using food as a way of relating.

Sometime later at the Building, we all performed our images of food. For about an hour, insanity broke loose, and it got wilder and wilder. One woman drank tequila, took off all her clothes, and poured whipped cream over her body. Another angrily crammed food down her doll's mouth, while someone else passed around Valentine chocolate candies filled with glass and nails. After the class piece everyone was tired and very upset, and we discovered a close connection between food and insanity. It's probably because we were force-fed as infants and believed the media's propaganda about food and its effects on the physical body. A lot of women shared fears about being too fat or too thin.

Food appeared in my work when I started using meat, eggs, lamb carcasses, and viscera of other animals. I had been a premed student, and I suppose that these interests came from my experience with dissection, not with cooking.

Montano: What does food mean to you?

Lacy: I have a real struggle with food, probably because I changed my diet a couple of years ago and became fixated on it. Now, when I go to a city, I pick out food signs and places to eat. I'm infatuated with food and cooking because that's the one place where I can slow down and relax. Lately I've begun using food on a mass scale, partly as a result of Judy Chicago's *Dinner Party*. I have brought together women for massive potlucks, probably because it's a metaphor for nurturing each other. When you look at what women do naturally, you find that they have made quilts or cooked or nurtured others. I've translated these ideas into art and have come up with large potlucks. I'm interested in

the chain-letter meal, where one woman tells ten women, and they each tell ten women, and then they bring food and talk with each other over meals. Both times I've done it, once with two hundred thirty women and another time with five hundred women, have been real powerful experiences. You just place all of this wonderful food on the table and watch the way the interaction happens.

For the *International Dinner Party* I asked women to have simultaneous meals all over the world to celebrate Judy's show. Again, it was sharing food to raise consciousness.

Montano: Has working with food in your art affected your relation to food in your life?

Lacy: Yes, I'm a vegetarian now. I'm not a complete vegetarian, but I stopped eating chicken when I lived with chickens and started again when I stopped living with them. Once I began going to slaughterhouses for my work, I found that I became less interested in meat for both health and aesthetic reasons.

LES LEVINE

Montano: How did you feel about food as a child?

Levine: The war broke out when I was five. Ireland, where I was born, was committed to supplying agricultural products to the British army in the hope of getting independence after the war. So there was never much food, and everything was rationed, and we hardly ever ate meat. I remember eating banana sandwiches, made from stewed turnips that were overcooked and mashed, and then banana essence was mixed in with them. That mess between two slices of bread was a banana sandwich. It tasted like munchy potato that had paint thinner in it. You couldn't eat it, and you couldn't not eat it. I would avoid eating it and then be starving and have to eat something.

Montano: Then was hunger an issue?

Levine: You'd be surprised how easy it is to get used to eating less food. I didn't see an orange until age eleven or a banana, a real banana (not a banana sandwich), because these things had to come across the water, as they called it. Everything came across the water and was subject to being blown up in transit. One only saw things that were grown in the ground, like potatoes or carrots or turnips. Butter was at a great premium. The equivalent to what people put on a slice of bread in a restaurant was our ration for a week. You would get out of the habit of using the things that were rationed. Butter and sugar were left to the elders, and we just wouldn't eat them. Americans have all these substitutes for sugar. Our substitute was not having it at all.

Montano: How have you translated those years into your work?

Levine: Obviously in some ways we are the product of our childhood whether we're artists or automobile mechanics. We're far more programmed by the language we use to describe experience in our childhood than by the experience itself. When you have a certain kind of activity, it is the language used to describe it that decides if the activity is a healthy, normal activity or a negative, neurotic activity. If one recognized something like, "Well, nobody has any food," and then said, "We just have to be careful about this. We have to use less of it," as opposed to saying, "I don't have food and therefore I should feel unfortunate. This is particular to me."

Montano: Are you recounting how your parents described the situation to you?

Levine: I'm describing a phenomenon. It's hard to develop a big ego when all the systems that normally support one's ego just aren't there. It's very hard to think of yourself as somebody of great importance when you can't even eat a decent sandwich. It's demoralizing to be in a situation where you have to forage for food all the time. There is no time for the luxury of a consuming ego, which most Americans have.

The mind is taken up with other activities. If you can overeat, can overdo everything, you might be inclined to think that you are king of the world. You might be inclined to think you can do anything you want. You cannot develop a great sense of self-importance if you are hungry a lot of the time. On the other hand, it may be good because it puts you in contact with other realities.

Montano: When and how did food enter your work as a theme, gesture, material, visual statement? Was that early? Was it the restaurant? [In 1969 Levine opened *Levine's Restaurant* at Nineteenth Street and Park Avenue.]

Levine: When I did *Levine's,* the idea was that one could actually turn a concept into a reality because I never actually believed that our sense of reality is as potent as most people believe. Our sensory reality is very much invented by ourselves and by how we use what we are taught to invent, a reality we feel comfortable within. So *Levine's* was just an invention of a reality, which may not have been a reality for all I know.

Montano: Fasting produces mental clarity. Did being hungry as a child make you more familiar with clarity of mind and make you want to reproduce that as art?

Levine: Hunger in and of itself does not produce awareness. Hunger can produce some pretty awful emotions. People can get highly competitive—not for money but more for food, because money is abstract. It's only less abstract in this highly conceptual God-world we live in. In other places, money is more abstract, whereas food is not. Who knows how much money they need anyway, and if they have ten million dollars, they probably feel that they need fifty million dollars. But you can't categorize being hungry in the same way. It's the strongest thing you can imagine, when you are really hungry. It is like somebody is trying to take your body away. And the struggle to keep that body then becomes an extraordinarily warrior-like fight. You almost become a general in front of an army. Strategies come into it, all kinds of tactics.

In Ireland, as a child, I became involved with children when they landed in our school removed from the horrors of the concentration camps. We kids felt that we must help and share. They, on the other hand, having gone through at this time [1944], four years of concentration camps, would be conniving and plotting to obtain as much food as possible and store it for as long as possible. No matter how often we would say to them, "Every day we come to school we get a sandwich, so you can eat that one because you'll get another one tomorrow," they would never believe us and would eat about a quarter of it and keep the rest. We thought we were hungry. We were in a society that was totally rationed. They were in a society where you couldn't get *anything*. Literally, you would go several days without food. So we couldn't convince them that there would be more food.

And one saw that victims have a tendency to victimize others. The compassion you might think would arise in a person having had a bad experience was not necessarily there. Victims, for the most part, associate with the idea that those victimizing them are in a position of power. That is the position they want to be in. So often you would find these highly victimized people victimizing one another in an extraordinary way.

We see that people are hungry, but it's too easy to forget it when you are eating three-quarters of the world's goods. The sugar piece that I did downtown is hard to understand under those circumstances, because when you think about putting five hundred pounds of sugar in the window, you realize that sugar is a commodity. The price will go up or down depending on which position will make a profit. When you think about food commodities that way and then superimpose hunger and starvation on that idea, it's extraordinary because you realize that people are trading in other people's welfare.

Farmers live on the land and produce the food. If they are driven out of business through commodity trading, then agribusinesses will take

over. You can well imagine the tactics they might use—the same tactics used to drive the price of oil up, the same tactics being taken right now to drive the price of oil down. Then you superimpose that mentality on starvation, which is massive, and we go out with five dollars to buy a record of "We Are the World" to stop starvation in Ethiopia. Essentially we're deluded, because the forces that could stop starvation are way beyond our five dollars. Those musicians used starvation as a backdrop for entertainment and fame. In four years that record will be a nightmarish reminder that the situation has gotten worse.

Idiot compassion simply doesn't solve the problem. You have to take action that is going to be positive, not simply nice. It has to spark some positive response. At the end of 1986 we have arrived at a point where we are willing to accept anything. AT&T can impose pictures of starving people over their theme song, "Reach Out and Touch Someone," and we don't complain. The world is more complicated than the idea of sentiment. One should not be totally cynical, but you have to be committed to what you are involved with. That commitment must be long-term. Rock stars make records and are heroes overnight, and the starving are still starving.

Performance is egocentric, extremely self-centered, trying to get attention. Those are not the qualities by which suffering will be relieved. When people are suffering, it's not a performance. It is real. So something equally real must come in contact with it.

It's too easy to take a position that everyone is an artist. When everyone is, no one is. We can only judge artists by the commitment they make. If their commitment is large and powerful, we will be forced to bring ourselves up to it.

An artist has to take a position. An artist can be extremely critical. The role of an artist is to do something with a cutting edge. Because in looking at art, you are confronting something that you have not previously experienced yourself. Art experiences that you feel comfortable

with don't seem to act on you in any way. Artists should be critical as long as they are not foolishly or selfishly critical or arrogantly critical. If they can be astute and discriminating in their observations, then the world will be a better place for their criticisms.

ANTONI MIRALDA

Montano: I've never seen such incredible celebration of food! You have created over two dozen colored spectacular banquets that are excessive, abundant, and festive. Can you trace your work to any memories in your childhood?

Miralda: I was born after the civil war in Spain. Celebrations were not that often and had to do with a cycle, a special event that we knew was coming. Outside of this, life was very normal, very unexcessive, so the moments of excess were wonderful events that I waited for.

Montano: Your father worked with textile design. How did he and your mother influence you?

Miralda: He was more involved in the technical aspects of textiles and made sure that the design was correctly fabricated in the factory. His real creative interest was in photography, which he did in a classical way. My mother came from a part of Spain that is extremely energetic, the Emporda. It's in the northeastern part of Catalonia, a place of mixed cultures (Phoenicians, Arabs, Jews, Visigoths), and one of the main Greek colonies. As you can imagine, the foods that come from this area are incredibly rich and delicious—a real mix.

Food was tied to a celebration, so my best child memories are all mixed with images of street events, family gatherings, costume, ritual elements, church, and incense. Catholic ritual had a strong fascination for me because the aesthetic and liturgic elements were so powerful, but soon I was bored by the education and dogma of Catholicism.

Eventually, when I realized that ritual elements were not just about Catholicism but were the same elements used in all ceremonies in every culture, I felt free to work with them the way that I was motivated.

I am happy that my father introduced me to photography in the later fifties. When I was seventeen, I started doing painting and photography, and I was more pleased with that last medium than any other thing. When I moved to Paris, I did photography for myself, and through that very modest and personal work I was asked to do fashion photography, but I left the field because of routine and limitations.

Motivated by having been in the military service, in 1967 I began to use toy soldiers in objects and sculptures. All these pieces were tied to my own inner obsession, implying criticism of war and irony about imaginary military invasions. Since the most unhappy color is khaki, I used white for all the toy soldier pieces. When I actually escaped from that subjective way of working, I moved to another language, something less obsessive, and found a way to approach the people's level, involving everyday reality rather than focusing on my own reality.

Montano: Do you become an intermediary so that others can celebrate, something like the role of the priest?

Miralda: I connect with the idea of a magician more than a priest. A magician has a way of repeating certain formulas, a way of operating with signs, a way of transforming elements so that others can understand the nature of reality. I was challenged to think this way when I came from Europe and I had to rebuild my own space here in America. Whenever I travel to another city or country, the popular culture is so rich and fascinates me and transforms my vision of the reality. For that reason, I like to travel—it is again like working with a palette—a new sound, a new texture, a new color. So, what I would see and then do in Texas I would never do anywhere else.

Montano: When did your work with food begin?

Miralda: Throughout 1967–68 and 1969, in collaboration with Dorthée Selz, we developed a series of edible constructions basically

made of meringue and presented as architectural cakes. In 1970 the gallery Claude Givaudan in Paris was turned into a restaurant, and a kitchen and dining room were installed. Sixty guests were served dishes of blue, red, yellow, and green colored food. This was our first public presentation as "Coloring-Caterers." We agreed that we would continue to offer our services like real professional caterers, only our meals would become celebratory rituals. We had ideas to have a totally black banquet in the White House and a red breakfast in China. Why not?

Montano: How was the collaboration?

Miralda: Collaborations are extremely rich, interesting, and complicated. We also worked with two other artists, Joan Rabascall and Jaume Xifra, on ceremonial events. The experiment of working together is like playing a game. You give and you take. It creates a lot more movement and much more involvement on both sides. And at times it finishes with dramas, but that is good, too—there is nothing wrong with drama.

Montano: Has your work with food changed your relationship to food?

Miralda: Possibly. In my childhood food was programmed because of the social situation, like the number of children or other realities of family life. We were allowed meals at certain hours, fish and meat on certain days. If I use food freely, it is like a language or a way to express an idea or to talk about culture or about a journey: Paris (Camembert), to London (ketchup), to New York (TV dinner). I certainly use food in my work, but my main interest is in the ceremonial structure—preparation, presentation, serving, eating.

Montano: Has this concentration on food changed your personal eating habits?

Miralda: Since I have a special rhythm in my life because I travel very often, sometimes I am concerned with eating, sometimes I forget. This is very interesting because food can be integrated into the reality of each particular environment, and that is how I eat—it depends on

where I am and what I am doing. Really, I am fascinated by all kinds of food, packaged or canned, ethnic, fast food. It is interesting to see how foods can be transported from one culture and then capitalistically packaged in another place. Fast foods have a private and human quality. You can eat them on your own time, sitting on a subway, or while looking at the Empire State Building. These foods are not always shared on a table.

Montano: There must be different reactions in each country and city to your work. The foods are different, and so is the audience.

Miralda: It is easy to establish a dialogue using food because it belongs to all on every level. You can communicate with children in the Communist suburb of Paris—or with the Ninth Avenue audience in New York City—or with sophisticated museum people in Europe. I like making art that can be approached in many ways, not just by a select public that has its own cultural bias. Food is in the middle of everything and is connected with human behavior. People choose a certain food because they belong to a particular social class. They also talk in a style relevant to the food that they are eating. People's behavior is affected by the amount of protein they do or do not have. The United States cuts off grain to Russia as a power play. Recently France and Spain seemingly had food problems, which are really political and agricultural problems. Being aware of all of these ideas about food in daily life makes the work richer because it can exist on different levels—political, religious, and ritualistic.

In 1978 I did a piece in Venice called *Coca Cola Polenta.* In the past, Venice was a wonderful city, and now it's decaying and smelling but it's also a mass tourist attraction. So, in a major historical location, Palazzo Grassi, a cultural center with gold ceilings and painted frescoes, I brought polluted water from the Grand Canal, placed it in a transparent plastic container in the middle of this exquisite room, and surrounded it with a border of black polenta (cornmeal) that was cooked

and colored with squid ink. Because in Venice it is possible to see fast-food garbage in the canal, I floated two empty Coke cans in the water propelled by four electric fans. I was interested in the combination of elements from the environment—elegant room, polluted water, and food from the area. One result was that the installation smelled very strong, because the polenta, squid ink, and polluted water decayed. After two weeks they could hardly take the smell out of that room.

My work is a process. It's about perception and the mind and the memory of the observer/participant to share pleasure and beauty even in a critical and dramatic context. It is a poetic/celebratory situation and a political/social comment on the environment itself. My role is to interact with all of this. People can miss some of the meanings of my work in the beginning—this is interesting because it works like camouflage. Usually afterward people are trapped by the work.

Montano: What are you working on now in 1984?

Miralda: I am working with Montserrat Guillen on an idea for a restaurant in New York as a permanent piece there. I am also planning a very official event to present a project that involves two icons, two public and well-respected monuments, one on each side of the Atlantic—one in the Old World, Christopher Columbus, and one in the New World, the Statue of Liberty. Both are in the same parallel. Columbus is in Barcelona, standing on top of a column and pointing to New York with his finger. He is directing, marking the line of travel, and in America, the Statue of Liberty, with her torch, lights the line that comes from symbolically welcoming all cultures. I'm interested in the idea of travel in this piece, and I will use food as the connecting link between the two worlds. Indian foods—cacao, tomatoes, potatoes, and cereals—were all New World foods that were introduced to the Old World. The continents traded with each other. The plans are to do a food event in both New York and Barcelona that will explain these ideas and show the physical link between the two centenary monuments. It

will be a symbolic marriage between Columbus, symbol of conquest, and Liberty, symbol of freedom.

SUSAN MOGUL

Montano: How did you feel about food as a child?

Mogul: I have only one early memory, and that is that I didn't like green beans. I hid them in my napkin—the old hide-the-vegetables trick.

Montano: Did you always enjoy eating?

Mogul: Yes, and I started cooking when I was twelve or thirteen years old by fixating on one thing like eggplant and then looking up all the recipes that my mom had in her cookbooks for eggplant—eggplant balls, fried eggplant, and so on. I always enjoyed making food.

Montano: When did food appear in your work?

Mogul: The first time was when I made the video *Dressing Up,* where I ate corn nuts, talked about my clothes, and got dressed. In the video I used food to mirror two obsessions, the obsession with the banal activity of getting clothes on sale at discount stores and the other obsession with the unconscious physical activity of eating to fill up time. When I'm under stress or going through a transition, then I think that food helps me relax. I eat corn nuts in the tape to push and accentuate humor. In *Design for Living,* I make a salad, which combines three actions—preparation, eating, and storytelling. There are some elements of nurturing in this piece, as well as humor. I talk about how I make salads at home for visitors, and the fact that they prefer iceberg lettuce and actually expect it. I don't like iceberg lettuce because it has poor color, no vitamins, and is all water. This fact allows me to question the taste of those who want it in their salad. I say that I should give them iceberg lettuce, which means that I have to make a compromise in order to

please. Later in the performance I "kill" the lettuce by tacking it on the wall to dry it out. This action gives it some color, so I can put it in their salad. I'm not gentle with the iceberg lettuce in this piece—it's nurturing with irony. I think that I use food as a buffer between myself and the audience. It gives me an activity to do and puts something between me and my guests, as it were. In fact, there is a line in my piece that goes: "My guests relate to red cabbage the way some art curators have related to my work—they leave it on their plates, and I end up clearing it away."

Montano: Has working with food in your art affected your relationship to food in your life?

Mogul: My work is very much about the present, which I arrange, push, exaggerate. Food is something I'm comfortable with. I care about it, and I'm discriminating about it. I will not order a salad when I go out to dinner because I know that I can make a better one myself. In fact, I only order what I can't make and think of eating as having a new experience. I consider myself an authority on food, and this helps my attitude when I use it in my work. I make salads every day and am familiar with that process. I observe the way people deal with salads and how they eat them, so it is only natural that I would rearrange that information in my art.

Montano: It appears that you are also interested in dealing with three simultaneous actions. Where does that interest come from?

Mogul: One time I did a piece in Pauline Oliveros's class at UCSD [the University of California, San Diego] where I was consciously thinking of performing two different tasks: talking and simultaneously making a salad. Now I also see that I was trying to create distractions for myself and distractions for others. I choose activities that are easy and natural for me—talking, making a salad—but by putting them together, I create a difficult task for myself. I do it for humor and for playing things off each other. Life is like that—there are distractions

that you hit up against, and sometimes simultaneous tasks, along with a range of mental and physical stresses and demands. Distractions allow me to move in my work. I'd feel naked without those difficulties. I need an obstacle course so that I have something to work against, work off of, or work through.

Something happened yesterday that seems appropriate to this question of food and art. There was an opening at the Annex Gallery, and one of the artists showing there made eggplant caponata, which was absolutely incredible. I wanted to go up and congratulate her about the eggplant, but I was conflicted because I didn't want to congratulate her about the food she made and ignore her art, so I went up and said, "I enjoyed your artwork, and your eggplant caponata was excellent. How did you make it?" She laughed (she's probably in her mid-forties) and said, "You know, I'm a good cook, and I debated myself whether or not I should make this tonight because I knew that this would happen— that my food would get more attention than my artwork. But I figured that the students like to eat, and the faculty like to eat." She figured that her food was very good and would conflict with the attention that her artwork would receive. This story, like my work, is about art and life. And life is often about food.

FAITH RINGGOLD

Montano: How did you feel about food as a child?

Ringgold: I was not a fat child. I was skinny, thin, and loved food, but I was allergic, so there were a lot of things that I couldn't eat. My mother fed me a kind of health food diet of steamed vegetables, fresh fruits, cornmeal gruel, oatmeal, but I couldn't have corn flakes, processed food, or bread. Instead, I had something called cracked wheat bread, and, as I recall, it had to be toasted. I could have baked chicken,

veal, and lamb but no pork, nothing fried. I am strong now, and I imagine that has something to do with it.

I liked to have breakfast in the morning with my father, who drove a truck for the sanitation department. He got up very early in the morning, and Mother made him a traditional bacon-and-eggs breakfast, but I couldn't have that. I had a piece of my toast. When my brother and sister got up, I would have breakfast with them, too— that would be my cornmeal gruel. After we would walk them to school up six hills, go back home, and then go back again to get them—and then back—four times up and down those hills. That was a good workout! When school was out, Mother took us to the park and let us play. We'd come home, they'd do their homework, and then we'd eat and go to bed. Early. Even when we went to Atlantic City in the summer, we'd get up early, walk all of the way across town to get day-old bread, walk back and play on the beach, come home, have our lunch, have a nap, and so on. My mother always kept a schedule for us. Now, I wish that I had kept that schedule going. I instead got into a slump after I had two daughters in the same year, 1952, and then I developed this inactivity. Besides that, after I divorced my first husband, I went back to stay with my mother, and since she was a very efficient person, I thought, "Why compete with somebody like that? Why not lie back and let her do it?" So I did. And that nurtured the inactivity until 1959, when I left her and got my own apartment with the kids.

Montano: When did you start making art about your life?

Ringgold: In the fifties, making art was very difficult because the kids were little. I was getting my master's in school, but at that time I didn't have the time, the experience, or direction to get into it enough to do anything. So it was not until the sixties that I was able to have a block of time to be able to say, "For the next two months I am going to do 'X.'" Then I was able to work the art in, but the depression came because

there weren't any opportunities. I mean, "Where the hell am I going to show this shit? Good grief, so this is what it's all about!"

Montano: Now you are doing a food endurance, losing a lot of weight as art.

Ringgold: Yes, and when I do performances about it, I talk about the different kinds of things that I ate. In the fifties my husband-to-be used to bring me pork chop sandwiches, which were great for me because as a kid I couldn't eat stuff like that. Do you understand? They were fried! Who ever heard of fried pork chop sandwiches? I also ate Sherman's barbecue, which is very famous in Harlem. We would go to nightclubs and the theater, but we always went to eat also. All of the men that I went out with didn't eat much—in fact, I've never been involved with guys that eat much. They are always thin, and food is just something that they do to keep from dying. They don't believe in just eating, but they love to see me eat, okay?

So the sixties was that depression over lack of opportunity in art, and that's when I became an activist, which brought me out of the house, not just to work, not just to socialize, because I had done that to death in the fifties. Doing my activist thing saved me because it got my mind off my kids, and it got my mind off myself. It lifted the depression, but I continued to eat, went to Europe, and it was there that I discovered fancy dining and wine with my meals! And, of course, bread and cheeses—I added that to my repertoire of things and even extended it to wine with my pork chops.

In the seventies, more fancy dining. I had more money, so I was going down to the Russian Tea Room and stuff like that, with my eating buddies. Gained more weight. I was still doing activist stuff and traveling around the country. The career was better because I was getting opportunities to show the work, but my body was beginning to feel like a burden. I avoided doing anything about it, and since I had so many other problems, I made excuses, because I felt that food was

owed to me. So things were still hard. And in order to do artwork all the time, I had to appease myself. I had to stroke myself. I had to give myself all of this food. I had to make myself comfortable. And the way to make yourself comfortable is to eat food and never exercise. Never, never do any kind of exercise.

In the eighties, after both my mother and my sister died a year apart, I started teaching at UCSD each year from January to June. Part of the reason that I accepted the job was because I needed the discipline, since I was literally doing exactly what I pleased. I needed to have someplace to go every day, to be there, to keep my body moving and to keep me from doing only what I wanted to do all day long, including eating.

Food and relationships are interconnected. People who eat too much have a lot of bad relationships in their lives. There is something that they are carrying on their backs like a big burden, and they are eating it! And that's not true of people who drink or use drugs. Eating is more insidious because everybody has to eat (you don't have to drink, and you don't have to take drugs, but you do have to eat). So I took my burdens with me and was maintaining up into the 250s. I knew that I would give my soul just to be alone for a while. Let me have some peace!

So the second January I went to UCSD alone, and even though I still wasn't able to do anything about my weight, I was more peaceful. It was then that I discovered Mexican food! And I decided that was health food! It was corn and chips and sauce. How could that be fattening? And there was this nice Mexican restaurant right across the street from my house in California, so I went there three or four times a week, but I also went for acupuncture and lost 15 pounds. When I came back to New York, I gained it back and went up to my 258.

That's when I said, "Okay, this is it. You don't have any excuse anymore. You have claimed that your life is so full and that you're giving much more than you are getting, and that's why you are eating—to

make up the difference. Now you are not giving anything to anybody. You are here alone. For the first time in your life, you can spend all of your time on yourself. Now, what are you going to do with that time?" And I said, "I'm going to lose weight, and I've got six months." So I made this contract with myself to lose weight and to document it. It stated, "You are going to do a quilt, you are going to do a performance, and you are going to do a video." So when I went to California, I went to a doctor and asked for a reference, and they recommended this program called Optifast, which takes food away from you and gives you this protein supplement to drink. It worked beautifully. I lost about 60 pounds. It's also based on behavior modification, so you drink this stuff and do exercise. It took me a little while to get into that exercise part, but I started running on the beach because I lived a block from it.

When I came back to New York in June, I got back on food, and now I go to Weight Watchers, but I have added exercise. I understand the body and know that I have to move it every day, and I try to think of new and interesting ways to do it. I don't eat anything fried. Period. In fact, I don't eat meat. Even chicken is too fatty for me at this point. I like fish much better. Basically, I'm eating very much like I did when I was a child, going right back there, and that sustains me through this, that helps me do this one-year piece. And I don't really have the time or the money for therapy. It's one hundred dollars or more to talk to somebody, and I said, "You talk to yourself. You know what you need to do. Do it. I mean, what's your problem? Your problem is that you eat too damn much. Stop it. And you eat the wrong things." People used to think that I was Nell Carter from *Gimme a Break*. So I said, "Well, that lets you know something. You got it now?"

Montano: In these pictures you look like a queen, like royalty.

Ringgold: That's because I was so fat I had to do something. I wore a lot of costuming. The fatter I got, the more regal I became because I

couldn't move. I became a presence because there was so much of me. I adopted that style in the seventies. There was a certain power about it, but now I'm into strength, physical strength; that's why I lift weights. I want to develop muscles because I've feared that if I was thin, I might be attacked and hurt. I feel that a lot of overweight people are big so that they can protect themselves. And when I said, "Okay, well, how are you going to deal with that?" I said, "Make yourself strong! You don't have to be fat to be strong. You can be physically strong and lean."

Montano: How are you connected to the women's art movement or art world?

Ringgold: I don't see myself in relation to the art world or to styles. I do what I think needs to be done. I've computerized my feelings about feminism, about being black, and so on. I've put it all in here, and I feel that when it comes out, it comes out right. I don't want to be self-consciously doing something because it is x, y, or z—or self-consciously not doing it because it's x, y, or z.

You can feel the power in women today. The Guerrilla Girls have a poster mentioning that the Met, Modern, Whitney, and Guggenheim haven't had women's shows—so there is another surge of activism among women artists to address that, although it may not be effective right now, but eventually it will. Things have to change. Activism energizes the group that is making the changes. It's great for the people out there protesting. They get to be with each other, they get to know each other, they get to feed that into their work. It takes away a lot of that sterility and that constantly looking at the galleries to see who's stylish and whom to imitate next. It's got to be positive all the way around.

Montano: Has your job teaching at UCSD taken pressure off your work? Your life?

Ringgold: That job takes me away from my family and gives me a lot of time to myself. And I keep saying, "Why do you need all this time

to yourself?" Maybe I won't need it forever, but it's my time. This year when I go, the big thing is going to be my exercising, weight lifting, bodybuilding, so that I can get a nice, strong body, and I think that I may want to learn how to drive a car!

We can't be awake to everything. There is always something that we're sleeping out. I am always looking around to see what I can wake up to next.

RACHEL ROSENTHAL

Montano: How did you feel about food as a child?

Rosenthal: I lived in a house where food was an art because we had a Cordon Bleu cook and, as a result, were renowned as one of the best gastronomical houses in Paris. I ate gourmet food every day, three times a day. However, I was a chubby child, and when I was six, my governess put me on a diet. It was a catastrophe because I lived in the midst of this plenty and wasn't allowed. My half sister was obese and was getting a great deal of flack from my mother, so I associated being loved with being thin. That created a lifelong problem and an eating disorder. For example, I can never remain an even weight because it either goes way up or way down. I eat emotionally—and for all of the wrong reasons. I think that food is a bit of a fetish in my life. In fact, it has poisoned much of it, although my sister's problem with food was worse. It was only late in life that I was able to make art out of this, because previously it was a subject of shame to be hidden.

The event that released me was my mother's death. After that I had the capacity to take my life and make it into art. Somehow I was not able to do that when she was alive, and from then on I did autobiographical works about information that I had previously wanted to keep secret.

Montano: How has revealing this information changed your attitude to food?

Rosenthal: I still have the problem. I haven't licked it. I go through periods of being real thin, then I put the weight back on. But I always say that I wanted to transform my life through my art. I didn't do that at all—all I did was demystify the personal/intimate secrets so that there was no longer a heavy mystique about my (our) sins. This mystique creates guilt and an unrealistic romance. Demystifying has made me much more relaxed about myself—it's made me laugh at myself, which was a very important step in my life. I am less tense about the paradoxes.

Now [1985] I am doing a food piece that is a dance and less autobiographically revealing except that I use Ellen Zweig's tape, which is about eating disorders, *Fear of Dining and Dining Conversation*. Otherwise it is about the food chain as a phenomenon of life. It has four sections:

1. Food as sacrament.
2. Solo for woman representing the sun (the source of all food), in harness, somersaulting high above the stage.
3. Eating and being eaten: an exploration of microorganisms whose life is about this process.
4. The politics of food: de-sacration. Three women in a restaurant. They devour the waiter.

I wanted to keep this piece light. It will be spectacular but not heavy. So, as you can see, my emphasis has changed. I have exorcised the personal material.

In fact, since 1981 the work has been about global issues, universal issues, about animals as food, et cetera. My belief is that there are too many people on the earth, and she is rejecting some of them. It will soon be our turn to be rejected, and in the meantime we are only fiddling as Rome burns.

Montano: Has that belief speeded up your own personal process? Aren't you frightened?

Rosenthal: I relate very strongly to the earth and feel that she is my true parent. Anything that happens to the planet, I feel very deeply about. It's a burning issue for me at this time, and since I have no personal life, so to speak, I feel like a balloon going up into the atmosphere, looking, gathering information, and relaying it back. I do my work, perform, teach, but my main grounding is my animals. They teach me, and because I have no other relationships at this time, I have the luxury of not fixating on my own personal problems.

Montano: How will food and animals evolve?

Rosenthal: We have lost perspective. Our spiritual connection with food and the eating of food and what it means globally in terms of cycles of life and being on the earth is in jeopardy. We've trivialized food and turned it into entertainment just as we do everything else. I personally don't know what to do about it; I am a vegetarian and would never eat animals again. We are eating the flesh of animals that are rendered mad by confinement, pain, isolation, tortures, and other unnatural ways of being. Eating such nourishment, in my opinion, cannot be very conducive to building sane and healthy human bodies.

Montano: Have you any advice for other artists interested in food and their lives?

Rosenthal: I think we, as artists, need to explore our moral landscape. How can we be moral beings, conscious beings, and continue behaving, in the strong tradition of Western culture, as if humans are the only life-form on this planet. Or the only life-forms with rights. Our treatment of other species is ghastly. But we don't stop there. We carry these supremacist views and actions in the realm of human race, gender, class, nationality, and so on. We are not sufficiently aware of the link between our behavior toward other humans. This has to end, for the result is more and more bloody as we add billions more of our

species on earth. Artists have been on the vanguard of future thinking. This question just isn't examined enough. We must look at our relationship with other animals very carefully and very critically, and make our findings vocal and visible. And then change our ways. I strongly believe that the future of the earth as we know it depends on it.

MARTHA ROSLER

Montano: How did you feel about food as a child?

Rosler: Food was often a burden because my mother believed that a fat baby was a healthy baby; as a result, I had to eat everything on my plate. She had very definite ideas about how much children should eat—my older brother still has a scar on his cheek from the time my mother jammed a spoon through it while she was feeding him in infancy. Naturally, I was fat until I was five or six—but my mother chastised me for being fat right through my mid-teens, though by then I'd been of average size for years.

When I was five or six, my mother would put out my dinner on a card table in the living room and leave me alone to eat it. I got in the habit of opening the window and tossing out what I couldn't finish. I just couldn't eat all the food she was trying to stuff into me. So one day the downstairs neighbor came upstairs and told my mother there was milk running down her windows.

I was prohibited from having sweets, which I loved, so I would pull a chair over to the kitchen cabinet where my mother kept the candy for her canasta and mah-jongg ladies, and I'd climb up and steal a handful. On school days I'd buy a giant sour pickle from the Jewish delicatessen and eat it all or chew a whole pack of Juicy Fruit gum.

My mother taught elementary school, and before she left home in the morning she would often take food out of the freezer to defrost.

On certain evenings, when she had meetings to attend, my father was supposed to make dinner for the two of us. He would come home from work and see the food on the counter, and because it had been out of refrigeration for eight or nine hours, he was afraid it might be spoiled. My father had been a restaurant inspector for the Office of Price Administration during the war, and he was disgusted by what he'd seen then of food handling. Anyway, he'd take this thawed food from the kitchen counter and throw it down the incinerator chute or offer it to the super, and then he would take me out to eat—which thoroughly pleased me. Often the discarded food had freezer burn from lying in there for months at twenty degrees. Of course, I enjoyed our conspiracy of silence against my mother. So in my house there was a steady stream of food that was flung or thrown or given away or given or taken surreptitiously.

Montano: When did you start incorporating food as an issue or object in your work?

Rosler: Not until I was in my late twenties, when I realized its central meaning for women. By then I had a small child and had been a cook for a decade. I realized how much food and eating behavior were an obsessive topic of interest in this culture, and probably in most. I saw that women stood in a special relation to food as both producers and consumers. I also began to conceive of women as put in a negative position in a system that suggested our very bodies were unacceptable "as is."

I came to realize that food presented a manifold subject, to be viewed biologically, socially, and even metaphorically. Women prepare the family's food and have primary responsibility for the nurturance of infants. But there are numerous other, contradictory demands on women in relation to food, centering on women's expected self-abnegation and also on the creation of food as a kind of art form. That one has to do with social standing as well as with the channeling of women's creativity into ephemeral and repetitive forms. What male chefs produce is, we know, highly regarded, but there are as yet very

few chefs who are female—women's creations are seen as a kind of necessary daily background to the rest of life.

People who live in the grand manner have cooks and other servants, and historically it has only recently become part of the bourgeois housewife's role actually to cook the household's food. The modern bourgeois wife, then, has an extra demand placed upon her—to produce artfully created dishes while still being expected to sit at the table as a consumer, eating. For most of this century there has been little separation between those two functions, producer of food and simultaneously consumer, because women aren't really supposed to eat. It's crazy.

Montano: Your parents' relationship to food certainly gave you material for your art and politics. Did you move from the psychological and early childhood concerns in your work to the political concerns?

Rosler: My tendency has been to return in cycles to matters I'd dealt with earlier. The question of having and not having, of food deprivation in the global political sense (the politics of food production) started shortly before my work on anorexia. Its first appearance was in a performance I did called *A Gourmet Experience,* which centered on food in the home. So the personal leads to the political and the political to the personal.

In any case, I see something of an analogy between, on the one hand, women in our society who are food producers—cooks, not growers—but who are expected to drastically limit their food consumption and, on the other hand, farmworkers and even many countries who must produce agriculturally but who have inadequate food consumption—not because there is a cultural proscription, but because they can't afford it.

On a metaphorical level, as I remarked earlier, women's creations are a necessary daily background. In a technologically advanced culture like ours, this role appears far less necessary and is therefore far less socially rewarded. In this realm, as in others, women are left placeless and voiceless while still being required to appear. Because I feel the validity

of these arguments and analogies about women's deprivation and other cultures' deprivation, I think there is, for me, little separation between psychological and political issues of food. I imagine myself as a child as both overstuffed and starved—feeding as nurturance versus loving as nurturance. I think the question of the politics of food in a grand scale and the question of food in the micropolitics of the family are always both present for me.

Montano: Who is your political mentor? Art mentor?

Rosler: I began as an abstract painter in my teens, but I was always quite concerned with political issues and was politically active. The women's movement had a great effect on what I wanted to do in my art. I felt at a dead end with painting, even though I adored doing it. I felt it was a secretive activity; it reminded me of my childhood habit of staying up all night doing thousand-piece jigsaw puzzles. I was mad for them; I liked the sense of moving toward completion and actually achieving it. And I felt similarly about painting. But I moved toward work that really made more personal sense when I started doing political photomontages about the Vietnam War and about images of women. But that also seemed restrictive. I was interested in achieving a fuller form. The first performance I did had to do with food; it was, as I mentioned, called *A Gourmet Experience,* and it substituted images and texts for actual edibles and combined a look at food as representation and as women's art with questions of starvation, especially of women and children in producer countries.

Being on the West Coast, around the women who essentially reinvented performance, like Barbara Smith and Ellie Antin, was very important to my development. And, earlier, in New York, Carolee Schneemann. Although her work presupposes a combination of a dance background and the Living Theater, it provided my first exposure to Happenings, which until then had seemed really male.

Before I did the performance called *A Gourmet Experience,* I prepared myself by reading about a hundred cookbooks and books of food his-

tory. I worked with food—photographing it, videotaping it, wrapping it, unwrapping it. I became very interested in the representation of food—the lack of connection between pictures of food and our knowledge of it as something real, something that grows in the real world and nourishes us, and also as something *produced* by human labor and especially women's labor.

I wrote a pseudo-autobiography in a series of postcards, a story about a woman who wanted to become a gourmet, which I mailed to a few hundred people, in and out of the art world. My basic list came from Ellie Antin, who was much more involved in the mail art network than I was at the time. When the *Village Voice* wrote it up, people asked to be put on the mailing list. I used the personal voice of the would-be gourmet, the would-be artist-cook, as the basis of *A Gourmet Experience* performance, and the postcards actually figured in it. I did two other postcard novels about a woman and food, one about a fast-food cook and one, in Spanish, about a Mexican maid. That was ten years ago.

The most recent work I've done is a video installation about food, language learning and subjectivity, children, and advertising called *Global Taste: A Meal in Three Courses*. So I come and go, but I'm always the same.

As a mother, food and nurturing have been a constant concern. Now my child is a big boy. He is reaching the point where some of the nurturance—though not through food—is flowing toward me, a nice development.

RICHARD SCHECHNER

Montano: How did you feel about food as a child?

Schechner: I had two big shots of vodka with this man, Yuri Lyubomov, just before I came over here, and I don't drink very much, so I'm very peaceful. How I felt about food? I was a tremendously fat baby,

and I didn't even sit up until I was past six months old. There's a picture of me sitting in a brown corduroy chair, and they propped me up. I had a huge belly, my hands were out to the side to balance myself. The reason was that when I was five months old, I got pneumonia. I don't remember anything about it, but I've seen the temperature charts, and for five days I had a temperature of 105 degrees. At the end of that, they found blood on my pillow, because my left eardrum had ruptured. This was before antibiotics and penicillin, so they had to wait out these things. It was also a time when they felt that they should feed the fever, feed the baby. And so they kept feeding me. And I kept getting bigger and bigger.

I still love milk shakes. I also like a vanilla float with Häagen-Dazs ice cream and fresh almonds in milk. Sometimes I get a meat urge, and I go to a place like the Old Homestead for a two-pound prime roast beef with the bone, and I particularly like the fat. Even though I know it's killing, I like to eat the fat—or the turkey's ass, the pupic, as it's called—I like that also. And just now I came from a favorite food, good lox and caviar and cream cheese and different kinds of Jewish fish—actually, they are not really Jewish, they're northern European. I don't know how we Jews got hold of them, herring and lox.

But sometimes when I'm feeling real good about myself, then I'll have a crisp salad with a light vinaigrette dressing with some good Balducci's rye bread. And then, occasionally, maybe once a year, a whole small Baby Watson cheesecake. And I like Japanese food and Chinese food and Indian food and Italian food and French food and Russian food. In fact, I haven't found any food that I don't like. The cuisine of every country is good when it's done right. The worst food that I ate ritually was in the highlands of Papua New Guinea, where I had to eat almost uncooked pig's skin with hair on it. I thought maybe this was the last meal that I would eat. That's exaggerating—I knew that I had to eat it and also knew that I would get dysentery.

Montano: How does your love for food enter into your work?

Schechner: I really should make dramas about food. But I may. I'm doing *Don Juan* now, and I might make that final feast with the Commander—where Don Juan eats and eats. The Commander takes Don Juan to hell, but Don Juan wants to stay in this world and keeps eating. Did you ever see *Mother Courage?* There was a meal in the center of the play. In scene 3, Courage and the chaplain are preparing a meal, because she has to earn her living by running this Good Humor truck, a truck with sausages, hot dogs—not a push wagon, because she is a little bit up in the world. It's the war, and her son, Swiss Cheese, has been arrested. She has to decide whether to mortgage her truck to find her friend, Yvette, the prostitute, and thereby get money to bribe those holding Swiss Cheese, but possibly lose her truck because she won't get the money back to pay off the mortgage and will therefore lose her livelihood—or not mortgage her truck and let her son die. While Courage decides, and thinks she'll finally mortgage the truck, her son is killed. And they bring his corpse in, and she has to look at it and deny that she knows him. And she bends over very close to him in my production—her nose almost touches his face—she looks at him, her innocent son, her good son, the son that is not shrewd. Courage stands up, shakes her head, and says, "No, I don't know this man." And they take the body away, throw it on the dunghill. Then she has to serve supper to the people—some of whom might have been her son's executioners. In our production we served food to the audience. And at that moment, the kind of tragedy of that scene dissolves into the celebration of the actual sharing of food in the theater. That lasts three quarters of an hour. I always like serving that meal. Upstairs in the [Performing] Garage, we cooked soup and bread, and we always served Swiss cheese because that is the name of the son. He had bread and soup, apples and cider. The audience lined up with tin cups, tin plates, and we doled all of this out—food we had cooked ourselves. We sold

it to the spectators for a fair price. Serving that meal and sharing the eating always made me feel good.

Montano: How do you feel about the way food is being used in the eighties?

Schechner: I always invent roles for myself. Just two days ago I invented a role in which I was a pugarexic, which is the opposite of an anorexic. An anorexic always looks in the mirror and says, "I'm so fat, I've got to stop eating." We pugarexics look in the mirror and say, "Look, I'm all skin and bones. If I don't eat, I'm going to starve to death." I suck my stomach in and say, "It's not so bad, I'll keep eating." Or I play Russian roulette with the cholesterol count.

But I have two feelings about this. I know what is correct to say—I deplore that the emphasis is on lousy food, that we see wars between Burger King and McDonald's, between the Chicken McNuggets and "We Do Chicken Right." The other side of it is that when I go to Chelsea or Integral Yoga on Fourteenth Street, where they sell good brown rice, or even to a posh place like Balducci's, which is not a health food store but has a lot of good fresh vegetables, then I feel very good about food.

I like markets. I like the Fourteenth Street Union Square market, which is there on Wednesdays, Fridays, and Saturdays, but what I deplore is that people are brainwashed into eating lousy food that costs more than the good food costs. I get very angry at that. But if the emphasis could be on good food, I feel that then there could be some kind of communion with nature. I don't think that we should eat too many animals, just a few now and then. When I feel bad about eating the animals, I think that carrots probably suffer, too. So my feeling about food and the eighties is that I'm not broken up about it, it's just that the emphasis is on the wrong kind of food.

Montano: Is there one culture that you feel uses food correctly?

Schechner: I like the way that Asian cultures use food. For example, in India, although I think that it's true too in China but less in Japan,

the idea of a banquet is to have more food than you can eat. There's more selection and more quantity so that you, in a certain sense, are choosing your way through the meal and selecting who you are by how you eat, what you eat, in what order, and how you move through that meal. It's very different from the middle-class American way, where you are supposed to finish everything that's on your plate, where the meal is laid out for you and, in a sense, you are fed. In Asia, you can eat at a leisurely pace, you are able to demonstrate your skill and artistry by how you eat and what you eat. Of course, this is possible only if you have a certain amount of wealth. The poor in Asia, as everywhere, live hard lives.

Also, there is the artistry and display of the food, which is very important, and you'll notice many foods, small quantities of many. There is no set menu but many selections. In even an ordinary Chinese restaurant, a distortion of this kind of thing remains in "Select two from Column A, two from Column B."

I also enjoy the fact that in Asian food, smell and sight are important, as well as taste. And that spices can be so spicy that you have to eat very slowly; you can eat only a little bit at a time.

Food is used differently in Japan. You go to the Kabuki theater and bring your box of sushi with you or buy it at intermission. It's proper and expected to eat during a performance. What we do is to make the theater like the Christian church, where communion comes at the end and isn't really very good eating. At intermission people go out and smoke, come back in. For example, at BAM [the Brooklyn Academy of Music], everybody squeezes out into the hideous small front lobby, makes a lot of noise, smokes, gulps down a few drinks. But in Kabuki, you buy the food, go in, and eat as you're watching, share chocolates and tangerines. And if you have a favorite actor, you stand up and shout for him, then sit down and take a little bit of sushi or chocolate, so that the delight that's going on for the eye and ear is matched, in a certain sense, with the delight that's going into the mouth. And you

warm up by taking a little sake, so you're warmed on the inside, as well as entertained on the outside, simultaneously, rather than sequentially.

Montano: Do you have a suggestion for somebody with a food problem? Are there ways to use art or life to deal with food fixations?

Schechner: Those diseases disturb me. The people who have them are very often young women, and almost always these women are in real pain, and the pain is often self-hatred. That is more difficult to face than a viral or invasive disease, which comes from the outside, although I believe all disease results from a collaboration between the person and the sickness.

Eating disorders are disorders of the spirit, disorders of understanding. Therefore, the remedy is in acquiring an understanding, and the remedy is also not to move swiftly toward a remedy. When there is so much self-hatred and self-victimizing, one can be victimized by the cure as easily as by the disease. One can switch masters, from that which makes you vomit to the person who tells you not to vomit. I don't consider that a cure, although it might be better for your body at a certain level. Curing is a step-by-step reclamation of your self-worth. How do you do that? First, the last thing that you want is a mail-order remedy. The remedy depends on the particular person's needs. Maybe they should be in a support group. And second, I would ask the person, "Even if you don't love yourself, is there someone who loves you?" Start by having a dialogue with that person or those few people. And if there is no one who you feel loves you, and you don't love yourself, enter a group where that love is a concern. I would emphasize dealing with it slowly, step by step.

Montano: Anything to add?

Schechner: We've gone from comedy to remedy, and I'd like to get back to comedy, which I think itself is a remedy. We are obsessed in this country with gorging and then denying ourselves food. That's a symbolic obsession happening because we are a wealthy country, and

the rest of the world is very often victimized by us. And so we, in a certain sense, displace that victimization onto our obsession with food. At the same time, food is one of those basic delights, very benign if you accept it and really enjoy the flavor of it.

And, in conclusion, I wouldn't be too uptight about eating.

BONNIE SHERK

Montano: How did you feel about food as a child?

Sherk: I can tell you a wonderful story. I used to have this love affair with coconut, probably because of its texture and subtle flavor. When I was young, there was a ritual game that my family and I used to play when we went to Howard Johnson's for ice cream. They had twenty-eight flavors, and I used to stand in front of the counter, take forever, and invariably order coconut ice cream. After I got the cone, we would go out to the parking lot, and it would fall on the ground. Consequently, I would have to go back in and order another one. There was a period of time when I did grass pieces that had that coconut texture. I think that I made an early connection between coconut ice cream and grass.

Montano: Was eating a pleasant experience for you at home?

Sherk: My mother was a wonderful cook, and my sister and I learned the art of cooking at an early age. Food was always overly plentiful, and I always enjoyed eating. I still do.

Montano: When did food appear in your work?

Sherk: The first major piece that I did with food was *Public Lunch* at feeding time in the San Francisco Zoo. I ate in the lion house while the other animals ate in their cages. It was a piece that was concerned with different kinds of equalities, because I was served in the same manner as the lions and tigers, except that they had raw meat and I had the human version. It was about analogies and being an object on view.

Montano: Why do you think that you use food?

Sherk: Because I've always been interested in the common object and common materials. It seems that the simplest and most accessible things can be the most complex. As a result, I didn't have to go very far when I started using food. After the *Public Lunch* I became more interested in the inner workings of animals and lived with a number of them in my studio. It was then that I began appreciating the invisible aspects of communication.

The Farm is an extension of these ideas and actually involves growing things. The growth of a plant from seed to bud to maturity resembles a complete and whole experience and is analogous to and seems like the art experience.

Another reason I use food is because my maiden name is Kellner, which means "waiter" in German. I used the name "waiter" in both the passive and active sense and have performed as a cook, waiter, food server, and bider of time.

Montano: Is there a connection between your use of food and the fact that you are a woman?

Sherk: Perhaps there is a connection. If I had been a man and had been around food, I might have used it as well. Daniel Spoerri, Dali, Magritte use food. But I use food in many ways—I've used it metaphorically, I've used it symbolically, I've used it sexually, I've used it politically, I've used it ritualistically, and it's nourishing as well.

Montano: How do you see *The Farm?*

Sherk: *The Farm* is a form that brings together a lot of the ideas that I had been working on previously, which include food, growth, life, and the human, plant, animal relationships. It's a triptych within a triptych within a triptych within the context of a counterpointed diptych— technological and nonmechanized. But now I'm in 360 degrees, and I intend to travel around the world and find places of connection. *The Farm* is still very much part of me, but it is time for a new form. I was

getting bored with the administrative and political performance that I was doing there, and now I want to do something different. I went to see the Picasso show in New York and got real itchy. It reminded me that I want to work on a different level.

Montano: How do you see this new form?

Sherk: I want to go around the world and create total experiences. An idea that I have is to create a vehicle that interrelates analogous systems of culture with other species. *The Farm* was this kind of server of situations, and it demonstrated connectedness and equality among people, animals, and plants. The new work communicates the philosophy of *The Farm* on a global scale. Along with the café events, this idea includes appropriated nutrition centers that will conscientiously explore foods from different cultures. I don't know if I'll actualize these ideas right now, but I want to look around, see what other people are doing, and learn.

> *RECIPE FOR CONCEPTUAL ART, 1970*
> Just add water. Box of flour with light bulbs.

> *RECIPE FOR FUNCTIONAL ART, 1980*
> 1/3 Reason
> 1/3 Intuition
> 1/3 Passion
> Add two handfuls of humor. Blend well and mold.
> Set in motion, and wait for synchronous tones.

STUART SHERMAN

Montano: How did you feel about food as a child?

Sherman: As a child I found food appetizing. I ate normally. My meals were prepared for me, and for that reason I couldn't indulge my more base junk-food habits, because my mother made the food. If we

went out, she supervised what we ordered. I ate three meals a day, drank a lot of milk, but have since stopped doing that.

Montano: How do you relate food to your work?

Sherman: I generally eat when I am nervous, so if the work is making me nervous, then I eat. And if the work is going well, I celebrate by eating. Sometimes when I have a lot of people involved in the work, we'll have food breaks. People generally like to order pizza at those times.

Montano: So you don't have guilt associated with food?

Sherman: Guilt? Why should I feel guilty? About being overweight or something? The only time that I feel guilty is when I am eating too much and getting fat because of food. Right now I'm a pretty good weight, but there have been periods when I ate the wrong thing, and then I would feel guilty.

Montano: Some people feel that they don't deserve to eat and so feel guilt when they are eating.

Sherman: Really? I've never heard of that. I deserve to eat, but more so, I deserve to stop eating because I eat too much and mark occasions with food, and that's not a good thing to do.

Montano: Your performances have a wry humor, and the fact that you have chosen to talk about food is unusual. Why is that?

Sherman: It's easier on my brain. I find talking on the phone a little inhibiting, and the topics are so general, so food is the easiest, not the wryest.

Montano: What is your work about?

Sherman: How does that question relate to food?

Montano: I don't know.

Sherman: Now you're going to make me think. I can't answer that. But I can say that I've done a short film called *Eating,* which is about food and people talking about their favorite restaurants in New York. I show facades of restaurants and shots of me taking little bites out of the

film, so there is a gap in the film where I have eaten or taken a bite. But I find the subject of eating more interesting than food because it's a verb. Food indicates specific kinds of food, whereas this is more general. When we treat food as an object, we take it into ourselves without thinking about it very much. It is consumerism, but a consumerism where the product ends up inside of us. Everything can be a kind of food—something to be experienced visually or sensually. Something to be eaten. And I feel that my biggest connection to food is when I see life in that way—taking it in, while enjoying the sensual properties. But then I do start to feel guilty because I think that is a very dumb way to live—it's like you're eating all of the time—you don't reflect on what you eat. Even in a relationship, you can take things in without chewing them. When you chew something, it's like thinking about it. But if you just swallow things in chunks and don't think about them too much, then it's pretty empty. I often think of that when I am experiencing media infiltration—it's like gorging on different kinds of food with no discrimination. It's gluttony and goes past appetite. It has nothing to do with appetite. So I very often think of food in that way, which is critical of eating and the eating process—it's more about an animal state. But eating is an animal function, and most people hide the fact that we share that with most animals. What's the difference if we eat a piece of meat or a lion eats a piece of meat? It's the same thing. I think that people are hiding by having beautiful restaurants to go to and having the food prepared in fancy ways. It's still an animal act, and why go to great lengths to disguise it by the ritual of eating dinner at dinner parties and restaurants—by using plates, knives, forks, spoons, glasses? A lot of that is just camouflage. I would be just as happy if I could take a few pills. In science fiction films they take one pill for a steak, et cetera. Food and eating are very often used as an excuse for not doing other things, both individually and collectively.

Montano: Is there too much art? Too much food? Too much media?

Sherman: There is such a thing as too much, but how can you say that there is too much art? And media isn't a problem as much as there is a bombardment by too many stimuli, which is more a state of mind and not a comment on there being too much TV or too many newspapers. It comes from being open without being discriminating. To counteract feeling overwhelmed by so much, you have to balance what you take in with what you put out, so that you are not just consuming but also producing—you are working on it, filtering it, shaping it, digesting it. But then you end up with another product! Cocteau said that making art was like shitting, and there is a connection if you see everything in terms of that analogy of eating and the resulting waste material that comes from ingesting. Mental food and physical food differ according to your own values and the importance that you give to the process. For example, someone eating rice in a Zen monastery will have a different attitude toward food from people having a bowl of rice in a restaurant on a Friday night. People are trying to assign value to food in their daily lives. There are macrobiotic diets and other experiments in ways of eating, but it's to have a healthy body and mental well-being. There is a connection between the two, but it's not done in quite as grandiose a way as the religious movements do it. So there are my thoughts on food.

ANNE TARDOS AND JACKSON MAC LOW

Montano: How did you feel about food when you were young?

Mac Low: I liked it pretty well. I don't remember any special things about it.

Tardos: I was deprived. I fasted when I was little because I had some sort of asthma caused by a liver malfunction. The cure was fasting, so they regularly fasted me, so when my parents left me alone, I would go

on binges. (They often left me alone because they were very progres-
sive.) And when they would come home I would have passed out from
having eaten all of these things that I wasn't supposed to. I had a pretty
traumatic relationship with food in the beginning, although things stabi-
lized, and now I eat normally. It seems that the cure worked: fasting
worked and straightened out the condition. I'm fine now. I'm a vegetar-
ian, which is not only for my health but also, as I. B. Singer said, for the
health of the chicken. We are careful about what we eat. We eat natural
foods; we cook everything ourselves and don't eat too much junk.

Mac Low: We get a very good balance of grains, legumes, vegetables,
and make sure our protein intake is good, since we don't eat meat, fish,
or poultry. We use hardly any preserved foods and don't use canned
foods or frozen foods. When I was younger, I didn't eat this way, but
changed in the middle fifties, 1953 or 1954. I became very conscious of
the relation of health to diet and from then on I began consciously to
become aware of how I ate and also took vitamins and mineral supple-
ments.

Montano: Did you see a correspondence in your work to the changes
you made in food?

Mac Low: I don't think that there was any special correspondence. In
fact, it never occurred to me before. Though my writing changed rad-
ically at the end of 1954, I began to use nonintentional operations and
work with indeterminacy, but I never thought that there was a causal
connection between that and food whatsoever. Anne, did you find that
your work changed when you switched to being a vegetarian?

Tardos: I tend to work less frantically when I eat this way. But the
other issue is that the cooking itself takes a lot of work. Choosing the
food in the store, bringing it home, and preparing it takes up a surpris-
ing amount of time and attention and creative energy. I can't tell if I'm
working less frantically because I'm getting older or if it's because I'm
healthier, but earlier I was on a higher speed for other reasons. Many

people, as they get older, instinctively eat differently because their bodies are becoming more sensitive. So we quit smoking and start maintaining the apparatus, which didn't take as much care when we were younger.

Mac Low: My beginning with vegetarianism, which I have gone in and out of a number of times, was very much connected with being in the anarchist-pacifist movement from the early forties on. Many people in the pacifist movement are vegetarians for similar reasons—ethical reasons—because they are pacifists. The first time that I became vegetarian for any length of time was in 1945 or 1946, but for various reasons, I ate meat intermittently. In the early sixties I associated going back to eating meat with my children being born. My former wife, Iris Lezak, and I had both been vegetarians, but we felt that the children needed meat. I've gone back and forth a number of times, the last being in 1977, and even now I occasionally eat meat and fish in special circumstances. So nonviolence was one of the motivations for not eating meat, and it still is. Another reason, although we've only known about it for the last ten years, is that there is a considerable amount of poison in meat and poultry, and even in fish. But health is a secondary motivation for doing this, even though it does reinforce it.

Tardos: I've done a lot of work with food. I've done videotapes about food and eating, a whole series of tapes about apple eating and about breakfast eating. *Artists' Breakfast* took place in their houses or a coffee shop. The *Apple Eaters* piece was done at my house. I had a loft on the Bowery in the early seventies, and I asked about thirty people to eat an apple: thirty different apples at thirty different times. The apple was the excuse to make the portrait. The breakfasts were called *Breakfast at Stefanotty's* because the piece was presented at the Stefanotty Gallery. There were six artists in it: Larry Rivers, Brendan Atkinson, Malcolm Morley, Vito Acconci, Bill Wegman, and myself. Again, this project wasn't about the breakfasts; it was a portrait of the artists that interested me at the time.

Breakfast is a difficult time of the day, and to share it with a camera was generous on the participants' part, although it wasn't easy for me either. I found the tape to be very successful and very colorful. Things were free about it. When I went to videotape Bill Wegman, I found that I wasn't interested in his eating breakfast as much as in his dog, who was a video star, so I left the camera focused on the dog, and he took over from there because he was totally camera-oriented. When he switched positions, he would make sure that he was still in the frame, and he would always check with the lens: the most camera-conscious dog that I have ever seen, Man Ray.

The project was wonderful, even though I felt like an intruder, and that part was difficult. Larry Rivers was very happy because he is such a ham, and so he staged a very dramatic breakfast—ham and eggs, of course. He loved it—and it was like this very interview that we are doing with you right now, a way to talk with people.

Mac Low: I don't remember any direct connections between food and work, in the sense of its being subject matter, but I may think of some when this interview is over.

Tardos: Food is one of the things over which people congregate. Food is what people like to share socially, so using it as a subject matter for art is very nice. I wouldn't be interested in studying someone shitting because I don't want to share that, although I know of artists and filmmakers who do that, too. One thing I discovered is that during meals, at a large group or family gathering, there is a tendency for the conversation to turn toward gory things as soon as people start eating. They can start talking about amputations with a sudden ease, and that is because the act of eating itself is destructive: you kill things by eating them. So notice next time you are at a meal.

Mac Low: I think that we approach food differently from most people. I notice that especially when I see the kinds of things that supermarkets are filled with. We get canned cat food there, because our cat would go blind without the taurine from fish or meat. But that is the

only thing that we get from cans. Oh, yes, we get tahini from cans and bottled spring water, but I always notice that our grocery cart looks very different from other people's. The other ones have huge amounts of Pepsi-Cola, Coca-Cola, canned goods, and packaged junk foods.

Tardos: And cookies.

Mac Low: Yes. I think that there is a difference in consciousness about eating that we have developed, and that is partly due to the health and nutrition movement. Vegetarianism per se, which is the avoidance of killing sentient beings, not only stems in my case from pacifism and is reinforced by Buddhism, even though many Buddhists aren't vegetarians. (I've always felt that that was a contradiction.) I feel that we should at least be harmless to things that move around by themselves. That is quite a different way of approaching food. Even when I would have (in the late forties and fifties) this ethical feeling, "Don't eat meat very often," I would get vegetarian baked beans and would think vaguely, "Well, that's protein." That's the level at which I thought of things then. Later, I developed a healthier vegetarian diet.

Montano: What do you do when you are traveling?

Mac Low: Ugh. It's always very hard, because it's hard to find the right food. We're lucky because in several places where we've lived in Europe, we've stayed with relatives or friends, or they would lend us apartments in places like Vienna or Paris, so that we could buy our own food. [Anne's mother lives in Vienna.]

Tardos: Many people in Europe take a strong offense at our not eating meat, because for them it's still a big deal to have meat. It hasn't always been available. So sometimes when they offer it, we break the rule and eat it because it would be wrong to offend when it is offered so generously. Most people, even those who don't take offense, like my mother, accept it. She thinks of all kinds of ways to feed us, but I feel that she is resentful. She takes it as ingratitude, "Now that meat is available and we've made the world so that you can have it, now you don't want it."

Montano: Is consciousness a goal or a goad of your art? Does the work have to lead to a clarity of mind the way meditation does?

Mac Low: I don't like to feel a motivation for art, be it consciousness or spirituality or anything like that. I tend to be suspicious of it, at least for myself, because it makes the art *instrumental*. I feel that art should be autonomous, and that if it's autonomous, then consciousness and spirituality will be there.

After 1954 I used methods that seemed relatively selfless, like nonintentional operations and indeterminacy, and my contact with Zen Buddhism and Dr. D. T. Suzuki was a part of my motivation. But I think most of the motivation came from a fascination with what actually happened when I performed such actions as composing poetry, et cetera, by nonintentional operations. It was an innate art fascination with what happened either when such relatively objective operations determined a good deal of the artwork or when the work was such that the collaborators were spontaneously making significant parts of it from whatever I had given them as a framework: materials, methods, texts, or whatever else I had given them.

My work is in some ways politically motivated, and also motivated by Buddhist ideas, but I am very suspicious of even this kind of instrumentality. Of course, there is a continual dialectic between politics and ethics and religion and art. That is inevitable. There are many people who make political art, and I too do so occasionally, but making the art directly an *instrument* of the politics or religion is something with which I am very uncomfortable. The communists and fascists and a lot of other people have done that.

Tardos: It's *using* art.

Mac Low: Many Catholics, Buddhists, and so on, have also made instrumental art.

Montano: Does that come from a greed of wanting it all, wanting the art and wanting the religion?

Mac Low: I don't think that that's wrong. I don't put that down, per se. But to make it the *primary* motivation for the art, so that you would make the art this way, and then it would, for instance, further the cause of Nicaragua, that isn't correct. From the late thirties on, I have known people (communists, for instance) who felt that art should serve a purpose, and I am not saying that there is anything necessarily wrong with that. It's just not what I prefer for myself.

Tardos: I love Christian church music, even though I am not particularly religious.

Montano: Do you want the work to function personally as does a thirteen-year retreat in a cave, which functions to transform or enlighten a Tibetan Buddhist lama?

Mac Low: Your work, Linda, is often involved with asceticism, and that has probably been a continuing theme since you were a novice. But I don't feel that kind of need or demand that from my work. I rarely make direct connections these days between art and religion or politics. However, I'm often ambivalent about it, and I often feel that I ought to do political action. It's not just politics; there is also a general connection between my art and Buddhism and Taoism, letting things be, although that was stronger in the past. More recently, I've been interested in the dialogue between the self and nonself.

Such a dialectic is obvious in performance pieces whose scores are made by means of nonintentional operations and whose performers choose spontaneously how to use the materials, methods, and/or structures given by those scores to produce many aspects of actual performances in the course of interacting with each other. Lately I've become especially interested in making conscious decisions while writing and composing. A crucial dialectic between self and nonself is inscribed in such a process, even though no nonintentional operations may be involved in it. I don't find such decisions very different from those made while composing a system for generating texts and performance scores.

The so-called self is deeply involved in the very decision to use nonintentional operations.

Besides, such terms as "the self" and "the ego" are very ambiguous. It is clear that the self is not unitary but composite. It is a node or knot constituted by the intersection of many lines of causes: social and familial and biological factors, to name only the most obvious. I think Buddhism takes this view also.

I learned from Dr. Suzuki, in the late fifties, that Buddhists consider all levels of the mind as parts of the self, even what psychoanalysts call the unconscious. Even systematic nonintentional operations, which differ from those surrealist methods that purport to rely on the unconscious, involve the self as conscious maker of the system. Using such methods makes one aware of the possibilities inherent in the conscious making of artworks, especially that one need not blindly follow so-called instincts or taste or fashion. I'm very much interested these days in the artist as *conscious* maker.

money/fame

introduction

LAURA COTTINGHAM

To engage in a dialogue with contemporary American artists on the twin subjects of money and fame may at first seem unusual or even inappropriate. Wouldn't such questions be better and more productively addressed to actual celebrities, such as sports, music, television, and movie stars? After all, unlike most contemporary practitioners in the fine arts—including those interviewed by Linda Montano here—people like Michael Jordan, Madonna, Roseanne, Barbra Streisand, and Bruce Willis have experienced real money and real fame. Even the relatively "famous" artists featured here, such as Eric Bogosian, Simone Forti, Allan Kaprow, and Meredith Monk, are not recognizable on the street to any but the cognoscenti and are not wealthy at all if judged by the standards of the really rich.

Indeed, it is perhaps significant that the one artist mentioned more than once during these conversations, who evidently stands for many as the singular example of someone who emerged from the American fine art performance community of the 1970s onto a national platform, did so by crossing over into pop music. Still, Laurie Anderson is not nearly as well acquainted with fame or money as full-fledged entertainment industry stars are: quantitatively, thousands of people must be more famous and richer than she. Although more than a few of her

performance art peers get wide-eyed over the sums Anderson was ru-
mored to have garnered for performances at the Brooklyn Academy of
Music and similar venues during the 1980s, the figures pale in compar-
ison to those given to television personalities or professional male
sports stars.

Indeed, given how relatively unacquainted with stardom and wealth
the artists interviewed by Montano are, one might well wonder what
compelled her to choose this particular inquiry. Why didn't Montano,
for instance, limit her focus to questions that would scrutinize these
artists' relationships to culture, the aesthetic basis behind their visions,
the motivations guiding their inspirations, and their sense of the histor-
ical determinants of their art?

Ah, and this is what's interesting here: for by prying into the seem-
ingly vulgar realm of money and fame, Montano gets close to the beat-
ing heart of the matter, perhaps even touching what may be the matter
with contemporary American art. How is it that a society as wealthy, as
globally dominant, as politically established as the United States can
continue to remain so ignorant of what culture is and what culture
needs? And are artists and homemakers the only workers left in Amer-
ica for whom the idea of a real wage is considered either absurd, un-
necessary, or communist?

Montano's conversations reveal a gritty, unpleasant, harsh truth: the
metaphor of the starving artist is untenable when it is not metaphor but
someone's actual lived experience. A constant refrain emerges from this
unorchestrated symphony of creative voices: these artists want and need
to get paid! Additionally, fame emerges as a glittery hope dressed in an
unmatched outfit of suspicion, necessity, corruption, and salvation.

It is ahistorical, unscholarly, uninformed—indeed, impossible—to
consider art and culture in the United States during the second half of
the twentieth century without confronting the emergence of money
and fame as central among the "new" quantifying American values. If

we credit Hollywood—particularly the star system established by the studios during its "golden era"— with amplifying, if not outright manufacturing, the desire for money, fame, and stars, we must admit that we allowed it to happen. If Warhol's proverbial fifteen minutes of fame were only proverbial, Montano's investigations might simply be dismissed as prosaic. But the fame culture of our society is so apparent that visitors to the United States are often struck by it, as was an art historian friend visiting for the first time from Sweden, who asked me quite seriously, "Why is it that everyone in America wants to be famous?"

Why indeed?

As artists engaged in and with the public, Montano's subjects have witnessed directly not only the desire for fame but also how fame is seemingly necessary if one is to exist as an artist in today's America. Yet many speak philosophically about it. Eleanor Antin acknowledges quite plaintively that "a handful of artists are adopted by history while the others are dropped out." Many note the political implications that separate the art world's haves from the have-nots. As Jon Hendricks observes in a conversation with Montano (not, unfortunately, included in this volume): "Fame is dangerous because many times museums will choose to have big-name shows, but the work is not so big. And they ignore other people, which disenfranchises whole classes and groups of people like women, who are pretty consistently ignored. Their work is never looked at for itself but in comparison to a white male's work and by a white male audience."

Most of the artists featured here recognize that money and fame neither make nor produce art—but try to live without them, and one may find oneself, as Julia Heyward fears, living without health insurance and housing. Serious artists in the United States, for whom economic remuneration for work is rare, partial, or nonexistent, face contradictory and even impossible situations because of the material need for money. Unlike those in other professional occupations, artists cannot assume or

expect that their good work will be financially rewarded. Indeed, these conversations are full of laments that suggest how often the opposite arrangement awaits them and traps them: they are expected to produce bad art to make money, because good art—which, by definition, is challenging—is so seldom financially supported. Or rather, good art is more likely to be financially valued after the artist is dead—a commonplace art-historical truth that offers little solace to either the living artist or her landlord.

In a revelatory exchange, Martha Wilson discusses her own strategy for how to separate the pressures of money and fame from the higher demand of art: "Many artists find that it, fame, is the currency rather than art. But if I'm worried about my reputation and thinking about fame, I'm crowding out other stuff. So I never pursue it. I never think about it. And I just wait and it comes to me. . . . Your work can't be directly concerned with fame. It just has to be concerned with your own work. Fame is a byproduct, which may or may not appear."*

Because of the performative model within which the artists interviewed here are most active, their hopes for economic remuneration are additionally curtailed in a world where art's patrons are still seeking paintings and other decorative objects to hang on a wall. For performative and other non-object-based artists, fame offers the hope that, like conventional entertainers, their performances and their very beings will be considered valuable and bankable. Interviewed the day after Warhol's death, Steven Durland considers that "the desire for money and power is a function of survival."

Mierle Laderman Ukeles reflects on a large project she did in Rotterdam, *The Garbage Machine Dance,* that involved the Rotterdam Sanitation Department: "I thought it was a beautiful thing that I gave everyone . . . magical even, but I didn't get a penny for it. I'm very

* This quotation comes from a part of the interview not included in this section.

grateful for the opportunity to work like this. The Rotterdam Sanitation Department took a big risk doing something so out of the ordinary for them, with a stranger . . . and they spent a lot of money—labor, equipment, video. For art! Because my art always grows inside a real work system, I am surrounded by people who earn a regular wage. And they are very proud of that fact. They have fought to earn a decent wage for doing their work, and here I am making art that celebrates that work, and I am the only person in this whole environment—really, the only one—who isn't paid for my work on any regular basis."

Taken together, the conversations on fame and money in this section offer a rare glimpse into the often frustrating reality of the daily obstacles contemporary artists in America face as they engage with the idealist challenges of art production while living in an accelerated consumerist society. Combining personal memoir, individual biography, social commentary, political insight, and philosophical reflection, these dialogues document an important and diverse community in recent American art production and reinvigorate one of the most ancient of all questions: Just what is or should be the role of the artist in society?

ELEANOR ANTIN

Montano: Your characters are heroes and heroines, famous people with missions, performing all kinds of fabulous moral deeds—the ballerina, the nurse, the king. Their visions are large. Did you have dreams of being famous as a young person?

Antin: As a kid I was always dreaming about being great people. Many great people. When I read about some hero marching through a city in triumph—after saving it, of course, not conquering it—the tears would roll down my face. And when an audience applauded a performer after years of despising her, I would get all choked up. The pleasure of victory was painful. It hurt. Kids are like that, I think, aren't they? Like all helpless groups, they dream of victory, of power.

I also had this fantasy that I would give up my life—be dead even—if only I could go back in time and spy on the dead people I read about in books. I would be invisible; they wouldn't see me. But I would watch Keats die, walk with Michelangelo through stony Gothic streets, watch Cleopatra making it with her slaves. I was jealous of the past. I would think, "How dare it exist without me?" On the other hand, if I had been born in ancient Greece, I would be dead already, and that was something of an advantage to a scared kid. I had so many complexes; I was a classic case of everything. But if I had lived already, I wouldn't have to go through the trouble of living anymore. I wouldn't have to go out and look for a job. I wouldn't have to study for classes. My life would be safely over, and it would have been a great one—that was certain. If I had lived in ancient Greece or in Charlemagne's castle, my life would have been terrific. I would have been a great queen or savior maybe. Or some kind of artist. Somewhere back in my childhood came my first desire to be an artist. But I had a misfortune. I had more than one talent. I could write, dance, act, paint, draw. I flitted from one to another. Just another proof that I was neurotic, said those analysts I

was always going to, but I held out against them. There was this light in me; I could feel it. Sometimes I thought I saw it. It had something to do with art.

Montano: Now you've brought all of your interests together and do performances as historical characters. How do you find characters to portray?

Antin: First, I have to find my time period. Before the representation can emerge, I have to find a style to receive them, to make them happen. Teaching here at UCSD [the University of California, San Diego] is great because I have the library. I take out hundreds of books. Sometimes I go wrong. After several months I may see that I'm in the wrong time frame. No problem. It was fun. Probably something will remain. When I did Antinova's ballet *Before the Revolution,* I studied the great revolutions, the French and the Russian. I live out in the country, and I would sit there on the porch hanging out over the canyons of sagebrush and chaparral, reading biographies of nasty cavaliers or administrative reports on the murky conditions of roads after taxes in eighteenth-century Amiens. Out of this work my representations will come. At first they're shadows. I move toward them, and they come toward me. We are careful, polite. We don't know each other yet. Then there are recognitions, surprise appearances, emergences. I recognize a stance, a petulance. We come together. I change. We come together. Myself and myself.

Montano: How do you feel about becoming famous while representing the famous?

Antin: Antinova isn't famous. She's been forgotten by history. Her friends are dead. Her art discourse is gone. Because she was black and a woman, history dropped her. She remembers having been a famous artist and then she wakes up one morning to find nobody knows her anymore. Only she's still alive. *Recollections of My Life with Diaghilev* is about that. A handful of artists are adopted by history while the others

are dropped. History is perverse, random, and mercenary. It creates these freaks—like Picasso. Where would he have been without that fantastic intellectual, creative scene of artists, writers, musicians, dancers? Nowhere, that's where! The famous freak show of traditional academic art is a lie. The natural condition of the artists is loneliness and random persecution.

Montano: Was fame difficult for you?

Antin: I never knew I had it—I worry about the future. It's out there waiting to do me in. Like all artists, I worry that my work will disappear. Now, they're redoing those early constructivist pieces. They look like ghosts, those revivals. Like disembodied creatures torn loose from their surroundings. Like Rip Van Winkle.

Montano: Writing a book about your work helps?

Antin: Yes, I had to write that book. It's about that life performance when I lived as the black ballerina for three weeks. It's an attempt to take hold of the transitory, to arrest it for a moment before it disappears forever. That's why I kept the journal in the first place. Because life slips away from you. Without the journal I would have been like poor Antinova—a ghost. So even if a lot of my friends hate me for violating their privacy by putting them in my book, I'm glad I did it. It was worth it. I've forced my memories on the world.

Montano: Tibetan Buddhists have a spiritual mythology that teaches the participant to merge with their gods and goddesses. And after the visualization of merging, they suggest that you dissolve yourself along with the mythological figures. Are you working on past lives? Does that relate to your work?

Antin: Once someone called me the Bridie Murphy of the art world.

Montano: Have you discovered other ways of defining fame?

Antin: I think about greatness, not fame. I want to do great things. That idea of Andy Warhol's of being famous for fifteen minutes is repulsive. The idea of fame is repulsive. I want to save the world. My

king is always trying to lead armies to the promised land. And he al-
ways loses. Maybe that's why people don't like him very much. He's a
loser. They think he's stupid. Who is this hippie king coming on like a
ham actor in a third-rate stock company? So how else would they save
the world? Do they have a better way?

Montano: Has there been anything that hasn't been comfortable
about the place you've achieved?

Antin: What place is that? You never wake up in the same place
twice. Who can say they've achieved anything? You bend down to tie
your shoe and you get run down by a kid stealing a grocery cart.

Montano: In order to say that education doesn't matter, it's important
to have had one. And in order to move beyond fame, it's important to
have first had it, to be famous. Is that true for you or true at all?

Antin: Ted Berrigan once said, "I want to be a famous poet before I
become a good one." Both wishes were granted. He became a famous
one, and then he became a good one. Who knows if he's famous now,
but he's still a good one. I don't think it's fame we need. What we
need is a space, a public space into which we can put our work so that
it can do its work. Nobody gives it to you. You have to grab it for
yourself. And hold on to it, so the cumulative effect of your work may
finally help you to be understood. And then you owe something to this
child of yours, this work that never lets you rest. My definition of an
artist is someone who never goes on vacation. And the larger the space
you have to work in, the more people will be touched by you. Maybe.

I'm a political person. I've always wanted to change the world.
There's this old piece of mine, a king piece, *The Battle of the Bluff*. I
probably held on to it too long. It was time to put away my sweet hip-
pie tale of how I led the old people and the very young people of
Solana Beach against the developers and almost won. But I thought it
was politically important. I insisted on giving people the message even
though they didn't want it anymore. It was about having to keep

human communities small. No king should have a kingdom that he couldn't walk through from one end to the other on any given day. Then he could govern by rules that he could change as the real problems and situations come up. He knows everybody, so every problem, every person, is a special case. Everybody is an exception to the rule. Fixed laws are wasteful and unnatural. They violate ecological principles.

I brought my message to a large auditorium in Montreal one Sunday morning. The little audience huddled before the huge apron stage. What were they doing inside on such a warm, sunny day? We were victimized together—they by their original decision to come and me by my appearance on this sleek alien stage. It was a great opportunity for revelation. Later an editor of some Canadian art magazine said, "Oh, she's so naive. She believes that childishness she's saying." What does that mean—I believe that? Of course I believe that. Like Sue Dakin running for president on an artist's ticket. Does she believe that the Democratic convention will nominate her? My position as an artist is absurdist and impossible. It is a paradigm for the human condition. I'm a political person. I want to change the world. I began passing the hat around after that performance. Every penny counts.

ROBERT ASHLEY

Montano: How did you feel about money when you were young?

Ashley: I never understood it. My family never had any money. They had come from a small agricultural society where money was not even a question in day-to-day transactions, and so they didn't understand money, the same way that you wouldn't understand music if you never heard or studied music. When I think about them now, I realize that they were always mystified by money, terrified by it, intimidated by it.

Montano: How did you handle that?

Ashley: I wasted a lot of time by doing things other than music because I thought that's the way you made a living. I wouldn't have had to if my family had been sophisticated about money. And I don't mean rich—and giving me money, but just teaching me that there is nothing to be afraid of. People can have money as long as they think about it clearly. If you don't know how to make music, you have to spend enormous amounts of time teaching yourself things that somebody else could teach you in five minutes. It's the same with money.

Montano: What made it all right for you to have money? A mentor? A situation?

Ashley: In choosing to be a musician, I had to experience learning how to make a living as a musician. It's not easy. It's a skill I had to teach myself, as I think a lot of people have to teach themselves.

Montano: Did you confer with friends about prices and methods?

Ashley: No. Most of my friends were jazz musicians, and they were as ignorant of what their contribution meant as anybody. But we kept on being in music and made money in typical and mundane ways— playing an instrument in a band or a club. After a dozen years, I had to give up those methods. It wasn't working for me. Then I confronted the fact that I literally didn't know how to make a living. It was then that I did things like working nights in the post office. I did menial work until I was forty years old, hard menial work. I was carrying things, lugging things, setting up lights, and doing sound tracks for General Motors films—really hard day work because I didn't know what else to do. I didn't know what the alternative was. The fact that I didn't know what to do is not a complaint but a comment on this time in history. We have to learn about things. If you are ignorant about anything, you have to pay the price.

Montano: Did you take on a businessman persona to help you make a living?

Ashley: I was desperate until I was thirty-nine. Then the accumulation of the things I had done in music brought up the possibility of teaching at Mills, and that got me out of the menial habits and showed me there were other things I could do to make a living. And then at forty-five I decided to try out things I had thought about but had never tried to do.

I began taking television seriously and thinking that it might support me and support the music. I think that I might be getting close to it. I'm not sure, but I still think the arithmetic is right. This is definitely an experiment with life and with making a living. It's like inventing something. You don't know what you are inventing, but if you keep working on the idea, then you learn something and hopefully are successful.

Montano: When you made the change ten years ago, did the music change too?

Ashley: I tried to make it change. I tried to make a program for television. I made a good program, sixteen hours, but it didn't get to television. It was shown on closed circuit all over the place for about eight years. Then I decided to give it a rest. Just this past year I decided to see if it was time to take it one more step. Now I'm trying to get it on TV. That means that the work has to be modified to match the new intention. In 1975, when I made it, the only thing I knew was that there had to be a certain technical relationship between the music and video. That's all I knew. I made tapes of people closest to me at that time, and I made them in a uniform style. I made a TV piece with the resources I had. That was what I had to do. Now to revive the sixteen hours of tape for television, I have to go back to them and apply the instrumentation of TV to them. It's like taking a piece for orchestra and redoing it for two pianos. I'm rebuilding it for another set of instruments. And unless I make a mistake, it won't change the piece.

Montano: What is your private music now since your vision is larger scale. Do you miss the intimacy of the past? Of jazz clubs?

Ashley: If you play jazz five or six nights a week in clubs, then you get a particular kind of experience from it. The positive things come in little, tiny increments. The negative things are obvious: the boredom, et cetera. But every night there are a few wonderful experiences. The way I'm working now, we might play thirty nights a year, so I have to make that style work for me. And that has different negative aspects, mainly that I don't get to do it as often as I wish. But the positive aspects are that the experience is a bigger experience. And you get the rewards back in different and bigger doses. That's okay with me. So the work becomes bigger, more formal, and more dangerous than if you are playing at Sweet Basil's five nights a week, where you walk in off the street, get your horn warmed up, and play. You try purposely not to make it such a big deal, because you'd get burned out. Kids, when they are just starting, put too much into everything, every night, and they get cooked, have to quit, and go into insurance or something like that. They cook it too hard by doing drugs, and alcohol, because they want to make that experience intense. They can't bear to have anything less than nirvana every night. So after about five years, it's over (even if they are making millions of dollars). It's like the Beatles' story. It didn't matter that they were making all of that fucking money; they couldn't handle the intensity, and they had to quit.

I am learning now how to make a certain kind of intensity only thirty times a year. If I had to give concerts on the scale that we give them now two hundred times a year, I'd be a hospital case. I couldn't do it. It would have to be much more casual.

Montano: Is there a danger in making too much money?

Ashley: I've never made too much money, so I don't really know, but what I get from reading the newspapers is that transactions with money are sort of recent for humans. People didn't think about money until two or three thousand years ago. And there are still people who don't think about it. I saw a documentary the other night about building the Panama Canal. It showed who built it, and one of those guys

who is still alive said, "You know, the funny thing is that we didn't know anything about money." I knew exactly what he was saying. He was explaining that they didn't know about money, so what they enjoyed about the piece was not making money that they could spend but that somebody came along and organized and presented to these people this huge-scale project and social interaction. And it was like a huge party for them. When you look at the documentary, you can actually see that. These men were working like maniacs, because they were having fun, not because they were being paid. And the guys who came from America thought, "This is wonderful, we don't have to pay them." As soon as the piece was over, the people who worked on the canal kept wanting to have another party. They wanted to build another Panama Canal, and they were sad, not because they didn't have any money but because there was nothing like that in the future for them.

The main danger in having too much money is that it's such a huge symbol, and unless you've really taught yourself or been taught how to be indifferent to it, it is going to preoccupy your whole life. That's what makes people sad. That's what makes the tragedy of rich kids. Compare an heir to one of those fortunes, like Johnson and Johnson, with Prince Charles, and you'll see that he knows how to deal with money. He knows exactly what it means. The idea of money doesn't blow him away. The money hasn't made him a better person; it's just that he is comfortable with the whole idea.

He's got a hard life, out on tour three hundred sixty-five days a year. He's always out shaking hands or kissing babies or doing something. He's got a real hard piece to do right, and his wife, Di, has an even harder piece. It's much harder for her because she wasn't trained like he was. When you see the two of them together, she's frazzled because it is harder on her, harder to have twelve people pushing her around, telling her what to do. But that's the way she is making a living. She's

doing what she needs to do, but it's wearing her out. Whereas Charlie, he was raised doing that stuff, so if somebody says to him, "Turn left," he turns left. It's like if B-flat comes around, you play B-flat. You don't, like, resist B-flat. You don't say, "I wish that was an F chord."

Charlie just plays it the way it comes, right off the score. You can see him do it. It is quite amazing. Di is harassed because she is harassable. She wasn't trained in all of that stuff. She didn't get it until she was twenty. Charlie has got a twenty-year head start on her. That's the way those two people make a living. They ride on an airplane to Australia, walk down the gangplank, kiss somebody, bow to somebody, have their pictures taken, and you think, "Gee, that's a hard lifestyle. Those people have spiritual pressures in performing twenty-four hours every day." But that's the way they make a living. Just like Elvis Presley, or me, or the pope—if that's your job, that's your job. I've got to go back to work.

BOB AND BOB

Montano: You were both among the first artists to use fame and to have an ease with money and the commercial aspects of art. Can you trace that back to your early life?

Bob and Bob: These questions are hard. Why are you making us think about things we do? We are totally nonviolent, and there's hardly the time or money to stop and think, but for you, we'll try.

We were always presented with the image of the artist as someone starving. We reacted to this subclass figure by showing the financial discomfort and by addressing the issue humorously. Besides, an artist's desire should be to make art. There is nothing to get rich and famous for unless you make some art; if you discipline yourself to get rich and famous, then your art had better be worth it to people.

Montano: Were there famous people in your family? Or was it LA and the movie star atmosphere and TV that influenced both of you? What is the message of the art represented by your art of fame?

Bob and Bob: Every kid thinks their parents are famous, but no, we had no famous or rich people in our families. We're both middle class in origin—and in Oregon. And obviously LA had something to do with it. Idaho makes famous potatoes and California makes famous people.

Montano: Who influenced your ideas about business and art?

Bob and Bob: Early on we had read and been influenced by Andy Warhol's lack of fear. He, along with Bob Dylan, liberated many artists in seeing themselves as businesspeople.

Montano: Were you always comfortable with money?

Bob and Bob: Money is earth's physical equivalent to God. Comfort isn't an issue.

Montano: Will fame and money help artists?

Bob and Bob: It depends on the artist. Some artists will be destroyed by money, and other artists won't bloom until they have it.

Montano: Do these worldly implications jeopardize the artist?

Bob and Bob: Depends on the artist.

Montano: How does the artist maintain or build balance? Integrity? Should we?

Bob and Bob: Making art is its own integrity. Rich or poor.

ERIC BOGOSIAN

Montano: What was your childhood like? Were you given permission to be outgoing?

Bogosian: I was pretty encouraged and actually told by my family that I was going to amount to something. But then when I went to school,

the kids didn't like that idea, and I had a very hard time getting along with them. As a result, I went off by myself, walked around the woods, went down to the basement to work on my chemistry set, or read. That's all that I ever did.

So from the time that I entered school to the eighth grade, I lived in a pretty elaborate fantasy world and had paranoid delusions, which seem strange when I say them today, but I guess they are common among paranoid people. One of my favorite ones was that I was the retarded son of the king of the universe and that because I was such an embarrassment to him and his wife, they made a planet for me, and the job of everyone on this planet was to humor me. Since I never spoke to anyone else, this paranoid delusion persisted for a long time.

Montano: Who were your heroes and heroines?

Bogosian: Jesus was my hero. And the Mod Squad. I had to go to Sunday school every week, so if you're going to pick out somebody really up there, then Jesus is as good as any of them. As I got older, I got into rock-and-roll performers and movie stars.

Montano: When did you start having permission to make your specialness a conceptual art form? Or begin to use that material to communicate?

Bogosian: I came into this scene via acting and now use my acting ability to make pieces. Two years ago [1984] I performed around Boston, in my hometown. Some people with whom I used to hang around when I was fifteen saw me perform and said, "You know, you do the same stuff that you used to do in the backseat of the car when we used to drive around all night," which is really strange because I've been working hard on this stuff. So much for conceptual art! I was basically a person who talked a lot, and according to my friends, I used to play out characters even then, although I don't remember doing that at all.

When I was fourteen I found my niche, because I started acting in plays. That was fine, but it became too confining. At its best, with the

best roles and the best people to work with, acting should be a very great experience because give-and-take with the director and script can happen. But after a while, I felt that straight acting didn't work for me, so I basically quit and decided not to do anything anymore. Then I got a job at the Kitchen and was the guy who answered the phone, typed letters, saw all of these performances, and I said, "Oh, what the hell, I can contribute to this." Jill Kroesen was also doing stuff, which was basically acting, so I said, "Why don't I do stuff like that? Why not use it, break it up, and change it!" After that I stopped looking at my work from the perspective of communicating character and started to look more for the strength of an idea. I was never given any particular license. It evolved.

Montano: What did you want to be when you were young?

Bogosian: When I was small, I was an artist. I drew constantly and was a good draftsman. The teachers would tell me this and would then say to my parents, "This kid should definitely become an artist. You should send him to art school." They would take me home and say that the teachers suggested that I go to art school, but they reminded me that I was also good at reading biology books and would then say, "You want to be a doctor, don't you?" And I'd say, "Yeah, I want to be a doctor." And I'd forget about the drawing. Even the other day I decided to pick up a pencil and paper to see if I could draw, and it's strange, but I can do line drawings. So I haven't lost it. If I see something, I can draw it.

Montano: What is your working process?

Bogosian: My least successful work happens when I start with an idea or image and work it all the way through until it is done. What works the best is when I turn on the tape recorder, make up a lot of things, take those things, chop them up, and use that raw material for a finished piece. It's best when my stuff just comes out intuitively.

Montano: Are you finding the fame and attention you are getting easy to deal with?

Bogosian: I'm not that famous. There's nothing to deal with, really. When I do have to deal with it, I take an aikido stance and always do the opposite thing that comes to mind. When somebody comes up to me on the street and says, "Hi, aren't you Eric Bogosian?" I make believe that I'm somebody else. I make believe that I'm David Niven or somebody extremely polite and wonderful. I'll say, "Oh yes, that's wonderful, thank you."

Fame is all in your head. It's such an abstract. There's no way to prove it, and as soon as you think you're it, you're not it anymore. It's not very useful, except it tends to help get projects done. I'm interested in that aspect of it. When I first started making my pieces, I thought that everyone was going to say, "Wow, this is the best stuff! Well, look, we have this grant that we want to give you," but then I found out that it doesn't work that way. And that the press is an important tool in the art world. I'm involved in the commercial gig, and they operate the same way as the NEA [National Endowment for the Arts] panel, although they are still a little more interested in the art if it will make money for them.

Montano: How does your personal life affect your work?

Bogosian: Lately, as I move toward the more positive aspects of my life, themes of power have surfaced, whereas the last piece dealt with fear and running away from something. Now, I'm moving toward something. But power and fear are flip sides of fame, which is on the minds of so many people. The thinking goes like this: "If you are really famous, you can do whatever you want to do, with anybody, however you want to do it. Nobody will get on your case about it." That isn't true; it's a myth, but a myth that appeals to our entire population. We're interested in famous people, and I think that reflects the powerlessness of our society. Not only are people interested in fame, they basically want to see an Elizabethan tragedy enacted in front of them. Aristotle said that you can't have a tragedy unless you start off with people who are regal—princes, kings. We have to see them fall, through

some flaw of their own. That's basically what we sit around watching from the perspective of the viewer watching the TV. We see John Belushi, who through a flaw in his behavior, becomes the king, is anointed, then falls. That is the final wrap-up on the fame thing. Watch the flight of Icarus! You can't just become famous. You then have to fuck up in our society. That's part of the deal.

Montano: Do you prefer live performance to TV?

Bogosian: I like live performance because we're all in this room together, sharing this experience. That makes it positive, even at its worst. People are brought together, and that's often more important than what is happening with the work. You don't get that with TV or with film, which is more dreamlike.

Montano: What is your work giving you now that it didn't give you five years ago?

Bogosian: I just did over one hundred performances of this show in a row. It started getting eerie on stage because I would find myself saying the lines exactly the same way, night after night. I didn't even know what day it was. I guess it's teaching me discipline, that's the word. I can't be as mercurial with my emotions or what I'm going through at the time. They are not as important as the creation and delivery of this piece. Doing it again and again also tells me a lot about the people who are sitting there and also tells me about myself. I used to think that whatever was going around in my head or gut was seen by everyone out there, but that isn't true. They are seeing the piece that I made, and that's the constant. And the thing that changes is Eric and what he had for dinner. I am not that visible to them. That's a very sobering experience. I've also learned that I have to do all of those breathing exercises, stretching things, and relaxation before the show, so that I can go out there and make those moments happen. Otherwise I will go up and down emotionally.

For example, last year at the Matrix Theater, one night I'd be on, another night off, on, off, all over the place, either because I didn't like

the audience or I didn't like the guy in the front row. But in this run, I knew that it was going to be for a while, so I went into the theater night after night and got into a good place. I even relaxed with the people who work in the theater, so that I could get into a smooth spot, and then went out there and worked through the piece, which is different each time because I am not watching Eric being an insane person—I am watching the piece which I sat down and consciously wrote at one time.

Lily Tomlin was at something that I was at the other night. She said to me that she went to a world's fair exhibit one time where robots and animated things ran exactly the same in each performance. But for every show, the audience would be different, so the whole performance would take on another flavor. I feel that I could be a robot up there, but every time I will be getting a different thing. That's part of the excitement, and it's part of the show business aspect of being out there night after night and continuing to do your thing. I let the audience come to me and I to them without my having to go up and down and sideways with emotions every performance.

Montano: Do you have anything to add?

Bogosian: I find fame to be a dangerous thing. I wouldn't pursue it. I use it as a tool. It's not a particularly comfortable place to be. At times I've been sitting around in a restaurant, and I've sensed someone staring across at me while I'm eating. They're trying to figure out who I am because they've seen me before. There's nothing particularly nice about being watched like that. The ego boost of having people recognize me on the street wore off after a couple of times.

What I like is when someone writes me a letter and explains to me what they like in the work. That is what I would do in that case. One woman wrote me a letter after seeing my work and said that the piece helped open doors for her and cleaned her mind. That's great, but it has nothing to do with fame. If I can do that for one person, that's terrific. But I'm afraid of fame, because it's so easily abused, and I'm ready to

abuse anything that's available to me. The danger of fame is that nobody tells you that you're wrong anymore, and everybody tells you that you're right. Then it's hubris time, time for the gods to come down from the heavens. We see it all the time, like Michael Jackson is really demented now. I wonder what happened to him? Who's next?

NANCY BUCHANAN

Montano: It seems that you, as a performance artist, have explored your relationship with your father, who was a famous scientist. He had something to do with the atomic bomb. That's an interesting challenge.

Buchanan: My father actually was not involved in making the bomb. Oppenheimer invited him, and he declined. I don't know why. Instead, he worked on developing radar in Europe and, after the war, edited all the volumes on radar developed at MIT. He wasn't what you would call instantly recognizable in terms of fame. When he died it was in all the papers and on TV in Palo Alto, where we lived. The most bizarre coincidence is that on May 24, a show called *Family as Subject Matter* opened at the Washington Project for the Arts in Washington, D.C., and Jock Reynolds asked me to put the piece on my father in that show. My father died May 20 in Washington at the Sheraton. The Capitol Hilton donated hotel rooms for the artists, and—you guessed it—the place used to be the Sheraton.

Montano: Was he aware of his fame?

Buchanan: I remember once he made my sister and me watch him on TV. I guess that did register as some kind of fame. My father was aware of his power; it was the trade-off for what had been lost by eventually being trapped into becoming an administrator, which he hated. He got a lot of rewards from the government. In fact, there will be a posthu-

mous award given to him at the National Computer Conference in Chicago this July 17, my son Page's birthday. I'm invited and am going to attend if they send me the airfare. He was responsible for getting one of the first computers built at the University of Illinois when he was dean of the graduate school in Champaign-Urbana.

Montano: Was he infamous?

Buchanan: Infamous? My father either had complete loyalty and almost worship, or people hated him. He was somewhat known for being stubborn, arrogant, and he could drink an incredible amount without any outward signs. So I guess in some ways, in some circles, he was also infamous.

Montano: Does his fame make you leery of fame?

Buchanan: Leery of fame? Well, I think that what I see more and more as we all grow older—and I saw this looking at my father's life, too—is that power is very dangerous. It does corrupt people. Individuals get an inflated notion of the worth of their own time and expertise and forget that once they had ideals, which were their overall reason for working hard, rather than money and recognition. Eventually the search for remuneration can take over. This, I think, is the danger of fame.

Fame can, on the other hand, be used for constructive purposes. Someone who is famous can come out in opposition to government policies of nuclear buildup, wasted money in "Star Wars," and intervention in Central America. Famous people are seen by many as leaders. If they do nothing, then they are wasting the potential for good work. I think that power should be shared, that as one becomes more influential, one can avoid falling into the trap it offers by stepping aside, by helping others.

Montano: Is your work about your father giving you recognition?

Buchanan: I guess in a small way, yes. *Fallout* is giving me a small measure of recognition. In comparison to rock stars, politicians, and the like, it is hardly fame.

Montano: Do you like that?

Buchanan: Sure, I like being appreciated for one work which seems to really speak to people. My job now, though, is to keep on trying to communicate, to make work that addresses the things I care about and uses the technical techniques for art making that I am trying to perfect, however I can. Sometimes I feel frustrated that other works are not as important. After all, that piece is now five years old. All I can do is keep on trying. The moderate success of that one work will perhaps make the visibility of new works somewhat easier.

Montano: Did you think about fame as a child?

Buchanan: No, I don't think I thought about fame. My family was quite an unhappy one on a personal level, and I think I just wanted the pain to stop. I had the same daydreams most of us had—that I would get married, have kids, and somehow be normal, since my own family was not.

Montano: Did you have heroes and heroines?

Buchanan: I don't remember heroes or heroines. Writers, I guess—I loved to read. I never was impressed with political figures. When I had tuberculosis from age four to six, I was thrilled that Walter T. Foster, of *How to Draw* book fame, lived down the road. I tried to copy all his stuff.

Montano: Do you feel that fame corrupts?

Buchanan: What is amazing to me is that it seems that in order to avoid burnout some people who know better lose track of their values, finding themselves somewhat well known and powerful. I don't think anyone is exempt. And as performance art gains an audience, in some instances, artists seem to be falling into the ridiculous trap of seeing themselves as alternative rock stars. I did a piece about this stupid fantasy in 1974. It was called *Rock 'n' Roll Piece,* and I never thought things would get to the point they have. Not that people should not be paid or have decent publicity, but—!!!

Montano: Anything more?

Buchanan: Really, the piece about my father is a mourning for lost idealism, at least for me. I hope I have learned the lesson of his life. To the end of his life he was proud of his one little antiwar play. Written the year I was born, it is about satellites with atomic bombs circling the earth. An accident trips off the warning system, the military people in charge of the keys overreact—! But of course what he ended up doing was very different. He lost hope; he ceased to believe that people can change things.

We are losing our sense of history, our mistakes, our struggles—so quickly. TV offers a constant present. The U.S. revolution is not understood. What history we have is being rewritten in an odd way. Even the notion of personal empowerment so dear to feminist hearts is sometimes, I think, going in the wrong direction, as people believe that they must examine so minutely their own personal desires, pains, et cetera, to the exclusion of looking outward to the power of trying to change society now, before it's too late. We have that luxury, and it is not shared by the majority on the planet. Sometimes I think there should be a little more counting one's blessings and less striving to have one's personal existence, ever more comfortable and more successful. How can any of us succeed when things are such a mess?

LINDA FRYE BURNHAM

Montano: I want to interview you because it's important to hear from women who are in powerful positions, women who are handling large sums of money, women who are administrating influential companies, women who are performance artists who have chosen to extend the idea of performance by supporting it, writing about it, making magazines about it. As a child, did you see yourself as an administrator? Or magazine editor, as you are now?

Burnham: One thing I dreamed of becoming was a novelist whose books were published.

Montano: Was money an issue in your early life? Something that you handled easily or had?

Burnham: When I was very young, I married a man who was in medical school. We assumed that we would always have plenty of money, so we borrowed a lot and spent a lot. I had two choices when I left him: one was to stick around and reap the harvest, and the other was to go off into the void and not really know how I was going to make a living. I chose the latter. I didn't even take any alimony from him, so I was really poor for a while. When I started *High Performance* on two thousand dollars I had borrowed, I struggled along with it and didn't expect that it would make any money. I didn't do it to make money. In fact I figured, having looked closely at the art world, that the magazine would last for about three years. I was hardly getting through the beginning of my third year when someone with plenty of money came along and offered to keep me afloat. I've had a regular salary ever since. But I don't have any ambitions financially.

Montano: Do you see *High Performance* as fulfilling your literary visions, your performance vision, or both?

Burnham: I have a master's degree in fiction writing, but it never satisfied a deeper dimension that needed filling. Writing was never enough. When I did discover performance, I realized that it combined many different things, not only words and language, but physical presence and art making.

Making the magazine is very different from performance. It's a different kind of storytelling because I tell everybody about what I see in the performance world. I also do all the pasting up, so that fulfills my need to make things. In fact, I make the magazine the way that an artisan would craft something. But my deeply creative urge is fulfilled by something else—writing stories and songs. I can tell by the way that I

feel inside that the magazine represents one level of creativity and my other work, another.

The magazine has diverse functions. It draws together many things that I find interesting in the world, not just performance but other kinds of writing, picture taking, pranking, and unusual ways that people give to each other. I want the magazine to communicate that vision.

Montano: What started as just a magazine, as just a collection of information about an art movement, a coastal phenomenon, has really evolved into something international and magnificent, with books, records, and more to come. How do you feel about that?

Burnham: People have started saying that to me, and it makes me laugh because I don't use it as a way to open doors and meet people. In fact, I'm really nervous around famous people, which is probably why most of what happens in the magazine comes from a rather young, unformed art world. But the effect is interesting; it makes that world seem like the avant-garde. Besides, I don't get the kind of feedback that you're talking about in California. Somehow in my hometown, people don't give me any honors because I'm surrounded by friends who are on the same level as I am. When I leave town, I get treated like a dignitary. I lived in New York for six months, and people told me that the magazine is the only source for a certain kind of information and inspiration. That's great, because I think that the magazine is really about and for artists. It's a way of broadcasting their work to the world. My ambition is to communicate with the people I want to communicate with. Then I feel that it's a big success.

Montano: Are you seeing any performances? Do you have a personal vision for the genre?

Burnham: I'm coming to some conclusions about performance lately because I started getting depressed about how stylish and fashion-conscious it was becoming. Apparently that happened because performance is reaching out into the popular media, into nightclubs. Other

performance magazines seem to be responding to that fashion- and style-conscious look. That got discouraging because the things I respond to most are gut-wrenching, emotional, deep experiences that seem to be a pathway to human feelings. I started talking to Paul McCarthy about all of this several years ago, because he has a kind of vision that I really appreciate. He's responding by gathering around him people who are doing his kind of work.

I suddenly got the scent of this and became very, very interested in some young people like Karen Finley or Johanna Went. They're doing work that makes a terrible mess physically. There's a lot of material, a lot of gooky stuff, tons and tons of props. And then there's a language or attitude that walks a thin line between humor and horror. You find yourself shrieking with laughter and shuddering with fear at the same time. It's not really a linear experience but comes close to the truth of how we really feel these days. I think that their style is postpunk; we had to admit first that we were thoroughly angry and frightened to the point of almost craziness and then move through that to some sort of statement. That's the sort of art that I'm interested in now, and I think that young people definitely respond. It seems truer to them than the more formal, contentless stuff that we're getting from Laurie Anderson and Philip Glass. Even though they're making beautiful things, I think that we're hungering for something that has a deeper twist to it.

Montano: What about money and art?

Burnham: My heart goes out to performance artists who keep going, no matter what. If I had to worry about money and my own personal income, I don't know if I could do it. It's hard enough, probably the hardest thing in the world that there is. It seems equally hard to make art that reaches down inside and calls on your deepest strength. So it's like a double job: making a living and making powerful art.

I'm still in awe of these artists because I don't see how many of them will make vast amounts of money. There may be a few stars who will rise like Laurie Anderson who got paid—get this—eighty thousand for her performance at BAM. She's got plenty of money now, and that's great, because she's a real hard worker and does good work. But I don't see that happening to people I'm interested in. It's just a tough road to hoe. Or is it row to hoe?

PAPO COLO

Montano: How did you feel about fame as a child?

Colo: I felt envy, because my father was a very famous prizefighter. Very, very early in life I was exposed to fame and saw newspaper people all around my father. I was thinking, "Why was he such an important person?" It really shocked me. In fact, fame was the first thing that I was exposed to, plus being surrounded by important people on the island [Puerto Rico], and it became for me the mark of competition. The competition was also the attention from my mother because, of course, I had less attention, because it all went to him; he was the important person. So you begin to feel a little the difficulty.

Montano: Did you have personal heroes you looked up to?

Colo: I looked up to artists because in Puerto Rico, artists and print-makers had their workshops half a block from my home. Every day I saw all of these guys coming from Mexico, doing prints and into classical music. I kind of admired them because I felt that they were very strong, spiritual people. But also they would wear beards and were very strange—like freaks in the neighborhood, even though some of them were from the neighborhood. So this kind of incognito hero I was in love with, because I was too much exposed to the obvious heroes all

the time. I looked up to these people because I thought they were doing beautiful things, although some people laughed at them.

Montano: How did you compensate and give yourself attention, since so much was going to the father? How did you make yourself important?

Colo: The family put a restaurant/bar business there, and all the artists and famous people went to this bar, so I grew up with all this activity and could watch actors, directors, musicians, TV producers. I did not feel important until I went into the merchant marines when I was eighteen. That is how I began to feel important.

Then I learned that to feel important was not important! I grew up among important people within the community and within my life on the island, but after a while I never felt that I needed to be important. It's a matter of historical chance, to be important. The artist's life is not about fame. Even if I do a very great piece, I don't feel comfortable. For me, what is important is to be healthy, very healthy. I do exercises every day. The body and the function of the body is the most important thing, because if that is healthy, I can continue to work. If the work is important or not important, other people will decide.

I am free of that push because what I saw around me when I was growing up was the incredible ego of the artist. From age eight to eighteen I saw actors looking at the mirror, feeling important, and hundreds of people feeling important. As a result, importance became demystified.

Montano: When did you begin to feel free of your father's fame?

Colo: When I left the island. Then I became free of that situation. I have friends who have famous fathers and who never left the island, and they are full of problems, because you are always the son of this and the daughter of that. The only way is just to leave and leave everything and go away. I haven't lived on the island for twenty years now, half of my life. If I lived there, they would expect me to be like my father because everyone knows the family. That is frustrating for any child.

Montano: How do you feel politically about fame?

Colo: I feel pro and con. In a political sense, if you are famous you can help things you believe in get done. People listen to you, especially since the famous person has created a mythology around their personality, which makes people really believe what you say, even when you say stupid things sometimes. I think that it is very, very dangerous for a personality to express himself in specific political terms. He has to be very clear about what he wants, and he has to be very clear politically because of this power to influence people, the media, and even governments. Artists can also influence students who will be affected for the rest of their lives. You have to be very, very careful. You are playing with the people's lives. It is simple. Famous people influence other people in very deep ways. People mystify the famous. They want to imitate you, but they don't know how you suffered to reach this point. They don't know the situation that you passed through. It's very easy to see the famous person in a gallery or see the work in magazines, but they don't know what the artist has conquered to get there, to that point. Fame is important. It's a burden and a responsibility, so it's wise to be very careful with that—very, very careful.

Montano: How were you able to bypass the need for fame and opt for health as a more important priority? When did that happen?

Colo: Life is about durability. It is not to do a good piece today and then in ten years you don't do a good piece. You have to do a good piece in a sequence and with a stability, and to do that and to be an artist, you need physical force, because that helps you with the mental force. The mental force must become and be made physical and visible— that is the work of the artist. And if you don't feel physically well, the mind won't produce that well. That is why I am obsessed with health and exercise. It's because of durability, continuity.

Montano: Do you mind living in New York City? Is it healthy enough?

Colo: I did not come to New York because of an economic necessity, so I am not here as an immigrant. In reality, I came for the competition. I love competition, not in a negative sense, but in a positive way. Here you see so many wonderful people, so many good artists, and I enjoy that. That is also healthy, and it gives more energy. You learn more that way about your trade. I give myself to this competition, and, like all of us, after this period of competition and learning, you wish to retire to a more peaceful life, a more clean life atmosphere, so I would find it difficult to be here after sixty. In fact it would be difficult to be in any big city in the world after sixty, but when you are effervescent and have life force, a city is fantastic. When you are young and need competition, need to learn positive competition, it is perfect. After a while you need the rest, and you need the meditation, and you need the writing. You need the most peaceful environment, in my opinion.

Montano: Do you have that environment picked out yet?

Colo: Yes, I want to live and travel in Europe, Africa, Mexico, Guatemala, South America, and so on, but eventually I will live in the Caribbean because I am a tropical person. I love the sea, and I love to go to the sea every day, so for me it is the Tropics. I want not only to live there as an individual, but I want to try to do something about the living conditions down there, to do that as an art form—not only a practical art form or a metaphysical art form but as applied arts, like making houses, making an environment for the community and with the community. That is my dream—a utopia. That is the perfect escalation that an artist can have, a gift to people who are really underdeveloped—to give them another way to produce, another way to think, another way to live. I think that is the goal of every artist and the artist's conscience. The power of art is not only decoration, not only metaphysics, but a reality of doing. The money is not important. In fact, I think that the money is never important to the artist, because even in the communist system, the artist has the strange ability to survive very well. So for a real artist, the money is secondary.

Montano: What is your daily performance? Formerly you did performances, but how have you translated making specific actions into a daily practice?

Colo: My performance is to lead my life in a disciplined routine, even though it is not a routine. I first do my exercise. I have to eat well, and I have to work until I am tired, until I go to sleep. If I don't paint, I am doing photography. If I am not doing photography, I am writing. If I am not writing, I am reading, but it is a commitment to continuity. I think art is a performance of continuing self-education. It is to try to better yourself, not in a greedy way, and not for the money. If I wanted money, I would be a lawyer or something else; I am smart enough to do that. But I see art as continuing self-improvement in the mental and physical aspects of your life.

Every instant you live, every second, you have to make a decision, and that means that there is always doubt. Doubt comes before decision, and there are strong forces between doubt and decision. Doubt is one of the key elements of life. I doubt which kind of invitation I should design, this one or that one? What am I going to have for lunch today? If I buy the paper now or later? Doubt is not negative. Let's associate this to a political situation. I, as a person coming from Puerto Rico, was born with a doubt: Was I North American? Was I Latin American? Is my language English? Or is it Spanish? In a way I am obsessed with doubt because I am born doubting my identity. It comes to me not as a limitation but as a philosophical statement that tends to be political because of my biography. That theory is the basis for a lot of my work. When I look at my doubt, I find that everyone has it. When I paint, I doubt: What color? What canvas? What size? What do I want to say? But doubt for the artist is his substance. We cut through the doubt to choose what we are going to say. In Spanish the word for doubt is *douda,* a good-sounding word.

My physical nourishment comes from good food, but my most important food is knowledge, the food of knowledge. I learned the

process of reading, knowledge, danger, and adventure when I became a merchant marine at eighteen. There was no school or university, and I began to read, see other countries, live with people of other classes, and I found out that I could learn things from them. My knowledge is related to danger, because being a merchant marine is a very dangerous way of living. I ate that knowledge in order to become a good artist. I didn't feel that as an artist I had to do artistic things. I felt that as an artist I had to learn life, the heart, the danger, and the knowledge of life. The knowledge of life is not only in books. Living became food for the knowledge.

Montano: Where is your danger now?

Colo: My danger now is my artistic commitment, which means that I do not want to become an aesthetic artist. "Aesthetic" to me means many people I met during the seventies who were artists have developed and gotten stuck in an aesthetic—have become oxidized. I think that the most dangerous thing that can happen is to get stuck. That is not good danger. The artistic life is dynamic and composed of three elements— will, power, and desire. You have to have great will to learn a medium, to understand it. You work a lot, ten years maybe. Then you have the power to do that, and you get a wonderful satisfaction with that power. You do your work for the desire of doing it because you know that your will has given you the craftsmanship, and the basics that give you power. That creates a circle of circumstances and creates a machine that goes around and around. Once you accomplish something, the danger is that you might stay in desire. Then you get stuck in desire and become an aesthetic artist and probably very successful. The challenge is to be successful, not get stuck, and learn how to create new will. One of the characteristics of youth is will. When you are twenty, you are idealistic and prove the will. That gives you energy. When you get to desire, you have to recycle your life with another will. Otherwise—*finito*.

Montano: What is your new will?

Colo: I am very ambitious. My new will is to create another kind of American aesthetic, the whole gamut of experience from the sociological to the anthropological view of the Americas. It is an impossible will and dream, but it is happening. What saves me is that I look a little crazy, but I have this terrific way of doing things—a business way, a diplomatic way, a conceptual way. I have to be this way because I am coming from Puerto Rico to another tribe to disturb and dislocate the established cultural values. That's what an artist wants, to dislocate the status quo. I come to that naturally and don't have to force it. I don't have to be political to be political because I am not from the tribe. By my presence I break the stereotype and melt everything.

LOWELL DARLING

Montano: I wanted to ask you about money and fame.

Darling: It's not something that I know a great deal about. I don't have much of either.

Montano: How did you feel about fame as a child?

Darling: I don't think that I thought about it. I grew up in a small town in Illinois where the milkman was famous. He was the one that you saw outside your home most often. We didn't have a TV. I hardly ever went to movies, and the only two artists that I ever heard of were Michelangelo and Norman Rockwell. And Walt Disney, of course. I ended up writing Norman Rockwell a letter once complaining to him about his whiskey advertisements. And he wrote me back and said that he sold those drawings when he was very, very young and couldn't control the use of them anymore. He said that he didn't do those things for commercials now that he was older, and obviously more famous and rich. And the lesson to me was, don't sell out too dear, too young. So I didn't sell any art until I was thirty-five.

Montano: Did your parents have famous expectations for you?

Darling: My parents assumed that I'd be lucky if I lived to be eighteen or twenty. They didn't have high expectations for me at all, but did buy me a lot of art supplies. Every Christmas I got paints and things like that. I don't think that they had any hope for me until they started reading about my California governor's campaign in the hometown papers and people they knew in other towns they had lived in would call and say, "Isn't that your son, Daryl's brother, Lowell, who is in the papers?" That's true.

Montano: Was it challenging to make a transition from the way that you were working before the campaign? Challenging to take on a political and public persona?

Darling: If I'm famous, I don't really see it. I'm really a hermit. I don't hang out that much. There wasn't really a big transition except for the fact that I wore suits. Running for governor was really tying up ten years' worth of work as a public artist because when I was in college, I "nailed down" my first city to the ground. Then I was working for Buckminster Fuller at SIU [Southern Illinois University]. It got picked up by the local radio station and got picked up by Chicago newspapers and TV. The next thing I knew, I was on the front page of the *Chicago Daily News*. There was a cartoon of an artist, not me, but someone who looked like Salvador Dalí with a Leroy Neiman haircut— he was on the world, nailing it down. I remember it distinctly because it was the day that Judy Garland died. So Judy Garland and I were on the front page together. Then I got calls from all these radio stations— all over the world—and I thought, "This is a pretty good format." But it happened all by accident. I just kept doing things, and the media kept picking up on my work. I hardly ever approached them.

I work on several levels, the most private being the stuff I do that keeps me together, the things that no one ever sees or knows about. It looks a lot like performance art, although it's very private. The other is

the work I do that the art world understands. The last level is the work
for the real, total world out there. Most of my work is on one level or
the other but seldom in between. It took the art world a long time to
figure out that a lot of the public stuff I was doing was actually my art.

Montano: How does the public work affect the private work?

Darling: The irony was that the more public I became, the more pri-
vate I could be. Until I was really public, I used to have people coming
by all the time with backpacks because as a nonpublic artist I had been
involved in the correspondence network and was fairly well known
among several artists. But I wasn't really public. I was a private well-
known artist. A big-time underground artist. That's a term that I heard
used once, and I always liked that.

Anyway, when I became pretty well known, I stopped being both-
ered by people dropping by randomly. That was nice. See, I had made
my address public and did that on purpose, in some cases just to see
what would happen. For example, *Art in America* would do an article
on me, and I'd make sure that my address was in there, because I was
taught art in art schools by art teachers who used art magazines as visual
aids. When I was a student, I decided that if I got in the art magazines,
I was going to make sure that people could get hold of me either to
congratulate me or say they liked me or my work. I was concerned for
students and wanted to make some connection with them.

Montano: Has fame affected your daily life?

Darling: No, I don't think that it has. Everything is very much the
same. The only difference is that I don't have to tell as many people
what I do as I used to, or who I am. On the one hand, it's good be-
cause you don't repeat yourself. On the other hand, it's not so good
because you don't end up critiquing your work as often. But I don't do
what people think I do anyway, and I'm not what people think I am.
You know what I mean. For example, some people thought that you
were a stripper who wore a nun's costume!

Montano: Are you dealing with the issues of notoriety, fame, and a public image now?

Darling: Right now I'm helping Sue Dakin organize her presidential campaign, and so I guess I am using it to a degree because I know a lot of media people. When she starts to forget what she's doing, I'll be there.

STEVEN DURLAND

Montano: How did you feel about money as a child?

Durland: I started working for money when I was nine—paper routes, lawn work, shoveling snow, handing out clothes baskets at the local swimming pool. It was coincident to the age when I started spending money—candy, baseball cards, toys, and movies. I was heavily indoctrinated into the process of saving money for college. That meant that, to me, one dollar equaled fifty baseball cards and fifty cents in a savings account. I think I was born with a savings account. I saved money for college from the time I was nine until I left for college, and then spent it all in the first two months away from home. Ultimately, I guess I'd have to say that I neither craved money nor scorned it. It was just a part of the life process. It was also probably significant that I grew up in the country, which meant that having fun was not predicated on having money. In fact, it would have been pretty hard to spend lots of money without being completely gross.

Montano: Did your parents have it? Fear it? Use it well?

Durland: Violins, please. When I was young, I never had any idea how poor we really were. I was the oldest of five kids. In 1960 my father was supporting us and my mother on less than four thousand a year. I never got everything I wanted, but I pretty much got everything I needed, and that included the appropriate status symbols commensurate

with my peer group. I only realized in adulthood the kinds of sacrifices my parents made so that they would never have to tell me they were too poor. That included homemade clothes, recycled toys, et cetera. I used to think my father took second jobs and worked during his paid vacations because he enjoyed it. My mother started working when I was eleven and has worked ever since. I was young enough so that it seemed normal, which it wasn't for the place and time. It created a situation that probably made feminism a much less threatening idea as I got older.

To answer the second and third parts of the question together, I'd have to say that they used money very judiciously, if not well. And I would never say they feared it, although they very possibly feared the specter of poverty. I do feel, however, that it ultimately killed my father, who died of a heart attack at a fairly young age, forty-nine. His death was directly attributable to the pressures he assumed to be a good provider. He was a throwback to the kind of person who would have functioned best living off the land, and I don't think he ever found any real satisfaction in making money.

Montano: Did your parents give you a good attitude toward it?

Durland: Good? I don't know. I learned to accept it. I'm still the same person I was as a child: I make it and I spend it. I spend more of it now because I make more, and I also don't have to save for college anymore. I inherited, and fight daily, my father's sense of responsibility. It feels like appropriate behavior, but I don't want it to kill me, too. It's a fight I sometimes feel I'm losing. I don't save for my future and deplore insurance except as required by law. I don't know what I'd be like if I had children—perhaps different—but I spend more money on myself and my adult toys, perhaps to acquire in the present the future my father always planned for and never had.

Montano: Does your performance address money and power?

Durland: Not directly. It has usually addressed competition—examining, among other things, the need to have more power and money

than you need to stay alive. I've never seen money or power as bad in a basic sense. Money is a tool of survival, and power is a tool of self-respect. To me, it's greed that causes pain.

The idea of competition fascinates me. It's such a primal instinct—at least for men, and becoming more and more so for women. I appreciate sports because they channel that energy in such a way that losing, even though painful, is an artificial condition. But I don't understand the kind of competition that dictates that the American way of life can exist only at the expense of all other ways of life. Yet it's so very, very primal. The goodness of philanthropists—hell, virtually every advance in the history of civilization—hides a history of competitive cultural destruction. Can this approach to living ever benefit as many people as it destroyed to get there? Is it inevitable, a biological condition, perhaps? To be a winner is to create scores of losers. Why do winners feel so much satisfaction in the face of so much pain?

Montano: Why are so many performance artists getting managers?

Durland: Competition.

Montano: Are power and money going to ruin performance art?

Durland: Andy Warhol died yesterday. Someday, when the dust has settled, his legacy will be that he convinced the world that the quality of art could be determined by its commercial value. He single-handedly wrested the role of evaluating art out of the hands of the people—primarily rich people. In five hundred years people will look back with perspective and determine either that Warhol was a social revolutionary who liberated an elitist activity, or that he was a crass, cynical shyster whose attitudes represented the epitome of a dark period in art history. In other words, I can't say whether or not power and money will ruin us until I know what we're intended to be.

Montano: How can we use it well?

Durland: Violins again, please. By caring. By caring about ourselves. By caring about other people as much as we care about ourselves.

Montano: Is it the last taboo—artists with money?

Durland: Right now it seems more taboo to be an artist without money. In principle, I get very frustrated with the attitude that equates success with selling out in the art world. I don't see any significant change in what Laurie Anderson was saying ten years ago and what she's saying today. I miss the intimacy of the early work, but her ideas translate well to a grand scale. If you ever liked her work, there's no reason not to like it now and allow it to be shared with a much broader audience. But neither her avant-garde beginnings nor her commercial success is an appropriate criterion for evaluating her art.

When you think about it, it's never been a taboo to be an artist with money. There have been quite a few rich artists in history. Any taboo that exists has more to do with artists who make their money selling their work or themselves. I think it's a shallow observation to assume that selling work is selling out. It assumes that the public consumers, if you will, are stupider than artists and will only buy inferior work. The issue probably hinges on the concept of conflict. In a sense, art is always about conflict—formally and socially. It's certainly harder to appreciate the expression of conflict coming from someone who is rich and obviously doesn't have to live with conflict than it is coming from someone for whom survival is a more vital issue.

Montano: How can we get more comfortable with it and not get greedy, corrupted, or fall from grace?

Durland: I've never known an artist who made the initial decision to be an artist because it would make him or her rich or powerful. The desire for money and power is a function of survival. Greed and corruption are functions of self-image. Artists are no different from anyone else, and the pressures affecting survival and self-image are great, perhaps greater than ever. Yet I tend to believe that there is something in that initial commitment to be an artist, the commitment to an ideal that marks most philosophical and spiritual pursuits, that focuses an artist's priorities.

To get comfortable with money and power is to first understand that it is not a function of your art, but a function of your survival and

self-image. A mistake I see artists making today, especially as they approach middle age, is evaluating the success or failure of their art in terms of its commercial viability, instead of its ability to achieve the goals they originally set for themselves. Certainly there are financially successful artists who are uncomfortable inside because they know they've never accomplished what they really set out to do. And there are many satisfied paupers. To be comfortable as an artist is to be true to an idea, whether it makes you rich or not. People don't evaluate art in terms of money and power; they evaluate people in terms of money and power. I don't even believe that Warhol actually meant what he said. It's just too bad he died before he admitted the sarcasm.

SIMONE FORTI

Montano: Your book on performance was one of the first written by a woman, so you have dealt with being public and famous for a long time. In your childhood were you able to explore being public and free?

Forti: In my family, at the table, I always felt free to talk and carry on, and at school I always liked answering the questions. And when I was twelve, I put on a play of fairy tales with some friends, and we invited the grown-ups to come and watch. So that's all public. Getting back to my family—at the breakfast table we would tell our dreams. It's not that we told our dreams every morning, but it was not unusual for someone to be telling a dream at breakfast. In that way we kids were encouraged to carry our share of the mutual entertainment and of the mutual communication at the social times with the family.

Montano: When did you start making your work public?

Forti: I went to college for a couple of years, got married, and both my husband and I dropped out and did some painting. Then I ran into

Anna Halprin, because I was taking dance classes here and there. I was so taken with working with her that for four years I dropped everything else and studied with her, performed in her company, taught children's classes that she had organized. I think that she was my mentor and my example; she was doing this, and I knew that at some point I would want to be not a student but an artist and doing that also.

There are artists in my family, and I think that my father would have liked to have been an artist—he always did some painting and wrote poetry. His father also did some painting and wrote small books of his philosophy. My grandmother did a lot of writing. Interestingly enough, in my family, which is Italian and wealthy industrialist, the men would have liked to be artists but had the responsibility of running the business, and it was my grandmother who was able to write and publish. I was encouraged by my parents; they gave me a lot of lessons, told me that I had talent, and so I had the support, and then I found the teacher. That was a tremendous stroke of luck to find a teacher, and, besides, we synched.

Right now I'm having a much harder time with it all, and it's hard for me to put my finger on it, but I'm finding myself disoriented because I don't know how I want to work. I could easily say that I don't want to work anymore, but that's ridiculous because I have to have some kind of continuity. I've been really struggling against dropping out and trying to understand it, but I think basically I'm going through some changes, and I'm going to catch the thread of something and find my energy again within one or two years. Sometimes I get scared, and I thought of it now because we were talking about my early childhood and my grandmother and father.

I think that my father had a very unique vision and could have done a lot of writing and painting. Somehow he had a terrific aversion to being in the public eye because he was very shy. He was a good chess player, not a master, but a class A player. More than that, he was a great

chess problemist. He would compose these problems and would pub-
lish them in the *London Times,* and there was one guy who appreciated
them, and then when this guy died, he never published another prob-
lem again. He felt that people didn't really understand or appreciate
them, or said that a different kind of problem was in style and that no
one appreciated his style. So that was that. He really withdrew, and I
sometimes find myself wanting to withdraw.

Montano: I did that for two years when I lived at the Zen center. It
was very valuable.

Forti: I would think so, and to do it completely would be important.

Montano: What are your new needs?

Forti: I don't know. I still love teaching; I love teaching because I can
really be in the middle of the interaction and can see people engaging
with some concentration and energy and doing something—I can see
them gobble it up, and I guess that I feel the need to feel needed. I feel
very strongly right now, especially in the dance world in New York,
that you really have to elbow your way in to get the grant, to get the
space, to get the audience, to get the attention. I could do it. I've got
that added leverage of fame. I could do it, but I'm just taking it away
from someone else, and I guess basically I feel that they could do just as
good a job as I could, and I don't feel like elbowing my way in because
I don't feel like I have any vision right now that has a natural life of its
own and needs to be put out. If I were hitting my stride in some for-
mat or had some paradigm that was working for me, one that I was re-
ally exploring—working in a way that I felt very natural about and
bonded to, even though it might be difficult or even if I had to strug-
gle to get the work out there—then it would be okay.

Besides, I feel that there should be some space in work. There should
be some silences, so that you can see what you just saw or maybe think
things over and then see the next thing. The ideal environment gives
you that kind of space, so you can see and digest and think about it and

maybe find that someone else is doing a similar thing, and so you see that and then think about the two things, talk about it with your friends. But when you're an audience, constantly going from thing to thing to thing, there's not the space around each thing that lets it shine or lets you take in the nourishment, so all that you can do is to shove it through your system as fast as you can. So why should I add to that?

Montano: Was there a time when you had struggles being famous?

Forti: I think that [my husband] Peter [Van Riper] and I had some difficulties along this line. We would do jobs together that were really collaborations, and then there would be a review, and my name would be there and his wouldn't! We'd say, "That's sad, but that's the outer world, and in the meantime we're doing this work, we're both stimulated creatively, we're working well, we love the work, we're collaborating, and that's what really matters to us." But it wears you down, and it's hard and it hurts.

Montano: When people treat you as a famous person, how do you react?

Forti: I haven't been aware of people distancing me because I am famous. What I am more aware of is when people are ready to take me in, in a very familiar way, because they've heard of me. I will come to a new city and receive the red-carpet treatment, and people will take me into their homes, let me be their guest, want to take me out to the country. So it's very nice. Maybe my need for familial love helps set the tone, but I just lap it up. It doesn't happen that much, and I'm flattered by it. I'm in a community where we are all known, and I'm not that much more known than the people I run into.

Sometimes someone will say, "Oh, Simone Forti! Oh, great!" and then, if there is some kind of rapport, we get past that to some kind of friendship or conversation. I have no guilt about this recognition, so for me it's a sense of security. Even during this hard period, I have that cushion of my past, and I know that basically the community has faith

in me. Even if I'm going through some years of not producing so much, when I do feel like working again, I have support and contacts and credibility and will be able to take advantage of all that I had before, so it's a sense of security that I have: I will not be forgotten.

Montano: Do you feel you'll move to another country?

Forti: I have yearnings to be in very beautiful, natural surroundings, and when I am, I find clean air so interesting, I find moonlight so interesting, and when I get away from it, I forget and don't retain what it was that interested me. I like it in the center of Australia, and I have longings for that, but I think that I would do well to satisfy those longings in the United States.

Montano: Is some of the challenge of New York to create the moonlight here?

Forti: No. You can catch the moon once in a while, but it's not about that. It's just that I've lived here so long that many of my dear, dear friends are here. They are the people who show me that kind of bonding that happens over many years, and I like to see their faces, I like to run into them. The fact that there are so many wonderful things happening here doesn't interest me. I don't feel like going around and seeing those things. What do I like about New York? I like the barbecue meat on the street. I don't know really why I'm here. I think that it's because my house is here and my friends are here. And because I really don't know where to go. I can't just pick at random. I wouldn't mind if a couple of years from now I'm somewhere else. I'm waiting for a natural occurrence to happen, some occurrence that makes it natural for me to move. It might be Vermont. It might be up to Mad Brook in Vermont.

Montano: Is there anything you want to add?

Forti: Let me think a minute. Well, I think that we're at a time when many, many people are very concerned with fame, with some degree of fame. That seems a little strange. I'm a natural example of it. On the

other hand, we're not as interested in personal bonds, and we will sever a situation of bonding, or would let situations of bonding go dormant. I think it's the nature of this era now. There are many reasons for that. In my personal life I'm feeling a longing for more personal bondings, more exercising of personal relationships and bonding, and at the same time, I'm interested in fame, but it's almost out of that feeling of security—of being somehow bonded to the world, and I fear that if I were not known, it would be like I was floating out in space with no bonds to anything. That's it.

MEL HENDERSON

Montano: Were you given permission to be creative as a child?

Henderson: As much as I wanted to be. When I was young, my hero was Amelia Earhart and also a local character of the Sierras named Lyman Gilmore, who was a mining promoter, a miner, and a turn-of-the-century inventor of airplanes—most of which did not fly. Kate, my daughter, is going to a school here in Grass Valley that's named after him.

Montano: What was the early motivation for your work?

Henderson: I attended the California College of Arts and Crafts in 1951 on the GI bill and had the extremely good fortune to study with Ms. Ella Hays early on. I had spent two years in the advertising department, hoping to become a commercial artist, but the first class with Ms. Hays changed my mind and life completely. I also developed a feeling for Noguchi and his sense of materials and space at that time. Now the work is about going back to exploring the earth again, almost in terms of survival—like discovering the wind and what to do with it, and water, the way of water. So I am building a waterwheel down at the Djerassi Foundation to be able to understand some possibilities. I have

a tremendous feeling for the earth. I dig down into it—feel protected by it. *The Solstice Cave* that I am also working on at the foundation involves that kind of womb feeling as well as a recognition of the sun and cycles. On the top of the mountain we're making an observation shelter down in the rocks and doing experiments with wind sound vibrations.

Montano: In the seventies you did a piece about Attica. What was that about?

Henderson: The prison riot there and needless massacre affected me a great deal. I still have a tremendous feeling about that and want to do something about it. The whole prison situation is not right. When I think about how people are being treated in prisons and what surrounds that whole idea, I feel that I will be doing some more public events about it. I think of it a great deal and will act on it at some point, but I really can't do it alone. There has to be some kind of formation or group to carry out some public demonstrations of concern. We have to get rid of prisons and jails. They shouldn't exist, especially in this country. There are alternatives.

Montano: Your process is most important to you, and you don't push toward public or art world name and fame. How do you do that?

Henderson: The reason that I know about an artist is because that person is consistent, has thoughts about things, and has acted on those thoughts over time. By what one does, a connection is made with someone else, and eventually with a number of people, and so forth. To think of it beyond that, you compromise the thing. It should happen naturally, and if you are doing something that makes any sense, someone will hear about that, and it will get transmitted. It takes care of itself. And so fame isn't something that one has to go after. It comes, but through the work and commitment.

If something is important to me, I'll make room for it. What is more important to me is that we act on our ideas and on our uniqueness and put that down in some way, and that could be in the form of music, a

poem, or painting, or sculpture—or planting a garden. Then the next step is to feel good about that. The third step is to be responsible to the thing that has been created.

In my work I'm finding that in spite of the way that the world is going and with the popular concern for material things, people with ideas can still turn matters around. If you look back in time, you can see how small groups of people have made suggestions or offered new ideas, then made a commitment to the idea, and eventually the course of history is altered. You come to that area where you have to believe in those ideas that come into us. Then the task is to sort out those ideas and act on the most important ones. For example, I have the thought that if I act on the prison thing, that I would be part of something that eventually turns it around. I get tremendous support for that idea from Richard Kemler, for instance, who makes gallery and museum installations dealing with jails and prisons. Just knowing that he is that concerned and committed is very supportive to me.

So there is that level of concern in the work, but there is something ahead—findings that will alter my thinking and will allow me to be even more believing in the different kinds of ideas coming to my head. Then I can act on them when it is appropriate. Sometimes working with groups helps the work because I tend to be too responsible or paranoid about some of my ideas. A group would be helpful.

Montano: Is there some connection between the way your father died and the fact that you are digging a tunnel and work in caves as art?

Henderson: He had a stroke in 1953 while mining by himself, and about three months later he died. I don't know if my work is about that issue. He certainly made me feel comfortable about working in the earth. In fact, I worked with him for a considerable time. I see it more as recognizing a cycle that he was an important part of. I flash on him quite a bit. He spent a lot of time underground, mining for gold, and made four trips to Alaska during the rush.

Montano: Anything to add?

Henderson: Essentially, I'm interested in working on places more than on objects that are plunked on the landscape and have nothing to do with the land. That's probably because I grew up with gardens. My mother put a lot of energy into them—packing water when the springs went dry, keeping flowers alive. She had a real feeling for the earth. Both of my parents had this relationship with the land that they taught me. And I am grateful to them.

JULIA HEYWARD

Montano: How did you feel about money as a young person?

Heyward: My father was a Protestant preacher, and even though he didn't take the vow of poverty like some religious people do, he acted pretty much as if he had. I, as a result, have a disdain and distrust for people with money, especially for people who were born with it. Preachers do weddings and funerals as extracurriculars, and my father would never take money for that, or if they really insisted and they put it in his pocket or gave him an electric razor, he would—that day—give it to somebody else.

In some ways I am like that, too, but in a different form. I can't stop being a hippie, for instance, and that mentality of sharing and taking care of other people is part of me, which means that in New York City, I am constantly being taken advantage of both by people who live with me and by next-door neighbors. I notice that I am doing it when I have been paying the gas bill for the whole floor for five months. It's a nobility that originates with my father.

Montano: Do you ask for money for your work?

Heyward: It's incredibly traumatic, incredibly traumatic. No. I can't ask for it, and this story illustrates my position. It's a tradition that back-

ers with money are invited to see an act for a Broadway show before it opens, so that they will support it financially. Well, I did that once, presented one of my pieces, only I invited critics—critics with no money and no power in the Broadway world. It was awful, horrible, and my partner and I ended up having, literally, a knock-down-drag-out fight afterward. It was one of the worst experiences of my life. But it is because work, to me, is not equated with money. In fact, it's a real contradiction and a conflict, not of interests, but of mentalities. I have a block against having to value things of real worth with money. There is something else and another way to assign value.

This real distress around money means I think that I don't deserve it. I look at it as my number one obstacle to overcome. Even when I get it, I use it for the stupidest things. One year I made a lot of money doing rock videos. Basically, I gave the money away—hiring a manager, paying him to take care of me when he didn't have anything to do. That was his idea, but I wrote him the check. It was a big mistake.

Montano: Have you written any money songs or done money performances?

Heyward: No. I haven't literally done anything about it. Talking about money in my family was about as well received as talking about sex. It was taboo. My parents sent five kids to college at fifteen thousand dollars a year, but I never had a dress from a store until I was fourteen. We ate out in a restaurant twice in my early childhood, and that was probably at some chain store or Howard Johnson's. For the occasion we all dressed up from head to toe—hats, gloves, pocketbooks. I remember that clearly. It was at my grandmother's—somebody had died, and we went out to eat.

Montano: Is your father more comfortable with money these days?

Heyward: He's retired now, and he and my mother live on a fixed income of one thousand dollars a month. They don't suffer, but they don't have any major expenses either. That's my big fear—that I will

end up in government housing when I am old. That's a really huge fear. I don't want to end up there.

Montano: I have fear of that, too—of ending up in a nursing home, forgotten and unconscious. It makes me want to transform nursing homes as an art project!

Heyward: Really. I feel like fighting legislation now so that won't happen. But do you know what probably will happen? I'll be waiting in line to get into government housing. That's what it will be. A friend of mine and I went out six months ago, and I drank two drinks, got completely out of my mind. We started talking about getting old, because he's also from a meager background. His parents as well as my parents are living in a trailer in a white trash neighborhood where the neighbors throw beers at them, men beat women—and my parents have never drunk a drop in their lives!

Montano: Traditionally the artist was supposed to suffer, but now there is a new, wealthy model. Does that make—

Heyward: Make me throw up? It is relative to what medium they are in as to how I react. I was a foreigner to jealousy and envy, but suddenly I realized that I am rapidly approaching middle age, and I don't have any money. When I hear that people are getting millions of dollars for movies—Laurie [Anderson] got 1.6 million dollars for a movie, and I imagine that she gets hundreds of thousands of dollars a year for her work—then I wish that I had a little bit of money, so that I could compete because I need that corporate support to do my work. I've never even tried to get that kind of money. Maybe only once I've taken a tape to a company. It's not really Laurie's fault that she's making that money, because she really went after it, tried for it, is a very ambitious and talented girl. In her case, I get over it and just look at the work and either like it or don't like it.

With most of the people I know who are making a lot of money, I still like their work—Robert Longo, I really like his work. He's making lots

of money, and I know that it's corporate art. Corporations buy it because it's large, or made out of metal. It's not the stuff that really touches me. What does is disposable stuff—conceptual, emotional, mental, non-sellable. Live work really gets me. Stuff that's very dangerous.

Montano: Does the ephemerality of performance remind you of religion, and is that why asking for money is difficult?

Heyward: My favorite paintings are Tantric paintings, devotional paintings. Even though I don't understand it, somehow it engages me much more than Western paintings of any type. That has been the case since I was eighteen and discovered it. I also enjoy devotional music, but I don't consider myself on that level yet, although that attitude makes its way in somehow.

Montano: What do you do to feed that?

Heyward: I don't really want to talk about what I do, but I have been involved in study for about ten years. I go about three or four times a week to a place, and I talk to people and work on a certain form—there's a physical form that's involved. I think that some of the ideas make their way into my work, but I doubt if anyone else who wasn't involved in that would see it, because it comes out in pretty neutral ways.

I am learning how to embrace suffering and to watch it. We all suffer, and if you embrace it and watch it, that's different from going out and bludgeoning someone else who is also suffering. I apply semiesoteric approaches to ordinary functions that happen to everyone, and these ideas that I study make their way into the work. No one has ever mentioned it, although when critics write they almost discover it. In general, my personal path is hidden in the work, and I'm glad of that because it's too delicate a function to be attacked and is just not open for discussion with anybody who wants to misuse the information.

Montano: Do you ever consider getting a regular job and forgetting the art and money dilemma?

Heyward: I had an agent, and they tried to get me videos. I really hate teaching. Although I start out good and interested, after three, four, five weeks, there will be three more months to go in the semester, and I feel that there are teeth in my neck, and I just want out. I'm great for about two classes, and then I have nothing to say. Advanced classes are one thing, because the students have so much to offer, and you can pick and choose what aspects you want to deal with. It's a wider band-width. When it's a narrow bandwidth, you're really talking about help-ing someone grow up in a not so interesting way, because you're also talking about holding people's hands. It's true that I have met some of my favorite people from teaching, so there are some really good sides to it, but for the most part, I don't like teaching, and there is nothing else for me to do and make money at the same time. I mean, I was a maid for five years!

Montano: Do you have anything more to say about money? About values?

Heyward: Well, oddly enough with my guilt and fear and confusion about money, I still need a lot of it to do the work that I do. That's quite an irony, and I feel this love-hate relationship is going to con-tinue for a long time. For instance, I've written a long-form video. It's forty minutes. A lot of money! Hundreds of thousands of dollars. And about two or three weeks of going to people to try to get it. It's funny because I've removed myself from it in a certain way and have come to terms with it by saying that this is still low-budget.

Montano: And you deserve it!

Heyward: No, not that. I still can't say that I deserve money, but this is what it will take to do these ideas. I've done eight videos commer-cially, and I know how much it will cost. It's basically coming to terms with what a cameraman costs, what lights cost, what grips cost, a van, dappers. It all adds up to this much, and there's a percentage that a di-rector gets. That's me. It's easier for me to go with that than to set a

price on what I'm worth. This is a set way—the director gets ten percent of the budget, so if this budget is three hundred thousand dollars, I get thirty thousand dollars, and that makes it easier for me to ask for money.

Montano: Are you able to ask for money in this case because you're asking for everyone?

Heyward: No, I'm able to ask because I've been working in this field long before MTV started. I look at TV quite often, and I see how things are done. There is no mystery. Occasionally I get excited by it, but very seldom. I know how these things are put together. I know how they are shot. I know how much money is put into them. I know where the inventions are, and I know where my inventions are and how long they can live before someone will come up with the same ideas, because it's a communal thing, these ideas. They are out there. You might have raced yourself forward out of some seedling and grasped upon a realization of an idea or an invention, but you only have a certain time to act upon it before someone else takes it. People are always saying, "Oh, I thought about that ten years ago." Well, me, too. So I watch my laziness and timidity.

I made a long-form video in 1979, before MTV, and you would think that I would be racing along in my career and making a lot of money, turning down business. But it is not the case. So this new idea is my way of getting ahead of the rent, so to speak, to get ahead of decay. Because if you can't get a certain momentum going, you just can't live in New York City. I mean you can live and work here, and right now, I'm living here, but I'm not doing my own work and haven't been for two years. I've been at the sketch pad.

I did a performance two years ago. It was very successful—people liked it, it got good reviews—but I lost twelve or thirteen thousand dollars. That was devastating for me and took six months of constant work to pay it back. And that left a mark. I can't work on that kind of

deficit again. Work has got to be food on more than just an experiential level—it's got to make money now. I've got to grow up and realize that it's got to make money. One can imagine all of the conflicts in that, but that's presently what I'm dealing with.

MIKHAIL HOROWITZ

Montano: Were you given a lot of permission as a child?

Horowitz: I think that I was. I've always had this idyllic view of my childhood, which is just now beginning to look a lot rockier in retrospect than my memory or private mythos of it. Now that I'm doing bioenergetics, my shrink is telling me that I had a horrible childhood, and that's all news to me, because I had a great time as a kid, although I did have a screwed-up adolescence.

I learned how to read very early, and I read fairly sophisticated books by the time I was six and seven. And in second grade, when I was eight, I started writing poetry, and the teacher encouraged me a lot and, in fact, was so impressed by my first fledgling attempts at poetry and the little drawings that accompanied the poems that she told me to sit in the back of the room, get my own notebook, and while the rest of the class was reading and being taught their lessons, I should just write. So I was ostracized, pleasantly for me—although it had social repercussions, because all the kids hated my fucking guts, of course. The teacher treated me special, and my mother reinforced it at home. My little pictures used to go up on the class bulletin board, and eventually this teacher skipped me and sent me into the fourth grade. That fucked me up because they learned arithmetic in the third, and I never learned how to multiply or divide, so I failed math all the way through the rest of my school years and took everything twice—geometry twice, algebra twice.

Montano: Who were your childhood heroes and heroines?

Horowitz: The other kids in the neighborhood were my heroes—guys who I thought were courageous or had that aura about them when they walked down the streets. You have to remember that I grew up in New York City, where there was a large gang of kids hanging out on the streets all of the time. I admired the kids who didn't take any shit from anybody, or who were clever enough to talk their way out of anything, and the ones who could survive by evading or manipulating the dumber or bigger guys.

Then, gradually, I started admiring poets. But I had an ailment rather common to adolescent minds, which is thinking that because someone paints a picture or executes a wonderful, marvelous pas de deux, they must be wonderful, marvelous human beings. I couldn't make the separation between, say, a beautiful poem and a beautiful person. I imagined that it presupposed an incredible person to make an incredible work of art. It wasn't until much later that I found out that this was not only often not the case, but was rarely the case—that art/life dichotomy. The sacrifice that people have to go through in order to create what they create often meant that they were giving up something, and that was creating an imbalance somewhere. To do what they did or what they had to do, they were denying something else, and usually what they were denying was being a decent human being. This did not keep me from having heroes. I probably admired certain people all the more because in spite of the shit and the adversity, they were able to do their work, they were able to do things that inspire us, able to give me sustenance in some way. I also liked baseball players because I love baseball, which is the poet's game.

Montano: You go about your work in a low-key fashion. You say that you don't want wider exposure—TV, for instance. Would that be a compromise that would spoil things?

Horowitz: There's nothing wrong with being on TV. I don't watch it or even own one, but people I admire have been on TV. You can't live in this country and not be affected by it; it's all around, but it's not

part of my focus. And I discount any of the arguments as to the efficacy or egalitarianism of TV. For example, some people say if your work is any good, you should get it out to as many people as possible. That's a belief that everyone agrees on. I completely disagree with it, and I don't feel elitist about it, either. On the contrary, TV thrives on elitism, creating instant stars and celebrities, sacrificial virgins and queens for a day. The attitude seems to be, you're nobody—nothing— unless you are validated by TV.

For me, withholding something is not an elitist gesture but is more about creating a sacred space, where I can learn to pay attention. I get it out there in the way that seems right to me and the work. And it's fun! I believe in having a good time and seeing other people have a good time when I do it. That's important. The way that I do that is to keep it really small. I don't distance myself from my audience. I don't use microphones. I don't talk at people. I talk to people. When possible, I'm not up on a stage but am with the audience. I interact so that there is a feeling of a person there, alive. All of those qualities are important and intrinsic to the work, and, for want of a better word, that Zen-like quality is important. Here it is. There it is. Here it is. There it goes. I don't like documentation of it, either. There is some documentation of the work in other areas, since most of my pieces are written, but I see them as frameworks or texts for performances. The thing itself is delivering it to other people.

Montano: Would it be hard for you to live in New York City because of career pressure?

Horowitz: I grew up in the city but would never consider living there. I've performed there, but I have an intense love-hate thing with New York. Being upstate and removing myself from the madness of the city, the pathology of the city, is important because I am sensitive to the vibrational level there. My eyes water, I get migraine headaches, I feel the foulness of the air. I see the despair colliding against me.

Now, I go down for a performance, and I experience it on a different level. It's a fling, and that's exciting. It can be very beautiful like that because there's a lot of vitality, but it's the vitality of something that's dying.

Montano: Is your energy or vision ever too big for here?

Horowitz: I don't see it that way. It's more that it might be too big or too little for who I am at any given time. It's scaled to me; it's not scaled to the place where I am. If I had to, I could live in New York City and make it work there, but it's more about how I go about doing it, not where I'm doing it. What is interesting to me is being in touch with the audience because, of the fifty percent of the audience I don't know, fifty percent of that fifty percent are going to be, if not my friends, at least on speaking terms with me when we next run into each other. My work is the way that I meet people; it's the way that I expand my sense of community. I make direct contact with them and get turned on to a lot of people whose work interests me. There's a lot of cross-pollination that goes on.

From what I've seen, when you get into the zone of fame, appointments and business, you don't have time for that. You become very insulated. To be completely honest about it, I don't know how much I really loathe celebrity and its attendant ailments, or how much of my repudiation of it has to do with fear or guilt that I'm not worthy of fame or good enough to make the big mazuma.

Montano: Has the external attention that you've gotten satisfied you? Do you want more?

Horowitz: I was always craving attention. Most kids do, but I had a heavy need to be the center of attention, to be the ham. Many of the ways that I was the center of attention were negative, and then this— bang-o, wow, I suddenly lucked out! I found a way of being the center of attention without being reprimanded or punished for it and was praised or rewarded for it. This was like a drunkard's dream, and I

knew that I had to develop this, had to keep doing it because it makes people like me, it gets me awards, it gets me favors, it makes me special. Here was a way that I could be the center of attention without the world falling on my head. Because I had been very disruptive in school, and part of it was because I was bored, because I knew everything they were reading. It wasn't stimulating, wasn't challenging. Part of it was also being the devil's advocate, being a pain in the fucking ass.

Montano: Why do you keep working? For attention? Because of habit?

Horowitz: I want to keep doing it, but it's also beyond want. I have to. I will. I guess I could be making it easier on myself. I could be going a little deeper, exploring a little more. Changing things. I want to perform as often as I can and as well as I can, but right now, given the circumstances of having a full-time gig—and a stressful one at that—it's just not possible. Plus the various complicated, incredibly byzantine emotional attachments that I'm engaged in keep me busy. All this is double-edged because, in one way, it all gives me material, and, on the other hand, it takes away my time.

When I supported myself with performance, the gigs were not as enjoyable. They were a lot more stressful because I was depending on them for money; I wasn't going to pay my rent if the gig didn't go smoothly. The gig became a job. When money was no longer the object, was no longer entwined with the reason for doing it, I had a lot more latitude and could have a good time, put a lot of work into it, relax with it. But now because I'm picking up the slack by having to make money, I don't have as much time to put into it. The balance could be better—more toward performing, considerably more.

Montano: What are the advantages of not being as famous as you could be?

Horowitz: Could the president of the United States come over here and spend half an hour talking with you? No, there'd be Secret Service

men all over the place. I can be anything and go anywhere. I can be an editorial assistant at the newspaper.

I need spontaneity. I need to be open to everything that's happening, and I need to be able to respond to people. Fame would prohibit that. I would like to find a person or group to collaborate with. That would be a way to be more effective, perhaps, not bigger or better. That's the direction that I would like to go in.

Montano: How would you name your philosophy?

Horowitz: Being nonattached to conceptions about the work. I just do it. When I perform, I let the work go.

ALLAN KAPROW

Montano: Fame came to you very early in your career—in fact, at a time when it was rare for artists to become well known. Now you are in all of the contemporary art history books. You're internationally famous, recognized and respected for your Happenings. That's a lot of fame. Can you remember wanting to be famous as a young child?

Kaprow: No, but I can remember wanting to be virtuously heroic. The Lone Ranger was a hero of mine because somewhere I heard or read—maybe it was in one of those comic books, as well as the radio station series—that the Lone Ranger was a masked man and lone for an undisclosed but apparently very, very disagreeable past. It was intimated that he was a criminal who, like the ancient mariner, had to atone for his sins by doing deeds in the world but never accepting praise for them. No reward. And this was my childhood image of myself—a secret hero atoning for some imaginary but enormous history of guilt, evil, and wrongdoing.

Montano: Can you imagine what could have been the childhood crime that prohibited you from accepting fame?

Kaprow: I was sick, really seriously sick as a child. I had asthma, and I was sent out West because the air would be better for me. My parents stayed in the East. I was five years old. So as a little boy I was sent away, separated from my family, and as a result, I felt abandoned and naughty because I caused them endless grief. I reasoned that I was bad for having gotten sick, and that's why I was being punished. In Arizona I became a cowboy. I became quite a little cowboy, entering all of the junior rodeos, hog tying, et cetera. I enjoyed it.

Montano: Did you continue to be the Lone Ranger as an artist?

Kaprow: I'm surmising that the image got buried, and so, yes, as an artist I would also be the Lone Ranger. My fame, if I were famous, would never be collected on. I wouldn't be at all of the wonderful openings. I would rarely show up at parties. I would, in effect, come and go as a guerrilla fighter, coming into town from the hills. In fact, I used to live in New Jersey and come into New York in just that way—do my thing, whatever it was, and then split. I was never part of the bar life then. I would touch on it now and again, but only briefly. That was a curious kind of fame if you want to call that fame. It's fame that isn't acknowledged publicly. I didn't get to enjoy it because there was nothing that I could do with it. It's was a kind of smug fame, in the sense that I secretly said to myself, "You see, you can do it. You did it. But it's nothing. It doesn't feel good."

I noticed this about myself in an interesting way. WCBS sponsored one of my most public works, which I did in the early sixties. It took place over four days in the Hamptons–Montauk area of Long Island, and it was one of those big extravaganzas, the sort of thing that we used to do in those days. Hundreds and hundreds of people were involved—skydivers, fire-fighting foam pouring down cliffs, marchers next to the sea, walking though artificial foam and real foam from the waves, nurses lying in beds along highways—a mixture of very, very weird, surreal images. The CBS TV team followed with cameras.

One of the sections took place in a garbage dump, and they took footage of it. The foam was pouring down the garbage dump slope,

and dozens and dozens of people—kids, mothers, and artist friends—
were walking along the edge, blowing police whistles and making this
infernal sound. I was among them, as I usually am, as a participant.
Photographers, for publicity purposes, concentrated on me, and in this
series of pictures I looked at later, there were wonderful, happy faces,
except for mine. I had this scowl on my face. I was not having fun, and
I thought, "Wow, there's something going on there." For years I didn't
want to recognize what the message was, but it really upset me. You
see, I was probably as famous there as anyone could possibly dream of
being, but like the Lone Ranger, I was masked and not accepting fame.
I was running away from it.

Montano: Were you eventually able to enjoy your own fame?

Kaprow: Yes, by doing what I've been doing for the past few years,
which is to mostly work for myself by doing pieces that are not di-
rected to the outside world but directed to me and maybe one or two
friends. I'm doing myself a favor. This has been a wonderful last few
years for that reason. I take in relatively few public projects, and not
because I say no to them: it's just that nobody asks because they know
the nature of the work. It's so private that it's not appropriate for them.
I engineered my career right from the beginning to enforce whatever
craziness I had about the Lone Ranger complex—I'm sure of that. I
made it so special, so radically different from what the art world needs
that it couldn't possibly be rewarding to the art world. If you look at
the kind of work that participation implies, then the number of people
in the art world who are auditors, spectators, or readers is cut out auto-
matically. The number of people who are managers and critics is also
cut out, and only those artists willing to become part of my work are
welcome. There are very few of those because many of them feel
needlessly threatened.

I designed an art form that allowed me to leave the art world. I be-
came an outsider. A minority came along, but I put my audience to the
test by saying, "If you really believe in me, you're going to have to

work for it. You're going to have to do all of these funny things for which you will not get any reward." People who wanted to be in my pieces in the beginning wanted to be recognized for having joined in a current Happening. It made them hip. Besides, the TV cameras were there. I kept designing things that would take them further and further from that possibility, so that the only reward that they would get would be friendship and their own pleasure in the insight of the experience.

Montano: You were dealing with fame both for yourself and for the audience. By pulling yourself out of the limelight, you also eliminated the possibility of others going for fame.

Kaprow: Yes, because on one level I was very suspicious of fame. Many of my friends and other artists I knew suffered from it. They got burned out very quickly from too much attention, too many late hours, too many crummy routines, too much traveling, et cetera. I knew from personal experience that all of this could wear you out while the work could get less and less serious, becoming more and more stylish, and more and more what you could get together at the last minute because you didn't have time or energy left over. The demand for that sort of continuous production and novelty was ruining the pleasure of fame for so many that I couldn't ignore that. You see, it was grist for my personal mill. It justified my impulse to be the Lone Ranger. So I would say, "I'm not going to suffer from the pitfalls of fame, not me. I'll be in all of the books, but they won't know where I live. You can't get me to go to a party. I'm not going to fuss around with that stuff." It really has been very lonesome. For example, a book that I've been trying to publish for ten years has been rejected by every single publisher, even my own. The reasons for the rejections are always that it's not sellable. They're pretty legitimate reasons, whatever the explanations. Sometimes, because they know me, they try to make it softer, but basically they feel that there's no interest in the work. I have to accept responsibility for not capitalizing on fame, but I'm not interested in doing that; therefore, I get rejected.

Montano: Do you want to create fame around what you are doing now?

Kaprow: I have the amount of noise or tension or public action to create interest, but now what I really want to do is what I am doing. Once I understood my Lone Ranger image, I realized that I was doing the right things for the wrong motives, and those are now beginning to be dropped more and more each day. I no longer feel compelled to seek and then smugly walk away from fame.

Montano: Or compelled to do and not enjoy?

Kaprow: The work is becoming more lighthearted in a way that it never was before. The attitude is more pleasurable.

Montano: Do you feel that the people you know who are famous have dealt well with it?

Kaprow: In a few instances, because their center was solid. Unfortunately, there aren't a lot of these people.

Montano: Does fame corrupt?

Kaprow: I think that it has become that. What I experienced in my life was the publicity machinery, which seeks a lot of noise and uses up people very quickly. Art managers collude with the publicity machinery. For example, the first thing that artist managers ask for is publicity shots. Then they give interviews and arrange all of this other publicity for you. That's so they will be given credit for what you're doing. The ball gets more and more snow on it, and it doesn't stop. But if you don't get a good review for your performance, then the gallery or museum that commissioned you doesn't want to do you again. I find that really destructive, because you end up seeking validation for the amount of attention you get rather than the quality of the work.

Montano: You've done something backward; you've gone from fame to a reevaluation of fame, and now to privacy. Most artists go from wanting fame to getting it when they are older. You got it early and did a backward flip.

Kaprow: It's because now I know what I want. Since I have the historical fame, I don't need that. I'm free to say what I really want because

I didn't get pleasure from fame. I believe that I'm getting some glimmer of what would make life more meaningful. It has to do with all of those simple but profoundly difficult things like what I am, what I really feel, who I am, instead of what I think I should be feeling or getting out of this, or what role I should be playing at this moment. The simplicity of this objective doesn't cloud the difficulty of it. In fact, it's extremely difficult to practice this kind of meditation that I do, and I don't expect a progress report from it. This seems like a much more real need—just to be and to be aware. It's much more interesting than any acclaim in the art world. Before, the intention was to impress someone else—to create a new image, to really wow them, to make an effect, to put something out in an objective, packaged form that is supposed to have an effect on the public. There's nothing wrong with that except that it's so patently geared to watching carefully how people respond. If you're always waiting for and watching what they'll say, you'll never have a chance to look inside yourself. You depend, like Judy Garland, that poor martyr, on applause all of the time. Or, conversely, you might depend, if you're a masochist, on people putting you down. Since many of us are both, it's difficult. The more you get involved in all of that, the less chance you have to pay attention to yourself and who you are.

TOM MARIONI

Montano: You devotedly and with purpose shunned an East Coast fame for the last twenty years, and you are famous for that. Can you trace your strategy to childhood?

Marioni: First of all, the reason I haven't been showing in New York for the last twenty years is that the right situation hasn't presented itself. Years ago, Alana Heiss asked me to do something at the Clocktower, but it was all at my own expense, and the trip being paid has always

been an issue, if nothing else. When I go to Europe for a show, my trip is always paid from California, and that's my standard for going anywhere and making art. The New Museum asked me to make a show in the summer of '84, but everyone knows that's the wrong time to have a show in New York, and I want my first time to be perfect. I'm a virgin.

Montano: What childhood heroes gave you permission to do things your way?

Marioni: I can't think of any as a child. Being Catholic and learning how to repress thoughts made my liberation more sweet when I decided to be an artist and think for myself. Later, Miles Davis, Lenny Bruce, John Cage, and independent types inspired me.

Montano: You build your aesthetic slowly. It has strict definitions and qualifications. Where does this tendency come from? Was there a mode for that?

Marioni: I wanted to be an architect when I was a kid, through high school. My influences are the Catholic church and its symbolism, the objects used in the mass, and also jazz (improvising within a structure), drinking beer (I was from a German, beer-drinking town, Cincinnati), and music. I play the violin because I'm Italian and the drums because I'm American. Put them all together, and it's Tom Marioni, drinking beer with friends, performing mass, using humor, symbolic objects, and improvising inside all of this. It all makes sense. Beer is my American wine—stimulants have always been used in religious ritual.

Montano: Were there mentors along the way?

Marioni: Working for a curator, Alan Schoener, in the Cincinnati Art Museum when I was an art student gave me a sense of scale in art and taught me to see many aspects of making and showing art. Presentation or context is half the art.

Montano: Do you want fame?

Marioni: Yes, I want fame, but just enough to make my art all my life. I don't want a famous face, only a famous name. I like to be invisible and would like to be discovered every day. I have no fame now. I

am known only in a small way in one part of the underground art world, mostly just by artists. I hope it's because I do what I want to do.

Montano: What about the attention that fame brings?

Marioni: Of course, attention makes me feel good. So does touching, being touched, listening to jazz, socializing, and making an art action that connects.

Montano: You are both low-key and highly visible. Did you orchestrate that?

Marioni: Your questions have a hero worship sound to them, and I love you for it, but I don't know exactly what you mean.

Montano: Is there a danger in being too famous or wealthy as an artist?

Marioni: You know that line, "The beautiful people say that you can never be too thin or too rich." The only problem I can see with being famous is that people are waiting for you to fall on your face.

Montano: Is living on the West Coast, near Asia, a determining factor in your ideas about fame?

Marioni: Living on the West Coast means that you don't exist. As a matter of fact, if you don't live in New York, you don't exist, like the Steinberg cartoon of the U.S.A.

Montano: Are young artists afraid of money and fame?

Marioni: I never met a person who was afraid of money and fame, especially young people.

MEREDITH MONK

Montano: You were one of the first performance artists to become famous, so you've had a lot of experience with the condition. What about your childhood allowed you to feel comfortable with fame?

Monk: I still don't feel very comfortable about it, and besides, I'm not really aware of what's going on in the outside world that much. Many

years ago Dick Higgins said to me, "You know, Meredith, you're really famous." I was surprised because it just wasn't a reality for me at all. The notion of fame seems like a relative thing. When I was twenty-five, I did a series of concerts at the Billy Rose Theater. It was a real Broadway house, and my concerts were part of a weeklong series of the so-called avant-garde. I wasn't ready for it at all. I was in a transitional period, had just injured my knee, and was not really interested in working on a proscenium stage, so I did a piece with people in boxes spread around the lobby and basically tried to get everyone off the stage. A lot of the audience was scandalized. The critics said that I was a disgrace to the name of performance. Actually, I felt good about allowing myself to present work in a raw, unpolished state within such a formal, goal-oriented situation. I think before the concerts I was scared to death of failing in such an exposed, hyped-up venue, but after I read the potentially devastating reviews and saw that a number of people whom I had considered my friends before the concert wouldn't talk to me, I realized that I was hurt but that I was still alive and ready to work on my next piece. I noticed that fame, notoriety, or nonfame didn't have that much reality in my day-to-day existence.

The old story is that if people are in business, they want to make a lot of money. Then when they make it, they become terrified of losing it. Artists are often attracted to success and terrified of failure or public humiliation. It's all a kind of illusion, which ultimately becomes extremely imprisoning. The only reality that seems to make sense to me is love for the daily work, the energy of working. I've been thinking a lot during the last few years about why I'm doing what I'm doing— what's the function of it? I realize that the only reason for doing it is the joy and interest of the work itself, and that this engagement or commitment is transferred to the audience in some way. To not let terror be a ruling force during the process of making a piece is what I've been working on.

Montano: Did you have a childhood that allowed you to work with your fears?

Monk: I had a lot of physical problems when I was a child. I had eye operations, a lot of allergies and skin problems. At seven years old I underwent two eye operations. I remember trying to be very brave and not cry, but I was miserable. When I had the first operation, I had it on two eyes, so I couldn't see at all. After a month, when they took the bandages off, I saw one thing out of one eye and another out of the other eye. I couldn't judge distances and was totally disoriented. I think the experience of going through that at such an early age helped me to work on dealing with my fears in one way or another. Now I'm just trying to see that they are there and not run away from them. What really keeps me going now is enjoying what I'm doing and having a great group of people to work with.

Montano: When you were small, did you have heroes and heroines?

Monk: I liked Buster Crabbe and the Flash Gordon and Buck Rogers serials from the thirties that they would show on television. I always identified with the male heroes because probably there weren't any heroines that were particularly active or lively. But I loved the comediennes. Imogene Coca was a real heroine for me. So was Beatrice Lillie.

Montano: Do people ever get so excited meeting you because you are famous that they don't really know how to act around you?

Monk: I'm not usually aware of it, but sometimes I can tell when someone is doing that to me, meaning that they are making me into their fantasy instead of seeing me as a human being. When that happens, I usually try to mess up the illusion as soon as I can. I am just a human being, like anyone else, with all the foibles and weaknesses of any human being. It's not very beneficial to anyone, especially the person thinking that, to consider me a guru or spiritual leader. I'm struggling with the same things that everyone else is struggling with every day of my life.

Montano: Do women have more of a struggle accepting success than men?

Monk: It seems so. I know that I received a lot of mixed messages about success from my family. My mother, who was a professional singer, had problems about it that she probably learned from her mother, and so on. A legacy of conflict. In the nineteenth century it wasn't ladylike for a woman to be too intelligent, so many smart women hid their curiosity and intelligence and endured a lot of boredom. For many years I was my own worst enemy because of not being clear about what I wanted in the world. It's a balance that I'm still working on. I'd like to be successful enough to keep on working in the way that I want, but not so successful that the pressures become unbearable. I've always wanted my work to speak for itself.

In general, success is a big issue in this culture because it tends to swallow up people. That's the pattern. First they are put up in the public's eye, then swallowed up and thrown away. Then the next one comes up. I think that if you want to have any kind of longevity, you have to break that pattern or at least be conscious of it. Performance is a public medium. That body of people completes the act; it comes to fruition with the audience as witness, but that's where the crazy balance comes in—on one hand, as a performing artist, you need an audience, and on the other hand, you work to make a piece that has its own life, that would be true or fine without an audience. It seems that it would be easier for a visual artist to have complete autonomy because he or she can complete his or her work in solitude. Unfortunately, or fortunately, a performing artist needs some degree of public profile just to get people interested enough to come and see the work. I saw very early on, though, that spending too much energy on that aspect perpetuates a kind of externalized rat-in-a-cage syndrome. It creates its own momentum, which doesn't have much to do with the work itself. What I used to do was to do the piece and then withdraw and try to

stay out of the whole pattern. I still try to do that as much as I can by maintaining my own pace and taking it all with a grain of salt, because when you get a bad response, and that gives you pain, or when you get a good response and that gives you pleasure, you see that both the pain and pleasure pass very quickly. These things just come and go—they don't really have that much to do with your growth or with what's going on. Actually, you are the best judge of your own work.

Montano: Young artists are doing a service by breaking down the van Gogh syndrome because they allow themselves to be comfortable with money and fame. They don't make an art of suffering.

Monk: Yes, that is a very positive thing, but I'm curious to see what happens in terms of the work. In a lot of cases things are just a little bit out of proportion, the fame is greater than the work, and that is a big problem. In other words, the work gets processed into the machine of culture, the media machine, but the work doesn't have a lot going on in it. For example, a person can be very newsworthy and read well in print, but the work isn't good at all. That's a big problem.

Montano: It then pushes us deeper into the source of the work, to avoid getting processed.

Monk: Definitely. I don't think that artists should be poor victims of society, but there has to be some stubbornness in an artist in order to grow deeper even while being constantly in the public eye. You can have the fame and the money if you play it safe and keep doing the same thing over and over again. You turn your work into a product that can be consumed without difficulty. It's easily recognizable because it remains the same. Eventually, though, you lose your curiosity and your ability to take risks and challenge yourself, which seems to me like a kind of death.

Montano: Is your place upstate in the country one of your sources?

Monk: Definitely. Being there gives me the time to actually hear myself think. I also have more time up there to spend at the piano. Right

now, I'm working on a solo performance, and the process of doing that seems like a kind of source. It's always hard to do solos because until you have the whole, it's hard to see what you're doing. I feel like a blind woman working on this material. But it seems that that's what it's all about. Getting back to essential things.

Montano: Do you have teachers?

Monk: When I was in school at Sarah Lawrence, I had some great teachers. I had Bessie Schonberg in theater and dance, Ruth Lloyd, Glen Mack, and Vicki Starr in music. I feel that they gave me a wonderful base to work from. Now I study classical singing with Jeannette Lovetri to keep my voice in good technical form and meditation practice at the New York Dharmadatu. I have a real longing to stop everything and spend a year or two in a music conservatory, going through theory and harmony, orchestration, and sight singing again.

Montano: Does external attention from audiences feel like wafts of unconditional love?

Monk: Years ago we did *Education of the Girlchild* in a huge auditorium somewhere in Ohio. I don't think the public had any idea of what they were going to see and hear. There were three thousand people in the audience, and the whole time that we were on stage, the door at the rear of the auditorium was opening and closing. People were walking out. *Girlchild* is a still, quiet piece, so we could hear the door opening and closing and people walking out really well. I remember what that felt like. Now, what is happening is that when I tour with my vocal ensemble, the response is usually bravos, yelling and screaming and encores. I've been noticing that we have been getting used to this enthusiastic response. When it doesn't happen, we think that something is wrong. Some members of the ensemble have never known what it is to have to hold firm when the response isn't great. I feel that it's getting kind of dangerous. Let's put it this way—to live your whole performing life and not to know what it is like when people

walk out of your performance is a bit deceptive. You have to know both sides to see the relativity of the whole thing. On the other hand, if you're primarily an entertainer, which is a very honorable profession, then your job is to keep people happy. A person like Marlene Dietrich knew how to work an audience. That was her business. Maybe you should call her up and ask her about fame.

JIM POMEROY

Montano: Were you an extroverted child?

Pomeroy: Not at all. I was very introverted. I still am, but now I'm just a bigger introverted person.

Montano: Did you have heroes and heroines then?

Pomeroy: I liked scientists more than anything else. I was raised in a rapidly growing small city in West Texas, which had a population of fifty thousand people. My family life was normal. I played with model airplanes, went camping, played basketball and football with my brother. My parents' expectations for me were that I was supposed to be athletic and successful at that. Also, I was supposed to be some sort of achiever either in science, space, or the *Sputnik* race. When that issue came about—*Sputnik,* that is—I wasn't allowed to take art in junior high and high school and was made to take math and science. The most disturbing thing about that environment was that you were supposed to be a success instantly, without support or practice of any kind. I was supposed to be able to be a good flutist without practicing scales—which annoyed my parents.

I dealt with that by relying on myself. My self-reliance was private, and I looked for support outside of the family atmosphere, that's because the artist's life was not conceivable, visible, or possible in West Texas or Montana in the early fifties. There weren't artists there. There

wasn't art. There weren't schools. It's a total non sequitur in my family context for them to understand or see anything about what I did or how I related to anything. I had to define and create myself. In that environment it's easy to see what a farmer or football player is going to be because you can look around and observe those roles, whereas the culture presents mythologized visions of the artist. All you know or see is Mr. Wizard and Jon Nagee—and Mr. Wizard is not a scientist, and Jon Nagee's drawings are not art. So I had this romantic notion of what artists did, and that was informed by the popular culture—the solitary, bohemian, expressionistic, sensuous, identifiable, relatable, ambivalent person. That was the artist.

Montano: Did you desire fame? Do you now?

Pomeroy: Fame actually seems to be a way of co-opting any kind of impact that somebody might have, especially politically. If you wanted to feel political, then the fame could get in the way. Fame means who you are, and when who you are becomes more important than what you do, then that really subverts intentions. Fame limits you because other people start seeing you the way that they want to see you, and so you are even less effective.

Montano: What do you give and get from teaching?

Pomeroy: I'm there to learn. I think that most teachers are students as well as teachers.

Montano: Do you intentionally program humor into the work? Is it Texas humor?

Pomeroy: It's just there, but I think that it's there because I really couldn't do it without it. Humor has a way of enriching something because it means that you are often talking about or doing more than one thing, and that reveals ironies, mediates pain, and inverts priorities. And so it's real efficient. When something is humorous, it is reflecting on itself and reflecting on something else at the same time. I don't have Texas humor, but there may be elements of that in there, although I

don't know what Texas humor means. I think that my humor developed after I left Texas because it didn't seem to come out in my stone carvings very much when I lived there.

Montano: Can fame ever be used correctly?

Pomeroy: Yes, if it's totally focused. Ronald Reagan does that very well. He isn't corrupted by fame because there is nothing there to corrupt. He's totally obsessed with realizing fame, and it doesn't compromise his integrity because he has none. That's because he's totally corrupt. He's an example of someone who sought fame, and he was not like the person who compromises what they are doing as they become more well known and as greater expectations are made of them. These people become constrained and lose access to their sources, their integrity, and are corrupted. Since he doesn't have sources to corrupt, he has achieved his ideal in an uncorrupted state of total corruption. He did it without talent and without tarnishing any noble ideals and without anyone losing faith in him as a noble person with a noble cause and idea. He achieved fame without compromise because he had nothing to compromise. So in that sense, without hubris, he can assume positions of total integrity and self-righteousness and satisfaction because he has achieved something that no one else can achieve because there was nothing to tarnish.

Montano: What are the artists' problems now?

Pomeroy: It's harder for artists to live or feel altruistically or communally the way things were in the seventies. Now it's about buying. Money has distorted the value structure, which at one time rewarded the personal. Now it's about gain and promotion. Technology hasn't ruined things as much as it has provided for more efficiency and directness. But the technology has been applied and tapped by other sources, not art sources. For example, the military and corporations use them extensively, but technology is neutral and blameless. It's the imagination of the people that exploits technology, and the ways in which it is made available that is harmful.

Montano: What are students saying now?

Pomeroy: They are saying that they are less conscious of history and other options than ever before. There is not too much that you can do about that except confront it and try to structure something, but it's like putting your thumb in the dike. You can't make people smart by correcting a single instance of unknowing or incorrectness, but you can strengthen people's abilities to learn, which means that you strengthen the process, rather than the product. You strengthen the awareness of context rather than the immediacy of a solution, but wisdom, experience, and intelligence have to be acquired through a great deal of self-motivation on the part of an individual. You can prioritize that as an identifiable element, and you can actually inform people when they are not going in that direction. It is cruel, awful, and hard to admit our ignorance. The problem is that ignorance is often invisible to the owner. I guess that it's like bad breath.

Montano: You seem to have a certain political mobility in the world. Do you want to be an art politician? As art?

Pomeroy: No, I don't see it as a piece. My feelings about art politics are informed by my feelings about politics in general. I'm not real concerned about it and don't do it very well. I don't get that involved in it because the microcosms of the art world are very contradictory and run counter to larger values. So I try not to do that as a piece. I try to do it as a transparent kind of thing. Some of my work addresses it, but I speak to social or global politics; when people talk about art politics, they are referring to the machinations of the New York dealers and their personal associations with museums and magazines.

I'd like to address my work to larger audiences and make it more transparent to myself and others, which is risky because that's something that a lot of people don't want to hear or see in the art world. And it's also at the risk of disenfranchising myself as an artist, because it then would cease to entertain or tantalize the microcosmic parameters of the art world. And so at that time, I probably would cease to be an

artist and probably would receive support from the political world, and then would be ostracized there because it wasn't political enough! And I've seen that happen to people—the work ceased to be art, and it ceased to be recognized as art.

WILLOUGHBY SHARP

Montano: You represent fame and wealth to me. You are a thinking artist, crossing over between the art world and the business world. How do you see yourself?

Sharp: My main interest in life is to acquire information. I get pleasure from reading volumes of books, magazines, articles, reports. I'm a print junkie. I have to read the *New York Times* every day. Generally, I try to get it at about ten-thirty in the evening when it hits the Gem Spa, a famous newsstand on Eighth Street and Second Avenue, not far from Eldridge Street, where I now live. I sleep better at night if I have already read the next day's *Times*. If I get that done, I have my morning coffee with the *Wall Street Journal*. You might think that that would be a duplication of news, but it's not. Each of those two dailies has its own distinct viewpoint. In the late afternoon, I pick up the *New York Post,* mostly for page six, but occasionally they have a short piece on computers or satellites. Rupert Murdoch, who owns the *Post,* is getting into Direct Broadcasting Satellites (DBS) in a big way, and some of these items are quite revealing. On Wednesdays, I buy the *Village Voice,* another Murdoch-owned newspaper. There's almost nothing to read in it, except Bob Brewin's "Monitor," which is heavy into the local cable TV scene and the Westmoreland-CBS legal battle. My mail comes around noon, and in it are the monthly communications: cable TV, satellite, computer, microwave, fiber optics, and other electronic magazines I get. There are probably about forty or fifty of these. Some

of my current favorites are *VideoPro, Video Systems, Video, Video Review, AV Video, Videography, Private Cable, Cable and Satellite, Satellite Business, Communications News, Electronic Design, Byte, Popular Communications, Electronic Imaging, Multi-Channel News, Creative Computing, Computer World, Computers and Electronics, Broadcast Engineering, Photonics, BM/E, Microwave Journal, Telephony, Video Age, Videoplay, Technology Illustrated, High Technology, Military Technology,* and the two worlds: *Wireless World* and *Unix World*. I go through these fairly rapidly, while eating, in the bathroom, even while talking on the telephone. I rip out the items or articles I want to read, trim them clean of ragged edges, staple them together if necessary, and then write the source and date on each of them. I dispose of the rest of the magazine as quickly as possible, generally a few minutes after I acquire it. The residue goes in one of two fifty-five-gallon trash cans I hide under my sink and food-cutting table. Throwing away the waste is sometimes more time-consuming than doing the reading. The "meat" either goes into my large briefcase or a pile next to my bed. Once read, these articles get placed in a small closet until I get a chance to group them together in subjects and file them in one of various filing places.

I do not read all of this material wantonly. I use it in my articles (I just started writing a regular column in the *East Village Eye*), in my classes (I am teaching a course at the School of Visual Arts called "Creativity in the New Electronic Technologies" and will soon teach two more, "Computers and Culture" and "Telecommunications and Culture"), and in a book I am writing called *Teleculture*. This information is a part of my general knowledge, my database, which I also draw upon in my businesses, Sharpcom, Integrated Telecommunications, and, since last year, Machine Language. Machine Language is a partnership with three other artists: Susan Britton, Julie Harrison, and Wolfgang Staehle. The basic business is video production and postproduction. But we are trying to position ourselves in the home videocassette market, and we recently

started having computer classes for graphics on the Mindset. Also, we have had two art auctions and published a seventy-six-page monograph on the young visual artist Joseph Nechvatal, which I wrote.

Montano: How specifically has telecommunications changed consciousness?

Sharp: That is a very broad question. As Marshall McLuhan so brilliantly taught, electronic instruments like the telephone and television are tools and, as such, are human extensions, amplifiers of our perceptional organs. The telephone is an extension of our vocal cords, our voice. Television extends our capacity for sight. Computers give us more mind. With these increased facilities/faculties come the ability and the need to process more information at rapidly increasing rates. (One issue of the daily *New York Times* contains more information than the ordinary eighteenth-century man processed in his entire life.)

Telecommunications speeds everything up. A few years ago, the standard TV commercial spot was sixty seconds. Then it fell to thirty. Today fifteen seconds is becoming the norm. In a few years television producers, at least the very highly paid ones who specialize in commercials, have cut the effective sell time to a quarter. The target audience is the young, often kids, and they get the message much more quickly than their parents did. And the reason that these children are more perceptive, more audiovisually acute, is due to the fact that they have cut their perceptions on TV, almost eight hours of TV a day ever since they could see. And now the same thing is happening with computers. Kids love them. They liked video games for a while but got bored with them when nothing better than Pac Man came on the market. Some children's first language is LOGO, a computer language, not English.

We are using telecommunications tools to deal with the increasing complexity of life—possibly our most pressing problem. But they are not necessarily simplifying things. Perhaps the opposite. We don't really know. Maybe it's too early to tell. One thing seems certain, though.

With all this information so readily available, the distance between public and private is diminishing. It's hard today to keep a secret. If you are a public person, impossible. We are rapidly moving to a state of instant access with everyone always online. President Reagan even has to take that black briefcase to the bathroom with him just in case the Russians . . .

Montano: Stelarc, in an interview with Paul McCarthy in *High Performance,* talks about the limitations of the body and the fact that it's now become obsolete. How do you feel about that?

Sharp: I would like the body to be the servant of the mind. The problem is that it almost never is.

Montano: Was fame or money important to you as a child?

Sharp: I was born at the Fifth Avenue Hospital, New York City, in 1936. The day I was born, January 23, Walter Winchell, the syndicated columnist, devoted his column to an hour-by-hour report on that event. My grandfather was a partner of J. P. Morgan's, broke away from him, and established his own brokerage house in the 1890s. He gave my father a seat on the New York Stock Exchange for his twenty-fifth birthday, and my father formed his own company, a partnership, Harde and Sharp, at One Wall Street. My mother's father was the theatrical editor and reviewer for the Hearst chain of newspapers. He also backed a lot of Broadway plays, which he helped make hits. Consequently, he was quite rich. My mother's stepfather was a founding partner of Warner Brothers. My mother started an acting career in her teens, was a Ziegfeld girl, and was very well known, along with my father, in café society of the twenties. They lived in a large Park Avenue apartment, with many servants and a chauffeur for the town car, a Packard. During Prohibition, they had a bar, the Circus Bar, that folded into the wall. It was painted with lions and tigers, and was the place where they entertained their friends and friends of friends and friends of friends of friends—a kind of open house. The photographs are great, even in black and white.

The stock market crash of 1929 brought an end to the party. My father's brokerage house did not survive. He used to tell me stories of looking up over his shoulder when he left One Wall Street in fear of being hit by people who jumped to their death from the building. Fortunately, he had given my mother a great deal of jewelry over the years—baguettes of diamonds, tiaras, emeralds, and they were sold slowly during the thirties. They retreated to Bermuda, where he wrote a best-selling murder mystery, *The Murder of the Honest Stockbroker*. It was translated into German and Spanish. After that they returned to New York, and my father started a publishing house, another partnership, Kendall and Sharp. For the first few years it was fairly successful, but then Kendall absconded with hundreds of thousands of dollars, and it went under.

Nevertheless, judging by the photographs of that time, everyone seemed to be having a very good time. And the glasses were always filled with fine drink. My father went to the Bedford School, Saint Paul's, and Harvard. He sent me to the Allen Stevenson School, an exclusive elementary school on East Seventy-eighth Street, which is still there, the Trinity School further uptown, and Brown University. I didn't apply to Harvard. After that, he died, and I inherited my trust fund left to me by my grandfather. It was in stocks worth $67,500—that was 1955 dollars. In today's currency it would be close to $350,000. My judgment is based on the fact that the Porsche I bought then cost about $5,000, and a comparable one today is $30,000. I went to Europe, studied at the University of Paris for a year, the University of Lausanne for another, met a beautiful German girl, and married. In 1961 I started doing graduate work in art history at Columbia University. That and the money lasted until the 1968 student revolution, which radicalized me. Yes, fame and money were both important to me as a young child.

Montano: What was the effect of *Avalanche* magazine on your work?

Sharp: As a Columbia University–trained art historian—they gave me an M.A.—I was supposed to either teach or take a museum job, and although I had entered into negotiations with both MOMA and SUNY, Buffalo, I did not want to work for anyone. Nine months of that at IBM just before my father died was enough. So, in November 1968, when Liza Bear came into my life, I started to work on a periodical that I had had in my mind for some time. I called it *Avalanche,* and it was published from 1970 to late 1976. We decided not to have any writers but, instead, to let the artists tell their own story through interviews or photo essays. I had to find the best possible talent. Consequently, I started to work with a wide range of extremely gifted artists: Acconci, Nauman, Smithson, Wegman, and many others. I was inspired by the *Avalanche* artists, and I eventually came to understand that if they could do it, then so could I. Video got me started.

Montano: What were your early video performances?

Sharp: The major turning point in my life was when I bought my first video recording system, the Sony PortaPac 3400, in 1971. I had done some video work with my friend Van Schley's 3400, and I knew I had to have my own equipment. The first tape that I did was with the woman I was living with at the time, Barbara Kramer. I set up the camera in front of us on the sofa and just pushed the record levers. Then we had this terrible fight and decided then and there that we no longer loved each other! That's the power of the media—it brings out the terrible truth.

When I saw this, I decided that I would take this truth tool wherever I went. At that time I was invited frequently to colleges and universities as a visiting artist. In performances I merely set up the camera on a tripod, attached it to the record deck, and connected that to a TV set or monitor, which was placed in the audience's space. It was closed-circuited. I tried to get the closest, most dramatic framing, mostly just my head. The content or subject matter of my early video performances

was certain specific states of mind or attitudes that I then entertained toward my mother, my dead father, my heterosexuality, the many women in my life, including my only child, my daughter, Saskia, whom I almost never see. They turned out to be intense psychodramas heightened by varying amounts of LSD, which I took just before each trip. My art is a trip from which I can never return.

Montano: It seems that you are always performing. You always look elegant and are very theatrical yourself. Are you intentionally making art your life?

Sharp: I am very fortunate. I'm white, male, American, six foot two-and-a-half tall, thin, have regular facial features and most of my hair. And, if not smart, at least well educated. Plus I have a certain sensibility. Offbeat. Out of the ordinary. Odd. Different. Even eccentric, as the author of a recent profile on me in a German art journal wrote. Yes, I do deviate from the conventional. Basically, I do what pleases me. Life is short. Why spend it trying to fulfill other people's wishes? It's hard enough for me to figure out what I want, what's best for me. Of course, there are those close to me for whom I extend myself. My theatricality comes from the fact that I put all of myself into fulfilling my wishes. And the fact that I am seldom seen without my hat. Question: "Willoughby, why do you always wear a hat?" Answer: "Why not?" I am intentionally making art my wife. You are art, Linda. Will you marry me?

Montano: What is your work now?

Sharp: I'd like to give you a glib answer like, "I'm trying to do with video what *Avalanche* did with print," but that's too simple and not completely true. I think my work is to keep on trying to understand what the new electronic technologies, particularly telecommunications technologies, are doing to us and to convey whatever understanding I may have to those that are concerned. Exam question: "Describe, in one hundred words or less, the impact of electronic communications technology on society. Be specific, and give examples."

Montano: You are in the big time—high technology, famous artist. How do you think that integrity can be maintained?

Sharp: By making more money than Andy Warhol.

Montano: What, specifically, do you want to be remembered for?

Sharp: For the really important work that I will accomplish before I die.

MICHAEL SMITH

Montano: One of the characters that you developed, "Mike," would not be interested in fame. Why did you develop that persona?

Smith: Right, he's not that ambitious, that character, but first I thought that you were talking about me. "Mike" would be more concerned about money than fame.

Montano: Were you an outgoing child?

Smith: I think so. My mother said that she took me places, and I always wanted to go to all of the luncheons that she went to. At school I talked a lot and was a clown, and as a result I had to sit up by the teacher all the time. But sometimes I'd like that, because I had a crush on one of my teachers. On my report card they always checked "Keeps profitably busy." I was social, but my mother was not, although she puts up a good front. My father has a compelling need to go everywhere and be everywhere. He's in real estate.

I was always provided for very well, and I was the baby of three. I have an older brother and older sister. My brother is a painter. He was very influential in my getting into art. My brother wasn't that outgoing, and my sister wasn't either. I was the first to be that way, and I guess that they construed that as being healthy—I come from a Jewish family. But I must have compensated for a lot of things, because I sucked my thumb until I was nine. I was pretty orally fixated. So that was the family dynamic—my father, a driving businessperson, successful. My mother, when she was younger, was moved away from her

family at a very early age because her mother died in the flu epidemic. Her parents, first-generation Jews, were pushed out of Europe. She lived with a foster family in Michigan. She knew that there was something different about herself, although she thought that these people were her parents. Then at thirteen it was announced to her that she was going to have to move back to the city with her family. It was then that she found out her real name, but she found it out in school. Her adopted family didn't tell her that her real name was Rosenberg. So she grew up in this anti-Semitic climate in Michigan, not knowing what this was about. It was hard for her—she was raised on a farm and then came back to the city, where her real father was a tailor. She is incredibly talented, makes her own clothes, and she had a seamstress shop before she met my father. I guess I get my humor from her because she has a very dry, intelligent wit.

Montano: Who were your childhood heroes and heroines?

Smith: People who paid attention to me. I looked up to those people. But if someone asked me what I wanted to do, I was never able to answer that. So there were no historical figures who inspired me, because I am pretty grounded and everything has to do with the here and now. I never learned much about religion, even though my grandmother was very religious. She ran a *mikvah* (ritual bath), and because of her I had to go through the entire religious bar mitzvah training. After that was over, I never showed up again in synagogue. I was very athletic. I was very fat. I was very popular. I liked to play a lot. I liked to goof off, but I never stepped out of line. I did everything pretty much by the book. I was never a juvenile delinquent or a real difficult problem child.

Montano: Did fame come to you with your work?

Smith: I was always looking for strokes. When I was a painter, I was very serious about it, and even though I started it early, I dried up early. When I got interested in performance, I did more and more, and I developed this character, "Mike," who is intrigued by what fame and

power would bring him, but I don't think that he would know how to deal with it. He's a victim.

Montano: What does it do for you to have "Mike" be a victim?

Smith: I feel for the character. I find him endearing. First of all, I don't think that he gets anxious. I get anxious. I'm in awe of that. He's without malice, and although I hope that my intentions are good, I've been told that when I am in relationships, my intentions are not always good. "Mike," on the other hand, is without guile. His intentions are always good. People feel for him. It's very interesting. When I look at home movies of myself as a very young child, I notice that I am very aware of the camera, and as soon as I knew that it was on me and me alone, I would leave the frame. "Mike," on the other hand, is always looking for acceptance, except that there's nobody there to acknowledge him. I, personally, tend to pull away once a certain trust is established, probably because deep down I feel everything will eventually leave me. Hmmm—maybe that's where the victim idea came from.

Montano: By letting "Mike" collaborate with other people—for example, Bill Wegman—is he learning new things via the dyad? Triad? The skill of trust?

Smith: I don't think so. In the tape I did with Bill, both of our characters are in their own worlds. I would say there is mutual respect for each of the characters, but I wouldn't carry it so far as to mention trust. "Mike" looks to him for knowledge, since "Victor" (Bill) is the teacher. I think he'd like his praise, as would most students, but I don't think that it would go beyond that.

Montano: By seeing "Mike" as endearing, that must reflect back to you as self-acceptance?

Smith: He gets the strokes and empathy. Or maybe I get the strokes, and he gets the empathy. I learn about the character through other people, and I'm curious about what other people say about him.

Montano: Do you like your fame now? Has it relaxed anything to have it?

Smith: Relaxed! That's not a word in my vocabulary right now. I haven't figured out priorities yet, which makes things crazy, so I haven't stopped doing certain things to concentrate on others. I'm spread out, and I say yes to everything all of the time. The fame has made me become more driven, and I feel that the next project is more important than the one that I am doing. The thing that upsets me is that I don't have the same amazement that I had when I was beginning and first working. It's easy to lose that and become jaded. I need that sense of discovery and have to remind myself that I need to have quiet to be left alone to think. It takes me a couple of weeks to unwind from something, and it's important for me to sit by my desk and look out the window. I did move to Brooklyn recently, which is a real plus. And I go to the mountains in the summer.

MARTIN VON HASELBERG

Montano: I heard from Brian Routh, the other Kipper Kid, that it was appropriate to talk with you about money and performance. Why should I talk with you about this?

Von Haselberg: You should ask him that. Didn't he tell you?

Montano: No. Are you an accountant?

Von Haselberg: No, I'm not. I'm a commodities trading adviser. That means that every day I have a show on TV and give my interpretations and financial advice to investors who want to know about different commodities and how they are doing. With charts, I demonstrate why I think an investment in a particular commodity will make or lose money. Then I invite the viewers to open an account with me. If they do, I invest their money for them.

Montano: Is this TV show on a public station? What are the commodities? Do they invest on the phone?

Von Haselberg: Yes, the TV show is broadcast throughout Southern California, and people invest right over the phone. That is, they agree to open an account, which means signing all kinds of documents. And then we trade in all commodities that look good.

Montano: Do you do this as life or art?

Von Haselberg: I do this for a living.

Montano: How did you feel about money as a young person?

Von Haselberg: Horrible. I felt extremely uncomfortable about it. Both my parents came from well-to-do backgrounds, but they reacted against their families by joining the Communist Party, which is where they met. But I've always been solvent, always had enough money.

Montano: How does having money affect your work?

Von Haselberg: It allows me to do performances only when I have an overwhelming urge to do so. I'm not forced to compromise and do shows that aren't right. That makes a lot of difference to me because performance people I know are always moaning about how little it pays, how little they make, and so on. I just don't have my attention on shit like that. Actually, I like negotiating and getting good money for bookings. Brian and I used to get paid very well for doing shows in Europe.

Montano: Do you feel that you would like to frame the job that you are doing as art? Or do you want to maintain it as a separate life activity?

Von Haselberg: I don't like thinking of my commodities job in those terms because by thinking about it, trying to define it and categorize it, there might be a possibility that I, in a sense, destroy something. I just do what I do. It's the same with the Kipper Kids. We do what we do. We were always being asked, "What does your work mean? What statement are you making? Is it art? Is it theater?" I think their trying to categorize work is flattering, but those are unnecessary questions and

have very little relevance to what we are doing. For example, I don't think, "Well, I guess what I am doing is performance." In a way it is, I suppose. I wear costumes and play a role, which is very different from the role that I normally play at my other work. In fact, people who see me on TV every day, dressed in a fancy suit, selling commodities and creating a certain impression, have no idea that I also like to run around naked, throw food, and do other bizarre things in museums and galleries. Maybe the different roles are ultimately all part of the grand scheme of performance.

MARTHA WILSON

Part One

Montano: Martha, the impetus for this interview came from having observed you and your activities at Franklin Furnace during the three-week residency of the women performance artists from LA and London. It seems as if you have utopian tendencies, that is, you are able to turn your home into a museum, you have many people working around you all day and continually support other artists. I'm sure that this has to do with who you are, but then you mentioned that you had been brought up for two years of your infancy in a Skinner box. What do you think was the effect of that experience on your attitude?

Wilson: I've thought about this since we talked a few days ago, and what comes to my mind when I relate my work at Franklin Furnace and the time that I spent in the Skinner box is the fact that I am extremely good at blocking out things that are around me, and maybe this related to having grown up in a very isolated way. I now have the ability to pretend that the world is gone, empty, and I can be alone in it. As a result, the things that are around me don't seem to affect me too deeply. I realize that this is a negative interpretation, and your utopian

view of my relationship to Franklin Furnace was a more positive view of the effect of the Skinner box on my life.

Montano: What is a Skinner box?

Wilson: My parents read a *Ladies' Home Journal* of 1946 and saw a diagram for one in it and an article titled something like "How the Baby Healthy in Body Is Healthy in Mind." So the premise that Skinner operated from was to create a sterile environment without physical impediments that would allow a baby to grow in a natural way. So he designed the Skinner box, which is a waist-level plywood structure, three feet high, four feet long, two feet deep, with shelves underneath, a roof, and two glass doors, which allowed the baby to look outside. Diapers were stored underneath, and a sheet was rolled up every time the baby wet, so that the mother didn't have to take the baby out of the box. It is also temperature-controlled and soundproofed. My parents were very pragmatic and later turned it into a dish closet.

Montano: Why were you in the box for two years? Did your parents decide on that time?

Wilson: They were living on a houseboat because my father has always lived on or near water. The houseboat was cold and drafty, so they told me that they put me in a Skinner box because it was cold and I wasn't allowed to crawl around on the floor. But I also think that they were postwar intellectuals who wanted to have the best for their child, because when I asked them about it later in a total rage and yelled, "Why did you put me in the Skinner box?" They looked at me in complete disbelief and said, "We were doing the best that we could for you." So I am convinced that they did not see the Skinner box as punitive.

Montano: Did you have brothers and sisters, and were they in the Skinner box also?

Wilson: Yes, my younger sister, Callie, was in the box for about a year, because my mother was more relaxed when she came along.

Montano: Were there periods when you were out of the box or were you always in it?

Wilson: Well, I have pictures in it and I'm awake, so I guess that when my mother got overloaded, I was shelved there.

Montano: What were Skinner's principles?

Wilson: He developed the stimulus–response model of human behavior, which denied the reality of emotions; that is, behavior could be modified if you changed the stimulus. I think his theory of having a controlled environment gave parents permission to experiment with the baby's behavior, because when I was put in the Skinner box, my parents could then withdraw from me. Skinner presumptuously believed that he knew how a baby was to act. For example, food was given to me every day at a certain time, and my parents paid no attention to the fact that I was screaming to be fed at other times. This notion of consistent, predictable behavior was implied by Skinner's theories. At that time, parents didn't modify their behavior for the sake of the baby. Now I see that being raised that way has affected my relationship to authority, because I often magnify authority figures and invest them with much more power than they actually have.

Montano: What were some of the other results on your present life?

Wilson: There are a few things that probably resulted from my experience. One is that I wait around for friends to call me, even though I like the person and would like to contact them. This suggests to me that I became conditioned not to reach out while in the Skinner box because I couldn't crawl toward my mother; I had to wait for her to pick me up. I've also noticed that when there are records on the radio, I can't hear certain word constellations, owing to the fact that I was raised in a soundproofed space. Probably the most striking result of the Skinner box on my life is the fact that I'm a visual artist, and this is because I only had access to sight as an infant. Environmentally, I was totally shut off for those first two years of life, and now I live only in storefronts.

Montano: Can you say more about being a visual artist?

Wilson: My art is therapeutic because it expresses what is going on inside of me, things I don't yet know or see. So I perform and externalize what I feel. I also value collaborating with Disband, because I can experience different states with them which I can't experience alone. For example, Donna [Henes] can go into mystic places, Ingrid [Sischy] can go into powerful and pugnacious places, and Ilona [Granet] is totally hilarious. Working with them allows me to participate in a sound or action that would never have occurred to me to do on my own. Perhaps being open and available to scrutiny is the result of the Skinner box on my life. I'm open and available in performance, and it's embarrassing but totally rewarding.

Part Two

Montano: You are now a famous woman, a leader in the performance world, with power and money and influence not only in America, but internationally. The space that you founded and now direct, Franklin Furnace, has given many, many of us a chance. How did you feel about fame and money as a young person?

Wilson: I was consumed by a mission then. I'm not going to say that it was fame, but a notion that I should do something with my life. That was the earliest relationship that I had to fame. I wasn't going to be born, to grow up, get married, and die without making a mark. Then when I went to college, I got inoculated with the notion that art was a calling and that art ideals were more valuable than money, but instead of doing that life, I went into English literature, because my dad wouldn't pay for me to start over in art school. When I got to graduate school, I decided to leave English literature and become an artist. I also got the notion that I should be aiming toward fame—fame in a certain place—New York City!

So, as a baby artist, totally naive, I moved to New York City and thought, "Why not try everything?" I didn't know that I was supposed to have limits. Since that time I haven't really worked for fame, but

I've been ambitious enough to welcome fame, if that's what is part of making a mark. When I got some, I felt, "So, you're famous!" but it didn't really do anything to my personality. In fact, I continued to do what I had been doing, and big deal, so I'm famous.

Montano: Is your job there a continuation of your performance work? Are you performing at Franklin Furnace as a character? Do you separate your art from life?

Wilson: In the very beginning I thought that Franklin Furnace was a needy child, hanging on my tit. I wanted it to get the fuck off and leave me alone. I would begrudge the time that I spent thinking about Franklin Furnace problems because I thought I should be thinking about art problems. So I would segregate my time, keeping three diaries: one for dreams, one for art, one for business. Now I keep one diary, and it's sequential. Thought is all the same, and any idea that comes my way is legit. Wherever it comes—toilet, shower, et cetera. Art, business, future, past, I write it down. Also, transformation doesn't stop when you stop doing art. It occurs in every single detail of life. So as I pick up a phone and deal with a problem creatively, I'm still forging a way for my creative life to live through the bullshit administrative life.

And here's my new performance problem that I've set for myself. It has to do with money. I used to feel that asking for money was the most horrible job. Why me? I'm the person who hates to stand up in front of crowds, and the person who is totally chagrined by the thought of asking anybody for money. I shouldn't be asking anybody for anything. That was my thinking, so I've had to develop an inside-out perspective to be the caretaker of an institution. I say to myself, "I'm doing something worthwhile. I can ask for money for it, I should ask for money for it, and I enjoy asking for money for it. I like going around and asking for money for something I believe in." So I've turned that whole equation around and now perform so that Franklin Furnace is

not a drain but a tree with many branches that can grow in any direction that I choose.

Montano: When did the ease come in the transition from performance having to be about performance, to performance being about life, job, and even asking for money?

Wilson: I think that Anne Focke identified the issue for me when she said that she considered the administration of AND/OR to be her artwork. She used to feel guilt that she wasn't doing art, but then she realized that she was spending all her time being totally creative, interfacing artists with the city of Seattle and creating absolutely new forms that no one had ever thought of before. This was art. She helped me realize that administration was one more mode, just like sculpture, for creating shapes in the environment.

ritual/death

introduction

LUCY R. LIPPARD

Killing Time

The first time I dreamed about my own death, I was amazed at how pleasant it was—like a swoon, not fearful at all. The second time I dreamed about my own death, I watched a boat with a little girl in it slowly turn up and over and sink, and I was offered a choice whether I wanted to come back then or later.

When I wrote a book about prehistoric and contemporary art several years ago, I was surprised to find myself writing about religion. I am no longer surprised that when you go back far enough or in deep enough to the origins of both art and languages, you merge with the origins of belief. Art has since, at its best, become a branch of belief—emotional, experiential, spiritual, or political. At its worst, art has become isolated both from the rituals and jolts of daily life and from death. This book serves as a vivid reminder that such separations are unhealthy, even deadly.

Ritual and death are merged here, perhaps because both are wrapped in time. Art can be seen as a ritual for countering and encountering death, but it is object art rather than performance art that "survives" and is a less ephemeral vehicle for immortality. Performance art, like ritual itself, is fixed in time even as it tries to prolong or resist time. It seems to have more to do with life and how to live life with some security. I

suppose that anyone with a strong sense of ritual is consciously or unconsciously coping with a strong sense of death. I often think of Ana Mendieta, whose art always incorporated death and deracination while it celebrated the elusiveness of life and roots. My grandmother used to say of wilting flowers that they were "going by."

I don't want to add more poetic or pretentious words to this book on the subjects of ritual and death. I was struck by the wisdom with which the artists in this section articulated the human condition, so I want to do what critics always do—let them speak for me. This preface is a preview. Ritual is about repetition, and death is not, so repeating instead of synopsizing or paraphrasing seems an affirmative way to look ahead. I have used fragments from several interviews as the raw material for my own views, rearranging these little corpses in a new pattern, or body, of words. At the same time, I have disembodied them by separating them from their names and known identities.

Sometimes art is merely a tombstone. These artists may have chosen performance as a way to avoid that moribund image. It becomes clear in the course of Linda Montano's interviews that art is not only a form of love and of healing but also a form of anger at fear and death, a resistance that might be defined as life itself. The role, or acknowledgment, of ritual varies, with an underlying agreement that art making— or work—is a ritual and a life-prolonging activity even for those who prefer not to think about that side of it.

Last night I dreamed that a nuclear holocaust had happened or was about to happen. There was a tremendous sense of doom. Everyone moved in a daze. Lots of tears, terror, an overwhelming aura of death. But as the dream continued, "the worst" never happened. People hugged. Desire rose again. And the image of green grass was pervasive, along with the sadness.

On the Seneca Reservation I was interested in the cremonies and how they persisted in the contemporary world: both waht was old and what

had changed (materials and behavior) as the lifestyle of the Seneca had changed.

LSD can allow you to identify with the world or all living things and experience global suffering and death.

I feel a little jealous of people I know who have died because I'd like to be in on the information they have. I want to know what I'm going to know then, now.

There is a developmental immaturity in Judaism that verges on idolatry because they are not moving beyond the idea of seeing God as male. I guess Christians and Muslims are in the same mess.

If women ran religion, they would do things differently. There would be much more process, much more emotion, much more catharsis, much more wailing—particularly around death.

Food means life to us [Chinese]. It means life to have that many people around the table . . . that's where my roots are—in ritual, in feeling.

I very early began to reject the rituals offered me and to think up others. . . . What I continue to do as an adult is to define myself by these rituals I accepted and those I rejected.

[During a duration performance piece] I dreamt . . . I was down from the platform and walking around with some friends. We were in a bar in New York, and everyone wanted to talk with me and be happy. But I wasn't happy, because my desire to be part of the real world had just disappeared. I was like a dehydrated pear.

I'm really confused about the death imagery. I think it's really my personality and don't think that [being in] Vietnam had that much to do with it. It's a touchy subject because a lot of anger that I'm not sure is really reasonable comes up. . . . I've always been fascinated by death. I'm pretty accepting of it, but I want to live.

As I grow older, I see that I am approaching death, and it doesn't seem alarming or like something to be avoided. . . . Margaret Mead said that since we live so long, there's no reason why we should continue to do,

all through our life, what we had dedicated ourselves to in the beginning. . . . So, in a sense, one could live several lives and have several deaths. . . . I've spent my whole life . . . thinking that I had a guardian angel, and the reason that I had that was because I had certain things to do. Now I have more the feeling that I have done what was necessary, and so there is no longer any need for such an angel.

My goal is to understand everything that happens to me. That way I won't be afraid to die. . . . I can't decide whether consciousness is like electricity (that is, it extinguishes when the mechanism runs down) or like energy (that is, it changes form but doesn't increase or diminish). If it's like energy, then I'm really curious about the quality of consciousness when it is disembodied and independent of subject-object distinctions, which is what must happen with the death of the body.

I started doing imprints to place myself and my body in the world. That way I can do something, step away from it, and see myself there afterward. . . . I don't think you can separate death and life. All of my work is about those two things—it's about eros and death and life.*

* The quotations above are from, in order, Jerome Rothenberg, Alex Grey, George Coates, Mierle Laderman Ukeles, Cheri Gaulke, Ping Chong, Lorraine O'Grady, Chris Burden, Kim Jones, John Cage, Adrian Piper, and Ana Mendieta.

MARINA ABRAMOVIĆ AND ULAY

Montano: If you were to trace the concept of ritual back to your childhood, could you remember any actions that you performed ritualistically?

Abramović: I remember very clearly, a need for order, for what is allowed and what is not allowed. This did not come from my family background or whatever I was taught, but simply came from my life. I will give you a few examples. I would go out on the street to walk, and when I reached the staircase, I felt I must take the first step with my left foot, then left with right, left with right, feeling that if I don't do this, something terrible will happen. Or sometimes I would go somewhere and there would be many seats to sit on, and I would know that I must sit exactly in the first row, the third chair from the right. Again, if I don't do it, something terrible will happen. And it was this incredible panic in me and also some very strange relation to order: symmetry and asymmetry. And I remember that I had incredibly traumatic dreams, waking up in complete panic. Often I dreamt that I would pick up one button from the uniform of the old Yugoslav army—just one button—and the whole cosmic order would change. I would be facing madness in the dream and wake up in complete fear.

Later on, I related this to my performances, because every time I had a concept in my head from my early work, I was incredibly afraid from it. It was total panic. And that was just from the concept. So every time I felt the panic, I knew that I was on the right track. If there was no panic, I would not do it. In my early works with the cutting and blood stuff I did, I had an incredible fear of bleeding, but I had to go through that. To break through the symmetry of early childhood. I broke through the inside voice, which told me that I should not do something. In real life, as a child, I listened to that voice, but in performance, I broke it.

Ulay: I have listened to Marina's story often, but each time it goes one step farther. I remember one thing in particular about my existence, one thing that disturbed me very much when I was born, or between being born and one year old. So often I was handled like an object, and so I couldn't be confident being a baby. I was put into a basement, a cellar, a bomb shelter, and my mother would, with force, open my mouth, because of the pressure of the bombs exploding, to keep my lungs from blowing up. That action was repeated sometimes three or four times a day over several weeks because it happened that I was born in a place, in a steel city in Germany in 1943, that was maybe the worst place to be born. I remember this very weakly because my mother told me and also people I talked to later on gave me many more details on the issue. There was also a certain sound I couldn't realize as a baby. I couldn't know what was happening, and that was even worse. I couldn't explain myself, I couldn't hide myself. And at the same time, it was an initiation. In other countries, initiations are done when there is not so much a particular age but a certain mental development. The aborigines initiate children around the age of fourteen. But I do think that what happened to me was a very powerful initiation but happened when I was too young. I was entirely passive, so I was made an object. That's my earliest memory from 1943–44.

So the whole notion of being an object became a very obvious thing in our work, in all of our performances—to make yourself an object. Marina was saying that she stood in front of the stairs and had to choose first the left foot. If you make a mistake and fall, at that very moment you are an object. T. S. Eliot in *The Cocktail Party* describes a lady coming down the stairs. She mistakes the last step and falls. She becomes an object because she is out of control; she is just falling. The moment you fall unwillingly, without a choice, without choosing, in that moment you are left to be an object, the same as lying on an operating table, where you are a piece of furniture. You see, it's the noninvolvement of self, of consciousness, of decision, of realization.

Montano: Is that similar to a state of void or emptiness?

Ulay: There is no one meditation. There is, for example, a one-pointed concentration. But each person has their subjective point of focus. I don't think that two meditations would have the same focus, the same awareness. I only know in our work *Night Sea Crossing,* which we are doing here at the New Museum, unless we become an object, the piece would be entirely unbearable, because there is itching or there is pain. You say, "It's happening to my body or to my mind." So you have mental and physical sensations and you call them for what they are. If I have a pain in my bum and I put my concentration there and just admit it, I make an object of it, and suddenly it becomes almost like a piece of sculpture. I think that it is a very intelligent mechanism, really, and would be very helpful to everyone, even in their daily life. It's another kind of survival. So I have an unpleasant memory of being an object in 1943 and now I use that in my work. It works for me now, but it took a lot of time.

[Marina leaves to answer the phone.]

Ulay: I don't want to use the word *ritual* for my work, even though Europeans are concerned with that word. We have very romantic souls. We are much more romantic than you Western people, and ritual is a daily exercise of many people, whether they are conscious of ritual or whether they are doing something for the sake of ritual. It can be divided into two areas: the mechanical actions, which for most of us comprise all of our daily actions, but which can be done ritualistically—like brushing your teeth—and the second area, where something is being done for the sake of ritual itself. Then there is an initiation, a liberation, a different sound, which involves a different sensitivity. But I really do not use the word *ritual.* I have been witnessing real rituals, mainly with the Australian aborigines and the Tibetans. They have a context, a motivation, and an action that is very foreign to me. I look at it and understand it in my way, but I could not place myself in such ritual.

Montano: Performance is trying to change the chemistry of the brain by designing actions and new techniques that keep us attentive.

Ulay: Here is already the big difference: I consider the brain as absolutely secondary—primarily secondary. I consider the brain to be first second, but not first first. I think your heart is primary, of the essence, for the simple reason that emotion conditions the whole chemistry and thinking; intelligence is secondary. The new Western world overestimates the brain and underestimates emotion, so the whole emotional life in the new West is disastrous. What you substitute for managing your emotional life becomes psychiatry. A therapist runs your emotional life. If you look at art, minimal art, it is a typical invention of the new Western world because it is much less emotional. It becomes an intelligence, a kind of language, minimalized, unemotional. And there's a big difference. We Europeans have an emotional hangover, so our rituals are different.

[Marina returns.]

Montano: How do you feel that the work changes your daily life?

Abramović: Actually my way of life doesn't change the way of my art. The way of my art changes my life. In periods of growing and experiencing, I see obstacles, I see something that I must go through. Then, immediately, I think we must build the work which is about that obstacle, and then you go through it. One example: when we came to the end of our physical performance work, we needed a new solution to problems. To get the solution, we needed different circumstances, so we decided to go somewhere where we didn't know if we could exist—that's the desert. In the desert is born the new work. So we create situations where we confront life very heavily with our art concept. And then, through the execution of the work, we find our experience and our life on a different level. So it's going on like this all of the time. Life does not change the art; it's really the other way around.

Montano: It's using life material to make art, and the art affects the life.

Ulay: That's already a therapeutic implication, which is very, very interesting for us, but not the most interesting for the observer. Certainly,

by the nature of the work it has a strong therapeutic impact, which is very good, but there are other values. There is a communication value, aesthetic value—it's not enough for it to be only therapeutic; that's not enough for our way.

Montano: Can you talk about one of your pieces? Are any easy?

Abramovič: I don't remember that ever happening. I do remember a theater piece, called *Positive Zero,* becoming bad from my point of view. I became physically sick. It was so difficult. We invited Tibetan lamas and [Australian] aborigines to do the music part in a very big theater. It was an important encounter because it was the first time that the aborigines and Tibetans met. But there was something about the piece that I could not handle. Something ran over me. Too many people were involved—thirty-five people. And how it came out was not good. It was the first time for me, because every time we do a piece, it's for a state of mind at that moment, so it's not a question of being good or bad.

I find that the most important time in our performance is when thinking is not involved. There are not too many such moments, and you really have to work very hard to get to that point. And I think that if we can extend that, put our life into that moment, then we talk about realization. The future has to do with direct transmission, and there will be no object between you and the public, just this transmission of you, being there. The only way to do this is to work on yourself. Nothing else works. If we have such a power to make objects, then we can do without objects, too. We can all go and sit on a mountain and go on a retreat, fine, but our function is very difficult; it is to do this purification work, to do it at the same moment that we are public. It is really hard in a way, because it is easier to go to the Himalayas and meditate and be in the right vibrations and not be disturbed. But in the job of performing we bring to it all of our imperfections plus the public's plus the effort to do it.

Montano: Then we have the responsibility to be refreshed, revived, or taught so that we can do the job. Do you have a spiritual teacher?

Abramović: In Europe the idea of art and religion is very dangerous. They criticize anything that has to do with this.

Ulay: This is true and not true. It is not necessarily appreciated to mention the word and talk about it, but there were a large number of important artists who were very religious—Rothko, for instance. In general I think that we fail to apply things to daily life and things stay intelligent philosophies. And this is a symptom of what happens with religion. Religion theoretically is a philosophy, and for most people it is a doctrine that is readable and understandable, but unless you practice, there is no religion. And this is one of the attractions and reasons why we like to go to Asia, because in Asia, in every corner, in every piece of dirt, you find philosophy, and it is applied and entirely absorbed in people's behavior and existence and daily life.

Abramović: From the moment of birth until they die. In Western society, art is a result of disconnection between nature and humans. In Asia, art is not only functioning in its religious sense, it is completely connected and does not exist independently. Here it is disconnected, independent. We would like to start a new kind of school that brings together philosophy, religion, art, and all things. It would be in a beautiful setting and someplace where we can transmit what we learn. Maybe we can all get together and make a big school.

Montano: This interests me also very much. I have attempted something like that. For sixteen days each year of this seven-year piece, a collaborator will live with me so that we can learn from each other. When you work together, what do you do for each other?

Ulay: There is no question: we couldn't do what we do if we weren't together.

Abramović: What is interesting is that there are two different elements. For us to put something together and produce a third thing, and for us not to kill each other but to stand next to each other, we create a third energy. The third energy is called that self, not myself, not himself. That some-

thing should be independent from both of us, especially free of egos. It took years and hell to do this. We really fight and have different ideas.

[Ulay leaves to answer the phone.]

Abramovič: He would come with one [idea], I with another one. We'd always start with an enormous amount of material. Then we'd reduce, come up with one or two elements until it's just right for both of us. Until then we don't do anything. This third element should go out to people. It's very difficult because we started out as independent performance artists. And the ego problems are enormous. And now it's a step further to work together. If anything happened and we didn't work together, I would never go back to working alone. I would work with three people or more. There's something so attractive about the collective energy. We just did a theater piece with two more people. There were four of us. It was incredible. Real hell. We fought like mad. And then the piece came out, and it had all of these elements in it. No one thing was destroyed. That's very important. And mistakes are important. From the piece that I considered not so good, I learned so much. I had incredible physical troubles. I was sick to my stomach. I couldn't trust thirty-five people. When Ulay and I make a performance, I know exactly how far we can trust each other, but in that situation I didn't know.

[Ulay returns.]

Ulay: You mentioned earlier about finding a teacher. I have found him [points to Marina]. I think the whole process of collaboration is wonderful. It's not that she tells me what to do or I tell her what to do, even though sometimes we are critical of each other. What we really do is teach each other. I have another teacher. I have been a long time in India, seeking the teacher, and I didn't find him. But I found one where I never expected to find one and in a place where I was not looking for one. That was in the Australian desert, where I met this old aborigine, and for some reason, maybe because the aborigines

are the oldest culture remaining alive on earth, it's difficult to grasp their minds. But at the same time I was very close to the man and it was simple. He must have recognized me for something, for being someone or nobody. And I recognized him. We were without introduction. We didn't need an introduction because he has two eyes, a nose, and mouth—as I have. But there was that click. And he became a teacher for me, not so much when I was in the desert with him but when he came to my place. In 1983 I went down with a plane to the desert, picked him up, and brought him all the way to Amsterdam. And we had a very good time together. We spent twenty-four hours of the day together. Suddenly, after a day or so, I realized something, and that just blew my mind in a very good way; it was a good implosion: the man did not know the concept, nor did he use the words *no* or *yes*. He never used these words, and that brought a little bit of trouble. So each time when I went to bed at night when he was lying down or sitting quietly, I lay there and thought over the day in detail to see if I did everything well or not. Did I make a mistake? I didn't know because he didn't say yes or no. So the moral impact was of such a degree that I found him to be a good teacher. We stay in contact. I will visit him again, and the simple thing of not telling me yes or no was my realization of having found a teacher.

Abramović: I have a dog. That is special. I obsess about her when I travel. Anything wrong, this dog picks up. She is a barometer. It's a very big dog and has been with us ten years, since Ulay and I have been together. This aborigine came and he looked at this dog, and I was afraid that she would attack because she is really a wild dog. And he looked at her and said, even though she is a female, "Oh, I know this old man for a very long time!" And I really felt so strongly, "That's true." And when the aborigine sent us a letter, he ended, "How is this big dog, the old man?"

HELENE AYLON

Montano: What were your childhood rituals?

Aylon: I was born into a very Orthodox Jewish family. I shared a room with my grandmother, who wore a *shaitel* [wig] and spoke only Yiddish. From the time I was twelve until my seventeenth year, the year she died, she would say over and over again, "*Hindelle vielynemen a Talmud chacham*" ("Helene will take for herself a Talmudic scholar").

So you might have surmised that we observed all the Jewish rituals, which continued into my marriage to an Orthodox rabbi—whom I married at the age of eighteen—until he died eleven years later. Of course, I kept the Sabbath, preparing for its arrival from Thursday on. Come Friday at sundown, I would be panting and shaking lest I be even one minute late in lighting the candles, for that one minute would desecrate the Sabbath. Not like my mother and grandmother, who were always on time, their silver candlesticks shining, their faces aglow. On Saturday at sundown, we lit another candle bidding the Sabbath farewell and separating the holy from the profane weekday in the *Havdala* (separation) ceremony.

I tell you, we had a prayer for every single occurrence, from tying one's shoelace in the morning to noticing a rainbow. And in the marriage, I went to the *mikva* every month. You know what that is, don't you? You should. It's the ritual bathhouse. After the five-day menstrual period, the woman counts seven more days and then immerses herself three times. Only then is she ready for her husband, of course! We also poured water over each hand three times before meals. We had to say a prayer upon drying our hands and then remain silent until the benediction over the first bite of bread.

Montano: Did you like these rituals as a child?

Aylon: Oh, I loved them, loved them, but it's mixed with some self-consciousness. My sister and I could not keep a straight face when any

guest besides our father sang out his benediction over the wine. Only males make kiddush. We would just get the giggles uncontrollably. Everyone at the table rising decorously for the holy benediction, sanctification, and the two of us holding our breath, not daring to look at the poor guest or at each other lest the peals of repressed giggles explode! The holiday I loved most was Succot. Right after Yom Kippur, in October, we would build the *succah,* this shack against the house with a homemade lattice roof, which was covered with long reeds. We could see the stars through the reeds, called *schach.* In this most magical dwelling we ate for eight days. Out of the back bedroom windows my mother and grandmother handed out steaming chicken soup with matzo balls afloat. I'd be in the *succah* below, standing on tiptoe on top of a chair to receive the dishes: homemade challah bread in the form of a braid or a round swirl, crullers, tzimmes, lukshen kugel, gefilte fish, jellied horseradish. Sometimes I'd be the one on high to hand down the food. Below me was my handiwork, the *succah,* the walls covered with white sheets, the proverbs, and sayings from Pirke Avot written in outlined Hebrew letters and filled in with Crayolas, some imaginary scene of the desert—what I imagined were days of yore when the desert was crossed en route to the promised land, and the shack was the transient dwelling place. On Succot, I made points for being artistic.

Montano: How do you feel about these rituals now?

Aylon: In a sense, they're deeper because I get to interpret them. Yet if I interpret them too differently, they lose that authenticity that comes from a long tradition. There are some aspects that troubled me when my life changed. For a long time I could not practice the rituals, but when I ignored them, a sense of acute formlessness clutched me from the inside. As for belief, actually, I can relate to the idea of the Sabbath, the divine rest that follows creation. Here's my interpretation: God created godliness in all of these six acts of Creation but then rested and did not stop resting. In fact, God is the Messiah who has yet to arrive!

Montano: When and why did you incorporate ritual into your art?

Aylon: From the beginning I came to art as though it were a *Havdala* from the mundane. In 1966 I painted the Hebrew letters that spelled *"ruach"* over and over on the synagogue library wall at Kennedy airport. The word *ruach* means wind and also spirit and also breath. I found out later, this pervading spirit was meant as the feminine presence. I must have felt this in the process of fogging out and reclarifying until the letters themselves took on some amorphous images of archways. Only one construction worker and I were in the building at the time. He was literally putting up the walls around me. On his lunch break we'd sit together behind the forty-foot Ten Commandments. *Ruach* was a bridge from my former existence into the art world. Thus, the act of painting this word was a ritual in itself. It was also my statement that this was the one word to bring back to the "Temple." But that's another story that I have yet to play out.

Now that I look back on it, to have chosen that particular word charted a course. It's as though the light behind the later 1970 silvery glass painting came from this *ruach*. *Ruach* is the only way to explain the paintings that change in time, the ones I did in 1975, where the oil seeps through the painting years later. I wrote my predictions for the future of each of those works, like a witch who can make predictions. Mind you—these witchy predictions were hung in MIT for all those Cambridge scientists! But I felt somewhat like a scientist myself. In the 1977 *Pourings* I came to sweeping conclusions that the primary form in the universe was the oval because when I poured the oil, the puddle always crystallized into an oval shape. There was always a radiating center in that oval. And then came my pronouncements about inevitability. This conclusion came from pouring lakes of oil onto six-by-eight-foot panels, which were lying on the floor of my studio. When the top layer of oil would dry, I'd send formal invitations to initiate a "Breaking": You are going to initiate a Breaking, and I am going to accept it. I would

stand by holding the pan to catch the gushing oils like a midwife as the participants lifted the panel off the floor onto a wall. All of the liquid beneath the dry outer layer would cascade down, filling up the membranous skin to create its own sac until inevitably the sac would burst, and I would say, "Whatever is contained must get released." This liquid sac of 1979 was the start of the sac metaphor that has kept me riveted through the eighties.

Montano: Was oil used in Jewish ritual?

Aylon: In biblical times oil was used to anoint a new king. In fact, in 1981, I did an "anointment" at a women's spirituality conference, where women dipped their bodies in oil and then leaned on long runners of paper. The blotting became a record and a painting.

Montano: Does this kind of empowerment come out of Jewish ritual?

Aylon: Well, the Hebrew word for art is *amanut,* which comes from the root *amen* and *emuna,* faith. I personally don't mind that sanction against graven images. For example, we know what the feeling of peace is, but the moment we engrave the word *peace* into a tablet, it loses its essence. Even the word *ritual* is too frozen. I'd rather think in terms of creating an order, an arena for an artwork, so I let the light come through, and the cracks come through, and the stains come through, heralding each arrival. The liquids pour and the sands fall and the rivers carry. Watching for the inevitable. Looking straight on into the void. Relying on it, predicting it, looking for clues. Hearkening to the sand sounds.

I remember when I met you, I had come to gather sand in San Diego [in 1980]. It was amazing to drive to the San Onofre nuclear power plant, right on the beautiful Pacific Ocean. The sand had tire tracks instead of footprints or bird feathers. In the San Francisco Women's Building these same San Onofre sands were carried in a large, transparent box by eight women. Then eight other women, situated above on a high scaffold, poured ocean sands on top of it. The

ocean sands had been gathered by pregnant women. Of course, this
Sand Sounds piece seems like pure ritual as I look back. The *Sand Carrying* was very majestic, with five hundred people carrying out ten tons
of sand, and Pauline Oliveros accompanying them with "Mmm."
"Uhh" was voiced when the burden got too heavy.

That night I realized that the sand could be common ground for
women from warring nations. This led to the stone gatherings with
Arab and Jewish women in Israel and border earth sacs in Lebanon in
1981, and the pillowcase exchange with Soviet and American women
in the Soviet Union in 1982.

Montano: Did the ritual aspects work?

Aylon: I think so. It was a handle to do something—anything—to
ease that helplessness regarding the takeover of the earth. Even just
holding on to it for a moment. The sac is what we carry. The image of
refugees holding the sac is very much with me. If there is a fire or a
pogrom and one has to escape, one throws whatever is most treasured
into a sac and runs. In 1982 I gathered earth from twelve military SAC
[Strategic Air Command] bases. You see, a play on the phrase "SAC."
Well, the finale could only be in Japan, for after Hiroshima, where else
to go? Three years later in *Current: Two Sacs en Route,* I floated two
empty sacs down the Kamo River en route to Hiroshima and to Nagasaki. Japanese students from a college in Kyoto joined me in a ritual
sac sending, placing resuscitative ingredients into the sacs before sending them on their way—one kernel of rice, one tiny grain, one bamboo shoot, and so on. The young women were so still; there must not
be a word for fidget in Japanese. It was powerful all along because the
sacs did not sink en route when they floated down the Kamo River.
We were fixated on the sacs as though they were lovers, or maybe children like Hansel and Gretel of the fairy-tale world, lost but making
their way. Because the sacs never sank, it heralded a hopeful sign.
When the sacs arrived at the shores of Hiroshima and Nagasaki, other

Japanese women came to the sand gatherings to fill the sacs with these sands.

I felt the same way when I did the paintings that change, because I was testing to see if the paper would rot from the oil, and it never did. I might get to believe in immortality. At least I know that something can become more beautiful as it ages. Perhaps if the sacs survived, we will, too. It is very all right to focus on the beauty of passage. We are desperate for permanence, but impermanence is the stuff of life. What was it that Alan Watts said? "You cannot capture running water in a bucket, for in a bucket it does not run."

Montano: How has this work affected your daily life?

Aylon: I have put ideas into practice, and as a result of that, I am hardly home. In the political world I am too arty. A typical question, "Do you think this will reach Congress? What will it accomplish?" And in the art world I am too political: "We don't know what you are doing, if you are working, if you will be showing." For a long time this was very lonely, and I was coughing all the time as though it were hard to breathe. There were expectations to explain this vision to the inter-rogators, to everybody who was an authority on whatever, and to art people most of all. How to make intelligible what is instinct? And then family—how could I justify sleeping out at the United Nations for fourteen days and nights under one thousand pillowcases to my per-plexed mother or to my son, the scientist? It's not easy for her to have such a daughter. Or for him to have such a mother. My daughter is in California—happily, she found out about this after it was all over.

Montano: What do you want to see?

Aylon: There should be a retrospective to show the whole story of all the art pieces that came out of this odyssey and were never shown. I yearn to be able to come to art apart from all known notions, apart from hipness. Actually, I haven't thought about my daily life until you asked. Now you were a nun. You went out of a convent to put your-self into your own self-made convent. I guess, in a different way, I am

living in a mystical world of the Nistar [the hidden], the secret and the coded. Like all of us, I'm trying to locate a map and a compass. I used to think that the poignant smallness of these attempts could not even touch the enormity of the problem—now I think that very smallness can penetrate the subconscious and come out in dreams. I wonder if any of the soldiers behind the fences dreamed about the pillowcases hanging and billowing across two miles of the Seneca Army Depot. And that is what the artist can do. We can find metaphors that can never be forgotten.

CHRIS BURDEN

Montano: Your past performances have obvious connotations to physical and psychic danger, risk and possibly fatal outcomes, but that is only one level—maybe it could be seen as the content of the work. There is also another aspect, which is the effect of that kind of one-pointed, totally absorbing attention on the chemistry of the brain itself. From what I know about you, you mention that the mind is the important element in your work. Can you explain that?

Burden: You know, it's weird to talk about these works, which are ten, fifteen years old, but generally, once you've conceived something, you've almost done it, especially when it concerns an artwork.

Montano: Were you energetic as a child? Did you take a lot of risks?

Burden: I was active sportswise, not in American sports but in skiing and crew. Also, when I was smaller, I got a lot of personal injuries while playing, like cuts, and I used to expect to get them. If I hadn't gotten one in a year or two, I would feel as if I were overdue. But going back to your original question, there are considerations like the myth and the reality, fantasizing something and having it be real—the early pieces were apparitions.

Montano: Is danger an American tradition?

Burden: Well, sure, that's what World War II was all about. I think that our culture is totally fascinated with violence. It's our heritage from Cortés on. A lot of people have accused me of using danger for sensation, but I stopped doing those pieces when I got that kind of publicity. I'm not an Alice Cooper. When I did those early works, I made damn sure that NBC and all of those people weren't there because they would screw it up. It was okay to have Tom Marioni and a few of my friends there.

Also, the pieces were about time, a way of marking time. Now I look back and remember when I did certain things, and they become like birthdays or marriages or graduations or deaths. You say, "Oh, yeah, I remember when I did that piece." After years and years, time blends everything, but events like those stand out as peaks—not because I was hurt or shot but because they were events from my life.

Montano: Do you fear death?

Burden: What I fear is the Coast Highway. I'm serious—it's no joke. I drive a lot, and in LA you drive and drive, and it's gotten crazy, even worse in the last ten years. Very bad. People are driving without licenses. People right off the boat are driving their BMWs, stoned out of their gills on cocaine or something else. It's really deadly out there, and it's really scary. It's nerve-wracking to go into town because you almost get into a couple of crashes. That kind of danger is never really seriously considered.

Montano: Once the edge of danger is learned, can that awareness be applied to life? What do you learn from the work?

Burden: One of the interesting things that I learned from the performances I did, especially *The Locker* and two different twenty-two-day pieces, was that at first both seemed like I was there for an infinite amount of time, and it was mind-boggling and scary. I thought, "What if I get sick up there? What if I faint after three days without eating? What if I get delirious? Who would know?" When I was down on Market Street in the bed, at first it seemed like a really hard thing to do,

an impossible thing to do, but once I set my mind to it and the longer I stayed there, the more I liked it. It was spooky in a weird way, not scary-spooky but something to observe. Toward the end of the piece, I was really sad that it was going to be over, and I realized that I couldn't do anything about that, because if I stayed on the platform, they'd come with the guys in the white jackets and drag me off, so I might as well come down. But those pieces did become micro-models for life: in the beginning it seems real long, and toward the end it doesn't seem long at all. It was strange that way, because I really felt a nostalgia or homesickness and would think, "You mean I only have two more days up here? Oh, no, this is great, and it's too bad that it can't go on." I had that same feeling in both pieces.

I even had a dream when I was on the platform. I dreamt that the sheets were hanging down and it was looking real sloppy, but I couldn't look over the edge because then someone would see me. In the next scene I was down from the platform and walking around with some friends. We were in a bar in New York, and everyone wanted to talk with me and be happy, but I wasn't happy, because my desire to be part of the real world had just disappeared. I was like a dehydrated pear. That wasn't the way that I really felt when I came down from the platform, but it was a real heavy psychological fear that I could get so blissed out that school, money, people, food, life meant nothing. It wasn't depression, but it was as if some life force had evaporated. I guess that's something that I feared when I was up there, so that's why I had that dream, the fear that I was getting zoned, but it wasn't that way at all. I came off the platform and I was just zapped. I could walk down any street, and it was super-interesting. Everything tasted good. But the dream was real—I wasn't part of the real world anymore.

Montano: Are you still experimenting with yourself? Testing?

Burden: I don't think that I'm interested in physical risk. That's why I brought up the thing about the Coast Highway. Real life has substituted itself. I'm really serious about it. I don't go anywhere for a couple

of days because I just don't want to go out there and drive. Mostly I've been thinking of making things, and there's some kind of risk in their failing. For example, *The Big Wheel,* which is constructed like a maypole out of sheets of steel, spinning on three-foot-long chains so that the three-foot-long sheets come up to an arc, extend, go rigid, and then flatten out. It is big, and space will be activated, but the risk in these sculptures isn't personal, although one of them could get loose. Whereas in the performances, risk was the enzyme of the work.

Montano: What do you think about the times now?

Burden: It's a pretty weird time right now. I've been thinking about the concept of moral culpability. I'm very upset about the creeping fascism that is taking over, and I'm very upset about the way that people follow orders. You know that I teach at UCLA, and it's really creepy. The mind-set that people have for the corporation right now is no different from Lord Baron Rothschild telling you that's how it is and having everybody going along with it.

The work that I have done is about being an individual. I'm trying to figure out what is real and what isn't real. In a way it's stretching it, and a layperson would have a hard time following that line, but it's something about being a person and not being this chaff of wheat. There are so many people like that. You can say that they're educated, they can figure it out, they went to college, and so on. But they seem programmed. I just got in a big fight with an ex-student a couple of days ago about a urine test. You know that all of the big baseball stars were asked to do it so that they could test for drugs, but they refused, and only the backup players went through with it, so I said to this woman, "If you are going to teach at Extension, you'll have to have a urine test because all of the faculty have to have one now." She said, "Oh, well, that's fine. Sure, I'll do it." And I said, "Elsie, I'm joking, and the day they ask us to take urine tests is the day that they can take this job and shove it up their ass. Just that quick." I'm not kidding. She doesn't understand that fascism has crept in.

Since World War II the question has been "At what point do you resist authority?" Gee, we're all feeling sorry for the Vietnam vets now, but why did they go there? Couldn't they figure that out then? Are people having to be more responsible now? In the past they could live in their little town, pray to God, and go off to the Crusades. And that was okay. Why did the German people go along with the Nazis? Just because UCLA or Exxon or President Reagan tells you what to do, doesn't mean that it has to become law. By doing some of the kind of work that we're doing, we get to question what are values, not moral values, but what is right, what is wrong. Who says that I can't be shot at and let it be all right? When I was living in my little studio in LA, I had this fantasy that I was training to be an astronaut. People think that going to outer space is going to be great, but they have no idea how bizarre and creepy it's going to get. It's like 1984 came and went and nobody really noticed it. They are just starting to get an inkling of that. We've made art as a way of dealing with some of those problems.

JOHN CAGE

Montano: Can we move on to death now?

Cage: If you like.

Montano: Does your comfort with that word come from your childhood?

Cage: I don't know, but it's just that as I grow older, I see that I am approaching death, and it doesn't seem as alarming or like something to be avoided. Did you see that film *Dream Child?* There's a marvelous English actress who took the part of Alice in Wonderland. She was eighty years old, and at one point she said, "The Grim Reaper has a smile on his face." I think that's very beautiful.

Montano: Is letting go of the fear of death gradual? How do we do that?

Cage: I think it does itself, so to speak, for us. And the circumstances of life do it, so that some people as they get older actually desire to die, and they commit suicide. And they are not unintelligent people. I think that it may also be connected to the fact that we live longer. Once Margaret Mead said that since we live so long, there's no reason why we should continue to do, all through our life, what we had dedicated ourselves to in the beginning. Do you understand?

Montano: Yes.

Cage: So in a sense, one could live several lives and have several deaths.

Montano: Change your career many times?

Cage: You could, as we live longer, or you could do as I do. I was asked some years ago about how I felt being so old. I was asked by a very young person, and it was early in the morning on the way to an airport. At first I thought that the question was a little rude, and then I decided to take it not as rude but, rather, as an interesting question, which it is. And I found that as I answered it that getting older had meant getting interested in more things, probably because I had less time, so that if I'm going to have any time at all to be interested, say, in rocks, and say, before that I haven't been interested in rocks, then now is the time to begin if I'm going to enjoy them. Actually, I have quite a collection of rocks, but I don't know what the next thing will be that will invite my interest.

Montano: Did you have the same kind of conventional training in the concept of death as we all did, or was yours more open?

Cage: I don't know, but I suppose that we're taught either to not think about death or to think of it as something to be avoided as long as possible. I remember that a classmate of mine died in the sixth or seventh grade, when he was that young, and it was simply from constipation. And that seemed to me like such a strange thing, but I don't remember feeling worried about that in relation to myself. In fact, I've spent my whole life, or at least a great deal of it, thinking that I had a

guardian angel, and the reason that I had that was because I had certain things to do. Now I have more the feeling that I have done what was necessary, and so there is no longer any need for such an angel.

PING CHONG

Montano: Do you remember rituals from your childhood?

Chong: The first thing that came to mind when you said childhood and ritual was the large Chinese gatherings that we had, whether for birth or death or New Year's or the first year of a child's life, and at each banquet table would sit ten people, and there would be anywhere from four to twenty tables of diners. Children became part of the event by being asked to help serve food to the elders.

There was something else that happened, but I'm not sure if you would call it a ritual because I think that it is a cultural event. As an adult, a Chinese is always expected to pay for the whole meal and for everyone else when they go out. This ritual has gotten to be a real strain here in America. That's another living ritual that's part of my culture.

I grew up in Chinatown, in a Chinese ghetto. My parents didn't speak English, and I was enclosed in my own world and culture. We had the first coffee shop—or actually, the first Chinese anything—on Bayard Street, which at that time had Jewish clothing stores on it. Before that it was an Irish and Italian neighborhood. On Chinese New Year's, the dragon dancers would come by the store, and we would offer them envelopes of money. We don't give gifts—we give envelopes of money. Then we burned as many firecrackers as we could while the dragon bowed to our business before moving on.

Money was pragmatically figured into all our rituals. For example, when we went to a wedding, each guest would give a gift of money, and that helped pay for the wedding. And it is done anonymously, because

you get the envelope and it doesn't say who gave it to you. It would be gauche to open it in front of the person and have to say, "Oh, there's only a dollar in here!" But guests receive a box of wedding cakes the day before the wedding. That was the old custom. Now each guest receives a coupon so they can go and pick up some cake or roast pork. That's new! I don't remember that at all. In fact, I received my first coupon this year as a guest.

Montano: Did your family influence your own private rituals?

Chong: Since my family came out of southern Chinese opera, it was my first experience of live performance, so obviously it had a very, very profound effect on me. I have absolutely no connection whatsoever to Western theater as an influence, and I mention this because I seem to have suddenly come into the focus of the straighter theater world. For example, I was just invited to the Theater Communications Group Conference, a national event composed of regional theaters, which primarily do traditional theater, but it is ironic to be going because my influences are non-Western.

Montano: What artistic activity set you apart from other children?

Chong: When I was a kid, I made up and directed half-baked Chinese operas for the other children that took place in the basement of my parents' coffee shop. I assume that that's a classic condition for people who end up in performance art, although I never performed in my operas. Of course, most kids growing up play the game "Cowboys and Indians," but mine was "Chinese Swordsmen," which I played in the hallways, because I was raised in the stairwells of tenement buildings, on the roof, in the basement and the backyard.

The other thing that I remember is that my father's best friend was a scenic drop painter, so he, in a way, was the one who enthralled me with the visual arts and gave me Chinese art books. I was also exposed to books on Western art, Renaissance paintings, and I thought that it was the most foreign thing that I had ever seen. I just didn't know what

it was or where it came from. My father's friend would also give me books on Japanese woodcuts, and I identified with them a little bit more.

Montano: What was the impetus to start doing the work that you are associated with now?

Chong: When you are a theater family, you are automatically different because theater people are odd and a breed unto themselves. All of them who came through town visited us and paid respects to my father, so we would always get front-row seats to the shows, which happened in the movie houses in Chinatown. Both my grandfather and my father were in the opera business, but I got to do what I am doing because of a long series of things.

When I left Chinatown to go to high school in art and design, I went into culture shock. That's when I realized that I didn't fit into the whole thing. Then I went to Pratt, and these years were the hardest culturally because I couldn't relate to Western painting and I didn't understand that this wasn't my culture. I really didn't have an instinctive feel for oil painting, even though I knew a lot about it and studied it extensively, so I began focusing on cinema, which I had been into since I was a kid, when I was seeing thirty Chinese movies a summer.

When I left Pratt, I went into filmmaking and graduated as a filmmaker. Then I met up with Meredith Monk, because I was always interested in dance, but I didn't want to do it because I felt shy about it and it had bad connotations. But when I met with Meredith, I realized that I was meeting people who were kindred spirits. And that's how it all began. Really, it was recognition.

Montano: How long did it take to reinstate that early sense of ritual in your work?

Chong: Although I was still in cultural turmoil even after I met Meredith, and it took me some eight years before I had made some kind of peace with my double heritage, eventually I could look at a

movie and say, "That's not mine; I can't identify with that." I can love it as a form, but I can look at Fred Astaire and Ginger Rogers and say, "That's not my world, that's not my world." So I had to really come to terms with all these things. When I was growing up, there wasn't any Asian American consciousness or anything like that. I came before that and had to go through it by myself without any kind of help at all. When the Asian American Basement Workshop started in Chinatown, we would talk a little bit, and I would say, "You guys, you are really lucky. Growing up, I didn't have any of this, and it was rough."

Montano: Is the dilemma that you want Ginger Rogers and Fred Astaire? What is the cultural struggle for you?

Chong: It's not about Fred and Ginger, but it's about looking at the images on the screen and suddenly realizing that what it represents is cultural imperialism. It represents a way of life that has made it difficult for me to not be an aggressive person because American culture demands that to get ahead, you have to be that way. And when you look back at the history of the West in relation to the Third World, what you are seeing in the movies are your oppressors. It's complicated. You grow up with these glimmering images on the screen, and you say, "At whose expense was this made possible?" And at the same time, you also love it because you grew up loving it, too. So how do you come to terms with the fact that you are of two cultures?

Montano: How do you take care of that?

Chong: I still cook Chinese food! There's nothing deeper than that. My own culture is heavily sublimated, although I do still want to gather with large numbers of people and serve them food. We're like the Italians in that respect. Food means life to us. It means life to have that many people around the table.

There's another thing that I've been thinking about lately—that's the Western need to be alone. Chinese people don't need that kind of privacy. I grew up in a household with five kids, and I hated it, so that

when I left home, I wanted to be alone. And yet, as the years go by, I think that maybe it isn't really so great to be alone. I haven't resolved that one yet. Maybe life is about being with all these people.

In Chinese culture you notice that the restaurants are very bright and very noisy. And again, the idea is that to eat alone is to be denied life, and to have a lot of light and a lot of noise is to be alive. Because there is no privacy, there is no self-consciousness in that world. All cultures have their problems, but when I go home I notice that everybody is always serving each other as opposed to the WASP culture, which is very, very cheap and Calvinistic. It's so different.

My work is ritualistic in the sense of honoring something, and to me, that's what ritual means. I've lost a lot of that early ability to be ritualistic in the work, but as I get older, I want to be more that way, even in my own life. I've spent a lot of time dealing with the polarity of the East-West thing—of the casualness of being an American. The signals given in this culture are that it is bad to be formal. For example, there is an article in the *Village Voice* about Karen Finley. I could never work like that. And in that case, my culture asserts itself much more clearly. Also, I don't think that I would be very good at improvising off the top of my head. It's just not part of my cultural makeup—it's not organic to me, although I appreciate it.

Montano: Do you feel better when you are working formally?

Chong: Yes, that's where my roots are—in ritual, in feeling. Much of my work is about shrines, places where things are honored. I just did an installation at MIT called *Kindness*. It was a duplex room. The lower one reflects my roots, because it was based on a room in the Forbidden Palace, which was the emperor's city in Peking. That one had thousands of small, gilded tablets, about the size of your hand, of Buddha's image. For my room I made twelve hundred tablets, and even though they were not recognizable as Buddha, it was a ritualized-looking space. The upper room was white, modern, technological. I visualized

and made real the duality that I am. And the part of my culture that has to be sublimated expresses itself in my art.

The other theme of my work is recognizing the other. And that is not specifically another person but could be another political system, another class. Basically, it's honoring the other. Sometimes talking like this helps refocus things, and although ritual is a deep part of my work, I find it harder to do it in daily life in the American world.

GEORGE COATES

Montano: How did you feel about death as a young person?

Coates: I think that I felt that death was something magical. When I was a teen and my best friend, Ricky, died, I died with him. It happened like this. I took a plane a day after he did. By chance we were both going to visit our families back east, but a day apart. As my plane landed, I started retching and got the dry heaves. It was pretty bad. This was in Boston, and it got worse on the bus trip from the airport to Providence, Rhode Island. So I stayed in the back of the bus, alone, heaving, figuring that I must have had something bad to eat on the plane. It was violent, and when I got to Providence, the dry heaves were so bad that I had to be taken to the hospital, one o'clock in the morning, Christmas Eve. I couldn't stop retching, and they had to shoot me full of Valium. The next morning I woke up, and my mother told me that my friend, Ricky, who'd arrived the day before me, had died that night in an automobile accident. As it turned out, we were both in the same hospital at the same time. He had been in surgery for six hours, during the same hours that I was retching on the plane with the dry heaves. At one point I was wheeled into an emergency room next to the surgery room where my friend was dying. I didn't know any of this at the time, but when I learned about it, it was difficult not to believe in the magic of death. So that was the first direct connection with death.

The most recent experience was when a friend of mine asked me to drive him out to a cliff overlooking the Pacific to scatter the ashes of his friend who recently died. We had to be there by 5:32 exactly, because the year before his friend had passed away at that time. So we rushed and rushed and rushed to get out there, and made it just in time, 5:32 exactly. When he poured the ashes out over the Pacific, seven pelicans flew by very low directly in front of us. The individual who was pouring the ashes was delighted. They had lived together for seven years, and the pelican was the bird of Florida, where they were both from. So that was very much a miracle, a direct connection experience.

My work is about making contact and also about having the opportunity to collaborate with indeterminate forces so that forms of participation can occur that are impossible to quantify. When I do a "see/hear," I gather together a group of artists from different mediums and disciplines. We don't always start with a script and don't fully know what we are looking for or what we are going to find. Every day we come to the studio and interact. In the process of interacting, things occur that we would never think to look for, so material arrives and rich juxtapositions of events are born.

The time is set for these meetings—it's between 7:00 and 10:00 P.M. We turn out the regular lights and put on focused lighting that creates an area of interaction. We play music and make entrances and exits. Fabric artists make fabric things and start to play with the light in a way that may not really work until the fabric finds its music. So when things start coming together, a compelling presence is achieved, and chords are created between the light waves and the sound waves, a resonant harmonic or dissonance that you can "hear/see," but impossible to design in advance. It's trial and error, and subject to the play of light, sound, and human interaction. Often the number of resonant events that work theatrically is greater than the law of averages can take responsibility for. These fantastic "see/hear" image/sound/human events happen, and it feels like we are running alongside some other kinds of

information that is coming through. We put ourselves in a situation where we can experience each other as antennae, running parallel with this almost channeled information. And in this process, imagination is concretized in the form of performance work.

Montano: Is your work preparing you for your death?

Coates: I think about death a lot, not in a morbid way or a fearful way. But I feel a little jealous of people I know who have died because I'd like to be in on the information they have. I want to know what I'm going to know then, now. And actually, I think that it's possible to open up and get some of the information. I had an experience when I was sixteen years old. I took a psychedelic at the Newport Jazz Festival in 1967 and I was absolutely certain that if I destroyed my body, I would have remained conscious there in that state of consciousness and that I wouldn't return to my body. And that didn't feel like an unpleasant hallucination. Something special happened. I was outside my body and I didn't want to return to it, but I did.

My work is another way to make contact with that place, and I can achieve a kind of death without having to destroy my body. When the unreal calendar time, clock time, can stop, and a quality of eternity and presence can take hold, then it's possible to tap into a power and intelligence that I think—I believe!—is in the realm of the dead. So in our work we discover performance pieces that are a kind of dance from here to there.

BETSY DAMON

Montano: Were there things that were ritualistic about your childhood?

Damon: My childhood was extremely isolated until I was about eight. It was then that we left Turkey, where I went at four and lived in the hills. A very old woman used to read the Bible to us. We were there

because my father opened American diplomatic relations with Turkey, where he grew up. I rarely had playmates, went to a one-room schoolhouse, made up stories, talked to the clouds, counted daisies. The Turkish people influenced me, and I have memories of the Muslims praying six times a day. I heard that sound and watched everybody bow down to Allah, no matter where they were, praying in the same direction. The sound of prayers was constantly in the environment. I also remember the vendors, gypsies, and impoverished village kids who would throw stones at me. Despite the fears, I had a deep love for the culture. Turkey gave me a language. It formed me, kept my imagination alive, and taught me how to use time alone so that I could access personal material.

I came back to the United States in 1948, and after a year of trying to connect with people by talking about my experience or forcing my sister to reenact the praying images, I found that no one was responding, so I buried it all very deep. It was difficult for me to be part of American culture because my father had been raised in the hills of Turkey and my mother came from an upper-class, wealthy estate. The messages were mixed. I wasn't allowed to chew gum, go to the movies, or hang out. If I did, I was told that I wasn't like everybody else, so I tried very much to be like them, and to do that, I became a leader and made myself look like I belonged.

Montano: When did ritual consciously enter your work?

Damon: There were two events that led up to what I call ritual. The first occurred when I took my hard-edge paintings off the wall, put them in kaleidoscope forms, and allowed the audience to rotate and interact with them. I knew that I was trying to change how I communicated. But even more important than this was a realization that I had, a realization that women were in great pain and were also isolated from each other. That was a comment on my own isolation, which got so compounded when I was a parent. In fact, I think that female parents are some of the most isolated in the population. I did something about

it. I formed a class for women. We met for a year, and after that time I began to think, "How can we be together and not exhaust each other? How can we collect our energies? How can we turn our grief, anger, and despair into celebration? How can we create rites of passage for each other? How can we pull each other up and not down?" I tried some new strategies in the group, which were designed to change energy. One day I formed a circle with them, and these words came out of my mouth, "I am a woman and I give you my hand. We are women—our hands form a circle. We are women—the circle is powerful." I took them into themselves deeper and deeper until I could say, "Okay, now work. Now do the work you need to do." Everyone worked from a place of connection, and this ritual was so effective that I used it and similar ones to connect us together so that we could reclaim our right to nurture ourselves. I didn't think of these events as rituals but as spontaneous actions that informed my life and came from a need.

Two years before that time—1971—I also made a decision and commitment to notice and create my dreams and to follow my deepest obsessions. For example, if I was involved with even one word, I would allow the word to take me wherever it wanted to go. After that decision, everything followed, everything came in my life. As a result, it's never been difficult for me to know what to do next. I just follow inner impulses, based on a conscious decision to do so. Looking back, I can see that I had fear when I brought people together, but it is my natural work, my form. I gather people and then model the amount of sharing and energy that can happen. That's the life job I took on.

Montano: Do you remember any specific dreams that you structured?

Damon: Yes, one of a tall pole with long, red streamers on it. I made it, and when I saw it, I realized that I had re-created a maypole. Then I held a maypole rite. That experience informed a process of remembering and remembering. When I read the literature, I found that I was reenacting and remembering female archetypes. I was channeling im-

ages, and it is incredible how the images connect to my personal history as a female.

Montano: Is the seventy-thousand-year-old woman that you do a channeled image?

Damon: Yes, and the hardest person I have had to channel. On the physical level, to have to wear sixty pounds of flour tied into sacks on my body over and over again was exhausting. I did her nine times. For each appearance, I would dye the flour, fill the sacks, which took four to six hours, then tie the sacks, hang them together, and put the whole thing around my body. It was an entire process, which created an environment in and of itself. Then I would go to the streets, be her, and give away the sacks. It was a personal puberty rite in a culture that excludes and does not seriously celebrate women. I thought that it was about putting positive female energy on the street, but it was more about trying to find my own space. Since the streets are free, I went there and learned. The image was dramatic—my hair was white, lips, black, and I was covered with red bags filled with sixty pounds of red flour. The first time I went out like that, two black men came by, screamed, ran in opposite directions, and I said, "Yeah, I'm a witch, I'm a witch," and we all laughed.

After the piece I was always extremely calm because I would create a safe space for myself for a couple of hours. It was okay, for that time, to be fully female. In modern times, the word *bag* is terrible and derogatory, and in one basic aspect, that's what we are as females—containers, bags. After I had my children, I realized that I was a container of life. With life comes death. In this culture you have to have children to understand that cycle and that power because it is very hidden, but in other places there are still celebrations of the polarities. It is memory.

Montano: How does ritual affect your daily life?

Damon: There is another decision that I made, that any time I was not totally at ease with another person, that it was my projection. In other words, if I saw fear, it was something that I was putting out. That

philosophy made complete sense to me, and I incorporated it into my daily life. In some ways, I ritualized that idea. Things that I do ritualistically are cooking, with an emphasis on the quality of the food and the quality of the cooking. I manifest love for my children. I make my home a sacred space by letting go of tension and stress so that it doesn't affect the environment. I notice every time I am projecting on someone and not appreciating them. I expect the best even when everything goes awry and I have a headache. Those are my daily rituals at home. In public I heal people with stones, but I go from here, from home to there, to the outside, from the personal to the public.

Montano: Are you interested in getting people over fear?

Damon: One of the things that I do is reevaluation counseling, and I have learned from that work how much our choices are made from terror and not from a free place. There is so much pain attached to everything. Growing up is letting go of that. When people work with stones and knives in my pieces, I ask them to clear out any fear they have connected to these objects. Intuitively, I know the need to connect with the energy of the earth, and getting rid of fear is a prerequisite to that.

Montano: Do other cultures inspire you as well as the Turkish culture?

Damon: Yes. When I went to a Sioux sun dance with my children in 1983, I knew that I was a novice in terms of raising energy. It's said that we modern people have forgotten an enormous amount. I have never experienced anything like that dance before or since, and maybe our culture has translated energy into computers and rockets instead. When the medicine man was speaking about the tragedies of the Indian people, it started to rain for five minutes out of a clear, blue sky, and that isn't an unusual event. The amount of energy in the circle was breathtaking. It humbled me. It humbled me a lot. It made me want to be more careful. I've always known that there was energy, and when making a circle it must be done very seriously. If you're exchanging

energy, it's serious. There are responsibilities attached to it. It can't be done lightly. We do silly things because we are inexperienced with energy. Now I'm less willing to go places and do things here and there. Less willing. I know how to be open, and I'm learning how to protect myself. The more power there is, the more protection we need, so we can be available by choice. Then we can do things when the situation is right. Of course I was also influenced by Japan, where I took myself when I was twenty, but that's another story.

TERRY FOX

Montano: How did you feel about death as a child?

Fox: I remember, about kindergarten age, pushing bright green wet grass down the throat of a dead sparrow to make it better. The same year my brother put a dead snake in my table drawer, just before the family left for a two-week vacation. When we got back, my drawer was teeming with maggots in the coiled form of the snake. Our school bus ran over a dog directly in front of us as we waited at the bus stop. I remember watching its wide-open eyes first fade away and then cloud over.

Montano: Was death a taboo subject?

Fox: I don't think it was a taboo subject. I thought about it, but I don't remember talking about it.

Montano: Were there death experiences in your environment or family then?

Fox: At about this same time [as above], an older kid, about sixteen, whom we knew quite well, was shot and killed by the police in the street in front of the house next door to ours. He was being chased on foot after abandoning a stolen car. I knew his body was going to rot, like the animals that had been rotting beside the highway. But I wondered

where he went and what happened to him. Then my grandfather died and, after him, an uncle. My feelings were sadness, not awe or curiosity. I was not preoccupied with death as a child. That came much later, when I had my first operation for cancer. I was sixteen.

Montano: Your performances of the seventies were powerful readings of hospitals and invitations for the viewer to think about his or her own death.

Fox: I used my performances of 1970–72 to rid myself once and for all of this nagging disease.

Montano: Have you touched fear and gone beyond it?

Fox: Yes, of course. We all have.

Montano: What is the function of art? What is the function of life?

Fox: I don't understand what you mean by function. Before speaking about function, I think that we have to formulate a definition for both words, *art* and *life*. And I'm certainly incapable of doing that.

CHERI GAULKE

Montano: You literally reenact death in your performances, a reenactment of the most controversial death, the big death as far as Christians are concerned—the death of Jesus, the Crucifixion. Your father is a minister, and as a result, Christian imagery is natural in your personal imagery. Did you learn about other deaths as a young person?

Gaulke: Because my father was a minister, I attended funerals for people who were not necessarily close to me, and I was always disturbed at how emotionless they were. The more I began reading about other cultures, ancient cultures and women's roles as officiators in religion, I began thinking that if women ran religion, they would do things differently. There would be much more process, much more emotion, much more catharsis, much more wailing—particularly about

death. Once I went to a funeral and my father gave the sermon for a close friend of his who had died. My father was in so much pain up there, wanting to cry, talking about his friend, but crying was against the rules—a thing that you weren't supposed to do in church. That event affected me very much, so that in my own work I added the wailing, keening, and female process.

Montano: Can you describe your crucifixion performance?

Gaulke: *This Is My Body* represents a cycle. Conceptually and structurally I see it as the snake biting its tail. In the first image I am the snake in the tree. In the last image I am Christ on the cross. Death imagery in Christianity is a perversion and reinterpretation of the snake in the tree. Actually, the snake in the tree is the spirit in the body, united in paradise. Conversely, Christianity teaches that you can only achieve the spirit through the death of the body. That's why Christianity is basically an antiflesh, anticarnal, antiwoman form. Woman is flesh, carnality. By dying in the performance, I'm trying to let a part of me die. And I see myself and my Christian spiritual path as being like the snake—shedding its skin. This is a kind of death, but it's not a death—it's a rebirth.

Montano: Your work is grounded in ancient myths. What information has most given you permission to be free of Christianity?

Gaulke: For a long time, I struggled with Christianity, being the satisfied good girl. But essentially I learned at four that I could not be like Daddy, the person I admired, that I couldn't be a spiritual teacher or spiritual leader or priest or priestess. I was a girl. Eventually my involvement with feminism changed everything. So many people see the movement as merely an opposition to sexism, but for me, it's about something much deeper than questions of equality. At the Woman's Building in LA, I became spiritually connected with other women, and this extended to women in the community. It fed me. At that point, I started doing research into prehistory, the nonrecorded matriarchal earth-centered histories. That was around 1975.

Montano: How do you see death now, having been the priestess and having worked with death imagery?

Gaulke: We live in a death culture and are surrounded by it all of the time. Pornography is Christ on the cross, and that kind of violence against women makes me very angry. That's metaphorical death. As far as actual death is concerned, I'm sure that the death of someone close to me will be very wrenching and instructive. I still see myself through my parents' eyes, so when they die, I feel that I will have to struggle with many things. My passion is to be life-affirming and creative. That's why I'm an artist. Art is a life act. War is a death act.

Montano: Having done work on yourself on those issues, do you have advice?

Gaulke: Crucify yourself. Hang on the cross! No, I'm only kidding. I actually feel that the crucifixion image should not be used lightly because it's very powerful and has deep significance. As a woman it's actually terrifying for me to crucify myself because, by doing it, I'm saying that I am divine. There's a feminist theorist who says that Christ was killed because he said that he was divine and yet he was flesh. The culture killed him because it had already decided that the flesh could not be divine. I am treading on forbidden ground when I do this piece.

Montano: Do you suddenly feel your own divinity? Is that what you mean?

Gaulke: Not necessarily. But in the foot-binding piece, I remember in one performance I danced to exhaustion, fell on the floor, sobbed, and literally saw a light. It became clear to me that the piece was about guilt for being in a female body. I've performed *This Is My Body,* the crucifixion piece, many times, then put it away, brought it out again, toured with it, and yet every time I do it, I cry. I'm in terror because I have to stand on shelves that are high above the audience, and I'm afraid of heights and physical risk. I climb on the shelves, sob and shake, and go through incredible fear. I'm also still working through the ingrained guilt. And my performances are the vehicle for this process.

When I truly experience my own divinity or the integration of the flesh as divine—which I believe in intellectually—then I will probably be finished with this crucifixion imagery. It is finished, so to speak.

ALEX GREY

Montano: Much of your work is literally and symbolically about death. Most people are afraid of their death, but you face the issue with bravery and insight. How early did your interest in the subject begin?

Grey: When I was ten, my grandmother got sick and died. I realized I would never see her again. She would be buried and go away forever. Life took on a different texture after that; time became precious. From the ages of five to ten, I was a mortician for dead animals in the neighborhood. I had a graveyard in the backyard and would perform funerals for birds, cats, dogs—anything my neighbors or I found dead. I remember also dissecting worms and dead insects. Dead things were different from living things, and I wondered why. That question still fascinates me.

Once I tried to help a sick bat, which had fallen out of a tree. The bat bit me, and my parents had the department of health come and take it away. They found it had rabies. The series of rabies shots were excruciating and made with dried dead duck embryos, but medicine became fascinating because it saved my life. I also adored monster movies, and I worked hard creating makeup to imitate my favorite monsters. Lon Chaney was the master, and an early performance artist, I think. My mother saved a drawing of a skeleton I did at age five, and I also still have a drawing I did at age ten of a gravedigger in a graveyard.

Montano: Did you continue your interest in death while in art school?

Grey: After high school I got a full scholarship to the College of Art and Design in Columbus, Ohio. For a sculpture class I brought in several garbage bags with rotting grass and vegetables and cut them open,

allowing the odor of decay to fill the room. I brought a dead dog in a bag into the classroom and showed it. The administration and I never saw eye to eye, so I left school and painted billboards for about a year. Then I went to Boston and studied with a conceptual artist, Jay Jaroslav. I started doing more performances and began a series of works that had to do with polarities. I shaved one half of my head and left the other half shoulder-length for six months. The piece was inspired by the polarities of the left and right hemispheres of the brain—the intuitive and rational sides.

Montano: Were you becoming fearless by doing this work?

Grey: I don't consider myself a fearless person. It seems that the way I grow is to face fears, and so I was working with the things that scared me the most. My performances educate me, morally and philosophically. Even though I never entirely understood the pieces, I knew that I was scared doing them and that I would probably learn something.

Montano: After a frightening experience, were you reassured because you had passed through the fear?

Grey: Yes. I didn't always know in words what I had learned. I knew when to shave off the other side of my hair. I had either taken enough grief from looking ridiculous or something had been learned. I think that there is a natural communication from the unconscious that lets us know when it's time to move on.

Montano: One of the wonderful aspects of performance is the permission it gives artists to create initiation rites and ordeals. In our initial innocence, our work often looks like ancient ritual.

Grey: Looking back at my performance work, I relate it to the shamanic journey: going to the underworld, facing death, and then coming back with new insight.

Montano: Didn't you take a job in a morgue and continue investigating death?

Grey: Yes. In my job I received bodies, looked over the death certificates, and tagged the toes. Eventually, I did the simplest form of em-

balming for medical dissection purposes. By opening the femoral artery in the upper thigh and inserting a catheter attached to a pumping device, fifteen or twenty gallons of embalming fluid can be pumped into the body, and it gets puffed up. Embalming fluid comes out of the ears and mouth but eventually drains off. Then the body is pickled. It feels very leathery and looks unreal. As part of my job at the morgue, I visited other medical schools to see how bodies were kept. It felt strange to come in off the street, where everybody is walking around alive, to see a freezer crammed with fifty or so dead bodies on top of each other or to see a vat filled with embalming fluid and ten naked, bloated, shaved bodies, men and women, all floating together.

Certainly death was as shocking to me then as it is to medical students who come into their first anatomy class and see twenty tables with dead people on them being cut up. They are seeing anonymous death, as opposed to the death of a loved one. Philosophical rather than emotional questions arise.

I had many strange assignments in the morgue. I cut off people's heads with a chain saw for an ophthalmology class and harvested people's hands for dissection. It's weird—here you are with your hand and a handsaw cutting off a person's hand. I never really got used to it. Of course, my understanding of the physical body and its numerous systems is much more detailed now, but the shock and mystery of death have never paled.

The events there changed my life, changed the way that I looked at dead people, changed the way that I looked at living people. I was faced with the moral imperative that we are in relationship to each other and should treat others the way that we would like to be treated while we are living. Really, the basic moral stuff. We are all rather fragile beings who depend on each other's compassion.

Montano: Didn't the intensity of the morgue work eventually lead to a different perspective?

Grey: Yes. In 1975 I fell in love with [my wife] Allyson while on LSD. I continued working on death pieces, and we continued to experiment

with drugs, putting blindfolds on, blocking out sight and sound, and experiencing death in a different way. With psychedelics it's possible to feel as if you are dying, since all your fear, resistance, and beliefs about death come up. You won't die, but you feel as if you could stop your heart from beating, or you may hallucinate wounds and actually see your body dying. It's like practice dying. It was therapeutic for me to go through this kind of ego death because it freed me to experience transpersonal or spiritual realms.

In 1976, while tripping, I experienced a nuclear explosion over a large city. I was on a hill overlooking the city when I saw a giant mushroom cloud billowing up. An image of Christ crucified appeared on the cloud. It seems that Christ represented what was good about the human race—namely, the potential for love, wisdom, and acts of compassion—and that the nuclear arms race was a murdering of that potential. LSD can allow you to identify with the world or all living things and experience global suffering and death. Fear of nuclear war became a prevalent theme in a number of my performances and paintings.

Death awareness can be positive because it makes you appreciate life. Allyson and I now create work about the things that we value—the development of consciousness, the experience of love, and the psychic bond between people. I did a series of paintings, the *Sacred Mirrors*—twenty-one life-size figures detailing the human physical and metaphysical anatomy—which reflect a more positive outlook.

In the morgue I was always overwhelmed when cutting open a body. It's awesome to look under the hood of a car, or open the back of a TV or computer for the first time. But the human body is a million times more complex. It's a miracle. You can stand in front of my *Sacred Mirror* painting of the circulatory system or the nervous system and mirror your own anatomy. You are looking at the building blocks that we are made of. Now I'm doing paintings about relationships that make visible the interconnections on physical, mental, and spiritual levels.

One painting is an x-ray view of a couple copulating showing the anatomical and metaphysical energies that pass through the body when we make love. Another painting is *Kissing,* and I've done *Praying.* Performances, like *Prayer Wheel* and *Living Cross,* are about the self, integrating the forces of male/female, birth/death, seeing them in the context of spiritual evolution.

Montano: You and Allyson have a rich art/life together. You support and mutually inspire each other and continue to work alone and together.

Grey: That's absolutely the case. It would be impossible to imagine doing the performances without her, and our later pieces are collaborations. Our relationship is the source of much of our work.

Montano: When I see the both of you together, I am convinced that our ultimate art/performance as human beings is kindness and letting go of ego struggles.

DEBORAH HAY

Montano: Do you remember from your childhood any instances of letting go or of witnessing death? Or traumatic or dramatic events that would have made you let go?

Hay: My mother was often carried out of the apartment on a stretcher. Several times during my childhood she was taken to the hospital in an ambulance with a heart attack or whatever. And I remember on several occasions standing there, watching her being carried out, and I don't know if any letting go was being done, because I never really examined it very carefully. But I do know that there was a lot of fear being stored from those events and the accumulation of those instances. My fear was always that she wasn't going to come back. And I remember that one time she was carried out and I imagined or thought

that her head was covered with a sheet. Years later someone pointed out to me that if she wasn't dead, then her head wasn't covered by a sheet. I always had a lot of fear of her dying all through childhood. I don't remember how I dealt with that. In fact, I remember relatively little about my childhood, but probably if I had the opportunity for that to come out, and if I spent time and energy on it, I might remember.

Montano: What were your favorite things to do when you were young?

Hay: Running, being with my girlfriends, playing athletic games and games that involved a lot of energy. Even though I was not very good at them, my sense of joy came from athletics—volleyball, tennis, softball, Johnny on the pony. I lusted after getting to the schoolyard to play those games so that I could run and play full out because I sensed, and later understood, the liberation that I achieved through total physical action. I was also dancing, but my sense is that then it was not filled with the kind of pleasure that it has now.

Montano: Were you taking ballet lessons?

Hay: I studied dancing every day. My mother was a dancer and my teacher, but she also saw that I got to the next teacher, so that I could study dance in a very disciplined way.

Montano: When did you start moving from discipline to pleasure? What did you have to let go of to do that?

Hay: It was a very, very literal process of letting go, because when I left New York in 1970 to move to Vermont, I wanted to continue a movement discipline. I had been studying tai chi for four years, but the form just wasn't enough for me anymore, and without thinking ahead, without having any future interest in what this was leading to, I looked for a form that would satisfy me daily, because I had been hooked on physical discipline since childhood.

I invented or came up with this idea that I would be in a room for an hour every day, and in that time I would bring nothing with me to the

room, but I would listen for the movement and perform everything that I heard, any time I heard, with absolutely no editing. My process was to go in there empty, listen for the dance, let it go, so that I could listen, let it go, listen, let it go. It was absolutely beautiful feedback of listening and letting go. Anything was possible, and I did that for ten years, six years at Mad Brook, in that very specific form—letting go and letting go and letting go, so that I could listen and listen and listen and be open to do whatever it was that I heard. I could not take anything in with me from the day before. It was my first religious experience. I learned that there is a gorgeous dance to do every day, and that as long as I didn't bring anything in with me, I would find incredible illuminations, infinite information. So I built a level of trust in this state of being. Why should I interfere when there is revelation out there, daily, to show itself to me?

Montano: What had to die in order for that to be born?

Hay: One thing that I'm really afraid has died is my memory. I think that I went too far in practicing letting go. I've lost all capacity for that function, and I just hang on by my teeth whenever somebody asks me a question because I can't remember anything. So that's one control that's gone. What also had to die was the idea that there was something that I had to create. I talk about that a lot when I'm teaching: "You don't have to create anything!" Creative dance, creative movement is such a funny idea because the creation is the doing, is the perception. Your perception is the creativity. Anything beyond that I really let go of.

At this point I find choreography an obsolete experience for me. The idea of choreographing a dance outside of one's perception of the moment doesn't work, although I can enjoy choreography in other people's work. Personally, I have isolated myself from that experience and have lost the taste for it. Although I have a couple of pieces that are choreographed that I like, I'm finding it harder and harder to create in that sense.

Montano: How has your process affected your daily life?

Hay: I live whatever happens or whatever is supposed to happen. And when there is an interference with that pattern, I can recognize the interference and let it go. Close friends of mine say that they really feel like I have that ability even with things that are highly emotional. I also see that I am freer of the emotional things that come up, a lot faster than they are. In one sense I feel that I could look at that as insensitivity, but it's really that I don't hold on to painful experiences. I let go more readily. Of course, I have some doubts and ask, "What am I not looking at?" But, on the other hand, I don't feel that letting go quickly lessens my compassion.

Montano: One of the functions of art is to allow us to look at and deal with fear. In the past this was done with angst and suffering and was like fighting fear with fear. When did you move from fear to pleasure? How did you give yourself that permission?

Hay: This is going to sound real hokey, but I have a very active guide who shows me what to do next. My conscious mind does not make the decisions to go along the path that I have taken. When I decided to go into that room and do the work, I didn't know where the fuck the idea was coming from. And I feel that, step by step, I'm being shown what to do next. I take some responsibility for being available to hear what it is, but somebody is really showing me what to do next. The question is, How did that happen? I just find it happening, and the path is very clear for me. I guess that trust was initiated in that room, because if you go into a studio every day and have that experience of being alone in it every single day—I mean I would weep at what I was exposed to in that dance and in the process of that kind of listening. And I experienced humility there for the first time in my life.

My dancing is my teacher, and it shows me what love is, what humility is, and all those human values. And it is still happening. The *Love Song Project* ended in May, in Austin, and now I am having a very cre-

ative time working here in New York City, and I've been wondering what is going to happen next. In *Tasting the Blaze,* I wrote an epilogue, and what I wrote is exactly what I did this year. The next thing to do has always been there, but it comes through the movement. That's how it works. If you're a painter, you do a series of paintings, and that leads to a discovery. It is the act of dancing itself that teaches me. It isn't an idea outside of it. I never say, "I don't think I want to try this or that." The next thing comes in the movement that I'm doing.

Montano: Do you think that there is any correlation between your mother being moved out of the house on a stretcher and your attitude toward your incredibly sensitive and vulnerable movement?

Hay: I'm not sure about that, but I do have another very strong visualization of my mother. It's of her moving; and her movement is very present in my work. It's a movement that is very grounded—expansive and grounded. That was the kind of movement that she did. I guess that it was a form of wholeness that I saw in her.

GEOFFREY HENDRICKS

Montano: What were your childhood rituals?

Hendricks: Climbing trees would be a good place to begin. When I was two or three years old, my father discovered me high up in a tree. Later he enjoyed telling the story of finding me there and saying, "Now, Geoffrey, you just stay there while I go and get a ladder." Somewhere there is a photo documenting the event. Summers were spent in Vermont, winters in Chicago. Country—city. That contrast entered into my play, ritual, and dreams. In the country I had special rock ledges where I created miniature worlds, vehicles for private fantasy. In the winter when I was about eight years old, I built little houses out of paper and cardboard, colored them, and set them up on streets

on my dresser top. I also made newspapers and maps for this world, Littleland and Tinytown. In both the city and the country, these small worlds were sites for solitary play.

When I was five years old, I lost a sister a few years older than I was. She died of an unmatched or mismatched blood transfusion after having come down with scarlet fever. The private play was, perhaps, a way of carrying on memories of her, having her secretly there. I remember one special place in a woods in Vermont by a spring, where two trees, a beech and an ironwood, had intertwined and grown together so much that they were like one tree. That was a magical place for me and a tree I liked to climb.

Montano: And adolescent rituals?

Hendricks: I learned how to swing a scythe and enjoyed the feel of that activity and seeing the tall grass cut down in even swaths. I also chopped a lot of wood. In a closet up in Vermont I came across a book that must have dated back to my father's childhood, a book of advice to young men, which recommended cold showers as a way of controlling sexual desires. Sometimes I would get naked and sit in the cold water of a fast-flowing stream, but it didn't work. I also liked to smell the spleenwort that grew on the rocks along these streams. Then I would still climb trees. I had certain special ones with good branches, perches way up toward the top where I could look off over the landscape and at the sky. There, too, I would sometimes strip naked.

Montano: Did you have models from history, family, or myth for your rituals in childhood?

Hendricks: I enjoyed reading about Norse mythology and Greek mythology as I was growing up. Summers in Vermont there was ample contact with the rituals of farm life. And I would help my mother bake bread, churn butter, pull taffy. And hoe the garden. As a Quaker, I grew up respecting silence.

Montano: When did you start doing rituals as art?

Hendricks: In 1951–52 I went to the Artists' Club on Eighth Street in New York and heard John Cage talk. Then in 1956, when I joined the art department at Rutgers University (Douglass College), I got to know Allan Kaprow, Bob Watts, and George Brecht. Within several years Allan was to develop Happenings, George had his exhibition *Toward Events* at the Reuben Gallery. I was in and around the beginnings of all of that. Through George and Allan I heard of what was going on at Cage's class at the New School. Cage also came out to lecture at Douglass College in the spring of 1958, about the same time Kaprow did his first Happening there. This all had a deep effect on me, but I was at Columbia during this time doing graduate work in art history, studying Baroque art—Roman Baroque church ceilings in particular— and that affected me in other ways.

In the summer of 1962 Bici [my wife] and I drove across the country in what was later to become the "Sky Bus." In Montana we visited the Crow and Northern Cheyenne reservations. On the Crow reservation there was a dance and drumming that went on continuously for several days, day and night. That experience gave me a lot of information about ritual and triggered thoughts about ritual and art. The experience at the Northern Cheyenne reservation was more private, but also got me thinking about art and its interrelationship to nature. Bici and I began keeping a collective journal, *The Friday Book of White Noise*. Performance work and rituals began to be tried out, sometimes in the context of a class. Performances in 1965 at the Café a Go Go were part of Brecht and Watts's *Monday Night Letter*—rituals of washing, cutting wood, cutting/scything grass. Country activities transposed to the city—sleeping, dreaming, fasting. In bringing together a performance with the reading of dreams, I found surprising connections. From 1965 to 1975 there were many performances of a ritualized and meditative nature. Sometimes audience was not important, but what needed to be done at a certain point in time and space was important. Mountaintop,

seashore. Solstice. Tower. Full moon. Equinox. And sometimes it was
a case of certain relationships coming together by chance. Exactly one
year after finding and taking a sheep's skeleton and pelvis out of a
Canadian spruce woods, I came back to the same place and took the
rest of the skeleton, especially the vertebrae.

Montano: What happened as a result of your doing rituals in art?

Hendricks: My most intense involvement with ritual was during the
decade 1965 to 1975, and also certainly continuing on into the early
eighties. But, of late, the urgency, the necessity of working with ideas
embodied in terms such as ritual, meditation, nonart, has faded. It is as
if this has all become academic and has lost its edge, is old hat. Isn't this
a rather natural process? One must sleep, and this can be as productive
as being awake. Things can take place in the world of dreams. To have
sharp perceptions while awake, sleep is also necessary. For a period of
time to walk along that border between art and life was vitally impor-
tant. Now to move away from it, and through an involvement with the
discrete art object, look from a different vantage point at that art/life
couplet, is equally necessary.

DONNA HENES

Montano: For the last nine years and probably longer, you have been
performing public rituals. You stand eggs on end once a year when
they will stay in position because of the gravitational pull of the earth.
You celebrate the equinoxes each year, chant for peace in public parks
and other conspicuous spaces, and more. What about your childhood
was ritualistic and would have led you to this way of working?

Henes: Once I was given an assignment in elementary school to write
a poem. I intuitively knew that if I went into the backyard alone, in the
middle of the night, a poem would come to me. I don't know what

made me think this. Of course, I wasn't allowed to go out at night alone, but I knew that I was going to do it anyway. All that day I was exhilarated because I was taking the responsibility to do something that wasn't allowed. And I did it. I waited until everyone was in bed asleep and then went outside by myself. I remember standing there in the dark, looking at the sky, and at some point I got a poem. Then I went inside, lay in bed, saying the poem over and over again, memorizing it so that I could write it down in the morning.

The second childhood event that affected me began when I was ten. I went into the hospital then, off and on for the next four years, and had a series of operations on my feet for congenital bunions. Even before that, when I was very little, my mother took me to doctors who fitted me for corrective braces that I wore at night and during the day in my shoes. My mother wanted me to have the operation while I was young, so that it would be over with and I could lead a great teen life like she had. She had millions of girlfriends, a million boyfriends, a million parties, and wanted the same thing for me, and she was determined that I was going to have my feet fixed before I was a teenager, so that bad feet wouldn't louse up those years. With all good intentions she found a doctor who would operate on my feet, even though they weren't even completely formed by then. Of course, that's why there were so many operations. He kept fucking up, so there were corrections, more corrections, more corrections.

Now my poor mother can hardly look at my feet because she feels so guilty. I've tried to explain to her not to feel that way, and even told her a story that once I was dancing barefoot with the Goddess collective of *Heresies* [a feminist magazine] at a party, and one woman looked at my feet and said, "You have the split toes of a shaman." That made me curious, so I did research and found that in traditional cultures, children were picked out to be trained for this role, and one of the clues they looked for were split toes. They are then given tests and disciplines,

including fear, drugs, isolation, and pain. And because of the operation, I experienced all of those ordeals, plus I was in casts, wheelchairs, on crutches, and wore orthopedic shoes. And the operations produced split toes!

Montano: So in some strange way your mother made you a shamaness.

Henes: In a way, yes.

Montano: Can you remember other early rituals?

Henes: In college I had an altar in my room. I always kept candles and incense burning and would sit for hours gazing at the candle flame, although I knew nothing of meditation at the time. I did my first ritual there when I broke up with someone; I wrote down all of the things that I felt about the situation on a piece of paper, burned the paper at the table, put all of the ashes in a salt shaker, and hung it upside down over my bed. I don't know why I did it, and I assure you that my roommates didn't get it at all. Now, when I study cross-cultural histories, I can find reasons for it. My process has always been to do something and then be surprised by what I have done. In fact, I'm always amazed. Then I set out to figure it out.

Montano: Did you use rituals in your work immediately after that discovery?

Henes: No. I was a political activist then at Ohio State and considered myself a writer. I was trying to look and act like everyone else. It was the year Kennedy was killed, and I was right in the front from then on. I did voter registration in the South, was arrested and shot at, bombed at Ohio because of civil rights work, and went to Quaker antiwar meetings. I eventually became a Trotskyist but became disillusioned with hierarchical structures, internal discipline, and crazy politics. My disillusionment propelled me into feminism because I refused to make the men coffee anymore.

My focus switched from writing to visual work when I was twenty-five. It happened because there was a fire in my building in New York, and everything burned from my past: old pictures, report cards, baby

clothes, my grandmother's stuff—everything—plus my collection of writings from the last fifteen years that I had called *Burnt Offerings*. It was dedicated to fire—a strange coincidence. After the fire I stopped writing, began doing visual things, finished my B.A., and went back for a master's of art. One of my teachers, Sherman Drexler, encouraged me, showed me around, gave me options, and completely changed my life or, at least, gave me permission to change my own. It was then that I began making visible a theory that everything and everyone is interconnected. Buckminster Fuller calls the idea "precession" and says that the whole universe works that way—random directioned, randomly velocitied bodies connecting briefly, interchanging energy, and continuing on their paths.

Montano: How has your life been affected by your rituals?

Henes: Because of ritual I have uncovered two more grandmothers. In my early life, my real grandmother was very dear to me. My hero. She was a revolutionary in Russia, put in jail, sent to Siberia, and was finally saved, getting out of Russia at night, leaving behind one of her twin sons. She was an aware socialist and died when I was twenty-one. At that point I was a rabid activist getting into trouble, and it seemed as if I was taking after her. She later became very disillusioned by politics and said before she died that I should stop. I would like her to know now that I am no longer running around carrying placards. Now I deal with political issues in a different way.

This is a story about one of my new grandmothers. In 1975 I had a vision. I had been making webs—freestanding ones that felt intuitively honest and right but were not quite aesthetically refined yet. I wanted them to be aesthetically accessible, visible, nonelitist, and politically correct. Sarahbelle, a woman I knew, moved to a Long Island building that had been abandoned for a long time. In the attic she found a trunk that contained scrapbooks, letters, white gloves, memorabilia. From the clippings she realized that the woman who had lived there was an American Indian princess and the last surviving member of a tribe that

lived on Long Island. In the trunk were two silver veils. They were obviously webs. Sarahbelle sent them to me because she knew that I was working with webs. I was sitting in the kitchen with friends when the package arrived. I immediately tied the veils across my face, ran to the mirror, and had this vision of Spider Woman, who is the archetypal grandmother. It wasn't a literal vision. I didn't see a spider and I didn't see a woman. It was a flash, and we don't have words for those things. All I understood was cosmic conductivity. Everything is connected: the web, my role, my connection to the grandmother.

After that my work changed. I began the *Spider Woman* series. The webs and street actions came together and became environments, and that year I did *Reverence to Her* for the first time. It's a winter solstice ritual. I began feeling as if I were a secretary, licking the stamps and waiting for someone to tell me what to do. Then I did research and became involved with people who knew about mythology. After those experiences the goddess studies and ritual became my whole life.

I have another grandmother story. It's about María Sabina. I made a pilgrimage to Mexico City to see her three years ago. But there is information that is preliminary and essential to know before I tell you about María Sabina. In 1977–78 I started doing meditation fasts for longer and longer periods. In 1979 I did a twenty-two-day fast. That was after I cut off my hair. I went up to the mountains in the Harriman State Park—the Appalachian Trail—and I literally didn't see another human being for nine days. The first three days I was completely silent, and then I chanted continuously until the end. I went to get a power dream. The first part of the fast was ideal, extraordinary. I was naked the whole time. It was from out of an Indian story. Then it started to rain, and it rained for three days and two nights. It was the tail end of some violent storm. And I was terrified. I was in my tent in my sleeping bag. I was afraid that the tent was going to blow off the mountain. Then I was afraid the tent was going to leak and that I would get wet. And since I'd been fasting for twenty days and was weak, that I'd die of

pneumonia. Friends were going to come for me on the day of the fall equinox, so I had no recourse until then.

I think that I went crazy at that point and had this power dream. It was a lucid dream; I could see myself lying there in the same position, in the tent, in the sleeping bag. The only difference in the dream was that the tent was unzipped and a big, black Doberman pinscher came inside, started sniffing me, left, and through the net door I saw that another Doberman pinscher and its master were coming up the path. The man came into the tent and proceeded to try to rape me. I pointed my finger at him, pushed him away, and said, "You better be careful. I'm a witch, and witches can only be hurt once." Then I blew on him with my breath, which was very bad because I was fasting. That was the end of the dream. It was my power dream and enabled me to see María. But there is another story before I tell you about María.

Fourteen years ago I was in Switzerland and met this Mexican man who was the boyfriend of a Swiss woman I was living with. He told me at the time that he went to an old lady in Mexico and that she was a mushroom guide. In 1980 I was in Mexico on my way to see María Sabina and had lunch with Mario, the same man. I said, "Mario, do you remember telling me about the mushroom woman?" Meanwhile, I had read about María in the *New Wilderness Letters,* and I remember crying when I read her chants because they were so much like mine. I felt like I had a grandmother because I had been doing all of my work in isolation. Nobody ever taught me anything. I don't really approve of gurus, and it's all been trial and error. Nobody to help. Occasionally different people on similar paths would exchange encouragement or experiences, but I never had an older person as a guide. So I said to Mario, "I'm ready to meet her." He said, "Oh, do you mean María Sabina?" This was an incredible event because I had no idea that his guide was María Sabina, and here I was on my way to see her. So he wrote down all of these complicated directions to her village, and I realized that I would never have found her without his help because it

was an extremely complex physical ordeal to get there—for example, we took seven buses over mountain roads.

While Sarah, a French woman, and I slept in a parked and empty bus waiting for a 4 A.M. connecting bus, a drunk man got on the bus, pulled out a knife, dropped his pants, and attempted to rape us. At that point, without thinking, I pushed him aside with complete disdain and said, "Permiso, señor." I then knocked him down with my finger. It was exactly like my dream. It was my test, and I passed it. If I had not had that dream, I may not have been that strong, and maybe would not have made it to María Sabina's.

When I finally got up the mountain to her house, I found her on her deathbed. It was wild. There were men there from Vera Cruz who wanted to be healed, and she ignored everybody and recognized me. I brought her candles. My fantasy was that I could touch her with my left hand and get something. She took both my hands and held me. I realized that we were exchanging something, and as her energy was fading, mine was growing. She gave me something, and she told me that she was dying. She had gone to bed and had stopped eating. The Mazatec interpreter told me all of this; I spoke in Spanish. She said, "It's just a pity that I have to die now, because people are thinking of me." I said, "Just because you die doesn't mean that people are going to stop thinking about you." And that's when she hugged me. That was it. I left her room, and outside there was a hen with her new babies, little chicks as soft as air.

KIM JONES

Montano: I read in *High Performance* that you had decided to do your mud-and-stick piece forever. Is that true?

Jones: Well, not forever. I like the idea that my body changes, and I know that I will be doing it until I am seventy-five, if I live that long,

but the image that I use does change. For example, when I brought it from California to New York, I cut it in half and put it back together. It's really organic. It grows.

Montano: Can you trace the imagery to your childhood? What were you doing between the ages of two and ten?

Jones: I had a bone disease from the time I was seven until I was ten or so, and I was crippled, in traction, and wore braces. I got around in a wheelchair and on crutches. The disease, which is called Perthes, is related to polio and eats away at the hip. It started in my left leg and then went to the right leg. My left leg is still a little smaller. The braces were used to take the pressure off the leg, and that's why I had to stay on them and in the wheelchair. Because I never put pressure on it, the hip healed by itself, but they had told me that I would never walk again. As time went on the prognosis changed, and I got better. The traction, braces, and sticks somewhat related to my present images. Also, when I was sick, I started drawing because I was always by myself, reading comic books and drawing cartoons.

Montano: Were you in pain?

Jones: Yeah, it hurt a lot. It hurt my legs. I can remember when it started; I was six or seven, and one day I got out of bed and crawled to the front room because I couldn't walk. That's when my mother started taking me around to hospitals to try and figure out what was wrong. I can't remember taking any pills for it, but I did have thousands of x rays of my hips and legs. We were always going to doctors.

Montano: Did you reach a time when you accepted your situation?

Jones: I suppose so. I couldn't go out and run around, so I ran around in my mind. I made up my own friends. I remember crying when I found out that it had spread to my right leg. But there was a point where I accepted it and got to enjoy the fantasy life that I had created. Once I got well, it was very important to be able to run and throw rocks. That was great, because when you're in a wheelchair, you can't throw rocks. I was half a person for those three years.

Montano: Once you were well, what lessons did you bring to your new life?

Jones: I continued the fantasy life after the sickness, and when I was in the fifth grade, I had a ghost friend, and even though I knew that the wind was opening doors, I would persuade others that a friend of mine, a ghost, was opening doors for me.

Montano: Did you continue with art after that?

Jones: I kept on making cartoons but lost interest in art in high school because I was worrying more about being in high school and having pimples. Then, at the end of high school, I became interested in drawing again and took a life drawing class. I even considered getting a studio and becoming an artist at that time but never actually did it.

Montano: What did you draw?

Jones: I drew sexy women. I drew trees. I drew animals. And I drew violent cartoons—dinosaurs and extremely violent cartoon characters tearing each other apart. Then I went to several different art schools, got sick of art school, and was going to be drafted, so I joined the Marine Corps, where I stayed from 1966 to 1969. I came back to Cal Arts, then to Otis and got an M.F.A. [pause]

I'm really confused about the death imagery. I think it's really my personality and don't think that Vietnam had that much to do with it. It's a real touchy subject because a lot of anger that I'm not sure is really reasonable comes up. [pause]

It's really odd that I spent those two segments of time, each three years, in very intense situations, and now I feel anger at myself and at other people who weren't there: anger at myself for not doing enough and anger at myself for doing too much. [pause]

I'm sorry, I can't really talk about this. It's sort of psychotic. I go back and forth, and at times I go into it and other times I clam up. Parts of your life you really can't forget. I don't think I'll ever be clean or clear of my past. I feel good about myself most of the time, but I never feel as if I've solved the problems of life by doing my work.

Montano: Are you comfortable with death?

Jones: I've always been fascinated by it. I'm pretty accepting of it, but I want to live.

ALISTAIR MacLENNAN

Montano: How did you feel about death as a child?

MacLennan: "Where do you think we'll open our eyes?" she asked. He looked up, saw the moon, and was filled with awe and not knowing.

Montano: Any death around you or death experiences?

MacLennan: There was a knock at the door. A telegram. Though he wasn't old nor had ever been ill, I knew my father had died. I've lived in Belfast for ten years now. Death doesn't die.

Montano: Do you have big fears?

MacLennan: If and when I have fears, they're self-generated. It's part of my job to dissolve them, art being skill in action, where skill is the resolution of conflict.

Montano: Were you brought up Catholic? Did that scare you?

MacLennan: I was brought up Protestant but loathed force-fed religion. The truth will make you free refers to neither Catholic nor Protestant dogma, not to any one religion.

Montano: When did you discover or choose to be an artist?

MacLennan: Since age eleven I aspired to be an artist. It felt natural to draw. I thought, why not draw, draw, draw?

Montano: Is the sadness and asceticism of your work—I saw your piece at Franklin Furnace—a formal or emotional position? Is it for meditative ends?

MacLennan: It's both. It's also for reflective purposes. The content shows the result of ill-conceived ideas in the face of actuality and the distortions, warping, and breaking of communication this brings.

Montano: Is your work preparing you for death?

MacLennan: I trust it is. If not, I'm wasting time. In work like this, one's addressing and being accosted by seeming futility, but yet finding meaning. The work is sacrificial. Nothing remains.

Montano: What is the prerogative or major concern of the artist?

MacLennan: For this artist it is: The resolution of inner and outer conflict. The fusion of opposites. The healing of wounds within and out with the self. Metaphors of hurt and healing. Manifesting creativity as ultimately uncontainable by any one form. The source of creativity residing in each individual.

Issues are: ethics and aesthetics; the "outsider"—political/social institutions; religious/political bigotry—inclusive tolerance; "dereliction" and public/private responsibility; institutional or consensus means of political/social improvement; place and displacement; death and decay; new life and mutation; transformation.

Montano: What is the bottom line in the work?

MacLennan: Art requires a spiritual, ethical basis, free from dogmas. Real art has little to do with refined sensibilities gaining pleasure. Its power is transformative.

ANN MAGNUSON

Montano: Was there a death in your early childhood?

Magnuson: No, not during my childhood. Our cats were constantly being run over by cars, though. And when our pet mice and hamsters died, we would have elaborate funerals for them. We used to find dead birds around and have funerals for them, too. Then, after a couple of weeks we would dig them up to look at the bones. My grandmothers died when I was in college. I hated those funerals. I couldn't stop crying. I can't face people when I'm like that. The Catholics have the right idea: hide your face under a black veil; it's the only way to cope.

Now, of course, I know a lot more dead people. I regretfully have had a lot of friends who have died from AIDS, from car accidents, from drug overdose. One was murdered. Very upsetting. Right now a very close friend is dying of AIDS. There are no words to describe it.

Montano: Have you become more cautious about sex?

Magnuson: God, yes. Those carefree hippie days are gone, unfortunately. And just when I'm entering my sexual prime! It's a real fucking bummer. But it certainly makes you reevaluate things. You learn that sex really is this very special experience that shouldn't be misused. As lusty as one might get, it's impossible to be casual about it—mentally, I mean. You're opening yourself up completely to another person, sharing your soul with them, and no matter how hard one pretends otherwise, you know you will be forever bound to that person. So I'm certainly being less promiscuous. Unfortunately, I seem to meet so many groovy, special people, and the hippie in me wants to make some of those meetings a little more special and a lot more groovy, but right now I'm learning to be content with mind-melds. I have bought an array of rubbers, but I get so much anxiety about asking guys to use them that, before I know it, I've worked myself into such a tizzy that I'm not horny anymore. So I guess they work, right? It's a drag. I'm writing a monologue about this very thing for my Mrs. America character. According to her, sex nowadays is like a Tupperware party.

Montano: Why do you choose to talk about death in relation to your work?

Magnuson: Because learning to accept death helps you to cherish life, and cherishing life is what I want my work to be about. I think about the other side a lot, and if there is another side and the inevitability of death and the fear of it, and I want to come to terms with that. I want to conquer fear. I don't want to be afraid of death because, although I have my moments of doubt, deep down I believe we live on.

Montano: How is your work helping you deal with the fear of death?

Magnuson: My work is changing. I want it to change. I want the end result to be positive. Although I'm searching for an understanding of people and life, I ultimately want to make people laugh. To me laughing is the greatest feeling. Besides making love, it's the best way to share one's life force with other people. When you deal with comedy, you get to do that. Get those endorphins rushing in! To actually feel that you can do that to other people is very magical. I like that a lot. The best is when everyone is laughing so hard that you're just sick, crying, begging for mercy. That's equivalent to a good orgasm, a good laugh. Sometimes it can be better. When I collaborate, often we're just rolling on the floor, laughing at ourselves. Sometimes that creative process is better than performing.

Montano: Who taught you to laugh in your family?

Magnuson: The kids in Holtz Elementary School taught me to laugh. Jimmy Silverstein used to crack me up all the time. I was not really the comedienne but the audience for the class clowns. I was the one egging them on, telling them, "Yeah, do it, do it, put those lint balls in Mrs. Sinclair's thermos." I was always the one getting sent out to the hall because, when everyone had straightened up, I was still in hysterics.

I do remember one incident in fourth grade. We were learning how to use a telephone. I was supposed to demonstrate and did an imitation of someone's mother. The whole class cracked up. I was shocked because it was purely unintentional. Needless to say, from that moment on, I was hooked. I guess that I learned to laugh because I was always attracted to people who were funny.

Montano: What is your current experiment? I heard that you are in a band.

Magnuson: I have two bands now, a folk band called Bleecker Street Incident and a heavy-metal band called Vulcan Death Grip. The heavy-metal band is in semiretirement since the guitarist moved to LA, but we shall rise again! I'm trying to start a new band, sort of a trash-

metal-psychedelic group under the working title of Bongwater. But we still have to find some musicians.

I did a couple of movies this year, *Making Mr. Right* with John Malkovich, directed by Susan Seidelman, and *Jimmy Rearden* with River Phoenix, directed by Bill Richert. Both out in the spring of 1987. Both taught me a lot and changed my point of view a little about my performance work. I want to explore the power of my emotional life more, never to forsake my satirical roots, but I do have a lot of irons in the television fire and with luck will have a half-hour special on one of the more upscale cable networks. Plus I'm developing new characters, and hopefully those will be produced in a new extravaganza in the near future.

Montano: Do you go into different characters for therapeutic reasons or theatrical reasons or metaphysical reasons?

Magnuson: All of those, and much more. I'm not sure why I do it. Perhaps because I like to try to understand extreme points of view. I want to get inside people's brains and look at the world from all its different angles. I want to know why and how people get trapped by ideology. Sometimes I think it's like being reincarnated without dying. It gives me the opportunity to be everyone. I remember when I was about six thinking to myself, "What do I want to be when I grow up? An astronaut? A veterinarian? A nurse? A prima ballerina?" Then I decided I would be an actress so I could be all of them and more. Why else? Because ultimately I see myself as more of a writer than an actress, and by performing my own material in an entertaining and accessible way, I can easily communicate ideas, observations, opinions, and reflect what's going on in America at that moment in time by becoming Mrs. Rambo or an East Village art dealer or a heavy-metal singer or a TV evangelist or a *Village Voice* critic—keep changing the channels, you know?

Montano: Was there any formal way that you dealt with the deaths of your friends who died from AIDS? Did that affect your work?

Magnuson: It's starting to affect my work, I think. It makes me realize that the work is ultimately of no consequence, that is, petty concerns about career dissolve, just melt away in the face of this plague. It's made me think more about the transitory nature of life and how important friendships are. More important than "the show must go on." I feel really blessed to have all these wonderful friends I can collaborate with. I feel really lucky to be able to entertain people. When you make people laugh, there's this certain ritualistic, communal thing going on. That's what's great about comedy. You need the audience. The performance is dead without them. You're all sharing the experience, melding together. So I guess these deaths have taught me not to take things for granted. It's all very Rod McKuen, I know, but what the hell, in the end it's all about love.

RUTH MALECZECH

Montano: How did you feel about death as a young person?

Maleczech: I had a brother who died when I was eight and a half and he was two. That was my first intimate experience with the death of someone close to me. It was angering and frightening, and I remember literally climbing the wall of the house. I don't know how I did it, but I stuck my nails into the bricks and did it. It is what the expression "I climbed the walls" means to me even now. I didn't know how to grieve then. I was more angry than sad.

Montano: Are there any links between your current work as a performer and that incident?

Maleczech: Well, I did a very theatrical thing at that time: climbing the wall was a pretty extreme theatrical moment, although not consciously performed. It was the action of a sad, angry child—a big, difficult effort. As far as how it relates to now, the energy behind an effort

like that, which I see as a negative energy, has been important in my work because I like to deal with opposite poles—the negative and the positive—so that an electrical charge is created. To do that, I have to be in a very safe situation and be comfortable with the people doing the work, because when I feel safe, my imagination swings wildly back and forth between this positive and negative charge, and the resonance in that movement is the place where I rest. And so when the circumstances are right—the material, people, and concepts—then this polarization takes place.

Montano: Does acting, performing, make you intensely feel life the way that your brother's death asked you to feel life?

Maleczech: Live performing can do that. There are moments in my daily life when I experience this also, but they are rare. They are very rare. But they are not rare in the theater because I am putting myself in the midst of the movement between polar opposites, and when I am in the middle, my mind, my feelings, my actions can be pulled one way or the other. That pull creates its own charge, its own rhythm, its own thing—life. It surges through me and comes out of my mouth—I hope! And the audience gets something from this because what I am doing is clear to me. Although they may not see what I see or hear what I hear, I think that they experience me—hearing, seeing, thinking.

Montano: Do you want that all of the time? Outside the theater?

Maleczech: All the time. I'd like to have it all the time. And there are moments in life when that is happening, but personally I don't know how to get there on an everyday basis, except in the same sense of staying in the middle of it, the way I do when I'm performing. But in life there is a kind of self-preservation that goes on that doesn't go on in art, and that makes it more difficult to maintain the attitude I am describing.

Montano: Is collaborating a difficulty for you? Do you have to drop ego to do it?

Maleczech: If I feel safe, it isn't a hard thing to do. It's a necessary thing to do in the theater, which is about collaborating all of the time. It's the nature of the beast. The hard thing in performing is the performance—not the role or the language or the direction. Keeping myself available and accessible at the moment of the performance in front of the audience is difficult. To do that while maintaining a rigorous honesty is the challenge. I have to allow the audience to know me. That can be difficult with people I know, as well as with an anonymous group.

Montano: Do you consider that you are preparing for death by working on that fear of showing yourself via performance?

Maleczech: I don't feel I am working out a fear by performing and conquering it with the help of an audience; that's not what I'm doing when I'm working. But if death would be as joyful as that confrontation that I am having when I perform—sure, that would be great. I'm not sure that death has many surprises in it. Performance does.

Montano: If we were more consciously conscious of our mortality, would we act more wholeheartedly?

Maleczech: I don't know. I'm pretty conscious that I'm dying, but I do know that my children ground me in reality and have greatly improved my comedic sense.

PAUL McMAHON

Montano: How did you feel about death as a young person?

McMahon: As a young person I thought that I was going to die young. For some reason I thought that it would be at the age of twenty-three. Then I didn't. Death frightened me a lot— even though I had little contact with it, although I did have a friend who moved away when we were both seven, and he died when he was eight or

nine in a really freak accident. He was a total daredevil, but he didn't die because of what he was doing; he died because he was riding in a car with his family, and this huge tractor trailer tire disengaged from a work site up on a hill, rolled down the hill, smashed into the car, and killed only him. It was amazing for a daredevil to be killed that way.

I think that there is such a thing as the soul, and that the soul goes beyond death. Death is not the end. Maybe death is just a different place in which we exist. Actually, I had an out-of-body experience and actually felt that. Once, in a difficult moment, when I was incredibly frustrated, I felt something weird happening in my body. It was like my stomach was being vibrated by electromagnetic waves. Instinctively, I knew to lie back and allow whatever was happening to happen. I had to suppress my urge to control it; I had to give myself over to it. I closed my eyes and saw my feet standing on the floor beneath me, but this floor was where the actual ceiling was. Like in a dream, I realized that the body I was seeing was me, but it also wasn't me. It was a different me. Then my sense of gravity flipped 180 degrees, and I was vertical and suspended in the air. I began to fly around the room, made a few passes, and flew through a closed window and out over a woodland scene. I felt I was on a mission to help someone who was in trouble. I came to an ancient stone ruin and saw a small object that may or may not have had some significance. I then came out of the trance. All along I had been conscious of myself in bed. At this point I was back in bed, no longer out in this other place. My eyes were still closed. Suddenly I thought, "Oh no! What if the spirit can't get back in the body? Will I be dead? Will I be without a soul?" I felt something firmly jerk my head up off the bed, and my spirit come back into my body, which felt warm, tingling. Afterward I was extraordinarily energized for some time. The episode of astral projection made me believe in the existence of my own spirit as an actual entity, which inhabits my body at least part of the time and which may exist in other realities as well. I distinctly felt

that the spirit was not going to die with the body, and this gives me faith that there is life after death.

Montano: Has that affected your work?

McMahon: When you are alive, you have a chance to do something on the earth. That's a motivation—that you are going to die. So, do it! I'm inspired by people who understand that what you do when you are alive is more important than whether or not it kills you. In other words, I stand for the spirit. I'm inspired by people who insist on the dignity of the human spirit even if it costs them their life. Gandhi did that. Martin Luther King is another model who lived that way. For me, it's a religion. I don't subscribe to an organized form, and I have no reason to believe in a god as such because I don't understand that concept, but I do know that the spirit is greater than I know. I have faith in that.

Montano: What is the motivation for your work?

McMahon: I want to get it out. I want to get myself out. I want to turn myself inside out. I want to put what's in, out. I want to see myself and show it to the world. And what I'm seeing is not as important as the process of growing, putting things out. What is as important as living and making? I have to facilitate that process. I'm talking more about the how than the what. If I didn't get out what's in there, then it would fester and not happen and cause me to act strange. And if I do get it out, then it's like breathing, and the next thing can come out, and so on and so on. What frightens me is that I have to live my life, that I am actually living it all of the time—the meter is ticking.

ANA MENDIETA

Montano: In your work, you embody the earth, become it, leave your impression on it. Can you remember an instance from your past that may have encouraged you to leave images of yourself on the earth?

Mendieta: I came from a tropical country, Cuba, and I have pictures of myself, seven months old, crawling around on the sandy beach. We had a house there, and I would be outside from 7:30 A.M. to 2:00 in the afternoon—out in the water and the sand. I learned about my body from doing that. Now I continue to use my body to communicate with the world, so that things that I have learned are things that I have experienced and internalized. I'm five feet tall, so I even measure things with my body. I started doing imprints to place myself and my body in the world. That way I can do something, step away from it, and see myself there afterward.

Montano: When did you first do imprints?

Mendieta: I came to this country from Cuba when I was twelve. I was sent by my parents after the Cuban revolution, but they stayed there. My sister and I were alone, without speaking English, having been placed in a Catholic orphanage run by nuns in Iowa. It was a very devastating experience because I felt alienated and totally misplaced—a culture shock. America is a multicolored society, but I came from a place where everyone was alike, so when I finally got to Iowa and finally learned the language and talked to other people, I found that we would look at the same event, talk about it, and would see it totally differently. It was then that I realized that I lived in a little world inside my head. It wasn't that being different was bad; it's just that I had never realized that people were different. So, trying to find a place in the earth and trying to define myself came from that experience of discovering differences.

I had been a painter and worked always with one image, but I gave up painting because it wasn't real enough. In 1973 I did my first piece in an Aztec tomb that was covered with weeds and grasses—that growth reminded me of time. I bought flowers at the market, lay in the tomb, lay on the tomb, and was covered with white flowers. The analogy was that I was covered by time and history.

Montano: Do you feel that there is Catholic imagery in your work?

Mendieta: I was raised Catholic and can't deny my heritage. I like very much the idea of history, and I admit that the Catholic religion has made a rich cultural contribution to the world, but they've also destroyed a lot of things. When I first started working this way, I felt a very strong Catholic connection, but as I continued to work, I felt closer to the Neolithic. Now I believe in water, air, and earth. They are all deities. They also speak. I am connected with the goddess of sweet water—this has been her year, and it is raining a lot. Those are the things that are powerful and important. I don't know why people have gotten away from these ideas.

Montano: How important is your site?

Mendieta: It's crucial. There are many places that I've gone to time and time again just because I feel connected to them. But if I'm working in a city that I don't know, I usually drive around until I find a place that I can respond to. When I find the site, I have things to do there—work rituals. For example, I wear comfortable clothing, have special tools, and insist on working alone. I have recently realized that nobody can make art when listening to rock-and-roll, and vice versa. I cannot be distracted—I need privacy because I claim territory somewhat like a dog, pissing on the ground. Doing that charges the whole area for me.

Montano: Are you using death and burial images consciously?

Mendieta: I don't think that you can separate death and life. All of my work is about those two things—it's about eros and death and life. In 1976 I made an image out of sand and stuck pieces of wood in it—it was a fetish piece. That summer my mother had a cancer operation, and I didn't consciously set out to help her, I just did the piece, but I think that it was connected to death imagery.

Montano: Did you perform ritualistic acts as a young person?

Mendieta: We had a little chapel in our house, and I used to play priest all the time. I would tie a half-slip around my neck, ring bells,

and act out all of the ceremonies in Latin because I had memorized it in church.

Montano: What does your work teach you?

Mendieta: The work continues to teach me everything. It has always been ahead of me, and I learn what it is about years later. Work makes me strong—it defines me.

Montano: The work has two elements: it is very poetically sacred but also has an edge of the profane—the dog pissing to mark territory. That makes for a realistic balance.

Mendieta: The beauty of anyone we might consider sacred is that they are also human. I'm glad that I was raised in my culture, because we learned not to believe the one side, even though it's taught to us. I had no problem shedding all of that holy stuff. The interesting thing is that education is about *un*educating yourself—always—and it's not about getting something, but getting it and then dropping it. We spend the rest of our lives doing that.

Montano: Was anyone in your family a healer? Did you have access to that kind of information in Cuba?

Mendieta: No, my family was against anything like that. It was considered to be low class and an activity of the uneducated. However, I became interested in these things after I had been working for a while, and I found that my work shares a lot of healing imagery. I have used gunpowder in pieces. Later I found that in certain rituals the Santeros, healers in Cuba, make five piles of gunpowder, light them, and if they burn, it means yes to a question, and if it doesn't burn, it means no.

I also did an interesting piece that crosses the line between art and life. The Santeros use a tree that in Spanish is called *sela* and in English is called a cotton silkwood tree. It has very long roots that stick out. In Miami there is a tree like that, which the Santeros have claimed, and the people do things to that tree when a healer tells them that they have to make a sacrifice. When I was there, I decided to do a piece on the

tree. I was in the Cuban section and collected human hair from the different beauty shops, so I knew that it was Cuban hair. Then I made an image of a figure on the tree. A root was sticking out, so the figure appeared to be either a male or a female being screwed. There were also three knots on it that happened to look like female genitalia, so I surrounded them with hair that I glued on. It's amazing how Elmer's glue withstands weather, because I did it in 1981 and it's still there. The last time I saw the tree, people had added coconuts, chicken wings, all kinds of offerings. For a while they put a figure of Santa Barbara underneath it, cut an opening in what would be the face, and stuck a shell in the mouth. They have really activated the image and claimed it as their own.

Montano: What are you thinking about now?

Mendieta: I have been given a beautiful studio in Rome. I have never had a studio before because I have never needed one. Now I have been working indoors. I've always had problems with that idea because I don't feel that I can emulate nature. Installation is a fake art. So I've given this problem to myself—to work indoors. I found a way and am involved right now, working with sand, with earth, mixing it with a binder, and making sculptures. I am very pleased because I am able to get the same kind of textures that I get outside. I was working and working and not sure if anything was there, and then one day I came into the studio and saw that the sculptures had a real presence. All of them have a charge in them. A friend of mine brought me sand from Egypt, so one of them has an Egyptian charge. Each one is different.

Now that I am in Rome, I was able to go to Malta, a tiny island in the Mediterranean where the oldest Neolithic temples are located. Their culture was matriarchal and based on the image of a sexless fat woman. She isn't like the Venus of Willendorf—this one has a skirt on and is sleeping. One theory states that she is from a cult of sleeping and death. The temples of Malta are shaped like this big fat woman, and

there was one that was carved out of a cave with red spirals painted on the ceiling. I went into it and felt as if I was in a big womb. That's really what art is about—it bonds us historically.

HERMANN NITSCH

Montano: How did you feel about death as a child?

Nitsch: I was afraid of it.

Montano: Were there any deaths then?

Nitsch: My father—1944—died during the war; later, my grandparents. A couple of friends died; a dog was shot. In 1977 my wife died in an accident. In 1984 my mother died.

Montano: What were your childhood fears?

Nitsch: They were very real—the bomb attacks of World War II.

Montano: When did you begin the ritual work that you do?

Nitsch: In 1958.

Montano: What happens to you and others as a result of your work?

Nitsch: We reach intense states.

Montano: What do you want to happen?

Nitsch: That life should be lived intensely.

Montano: Does the intensity of the taboo associated with blood and those issues frighten you?

Nitsch: It frightens and fascinates me at once.

Montano: Is the work dangerous?

Nitsch: Less than our repressed aggressions.

Montano: Describe a piece that was most memorable.

Nitsch: *King Oedipus* of Sophocles.

Montano: Is your background Christian? Are you going beyond that?

Nitsch: I am interested in the myths of all people and of all periods in history.

Montano: Did you fear God? The devil? Death?

Nitsch: More death.

LORRAINE O'GRADY

Montano: What were your childhood rituals?

O'Grady: When I was born, my mother was thirty-seven and my only sister was eleven. I guess I came along just when my mother was imagining that she was about to become free, and the feeling that I was an afterthought, that I wasn't really wanted, was somehow always conveyed to me.

Because I was unhappy in my family and, even then, dissatisfied with my culture, which I still see as provincial in an unattractive way, I began very early to reject the rituals offered me and to think up others. At family picnics, for instance, I would be ten years younger than any of my cousins. Everybody else would be having a great time playing and kidding around, while I would just be bored. Even though I participated in some of the happy times, like Christmas and Thanksgiving, I always had this feeling that these occasions weren't for me, that they were for the real family.

I think that what I unconsciously began to do was to search out rituals that wouldn't interest my family at all, like going to church. Most people's rebellion takes the form of rejecting their family's church, but mine was the reverse. My parents were generically Episcopalian because they were middle-class British West Indians who never went to church, except for funerals and weddings. They thought all that kind of socializing too simple, almost lower class. Perhaps I did, too, because that wasn't the part of church that attracted me. What I liked were the rituals and the idea of belief in God. While everyone else hung around the house on Sundays, I sought out the most ritualized Episcopal church I could find in Boston, not the West Indian parish, which was

very Protestant and low church, but one that was so high church as to be almost indistinguishable from Catholic. By the time I was fourteen I didn't just go on Sundays; in Lent I went to mass every morning before going to school. When I look back, I think that what I was doing as a child and what I continue to do as an adult is to define myself by those rituals I accepted and those I rejected.

By late adolescence, the rituals had less to do with things like family and church and more to do with the outside world. At sixteen there was the birthday party. I didn't want a birthday party. I wanted a formal sit-down dinner. At seventeen there was the cotillion. The two most prestigious black social clubs each sponsored an annual coming-out dance, and both invited me, but by that time, my pattern of rejecting the usual rituals was already established. I seemed to be the only girl from that social set who didn't come out that year. A year later at college, the expected bids to join the two nationwide black sororities, Alpha Kappa Alpha and Delta Sigma Theta, came in. Even though my sister had been president of the Boston chapter of Alpha Kappa Alpha, and everyone assumed I would go AKA, I didn't. I refused to have anything to do with that sort of thing. The irony is here I'd refused the cotillion, refused the sorority, but when I created *Mlle Bourgeoise Noire,* a satirical international beauty pageant winner with a gown and cape made of one hundred eighty pairs of white gloves, she was described by critics as a debutante. I guess I was doing those rituals in my own way in my art later on, but distanced, as antirituals. They have nothing to do with nostalgia or an acknowledged longing but are more critical modes of attack than participation. But who knows? They could be a longing that doesn't know its own name!

Montano: Did you go through a traditional art school training before this character emerged?

O'Grady: I'd had an exceptionally traditional and elitist education, which I had to work hard to rid myself of in order to become an artist. I went to Girls Latin School in Boston, where I had to study six years

of Latin and three of ancient history, and then to Wellesley College, where I majored in economics. After graduating, I worked in the Bureau of Labor Statistics in Washington and then at the Department of State. Altogether I was an officer in the U.S. government for five years, at one point the disparity between who I was and what I was doing became so great that I had to quit, and I have never held a full-time job since. I left Washington to write a novel, but my technical skills and my understanding of art were so limited, I wasn't able to do anything remotely like that. It took a long time to find out what I wanted to do, what I could do, and I discovered it in a very accidental way.

About twelve years ago I left a second marriage and came to New York as the girlfriend of a big-time rock music exec. In order not to be just his girlfriend, I began writing rock criticism and feature articles, first for the *Village Voice* and then for *Rolling Stone*. I guess you could say I had a meteoric career. My very first piece was the cover story of the *Voice*. A few weeks later, I was traveling in private jets with top rock bands. It was weird; I wasn't making any money, was living in this sixth-floor walk-up in Chelsea, but every day, a chauffeur-driven limousine would pick me up to take me to some glamorous place that other people would kill for. Within six months I was totally frustrated and bored. I knew that life would just be the same old same-old.

Then my life completely changed. A friend of mine was teaching at the School of Visual Arts and was so involved in a breakup with his girlfriend, he couldn't handle all of his courses. He called to find out if I would take one of them, a first-year English course, and I said, "Fantastic!" It was a way out of this crazy world where I was a forty-year-old rock groupie. But when I went to SVA, at first I was dislocated. Here I'd gone to Wellesley, a four-hundred-acre campus designed by Frederick Law Olmsted, the richest women's college in America, and SVA looked like a bombed-out factory. Yet there was such incredible

energy there. I threw myself into my teaching, learned everything I could to relate to those students, whom I found wonderful.

That first week, I went to the Eighth Street Bookstore to look for books on visual art. The first book that attracted me was Lucy Lippard's *Six Years: The Dematerialization of the Art Object*. It was the first art book I ever read, and it totally changed my life. It was an almost artless chronological catalog of documents and events, and I'm sure Lucy never anticipated that someone would read the book from cover to cover, but I did. By the time I finished that history of the conceptual art movement and all its subgenres—performance art, body art, earth art, and so on—I said to myself, "I can do that, and what's more, I know I can do it better than most of the people who are doing it." You see, I was always having those kinds of ideas, but I didn't know what to do with them. I didn't know they could be art, and until then, I hadn't been in a position, in an intellectual milieu to discover it. After that, the struggle became focused: to discover what my art was, where it came from in me.

Several years after that discovery and consequently undertaking the journey within, I felt ready to go outside. I didn't have anything specific yet, but I knew I was ready. I went to the opening of an exhibit at P.S. 1 called *African American Abstraction*. I'd seen it advertised in the newspaper, and it interested me. When I got there I was blown away. The galleries and corridors were filled with black people who all looked like me, people who were interested in advanced art, whose faces reflected a kind of awareness that excited me. For the first half hour of the opening I was overwhelmed by the possibilities of a quality of companionship I hadn't imagined existed. But then I settled down intellectually and became quite critical. By the time I left, I was disappointed because I felt that the art on exhibit, as opposed to the people, had been too cautious—that it had been art with white gloves on.

Then when I went down to Just Above Midtown to work as a volunteer. Helping to open their new space, I began to associate with

some of the artists whose work had been in the P.S. 1 exhibit. I wanted to tell them what I'd felt, but in an artistic way. One afternoon, on my way from SVA to JAM, I was walking across Union Square. That was before the square had been urban-renewed; it was still incredibly filthy and druggy. As I entered the park—perhaps to get away from its horrible reality—a vision came to me: I saw myself completely covered in white gloves. That's how my persona Mlle. Bourgeoise Noire was born. It was a total vision, and by the time I emerged from the park, three blocks later, it was complete. The only element I added after that was her white whip. I understood that the gloves were a symbol of internalized oppression, but knew I needed a symbol of the external oppression, which was equally real. The whip came that evening when I got home.

Montano: Did the character have a script?

O'Grady: Well, JAM's opening was to be in three weeks, and that was when she would have to appear. I spent most of that time going to every thrift shop in New York buying white gloves: it was very important to me that the gloves should have been worn by women who had actually believed in them. Then I had to make them into the gown and cape. I didn't have much time to think about the script, but I knew I wanted her to shout out a poem that would embody the response to *African American Abstraction,* that black art should take more risks. An adaptation of a poem by Leon Gontran Damas, a black poet from French Guiana who was part of the Négritude movement in Paris in the thirties came quickly to me. Damas was a mulatto in revolt against his bourgeois black background, and his poem was perfect, although I made it address bourgeois black art.

Montano: As a form of protest?

O'Grady: Traditionally, and certainly when I was growing up in the forties and fifties, bourgeois black life has been geared to gaining acceptance in the white world, to securing recognition from it. It's not so

much a desire to be part of, to actually socialize in the white world—most blacks would find that quite boring, dead, not fun—but to be acknowledged as really equal. The problem is that, in the desire for materialistic parity with the white world and the psychological need for recognition from it, the real essences of internal culture have too often been left slighted, undeveloped, and unexplored. Measures of success are defined by the white world, and styles of being and behavior are inept adaptations of white styles instead of developments of original black personal and cultural modes. Of course, this is a far greater danger for the upwardly mobile black middle class than it is for the still almost totally isolated lower class, who have fewer barriers to the development of authentic style—except those invariably presented by the corruption of the mass media. *Mlle Bourgeoise Noire* was a response to a perceived need for internal development, the kind that can only be achieved through willingness to risk failure.

Montano: How did the character progress?

O'Grady: I don't think she has fully developed, and I am still searching for ways to make her more accessible. She grew out of the black middle class, and her original message was for them. But her next appearance was at the New Museum at the opening of a show, to which she was not invited. There she was protesting not just those passive black artists who accept their own marginalization, but white curators who do not feel they have to look beyond a small circle of friends. The appearance at the New Museum and the one at JAM were alike in that they were guerrilla actions in which, uninvited and unexpected, she invaded a space to give a message that presumably would be painful to hear. I will always admire Linda Bryant, JAM's "black bourgeois" director, for not only listening, but receiving thoughtfully my criticism of an activity she was deeply involved in.

Only two months after Mlle. Bourgeoise Noire's invasion of Bryant's space, I was invited to represent JAM as the performance

artist in a show called *Dialogues*. I've been interested in Egyptology for a long time, and, coincidentally, the day the call from Linda came, I had just bought a book called *Nefertiti*. When she asked what I would do as a performance, I looked at the book in my hand and said, never having thought of it previously, "I'm going to do a piece called *Nefertiti/Devonia Evangeline*." Devonia Evangeline was my sister's name, and the piece would be about her death as the result of an abortion, so the piece had feminist overtones. But for me its main political import was the placing of images on the screen that focused on the physical resemblances of a black American and an ancient Egyptian family. Egyptology has always been such a racist discipline. Because of Western European imperialist attitudes and policies, so ingrained as to be hardly thought-out, ancient Egypt has always been denied as belonging to Africa. For instance, I will never forget that when I was a little girl in the fourth grade in the early forties, in one of those old-fashioned schools where the maps got pulled down over the blackboards during the geography lessons, when we had our lesson on Africa and the teacher pulled down the map and pointed at it to our class of twenty-five kids, all but two or three of whom were white, she said quite blithely and unreflectively, "Children, this is Africa except for this"—the long wooden pointer touched Egypt. "This is Egypt," she said, "and it isn't in Africa but in the Middle East." The worst of it is that this is the way Egypt has always been presented, even at the most sophisticated museum levels. It has only really been since the sixties and the breakup of the empire, combined with the knowledge explosion, that there has been something of a revision of imperialist intellectual attitudes, but it takes generations to get an idea out of currency. Even now, when I did this performance in the eighties, it was revolutionary and, perhaps, arrogant to put those images up on the screen. Putting a picture of Nefertiti beside my sister was a political action.

MORGAN O'HARA

Montano: You have, for the last sixteen years, made a ritual of keeping track of every minute of every day, using intricate systems and structures that you created and designed. What, from your childhood, would have inspired, encouraged, or driven you to this?

O'Hara: My parents were very different from each other. My mother was energetic, emotive, and spontaneous in all of her actions, and the idea of reflecting before doing something was not possible for her. My father, on the other hand, was structured, emotionally repressed, very controlled. I was the first of seven children, so growing up in that situation was rough. Everything was a contradiction, and one method opposed the other.

I was trained to become responsible, structured, linear. It was necessary to be obedient, and now I have this capacity to structure my awareness by deciding what I want to pay attention to so that I can create visual and conceptual structures that hone my mind. In this way I have gotten more in touch with my intuition.

Montano: Was there one ritual that taught you this way of structuring?

O'Hara: The one I think of that is probably the most neutral and the most explicative is the shoe-polishing ritual. I had the responsibility for polishing shoes for seven kids and two adults every week. That's a lot of shoes. It's a good analogy because it was an extremely structured project, and it was set up by my father according to his specific requirements. Since he was a merchant marine, his training methods were quite strict.

The process went like this: all of the shoes were gathered from the various closets in people's rooms and were taken into the kitchen, near the back door. Then I had to spread newspapers on the floor, but they had to be the want ads so that there wouldn't be any distracting pictures or anything to interfere with order. I had to line up the shoes according

to size—largest to smallest—and according to color, so that brown could be done with a brown cloth and brown polishing rag, and so on with the navy blue and white shoes. The thing that was important about it structurally was that there was a specific way to do it, and the process was as important as the product. Everything was set on stage and attacked, piece by piece. And at any point along the way, I knew how much I still had to accomplish. There were also perfectly clear ways of knowing when I was finished, whether I had done well, et cetera. Basically it was a course in program planning, implementation, and evaluation without playfulness included. When I see my father now, I notice right away that his shoes are impeccably polished, almost mirrorlike.

Montano: Were there other chores?

O'Hara: Yes, on Saturdays I ironed for the entire family and was not allowed to do anything of my own until it was done. Sometimes it took an entire day, from 9:00 A.M. to 10:00 P.M. Also, Saturday afternoon at 3:30 my mother herded all of us, children and teenagers, into the car and drove us to church to go to confession. We all hated this, but one good thing about it was that I got a break from the ironing. The atmosphere in the car was horrible. We all fought because we needed a release from the damn obligations. And at one point my mother would stop the car to discipline us. I learned to sit in the backseat by the right window. Then she would impose silence on us. During our "silence" she would tell us our sins of the previous week, so that we wouldn't forget them when we got to the confessional. They all fell into one of the "seven cardinal sins."

Her favorite for me was sloth. When I look back on this now, I find it hard to believe that this was the one that she chose for me, because I was getting As and Bs in high school, was responsible for all of the ironing, the lunches, the dishes after meals, and a great deal of the care of the three little girls, which meant supervising all clothing, teeth brushing, bathing, homework, entertainment, nighttime storytelling,

and so on. I was on the basketball team, was winning art contests, had an elected position in several campus clubs, was doing all of the bulletin boards in the main school building, was learning folk and square dancing, et cetera.

After confession we'd all get back into the car, go home, and by then my father would be up and around the house in his khaki work clothes. He had a night job and slept until 4:00 P.M. every day, going to work at six. Then we'd go back to our jobs. There was always a long list, and the last item on it said, "Report back to WJO," which always meant that the list would be longer by the time things were done in their prescribed order. Sometimes there were only five or six things on a list. I remember I always looked to see if "Report back to WJO" was there. "WJO" are my father's initials. He signed everything that way, even notes and letters to his children. It was part of his "shipshape" training.

At 5:30 I could stop ironing long enough to serve him dinner and had to stand by the table while he ate, getting anything he needed, and keeping all of the noisy little kids out of the range of the kitchen. When he left for work, his parting words for me were "Be a good girl and help out your mother." Then I'd go back to ironing. Dinner with everyone was at 6:30. My mother controlled what she could by threatening punishment when my father returned from work.

To finish Saturday: after dinner, the dishes. After dishes, put the little kids to bed, give them a bath, storytelling, and so on. After that the option was to either go to one's room and work on homework or to watch *The Loretta Young Show,* followed by *The Bishop Fulton J. Sheen Hour.* Then enforced lights out.

Montano: What do you think now about all of this control? Did you have to give it up for a while? Rebel?

O'Hara: This sick preoccupation with control is deeply rooted in a fundamental distrust of human nature. The idea is if the external is controlled, the internal will follow. I have learned from my own experience

that this is not so. Obedience out of fear breeds hatred, because it runs counter to human nature. There is a lot of energy in living, and unless a large part of it is allowed to develop in its own way, the human organism becomes damaged and doesn't function properly. Sickness, psychological imbalance, unhappiness, and nonproductivity result. I was fortunate to have been strong physically, and my body protected my unconscious until it was time to work at undoing the damage.

I undid it by going, at first, to the opposite extreme. Not surprisingly, I entered the convent, and when I left after five years, I lost total control over my life. I couldn't earn a living; I lived like a hippie and took advantage of that by staying in a semiordered space in a chaotic, big house with some artists. I suppose that I overreacted to my father's style and lived intuitively and creatively, but I couldn't finish projects, resisted everything, and took nine years to get my B.A. The reaction to all of the order at home was manifested by my need to change and move.

Eventually I found myself in San Francisco, raising a child alone. Because I was on welfare, I had to take a CETA job and, as part of that, a class in welfare law and social systems. The material was dry, boring, and the physical part of sitting there and memorizing that information was tough. I'd come home afterward, sit on my bed, and feel part of my brain moving, almost the way you feel muscles after you've been exercising. I think that class and legal education work reactivated the left side of my brain, because it was shortly after that that I decided to do the time charts, which helped me use my ability to structure. It also gave life meaning. Prior to that I was living without a purpose, and it was driving me crazy.

Montano: And now doing *Time Charts* has provided an aesthetic purpose.

O'Hara: I do an accounting of how I spend my time and how I move through space. In some ways the sleuthing of parents and pedagogy and the Catholic church continue in this process. The biggest difference in

this artwork/discipline is the quality of the work and, especially, my motivation. Formerly I did what I was told to do for fear of being punished. Whatever discipline I now use is willfully imposed on me by myself, and most of the time I accept it joyfully. I record every activity and change in the twenty-four hours. Day after day, month after month, year after year. I've made a lifetime commitment to do this. That is my given and accepted and created structure, which uses all of the elements of the earlier methods but leaves out the violence. Having created my own structure, I simply observe and record my living pattern, but the quality of this process has changed radically over the years.

In the beginning, 1969, I thought there was a value in how I spent my time. I wanted to know how many hours I spent doing art, doing errands, being with friends, with my daughter, earning money, and so on. My premise was that whatever I spent a lot of time doing would be that which I was developing. I discovered that I spent very little time doing art and eighteen hours a week worrying! Logically, one of the things that my worrying was about was the amount of time that I was or wasn't putting into my art. A solution became visible. I cut down the number of hours that I spent worrying and used them for doing art. Slowly, as the process led me to greater consciousness, I began to change my life. Eventually I began to color code the information and to use paper, make drawings, monthly summaries, and end-of-year reports. I've been doing this for sixteen years now.

For the first five years I did not think of it as art. But slowly I began to realize that it was my art, even though it didn't seem to fit into any art context that I was aware of. By then I knew that I had to keep doing it, and I didn't care about the art world. The first few times I showed it as art, people thought that I was crazy, compulsive, and they dismissed it. But it became more and more interesting to me because it was raising my consciousness all the time. Art is a psychological necessity. It guides me impartially and without violence through processes

that reveal the depth of the damage done by the practices of family and institutions, and it explores the possibilities for healing and growth. Everything can be transformed. I honestly don't think that I could have made it through all of this without art. I am not grateful for the early life that I had. I can see the crippling effects of it. But the depths of the trauma provide a wealth of material, and this inexhaustible well is the basis for a very alive and regenerative art/life.

Montano: Do you have anything to add?

O'Hara: Yes, a story about a ritual that I did with my daughter, Monica, when she was eight and had done something that made me furious and pushed my limits. At that time I had no help raising her. I was poor and at the end of my resources. She ran away from home, disappeared at night, and left me a real challenging "Fuck you" note. I had been out teaching a seminar and came back to her note and her absence. My emotional reaction was very strong, and I was both scared and angry. I tried to find her, calmed down, figured out where she was, went and picked her up, ordered her into the car, and when we got home I was so afraid that I would hit her that I opened the back door of the kitchen and pitched dishes at the cement wall.

It was unusual for me to do that, and I made her watch me do it. But I still hadn't resolved everything and felt the need to do something else, so I ordered her to her room and told her to clean it up fast. She came out a half hour later and said that it was clean. Then I told her to go back in and put on her absolutely best dress, fix her hair, and look fabulous. In the meantime I went into the kitchen, cleaned up the plates, and something indicated I was supposed to make a salad. I made a great salad, found vigil candles, made a circle of them on the floor, and put the salad in the center. She came out of her room quaking because she had no idea what would happen. I didn't know either. We sat down in the circle, ate the salad in silence, and, when we were done, went into the kitchen and washed the dishes. Then she went to her bed and I

went to mine. That was an instance where I had an instinct for making a nonverbal and nonrational ritual, which solved an immediate problem and defused a potentially dangerous situation. Looking back at it now, I feel that nothing else would have worked so well.

PAULINE OLIVEROS

Montano: Your work is not definable. You are always examining new aspects of your reality. In the seventies you were interested in performing and composing rituals. Is there anything from your childhood that you can remember doing ritualistically?

Oliveros: I used to play in the dirt with lead toy soldiers underneath our house in Houston. It was around the time of World War II, and this play was my way of relating to the earth and dealing symbolically with the adult world. Every day I would go outside, through the pasture and woods, down to the bayou to look at and catch crawfish. That was a repeated action or ritual. Later, as a teenager, I would do a repeated action every Sunday: I would listen to the New York Philharmonic on the radio, then go for a walk in the park, go for some Texas barbecue, go to a movie, and, finally, come back at night to listen to Toscanini and the NBC orchestra on the radio. I did this alone for many years.

Montano: Why did you become interested in composing rituals?

Oliveros: Just as playing with toy soldiers brought order to my life during World War II, performing ritual events in the seventies served the same function during the Vietnam War.

Montano: Did you purposely incorporate ancient sounds and instruments in your own rituals?

Oliveros: I suppose I drew on ancient materials. I remember visiting the Pueblo ruins in 1970 at Mesa Verde in the southwestern Four

Corners. The pit dwellings, earth forms, and accounts of that way of life had a profound impact on me, and even though I didn't experience any rituals there, I saw the relics, the way of life, and the living plan. Another influence was karate training, which I began when I was forty years old. I drew on the attention states from that discipline, translating the information and working on it in my music through that period. Karate was a strong influence because having to work out that hard each day affected everything that I did. Right now, because my life is chaotic, it's interesting to see how difficult it is for me when I don't have order in my daily life.

Montano: Are you developing any new rituals to counteract the chaos?

Oliveros: I've done my work consistently all my life, and it's there as an anchoring force, so that no matter how chaotic my emotional and spiritual life is, I can still do my work. The work itself becomes a ritual. It settles me. If I were physically threatened, that is, living in El Salvador or Guatemala and had to survive that way, it would be difficult to work. I would have to develop a different survival strategy. Now my exploration is interior. The kind of ordering that interests me comes from the inside out, not from the outside. So actually the irregularity and chaos have been interesting elements to work with. In the recent *Science News* there are studies on the mathematics of chaos. In the transition from order to chaos or chaos to order, there are universal patterns. I'm now beginning to feel movement to order. I'm experiencing a new body feeling. I can see the edge, a more regular pattern.

Montano: Rituals are concerned with efficacy, results in the performer and audience, not making things. Was that your interest?

Oliveros: Yes, I wanted the work to effectively change my mind. It's about centering.

Montano: There are many kinds of rituals and many kind of officiants.

Oliveros: In some rituals there are officials appointed to office, and their efficacy is by this appointment; they have to learn certain procedures to officiate. Those procedures don't necessarily require deep concentration. Then there are officials who are practitioners, and their efficacy is dependent on attaining greater awareness or attention through practices. The efficacy of the official and the officiant is dependent on that attainment. It's a mode of consciousness. A good example of this way is the Tibetan Tara ritual. The officiant spends seven days and nights in meditation, visualizing the form of Tara, and then he confers her qualities on the recipients at the public ritual. Both ways have their importance.

Montano: What rituals do you prefer now?

Oliveros: In daily life I want a pleasant rhythm. A dailiness so that there is sharing, interaction, and a feeling of completion and accomplishment that comes from that rhythm. In art, it's the preparation and performance or execution of a work, the total cycle. In spiritual practice I prefer Tibetan initiations. For example, tonight I'm going to be initiated in the Medicine Buddha. I will make an effort to do that even though it means that I will drive back upstate to Woodstock from the city this afternoon for the initiation and then come back tomorrow for my concert. It's that important to me.

Montano: Are there any American forms that excite you?

Oliveros: Right now the shopping mall interests me. I'm doing a piece with Tony Martin called *The Shopper's Opera*. That whole scene is certainly an American ritual. One way of making the mind attentive is with spectacle. *The Shopper's Opera* goes right into the marketplace and, hopefully, the spectacle will heighten and illuminate the meta-experience of shopping so that people may receive the metaphor of shopping or find the nonordinary in the ordinary experience. That way when they go back to the shopping mall the next week, after our event, they will have something to heighten their experience.

ADRIAN PIPER

Montano: You were one of the first women performance artists who took risks that shocked me and also made me laugh—playing a fart tape in a library, wearing smells on your clothes on the subway during rush hour. What from your early childhood do you remember that might have given you courage to let go of your fear or permission to work with it?

Piper: I've got to begin by saying that I was always petrified while doing those pieces: of being arrested for disturbing the peace, of being assaulted by a hostile audience (who didn't know it was art, since I didn't announce it as such), of being out of control of my audience's reactions in general. I felt compelled to do those pieces by my very vivid perception at that time of political and art-political realities that led me to feel that my earlier, conceptual work was too rarefied and socially isolated to be personally meaningful any longer. It was the compulsion to assert and express my own changing perception of social realities and my own relation to them, in the face of a set of art world conventions and practices that seemed to me completely unresponsive, unrealistic, and insignificant, that motivated me to do the *Catalysis* series.

The dichotomy between unresponsive and unrealistic conventions and my own perception of what's really going on is a familiar one from my early childhood. My parents were both very cool, restrained, and formal in their manner, and not given to emotional expression or psychological analysis of family interactions. They relied very heavily on conventions of politeness and decorum in relating to each other, to me, and to others.

The real situation that these conventions masked was quite turbulent. My mother is a very capable, intelligent, and assertive career woman who was saddled with Victorian convictions, derived from her West Indian–English colonial background, about the importance of

being a homemaker, staying at home, and being supported by her husband, and was disappointed at my father for not making enough money to enable her to live out this fantasy.

My father was a shy, quiet man who had wanted to be a philosopher or historian but was railroaded by his own mother into being a real estate lawyer, which he hated, so he could recover the family inheritance—see my *Political Self-Portrait #3 (Class)* and *A Tale of Avarice and Poverty* for more about this. I reacted by intervening, talking to each of them about what was going on, and throwing tantrums when things were really bad. I also got sick a lot. My perceptions were usually ignored, denied, or transcribed into terms more amenable to the prevailing conventions of etiquette my parents practiced. They had a fairly elaborate idiolect for conveying emotions and reactions to the actual situation in formal and impersonal terms that would have had a very different and more innocuous meaning to the casual observer.

My way of preserving my own sense of reality and my sanity consisted in two strategies: (a) I refused to speak the idiolect; that is, I referred to the reality in terms appropriate to the reality (for example, I used words like *fight, angry, drunk, money*), and reacted to the realities rather than to the conventions. This meant that I was always being reprimanded for being "inappropriate," "ill-mannered," et cetera, and generally ostracized or ignored when I refused to shape up, which was most of the time. I spent a fair amount of time either alone or being ignored, and got into drawing, painting, and making up stories. I was encouraged in the latter by my maternal grandmother, who lived with us and took care of me while my mother was at work. I think now that being ostracized taught me to feel comfortable without social approval; and doing creative stuff and getting social approval for that encouraged me to do more of it—this is probably a standard combination (that is, alienation plus encouragement for creativity) for people who go on to become artists. The other strategy I used to preserve my sanity was

(b) to argue them down with logic when they tried to deny the reality. This started very early. One of my earliest memories is of my mother asking me in exasperation, "Does there have to be a reason for everything?" after I'd asked for a further explanation of some erratic behavior on her or my father's part that I thought she hadn't managed to explain by invoking headaches, being tired, et cetera. Not that I got one, but it impelled me to look for my own explanation, one that was consistent with the perceptions I was having and reacting to. Rationality and consistency provided norms of perception and response that were viable alternatives to the nutty ones my parents adhered to.

I see strategies a and b as mutually reinforcing: the realities I perceived and reacted to (strategy a) reinforced the consistency of my understanding of what was going on (strategy b), and that consistency was a kind of protection that enabled me to assert my perceptions and responses against my parents without feeling as though I was completely crazy. I think that in general, strategy a fuels my art-making stance, and strategy b fuels my philosophy-making stance; but both are interconnected and reflected in both areas of my life.

In the *Catalysis* series, I was reacting to a particular social and political situation as I saw it, and provoking others to respond to that reaction, that is, to engage with the realities rather than with the conventions. This is an application of strategy a. Part of what enabled me to actually carry out the performances was that I had thought out what I wanted to do and why beforehand (see my *Talking to Myself: The Ongoing Autobiography of an Art Object*) and knew that I could produce that explanation and show its consistency if asked. This is an application of strategy b. It's a good thing this assumption was never actually tested during the performance. I think now that I was extremely naive in thinking that consistency could actually be a defense in an irrational world—that explaining, producing my artist credentials, referring to Duchamp, and so on, could actually convince someone not to attack or arrest me if they'd wanted to.

Montano: Did you have fearless heroes and heroines?

Piper: Yes, of different kinds. My father was pretty fearless in withstanding his mother. He once threw her out of the house for using the word *nigger*. I was very impressed by that. Also, my mother had no scruples at all about yelling at salespeople (she called it "taking them to task") when they were rude to her, which they often were because she was a little too imperious for a black customer in those days. Other heroes and heroines: Albert Schweitzer, Mary Poppins, Nancy Drew, Mowgli the Jungle Boy, Pippi Longstocking, and Helga in Hans Christian Anderson's "The Marsh King's Daughter." My Aunt Betty, my father's sister, was the first black woman at Vassar and at Yale Medical School, and I looked up to her very much. Finally, Kathy Wuensche at Riverside Sunday School, when I was about ten: she was a large-boned, blond tomboy with long braids and a straightforward manner. She was really great at sports—totally without fear—and I became good at sports only by identifying with her.

Montano: When did you start using public reaction and difficult, humiliating situations in your work?

Piper: Actually, I began by accident. I did a collaborative process piece in 1968 called *Meat into Meat,* in which I documented the physical alteration of a quarter pound of hamburger meat in the stages of being wrapped, made into four patties, cooked, and finally consumed by my erstwhile boyfriend. It turned into a confrontation performance because, at the time, he was being very condescending and dismissive about my feminism, vegetarianism, and "avant-garde" art sensibility (that is, about all the things that were important to me), so I responded by being sarcastic about the inconsistency between his professed Marxism and concern with feeding the world's hungry, and his rabid carnivorism, while I was photographing him eating the hamburger. He represented the conventional world of repressed and repressive middle-class values, which I to some extent shared, hence my feelings of humiliation at his ridicule of me, but also repudiated—hence my

confrontation, ridicule, and objectification of him through the piece. I found dealing with him in the context of this piece one of the most difficult and painful works I've ever done, because I had to defend myself against his rejection of me at just that point in our relationship when I was most emotionally invested in him.

This was the first piece I had done in which my audience was also my collaborator, and the first time I had dealt with all the issues—manipulation, aggression, confrontation, political conflict; issues that complex relationships inevitably raise. The next such pieces were the *Catalysis* series of 1970–72.

As to why I started doing these pieces, I guess I think that basically my art responses are pretty much of a piece with my other responses, just tailored, as all of them are, to fit a particular context or situation in which I find myself; and that all of them are the consequence of my early realization that strategies a and b are a viable survival response to this society's rejection of my reality.

Montano: What did the work teach you?

Piper: First, it taught me that I could test the limits of conventional reality and get away with it. Second, it made me realize my extreme dependency on various social matrices for my shifting personal identities. I would not have believed that doing that work could put me through such profound emotional changes. Third, it was a lesson in both the acquisition and the abdication of control: I acquired control by "passively aggressing," that is, choosing to present myself in non-standard, socially offensive ways, and accepting responsibility for people's responses to me. In later performances, control also involved prediction, since I was able to incorporate people's expected responses into my prior planning of the piece. But I also abdicated control to my audience by trusting them not to destroy or attack me, and by needing to be completely receptive to whatever their reactions were.

Montano: Did you have to continue that way, or did the image change?

Piper: The image changed as I became more responsive to my audience and hence more concerned with political and social issues in my work. I'm no longer doing performance, as the last one, *Funk Lessons,* pretty much burned me out. But it has led me to what I'm working on now, which are issues of sexuality and the representation of erotic identity.

Montano: The fears in our lives are reflections of the big fear, that of death. Is your work a way of cutting through these obstacles to clarity?

Piper: Yes, definitely. It's a way of mastering the unknown and forcing it to reveal itself to me, thereby making it manageable (that is, intelligible) to me. My goal is to understand everything that happens to me. That way I won't be afraid to die.

Montano: What techniques do you use now in your life when you are afraid? Did you learn them from your work?

Piper: I visualize very vividly the worst-possible-case scenario, vividly enough so that I experience my own response to it (increased heart rate, difficulty breathing, nausea, goosebumps, shock, anxiety, the feeling of wanting to urinate, of being weak in the knees, of freezing up). Then I rehearse feeling that response to the situation over and over, until it's familiar to me. Then, when the situation actually occurs, my fear response is not as intense or uncontrollable as I'd anticipated. It's important here to try to visualize absolutely the worst-possible-case scenario and not to fool yourself about how bad things can be, since they will seem even worse if you think you're prepared and you're not. A failure of imagination can be lethal. I did get this from preparing myself psychologically to do each of the *Catalysis* pieces. Of course this only works with fearful situations that are anticipated. When one occurs unexpectedly, I either freeze up or behave as though there's nothing wrong, that is, conventionally, and try to get out of it as quickly and casually as possible.

Montano: Anything more to add about courage, fear, humor, death?

Piper: Courage: I don't think I have much, really. Usually when I plunge into risky situations, it's because I don't realize how risky they

are. But my experiences in academia are starting to make me realize how deadly people can be when they feel threatened. I'm still processing this information and am not sure how it will affect my character dispositions in the future.

Fear: I can't help but believe that one can be fearless in all areas of life only if one is truly stupid. But the kinds and variety of things people are often afraid of truly astonish me: intimacy, self-revelation, truth, uniqueness, self-abandon, novelty, et cetera.

Humor: I don't know what I'd do without it. One of my tests for how much unconventionality people can take is how encompassing their sense of humor is, how self-directed they allow it to be, and how compatible it is with feeling compassion for other people. I seem to be meeting lots of people lately who can laugh only at the expense of other people. I find this very depressing.

Death: I can't decide whether consciousness is like electricity (it extinguishes when the mechanism runs down) or like energy (it changes form but doesn't increase or diminish). If it's like energy, then I'm really curious about the quality of consciousness when it is disembodied and independent of subject-object distinctions, which is what must happen with the death of the body.

JEROME ROTHENBERG

Montano: What do you remember from your childhood that you would now consider ritual activity? How old were you when those things occurred?

Rothenberg: The ritual things that I remember I wasn't terribly interested in. Or maybe I was. But if I was, I was resistant to them also. There was a regular pattern around religious rituals, especially around Jewish holidays, many of which took place, largely, in the home. There were also

occasional visits to the synagogue in which my grandmother was a member of the congregation. My parents were atheists and didn't, except as a matter of courtesy, participate in these synagogue occasions, but since my grandmother lived with us, we carried out most of the traditional household rituals. I had a very close relationship with my grandmother, so maybe there was a kind of feeling, a resonance around that and, up to a point, a desire to please her. But after a while I was following my parents' way rather than my grandmother's, so there was a period in adolescence when I more and more distanced myself from the traditional forms. I don't remember creating alternative rituals, as such, although there was an interest in doing theater and setting that up with some friends in a more or less formal way. We wrote plays, acted out plays, and maybe there are ritual qualities in doing that. Maybe some of that underlies the writing of poetry—formalizing and ritualizing language.

Montano: So there was a double aspect—the fact that you had access to it via your grandmother and then not having to do it because of your parents. You had permission to go your own way.

Rothenberg: Yes, but you should remember, too, that neither of my parents took a really strong antireligious stand, even though they were atheists and had separated from the religion as such. In some larger sense they were against it, but there was also a mixture of respect for it, so it was never a question of putting down or knocking those people like my grandmother who were involved in the religion. Later, in fact, I found that they were actually hostile to the more religious and outwardly costumed Jews of the ultra-Orthodox and Hasidic sects. And when I became attracted to Hasidism as a historical phenomenon, they assured me that the Hasidim were narrow and even vicious people, and that I shouldn't be taken in by the exoticism of the outer trappings or by Martin Buber's sentimental accounts. What attracted me was the mysticism and a glimmer of the poetry. I have never otherwise had much sense that they were necessarily good people.

Montano: Were their reasons political, and was it a brave gesture for them at that time?

Rothenberg: At the point that they broke from the religion—and this held particularly for my father—it was a brave and painful gesture, because he had been raised in an ultrareligious Hasidic family. In other words, what he was saying about the Hasidim was really with reference to the world of his own father. My father was the oldest son in his family and had been sent from where they lived in Poland to the city of Vilna in Lithuania, to study and to become a rabbi. Then, as the story goes, when he got to the Slabodka Yeshiva, he found a group of young students there who were secretly reading Dostoyevsky and Tolstoy and French writers like Rolland and Zola. Yiddish writers also, lots of those, and Marxists, socialists, and Leninists. Kropotkin. Darwin. That's how it was told to me. And within a year, he had left the yeshiva, cut off his earlocks—shaved off all of his hair in fact—and returned home, a bald ultra-German type in a short jacket, wearing city clothes. Gentile clothes. All of this very much to the dismay of his own father. And shortly thereafter, he and my mother ran off to Warsaw to get married in secret and for him to set off for America the day after the wedding. Apparently on that same day—the day of the wedding—his father died, but word wasn't sent to him until he arrived in America, so as not to distress him or discourage him from going. After that he was socialistically oriented, although less aggressively leftist, less active than other members of the family who were further to the left. Politically he remained a moderate socialist in his beliefs. Later on he became disillusioned and disappointed, attitudes common to his generation.

So traditions form a part of my mental and physical memory—physical because of the sensuous recollections of the interior of synagogues and the sound of the singing, the chanting, when you're inside them. Also a kind of olfactory memory, particularly from the extreme holidays like Yom Kippur, when people would stay in the synagogue, in

their seats for hours, and you could literally smell their presence. I re-member my grandmother's first synagogue, which was in a loft in a building on Webster Avenue in the Bronx, where it crosses Gun Hill Road, and the Third Avenue El would go past there. And I remember very clearly the collage of sounds—voices in the synagogue, the words and music, and the El train making a turn as it goes from Webster Av-enue and then cuts onto Gun Hill Road.

Montano: When did sound, word, thought, and ritual correspond for you in your work?

Rothenberg: The impulses of what we do as poets and artists go back to a source in religion and ritual. I've known that for a long time, but in the beginning I had a conflict with it because I felt a strong need also to break from all of that. What I chose to do, I think, was to accept it as one of the givens of being a poet or an artist, and then to try to see what that could possibly mean in the basically secular and deritualized world in which we live. At some point, particularly in the late fifties and early sixties, I found myself drawn toward the inclusion and accep-tance of more and more ritual elements in my work, and more under-standing of those in the work of others. Poetry, art, and music have taken over some part of the function that religious ritual once had—true, with a great ongoing distrust of institutionalized, formalized reli-gion. But once I was able to deal with a sense of ritual in my own work, I was as happy to spend time going to a religious celebration as going to a movie or an art performance. Even more so with religions where I felt no sense of conflict or of kitsch—or felt a rawer, even a harsher, power.

Montano: What do you mean by ritual?

Rothenberg: *Ritual* is a tough word, and my tendency, as I've been saying, is to see it in a religious or quasi-religious context. *Performance,* on the other hand, is a very neutral word, and when you speak about something as performance, there is no question of having to think

about religion. It's like the distinction I feel between *mind* and *spirit*—distinct words in English, but not in other languages, where one almost always has a religious sense and the other almost always doesn't. When we speak of ritual, then, there is some kind of religious implication intended, unless we're talking like animal behaviorists—insect rituals and all of that—which usually we aren't. What many of us have wanted is to have a poetry and art that are as powerful and meaningful for us as religious and ritual poetry were for those who practiced that.

Montano: Your strength is that you are grounded in both. You are incredibly secure in your analytical processes as well as your right brain! Did you have to develop the thinking side of your work before you could let go into the trance of poetry?

Rothenberg: Both aspects came with a certain amount of difficulty and with some insecurity about my ability either to analyze or to take off and fly. If I've learned to do any of it, it's because of diligence. Persistence. Part of the process for me has been to make myself as informed as possible about what others have been doing, either now or in the past, ritual and art both. At first, as a young artist, I was a little concerned about exposing myself to too much outside influence, too much other art, with the typical fear that it would stifle me. But then I found, at least for me, that that was not the case, that the more I came to know, the more in fact I was able to do. In the German language—and in Yiddish, too—the words for knowing and for being able are virtually the same. So knowing something is an enhancement of one's abilities. Ability and knowledge go together. I don't mind that at all and am not hurt or repressed by knowing more.

Montano: You made a real effort to spend time with the American Indians. Do you feel that you have to take time to do different kinds of study?

Rothenberg: You get to know certain things by doing them, and in the process of doing, you find out what it is that you're doing. There is

a sense of uncertainty to begin with, and then all kinds of clarifications come with persistence and experimentation. You can contrast this to another kind of knowing that comes from distance—either from books or some equivalent medium: movies, even word of mouth. All of those are different from placing yourself in a position and observing or doing or participating. That kind of knowing—to put myself someplace in order to see for myself at first hand—opened up for me, really, around the late sixties. By that time I had already become interested in ritual poetry as a worldwide phenomenon and had researched it through books and the works and observations and experiences of others. I was then sent out—through Stanley Diamond's good offices—to the Allegheny Seneca Reservation in western New York, and from that point on, a lot of things began to open up for me. That first going-out was very significant, because suddenly I really knew the value of doing that, of going to the place where it was happening and placing myself there on the Seneca Reservation. I was interested in the ceremonies and how they persisted into the contemporary world: both what was old and what had changed (materials and behavior) as the lifestyle of the Seneca had changed. And then I was able to do that more—to go into other situations and to learn in the process—without, I hope, doing damage to the people I found myself among.

Montano: Was your trip to see María Sabina a similar placing of yourself at a source?

Rothenberg: With María Sabina it was a much more casual, briefer encounter. Others had gone to visit her long before us, so by the time I went down there, I knew a lot about her as a famous Oaxacan Mazatec shaman. Also, things had come together in a way that made it possible to see her under very good circumstances—with our friend Henry Munn, who had spent a lot of time there and had married into a Mazatec family. Since I was already aware of the glamour surrounding her—although in truth she continued to live in a very third world kind of

poverty—it was like going to visit any famous person. The experience, in other words, was like that of finally meeting a fellow poet or artist whose work you have long known and honored. We also participated in a Mazatec mushroom ceremony at that time, but not with María Sabina. Not mushroom tourism or anything like that, but a very sweet family occasion in Henry Munn's in-laws' house in Huautla. They were very nice people, and the part of the world they live in is very beautiful. María Sabina is a great ritual poet of that place, and what I wanted to see—and did see—is the way she is a contemporary of ours, a living human being who inhabits the same world and time that we do. Otherwise the books turn her into something too much "other."

On the Seneca Reservation I was interested in the ceremonies and how they persisted into the contemporary world: both what was old and what had changed with regard to materials and behavior as the lifestyle of the Seneca had changed. Obviously, I was an outsider to all of that, although I was invited to sit in with the secular Singing Society and, much more rarely, to trot around in a few of the larger public dances that were religious—ritualistic—in nature. I couldn't say to what degree I was personally involved in that, although the poems in *A Seneca Journal* are probably an attempt to place myself in relation to it.

My most personal experience of Indian ritual happened a number of years later through an immersion into the long, extended Easter ceremonies of the Yaqui Indians of Arizona. We were there for four, five days at a clip, in a ritual space filled with a large number of masked figures—Chapayeka clowns—who finally became very real, very much the defining figures of that landscape, that imaginal world. And what tied it immediately to my own imaginal life was that the principal masked figures for the Yaqui Easter were the Jews of the ceremony, who wear crazy and unbelievable masks that are really a whole collage of masking types. There are animal beings, pirates, white businessmen

and entrepreneurs, blackface clowns with big red lips and fat stogies in their mouths, masked figures who look like Arabs or like Hebrew patriarchs, or other masked figures who look like stereotypical, caricatured American Indians. And, after a while, it was for me as if the imaginal beings of "Poland/1931," Jews who did and didn't exist in time and history, were all around me. They were faces that I hadn't made up but that I recognized, and by the end, when the ceremony ended and the masks were burned, it was with a real sense of loss, a real kind of emptying. What was special here was that my world and theirs shared the same images, the same beings, that they had brought to life for me.

Montano: What is nourishing your performances now?

Rothenberg: Most of the performance work now is coming out of the poetry-music collaborations with Bert Turetzky. Turetzky's presence on the bass keeps the work charged for me. As I go around doing more and more poetry readings, there is a problem I run into because the act of reading becomes repetitive after a point. It's the sort of thing that David Antin says drove him from doing poetry readings into improvising talk-poems. Turetzky has a freedom of improvisation that I don't have as a text performer, but with him I'm encouraged into readings of the poems in which my rhythms and phrasings are pushed and colored in new ways and new directions. He forces me to surprise myself with my own work, with work with which I'm otherwise very, very familiar.

And then last year, just before I left California to come to Albany, I became involved, along with Bert and Theodore [Morrison] (an old hand from the Living Theater), in a theatrical production of my Dada poems [*That Dada Strain*], in the course of which (a little bit like the Yaqui ceremony) I was able to immerse myself in a living, moving fantasy world—another imaginal world of images that were here embodied. It is quite different when a work is fleshed out and you walk

among the beings that inhabit and empower the poetry as a part of them yourself. I'm aware, of course, that this is a theater and that the people around me are acting and performing. But it's a very personal theater for me, and it offers the possibility of a different presentation to those who come as audience, a visual way of projecting language and image to the outside world. Projecting that and then entering into it deeper and deeper is what ritual is about for me.

BRIAN ROUTH

Montano: Your work as a Kipper Kid seems to be parodying rituals of eating, politeness, and modesty. Do you think that you have more material to work with because you're British? How did you feel about rituals as a child in England?

Routh: I hated them. I especially remember one that happened every Saturday. My mother would vacuum and I had to do all of the dusting. And every Sunday I had to go for a walk with my father while she was cooking Sunday dinner. Now I look back on these rituals with a fondness, but at the time I really detested them. Everyone considers that Britain is ritualistic because we all supposedly drink tea at four o'clock. Actually that's true.

Montano: As a child did you make up any rituals that were specifically and privately yours?

Routh: I went to a school where every teacher had a strap of leather with tails on it. They walked around a lot with these things in their pockets. The education system in the northeast of England is really very severe. It's right on the Scottish border, where the Roman wall was built to keep out the Picts. The Picts were very wild, and the Romans couldn't tame them; they would attack people and actually start eating them. There seems to be some connection between that and the

fact that teachers in our school would ritualistically punish the students with these straps. I responded by making a strap of my own when I was seven or eight, and every night before I went to sleep, I would beat the shit out of the window ledge with it. That was a kind of ritual, I suppose.

Other than that, there were no other repetitive actions I did that I can remember. I didn't go to church at all—maybe once or twice. In fact, my parents drummed into me antichurch sentiments: the pope was a crook, and things like that. They believed that all religion was a means of manipulating ignorant masses of people. As a result, I had no religious coaching, although I do remember listening to radio dramatizations of stories from the Bible. At fifteen or sixteen I became aware of other religions, Hinduism and Buddhism. Even now I continue to read religious teachings and writings.

Montano: Eventually, when you did performances with the other Kipper Kid, Martin Von Haselberg, how did you both structure your rituals?

Routh: Martin and I had some pretty powerful experiences together in the early seventies. One time we were driving in the forest near Bochem, North Germany, and we wanted to have a beer, so we went to a small inn, tried the door, and found that it was locked. We looked in the window and saw two coffins near the bar, lying on the floor. That was pretty creepy. As we were driving away I saw a litter bin on a lamppost. Sticking out of the garbage was a black doll and a toy, a golden plastic saxophone. Those two became props for *The Birthday Party*. Usually we would find strange things in even stranger situations—alleys, streets, junk shops—and those things would wield their way into our performances.

All of the objects for *The Birthday Party* were in a suitcase, and all of them were sacred. I realized that they were sacred because we hadn't performed together in years, and then we were to do *The Tea Ceremony*

somewhere. I had left one of the objects out of *The Tea Ceremony* when I packed it, and Martin was really horrified that I had forgotten it. He thought that was sacrilegious. Actually, the way we treated our objects was very reverential. They were almost like idols or a priest's chalice. *The Tea Ceremony* was obviously a parody of the English tea ceremony and Japanese tea ceremony combined. Only we took it to a ludicrous extreme. Maybe my work was a way of making up for all of the church services and religious experiences I missed as a child. In that sense I'd say that our performances were ritualistic.

Montano: Did the rituals change?

Routh: Yes, I had purposely left the tea case behind a few times when we went on tour because I was tired of it—it stopped being religious for me. Some years later, some guy stole the tea case out of Karen's [Karen Finley's] car.

Montano: Even though you treated objects reverentially, there's also an irreverent parody in the work, which gives it an edge. Did you choose to do parodies?

Routh: No, in fact, in *The Tea Ceremony* we weren't saying, "Let's do a parody on the English tea ceremony or the way that the English drink tea." We were purely motivated from a subconscious urge, not from consciously deciding to do anything in particular. It came out of our rapport together and the energy that was happening between us.

Montano: The word *ritual* supposes that there are priests and mediators, someone who knows how to change consciousness, their own and others'. Was that true for you?

Routh: A lot of times we would drink as part of the piece; in fact, much of the time we couldn't do it without drinking. That became a ritual in itself. There was always a cup hanging from the ceiling, and we would pour whiskey into it during the performance and drink as part of the show. A lot of the experience of what I was doing was lost because it was done in drunken unconsciousness. That wasn't apparent to the

audience, but it certainly was to me. I do remember experiencing an incredible elation at the end of some performances—rather high, obviously from drinking so much but also from the piece itself. Other times I was too unconscious to feel anything.

There was one piece in particular that was particularly powerful. It was about self-punishment. When it was my turn, I would do a one-man boxing match and beat myself up. Martin would be my referee. And then, in other performances, we would switch over and take turns doing it. It was strange, but we would almost fight when we had to decide who would be boxing that night. We fought over who would get to punish themselves in public! It was a real masochistic ritual, and yet I would feel cleansed, as if I had confessed and gotten something off my chest after I beat myself up. It ceased doing that for me after some years, and that's why I had to stop doing those rituals.

Montano: Do you still work together?

Routh: We perform together, but we don't do it for the same reasons. It's now done because he's my best friend, and we are very, very close. We have this strong link that is still there no matter how much time has passed. It's friendship. Doing a performance with him is enjoyable; it's like having fun and goofing off.

Montano: What are your new rituals?

Routh: It's still in flux. I'm pretty much in the dark in terms of what I'm doing. I'm dealing with issues of intense fear. Out of some morbid curiosity I've been reading books that murderers have written, especially people who have no conscience about what they do. There's this one guy called Bansram who was executed in the forties when he was forty-five. He killed twenty-two people and had no conscience about any of the crimes that he committed. People would try to rehabilitate him, and he would let them, but he warned them that there was no point in trying to do that because he didn't think that he had done anything wrong. He'd say, "Go ahead, waste your money, I don't care."

The paradox is that he wrote a very literary book, somewhat like the book written by the guy Norman Mailer helped. It's kind of bizarre that there are certain individuals who have this real creative energy, real power and writing talent, and yet they get pleasure from terminating another person's life. That interests me. How does that happen? Why wouldn't they feel remorse? Why not realize that what they are doing is morally wrong?

Montano: Both you and Karen are very brave. Both of you are willing to explore the bizarre and the taboo. I admire that.

Routh: I enjoy working with Karen. It's that excitement of working with someone you know and finding that you have this rapport together. We did a lot of shows in Italy and Germany together. In Italy we made fun of the Italians and their everyday rituals. And in Germany we made fun of Hitler and the Nazis and almost got lynched. I guess we take a lot of risks.

Montano: You're never nervous about offending?

Routh: No, if I get nervous, I feel that it's a good quality. When I see other people's work, I look for risk taking. It doesn't have to be physical risk. It's more about playing with anything risky. I don't set out with the idea that I'm taking a risk. For example, in Germany I dressed as Hitler, went on stage, and said, "Heil Hitler!" There was a groaning in the audience. They were upset and uptight. Karen was Eva Braun, and we did a thing where we acted as dogs, sniffing each other's butts. A lot of them saw it as humor and laughed, but others felt that we were saying that all Germans were like that, Nazis. I didn't think that it would be such a big deal or that reactions would be so severe. It happens a lot. I don't intend to scare people with my performances. I just do what I do. When people react that way, I feel that something is happening to me for the good, but it's something that I don't know how to name. Sometimes it's elating. The risks aren't about shooting myself. They aren't life or death. They are more emotional, psychological.

ROBERT SCHULER

Montano: How did you feel about death as a young person?

Schuler: As a young person I ignored it totally. My parents kept me away from funeral parlors to protect me from it.

Montano: What motivated you to be an artist?

Schuler: Let me answer it this way by asking, "What motivated me to take up art?" I don't know if I was ever motivated to be an artist, but I took it up because a friend of my cousin's saw some drawings that I did and he said, "You should take classes." This was after I'd had an engineering degree. So I went to art school at night, in Milwaukee, Wisconsin. The first thing that I took was a ceramics course. Then I took a drawing course. From then on I went back to school as a full-time art student.

Montano: How did you bridge science and art? Was that an easy transition to bring them together?

Schuler: It was real easy. Although I hadn't started thinking about art until my late twenties, as a kid I always drew planes and ships and did airbrush paintings of them. I started that when I was very young. When I graduated from engineering school, I took a summer job as an engineer, and at that time I decided to go back, study art, and eventually I did some teaching in art.

Montano: How is your current performance, *The Tethy's Project,* like life or death?

Schuler: For my performance, *The Tethy's Project,* five-hundred-pound granite blocks, which have sandblasted drawings and some texts on them, are painted on all sides and dropped every one hundred miles around the world, into the bottom of the ocean. Each block has a map of the world on one side, indicating the latitude and longitude at which the block has been dropped. The subtitle of my piece could be *To and from the Void,* so, in a sense, I suppose that anything that you do, if you

want to trace it back far enough, is going to be involved with death, although the void isn't necessarily death. There was a theme from my childhood that corresponds to my current piece. I buried my toys then, partially to hide them from others but most of the time because I wanted to bury them, come back later, and find them. I buried trucks and toys, leaving them there sometimes for a couple of years.

Montano: Does burying represent an attempt to preserve, deep-freeze, or attain a kind of immortality by hiding something and then discovering it again?

Schuler: I don't see the fact that I am strategically dropping these cubes in the water as having anything to do with my coming back or even wanting to. It's a technique for avoiding the gallery system—but in an absurd way. Essentially I'm avoiding everything because the pieces can't be seen. Because it's the nuclear age, we have to have fall-out, and I have these detritus-like documents: photos, videos, and all of the garbage that I've collected around the piece. I've created my own museum, I suppose, a museum without any visitors, at least not for a very long time—except for when and if they resurface. Some museums have my work, but they will probably not surface again. It's only when you're famous that the work reappears, and if not, it lies in the bowels of the museum.

Montano: Is water an issue? What does it do to you to think of these five-hundred-pound blocks buried under water?

Schuler: I'm not even sure that the water has much to do with it. What I'm doing is dumping a piece of rock in very, very deep water, and that rock will eventually sink into the ooze at the bottom. The rocks are really going to be fossilized. The sediments can someday rise above the level of the ocean, and if they do, the rocks might come into view again, back to the world. But basically they are in deep, long-term storage. It's very practical; it has no religious, psychological, or philosophical implications at all. It's more like going out and cutting your lawn with a lawn mower.

Montano: Anything to add about death in the eighties?

Schuler: It's ever-present, which is like saying, one is one. I suppose that I'm doing this as a kind of prevention of death. I feel that if I can keep drawing, I will keep everything bad away from me.

THEODORA SKIPITARES

Montano: How did you feel about death as a young person?

Skipitares: I remember that death ceremonies were very flamboyant and festive events, even though black was the big color. My relatives, who are Greek, wore black for three years after someone died, but I still remember that as being colorful, maybe because there was so much festivity around death—there would be lots of flowers and lots of planning. Although it was a time without color, I remember it very colorfully. My father died when I was seventeen, and I remember that we had to turn off all electric things in the house like radios, and these were off for several days. When he died, I also let go of the tight strings that bound me to Mediterranean culture. For me it was the beginning of intense art making and social rebellion, because I had just gone away to college and was away from home. I always had wacky energy, even at home, but when I left, it took on a bigger scale. By wacky, I mean that I was always doing projects, sneaking out with my sister and dressing up in bones and furs, but when I left, and after my father's death, it became serious art.

Montano: What kind of letting go of death did the performances represent?

Skipitares: My early autobiographic works represented a need for me to formalize in what I thought was a very beautiful and orderly way the complaint of my childhood and adolescence, which was that I had one foot in the Greek culture and one foot in another, and that was always very messy and confusing and frustrating to me. The performances

gave me permission to experiment and explore, and this turned out to be a pretty rich vein. It was also a chance to exorcise the struggle but allowed me to order it and present it in a beautiful way.

Montano: Did you study philosophy along with art?

Skipitares: No. Actually I was a premed student, but somewhat halfway there I changed to art and theater. I probably changed because I am partly a product of or reaction to the things around me; since I was an undergraduate at the University of California, Berkeley, when our entire political structure blew apart in the sixties, my change of direction was influenced by that. In the seventies I was in downtown New York, and a certain kind of performance was happening, so that influenced my choices also. I always respond to sociological things around me. Don't we all?

Montano: What was the reason that you studied medicine?

Skipitares: It was an early interest in science, and in a way that interest has now come around full circle because my current piece, which has occupied one year's work already and which will occupy another year, is about the history of genetics. Then I was interested in medicine, but now I'm more drawn to the research aspects of medicine, and if I were still in medicine I would now be a research scientist, probably. I don't feel that my interest in being a doctor came from any examples that I saw in my family, because we are talking about working-class people, we're talking about a nonprofessional family. But I was a smart, firstborn child—although not male—and there is something about the ultimate wish of the immigrant family that one's child become a doctor, so maybe that was one reason why I studied medicine.

Montano: How did the puppets evolve from your autobiographical performances?

Skipitares: In some ways they seem like a drastic transition to me, but in other ways they represent a very subtle transition. I felt that my own life had become exhausted as subject matter; I felt the narcissism of that

era of the seventies had run itself into the ground, and I felt that I particularly needed to look at larger issues that involved more people. Basically I had a desire to communicate something larger. I wanted a couple of things: I wanted other people in there, but I didn't want other actors, and I also wanted to remove myself from it directly. I made images of myself and I started animating them by manipulating their arms, their legs, their heads, their necks. In doing so, I found that I had been creating these other characters that I had been looking for; they were sort of me, but they really weren't. They allowed me to distance myself from that early material, and that was a very important step in the development of my art making.

Montano: Did the anonymity function as a way of working on egolessness? Or was it a theatrical device?

Skipitares: I think that it was both, but I wouldn't use the word *anonymity*. I always knew that it was selves multiplied up there onstage. I never thought that those images of me—puppets—were anonymous, and most people who see my puppet work, even now, feel my presence very strongly, but the mask that is presented is not literally me. In fact, I've become more and more repulsed by work that fixates literally on the cult of the self, and this new way of working helps me move away from that style.

Montano: When did you move from the self via autobiography to the self as embodied in puppets? What aspect of yourself had you learned about in order to leave that early way of working? What fear had you conquered?

Skipitares: The first puppet work that I did was called *Micropolis,* and it was composed of several urban scenes with three-foot puppets. That was a transition piece, because I had used so many of those images before; they were remnants of my autobiography. After *Micropolis,* I went right into history and now, right into the history of science, so that is the transition.

Montano: When does the puppet come alive for you instead of just an accumulation of matter? When is the doll breathed into?

Skipitares: *Breathing* is really the right word. I didn't learn this until much later, but puppeteers always use the notion of breathing when they bring a puppet to life. That was very interesting for me to learn. In the beginning they came to life when I was pulling the strings or manipulating the sticks, but I don't do that anymore because I'm the overseer, and I have to wait for them to come to life when the people I direct move them. That is very thrilling, very exciting, but I don't personally do it anymore. The only time that I did it recently, it was rather thrust upon me. A week ago I went to Alice Tully Hall, where Lee Breuer had put together a giant spectacle that was a pan-ethnic festival composed of a samba group, a Jamaican group, a gospel group, the Brooklyn Choir. He had also brought a national treasure master puppeteer from Japan. Afterward I went backstage; the puppeteer had known my work and asked me to come and see him. He couldn't speak a word of English, but he grabbed my left hand and stuck it inside this extraordinary, spectacularly clad princess Bunraku puppet, and I felt inside of her that she was alive. But also, I was alive inside her. And then two minutes later, for no apparent reason, without saying anything, he yanked her away from me and put her to bed.

I have another story that illustrates the aliveness of the puppets. A while ago I finished a life-size puppet of Madame Curie and we were going to start rehearsal. The night that we started, a friend who had been working with me on the show, Michael Cummings, was with me, and we had the lights out, trying different lighting with Madame Curie. She is the first of the life-size female puppets that I have made. Michael was manipulating her, working her two arms and the back of the neck, and suddenly she seemed almost inhabited by something, and it wasn't bad or scary but was definitely something. It actually was a little scary. I said, "Oh my God, Michael, there is something inside

her. She is full of something." So he came and sat down next to me and we looked at her, and we both agreed. Michael said that the hair on his chest stood up on end because he could feel that something was there. I turned on the lights, and she was still full of something, but it was starting to go a little bit. I went over to her and wasn't sure that it was Marie but knew that it was a female spirit, and I said, "Look, I'm delighted that you've come to this rehearsal, and you're very welcome to come whenever you like, and I consider it a good sign that you have given your blessing to this play." The next night, we had a rehearsal with a couple of people and we were trying to do puppet tricks and have Marie hold up a chemical flask and have her flip through a book, so for a book I just happened to grab my *Webster's Collegiate Dictionary,* put it down on a table, and the puppeteer took her right hand. Now I must add that he was sitting in front of an illuminated, fifteen-foot version of the periodic table of the elements, which is part of the show. So he sort of slammed her right hand into the dictionary at random, and we opened it up and there was a picture of and a description of the periodic table of the elements. We all sort of gasped and closed the book again and said, "Okay." We let her hand go into the dictionary again. We opened it and saw the entry, *elements,* and it was a description of all of the elements that were on the chart that I had made. It was mildly amusing, and it wasn't scary, but I was apprehensive that at some point she might turn on us. But she never did, and she actually never manifested again either, or at least not overtly.

Montano: So now medicine and art and life have merged? You are an art doctor because you bring life to the supposedly nonliving!

Skipitares: Yes, they have come around, but at this point in my life I feel my work is probably a spectacular stage-set Western town to distract me from what is really there: an elaborate construction in the face of the ultimate.

STELARC

Montano: Did you have any childhood rituals?

Stelarc: I don't remember any. Even if I did, I would not ascribe any particular significance to them. Guess I'm skeptical about reconstructing the past. For what purpose? As if memory is untainted, as if honest analysis of self is possible or even important. The topology of human behavior can't simply be plotted by discrete events in an individual's history. Present action is triggered by the immediate environment (circumstance/site/society), releasing a repertoire of behavior skills and cultural conditioning. I don't think it's meaningful to go back into yourself. It's not even a matter of free will or determinism. Different situations offer different degrees of desire. Disposition can be defined in a totally nonteleological way. My past has collapsed. The present is not possible without the past first collapsing.

Montano: You are known and famous for hanging from hooks piercing your body. Who or what are you sources?

Stelarc: As an art student I was intrigued by Leonardo da Vinci's anatomical dissections, embryo drawings, mechanical contraptions, and obsession with flying, as well as being impressed by the power of Michelangelo's massive, muscular bodies thrust into space. The Renaissance conflict and heroic attempt to reconcile body and soul, nature and religion, art and science is powerful stuff. I saw the film *2001: A Space Odyssey* fifteen times, am still repulsed by Hindu ascetic rituals, and I have practiced biofeedback techniques since 1970. Dada events, Man Ray and Duchamp, the pop artists of the sixties, and performance artists of the seventies all affected me.

I occasionally read *Flash Art, Artforum,* and *High Performance.* How could I forget the impact of Marshall McLuhan, Teilhard de Chardin, and Martin Buber? I'm overcome by the poetry and power of Nietzsche, fascinated by Heidegger's proclamation of the end of philosophy,

and swayed by B. F. Skinner. E. O. Wilson's *Sociobiology,* Minsky's *Telepresence,* and Herbert Simon's *Architecture of Complexity*—all have special significance.

Montano: What have you learned from your work?

Stelarc: Nothing in a systematic way, ha, ha! But I think learning in the arts is not so much an accumulation of information, to adapt better to situations, but rather a sensitizing process, which heightens awareness. Consequently, it is more difficult to evaluate—it's not a quantitative process but a qualitative one. The suspensions and *Third Hand* events have created an interest for me in the nature of mind, in possibilities of modifying the body, in a desire to formulate a meaningful philosophy of technology, and in the plotting of postevolutionary strategies. What has become apparent is not the potential of the body, but its psychological and physical limitations, its inability to cope with deprivation—cold, pain, and stress—its delicate survival modes, and its inadequate sensory and cerebral capabilities. And its obsolescence amplified in zero G. The suspensions have never been a shamanistic power play with the body. What the events have done is to demystify and demarcate the body's parameters. There is this heightened realization that the body, in many ways, is poorly designed. When I refer to the body, it's the total system I'm talking about. I don't deny mind. But I have become more sympathetic with logical behaviorism, central state materialism, and functionalist approaches to mind rather than Platonic, Christian, and Cartesian dualist theories. Mind has no form. It is a function. Yes, perhaps this is merely a mechanistic model of mind. But I think it's the only plausible one at present.

Montano: Where is it leading you now?

Stelarc: It's not as simple as that. It doesn't have to lead anywhere. Then again, at any point in time, multiple approaches become possible. Going in one direction should not deny another. Sometimes working on different things in parallel may produce interreactive and synergistic

feedback. Acoustically amplifying and visually probing the body were done simultaneously with body suspensions using ropes and harness. The *Third Hand Project* was actually begun a little before the first suspension with hooks into the skin ten years ago [1976]. It is not the most recent work at all! I guess the suspensions affirm the limitations of the body and assert the primacy of gravity in our evolutionary development, while the hand events point to possible modifications and increased capabilities in our posthuman phase. Redesigning the body now becomes possible, both with technological implants and genetic tampering. But our general strategy should be to hollow out the human body.

The present organization of the body is unnecessary, and because of its lack of modularity, it is difficult to replace malfunctioning parts. The body is mass-produced, but with no interchangeable parts! Plugged into a planetary ecosystem, the body flourishes, but off the earth its complex structure is difficult to sustain. The solution to modifying the body is not to be found in its internal structure, but lies simply on its surface. The solution is no more than skin deep! If we could engineer a synthetic skin that would efficiently convert light into chemical nutrients and could absorb oxygen directly through its pores, we could radically redesign the body, eliminating many of its malfunctioning organs. Our circadian rhythms reflect the rhythms of the planet. They do not trigger the appropriate behavior in zero G and extraterrestrial environments. The body will need to hibernate for extended periods of time and yet will need to be alert for critical moments. The body's circadian rhythms are simply too swift and regular for the immensity of outer space.

Leaving the earth also means bypassing a complex, interreacting energy chain begun with the synthesis of sunlight by plants. Our aim must be to design a more self-contained, energy-efficient body, with a panplanetary physiology and a transspecies mind. Imagine a body loco-

moting, sensing, and communicating in varying gravitational and at-
mospheric environments. In fact, it is now time to redesign humans to
make them more compatible with machines. It is no longer merely a
question of human-machine interface but rather of symbiotic systems.
Implanted technology can energize and amplify postevolutionary de-
velopment; exoskeletons can protect and power the body; robotic su-
perstructures can become hosts for a brain or body insert.

Remote systems and surrogate robots simultaneously present the
greatest potential and the most intriguing dilemma, for technology may
well become merely a sustainer of vicarious experience, exacerbating
the mind-body split. The penalty will be planetary imprisonment and
the loss of mobility, perhaps ultimately resulting in the atrophy of the
body itself. The problem remains whether surrogate robots can ade-
quately sense and collapse the time-space between the body and what is
perceived at a distance. Should humans be passive, earth-based master
controllers, sensing at a distance, or engineered extraterrestrial explor-
ers, inhabiting new ecological and evolutionary niches?

Montano: Any different or new values?

Stelarc: I seem to be less nourished by memory and more driven by
desire, by expectation, and by speculation. The future becomes con-
crete not merely by human imagination but through technological
simulation. In the realm of the artifact, we have created an environ-
ment of high-fidelity illusion. Technology is the machinery that mass-
produces and mesmerizes. Its intense radiation of information and im-
ages creates a flux of fantasy that overpowers the individual human
dream state, externalizing the subconscious. Technology transforms the
world beyond the emotion, imagination, will, and knowledge of man;
it quantifies and calculates beyond the human scale.

The importance of the body is no longer as an individual, no longer
as part of a species, but rather as a component of the technological or-
ganism. It's of no significance to be a self. I've become suspicious of the

realm of subjectivity and skeptical of solipsistic conclusions. It's not a question of self but of substance—not being a someone but rather becoming something else. I am not interested in self-analysis but rather in formulating ways of becoming something other than I am. In our posthuman and postplanetary phase, what's important is the body as an object, not as subject. The body as an object that can be accelerated, amplified, and redesigned. The problem with space travel is no longer the precision and efficiency of technology but the reliability and durability of the human body. It is now necessary to fine-tune the body to technology, both to widen into a window of sensitivity and simultaneously close the human window of vulnerability. Death does not authenticate existence! It is an outmoded strategy of evolving as a species. Neither birth nor death should be design criteria for the postevolutionary body. This is no mere Faustian desire. In the extended time-space of extraterrestrial environments, the body must become immortal to adapt!

Montano: What most illumined you?

Stelarc: The three 16mm color films shot of the inside of my body between 1973 and 1975. Ha, ha! To record fifteen meters for each probe, it was necessary to keep the fiberscope inserted for two to three hours in the body. The experiences were most difficult, nauseating, and painful, using cumbersome medical equipment. For the stomach and colon probes, it was necessary to inflate the body with air and flood the tracts with light. The traumatic incident in filming the first body probe was the discovery of a polyp inside the stomach. What began as an artistic experiment quickly deteriorated into a medical melodrama. The doctor had to perform a biopsy there and then. With the insertion into the large intestine, I could handle the camera myself, peering and probing the ninety centimeters into my body. It was a weird feeling, penetrating and examining yourself. To film the inside of the bronchia of the lungs, it was necessary to first insert a hollow tube through the

mouth into the trachea to be able to guide the fiberscope into the body. The total internal space filmed—approximately 2.4 meters [almost 8 feet]—exceeds my height. It was the wetness, simplicity, and softness of the internal structure that was the most startling for me. And of experiencing light for the first time, illuminating within and spilling out of the mouth. The difference between the Renaissance and the twentieth century is the difference between pointing and probing physically. Technology orbits, lands, and now invades the body itself. Evolution ends when technology invades the body.

Montano: What do you want to be remembered for?

Stelarc: The question betrays a concern and a craving for social acceptance. I guess we all do in different ways, but it's not a matter of what one wants, although it has become a problem of the nature of memory! Cultural memory is recorded history. But cultural memory is no longer meaningful if history has ceased to be a record of the past. History is now manufactured in the present as if existence were affirmed only by being recorded, as if importance were evaluated by your positioning in history. What is necessary now is not to be remembered but rather to be forgotten. It's time to transcend human history, to attain planetary escape velocity, to achieve posthuman status. It's no longer important to be plugged into on this planet, to evolve as a species, or even to remain human. To be remembered is to remain embedded in human history. The body must burst from its genetic, cultural, and planetary containment. It is time to vanish, to be forgotten in the immensity of extraterrestrial space. It is time to depart and to diversify—in form and function.

Montano: How do rituals from your homeland affect your work? Or rituals from Japan?

Stelarc: My parents are Greek; I was born in Cyprus, grew up in Australia with Italians, Maltese, Yugoslavians, and Jews. Since 1970 I have lived in Japan. My wife is Mexican, and my children are beginning to

speak English, Spanish, and Japanese. And I travel regularly. Cultural and ritual influences are complex, superimposed, and subtle, sometimes exerting influence singly in short durations and continuously in multi-faceted ways over longer spans of time. I am not overtly eclectic in my approach to art or life, so it's not easy for me to pinpoint particular influences. It is difficult to honestly analyze and state what cultural patterns affect my work at any specified time, with what intensity, and in which direction. What is apparent in Japan, though, is the group mentality and energy—this delicate interplay between traditional ritual and technological performance, a hybrid of human gesture and machine efficiency.

ELAINE SUMMERS

Montano: Were there deaths in your childhood, or were you close to that in any way?

Summers: Death was a lie told to a two-year-old. It was a masquerade, a make-believe escape. My mother, re-creating herself as the poor widow, justifying abandonment. My brother, Johnny, not believing, never believing our father was dead. Me, feeling the loss. A lost father. If you can't find your father, what can you find? My mother's friend Jean, that was a real death. Jean was a young woman. Knowing she was dying from tuberculosis. I remember her giving me a box of beads and teaching me that I must never use metal in caring for my fingernails—I must use an orange stick, which she showed me in great detail the how of it. But what if there really had been a reappearance of the long-dead, undead father? Was that Johnny's wishful thinking? Johnny's disorientation, near-death of the mind, resurfacing to the mind the death lie. Anyone with any sense could have figured it out. Magical acceptance of disparate conflicting tales. Finally surfacing that the father had not died.

Montano: How did that affect your concept of play? Did you see it as potentially dangerous after that? What about your ideas about death?

Summers: Ring-around-a-rosy—ashes, ashes, they all fall down. Beginning at three in a convent school. I remember girls fainting there. One girl, tall and slender, fainted in chapel. But I, so sturdy and unromantic, never fainted. I admired her delicacy, but then she died of a hemorrhage. Later, everyone, all the little girls in the convent school came down with a kidney infection. Some died. Half of the kids died. Having escaped from death, I remember sitting up and seeing my feet. The nuns encouraging me to walk. The nuns walking with me and teaching me how to walk again. I must put my feet down, toes to touch the ground first and then roll to the heel.

Montano: Did you ever meet your father?

Summers: No. Is he dead? I wonder. Will he die? He was a terrible man, a con man. Romance and adventure, offering travel and desertion.

Montano: How do you see that you are using that childhood material in your work?

Summers: Fainting. I see a fabulously romantic girl with white hair and pink eyes fainting, then dying from hemorrhaging. But others, like me, are too earthy, too solid to faint.

Montano: Did you choreograph fainting into your performances?

Summers: I was involved with exploring falling. Not real danger but symbolic danger. *Fantastic Gardens* refers to death. Its evocative text created by Jim Wilson, using the chance method—an open invitation for words. Lines for men in black tuxedos, bare feet, white gloves, black evening-gowned women. One woman in white. All end up in a pile in the middle of the church floor. All dead but not dead. The audience asks, "What does it mean?" They know a story; they tell a story, whatever they wish. Everyone is fantasizing, projecting the performers, the performance. The dance is an object for projection. The title of the dance within *Fantastic Gardens* is "Projection Piece."

Montano: Have you made peace with the fear of death?

Summers: I think it comes through onement with everything. Meditating while rolling on balls. Entering a dream state, sleep but not sleep. In a real dream I imagine walking into a blue, sparkly ocean. The sun is shining and I think I will drown, but that is not terrible or frightening—to die is to become part of the ocean. If you eat a lobster, the lobster becomes part of you. If you're eaten by a tiger, you become the tiger. Transformation. This life into the next.

Montano: You have intimate contact with a lot of people in private work and in performance work that you do. What is that about?

Summers: I enjoy that kind of closeness because I find people fascinating, and I receive a lot of love as part of that, receive a strong sense of life, and get to touch deeply into people's humor and life spirit. Now I am preparing to try to write about the work and am setting up a kinetic awareness art center with certified teachers, because there have been some people studying with me for ten to twelve years, and they are all extraordinarily well developed in terms of knowledge of anatomy, psychological training, and kinetic awareness. I feel that it is wonderful that they are ready to do this work. And it is difficult work. You need a lot of resources to do it. And a lot of understanding.

Montano: Why did you choose to talk about death?

Summers: I think that I am much more aware of death now, as it approaches, and I think about what I want to do with the rest of this life. That makes every day become more significant. I always had the fantasy that when I reached sixty, that between 5:00 and 7:00 P.M., the most difficult hours of the day, I would have a salon and drink black coffee and cognac, and everyone would do some art form that they always wanted to do but didn't have time for because of the demands of life and their other work. I fancied myself reading poetry and playing the Japanese koto. I told someone this fantasy once when I was fifty and he said, "You had better not wait until you are sixty because you might not get there."

The thirty-three years that I spent in New York City have been wonderful. I feel very grateful and privileged that I have been able to do as much work as I have, even though I've complained a great deal, as we all do, about the fact that, as an artist, you have to subsidize your own work with your time, energy, and money. And there is no rainbow with the pot of gold at the end of it. It's uphill all the way. But I got a lot done, maybe not all that I wanted to, but a lot. So I'm content with that part of my life and am looking forward to the Museum of Modern Art's presentation of my film dance in April 1987.

New York City is a stimulating place and a center where you have so many friends who are as avidly, passionately involved as you are. That is rare and wonderful, but I feel that I can't do what I need to do for the last third of my life here. I need a place where I can have more time. I want to go and dance every day. I want to do kinetic awareness every day. I sacrifice those things when I'm rehearsing, when I'm trying to do administrative work. In a sense I am going toward a death of one phase of my life. I think that we all have to think about living to ninety and living to that age with your life force strong. You have to plan what you want to accomplish in that last phase, the last thirty years, because so many of us are going to live that long. There is a genetic, built-in time sense that we have, and we have to expand it because we are living longer, to ninety and one hundred. We need our intent, we need our will to claim that time.

FIONA TEMPLETON

Montano: How did you feel about death as a young person?

Templeton: I woke up on the grass, maybe too late for the sea behind our heads. One's friend was cleaning the room. Two's mother said, "No, Fiona does that." Why was I lying with two when he had no morality? But it was three, that was good, though he hadn't yet

invented his mortality. It was easier to say. Say his death easier than his life, because easier for him.

Montano: In your childhood do you remember a death experience?

Templeton: A child's old people die.

Montano: Are you dealing with or letting go of these issues in your work?

Templeton: In *Thought/Death* they all love Death because of the stories and drama. Stories are something changing. Drama is the change. I die fifty times. The essential event. No other story. In *Thought* I'm there, me not pretending or pretending not to, doing something, not being watched. The two parts are opposite. Opposites are things that need each other but can't meet.

Montano: What in your life prepared you for death?

Templeton: I sleep a lot; like death in life, except I dream. I wake up and sleep again, to know. So dreaming you do something—make your sleep life, your life death, invent your mortality.

Montano: Is your work what you want people to remember you by, or does it help you change personally?

Templeton: The work changes or finds me. It's the best expression of that part of me that makes it if it walks away. After I make, I feel more whole with and thus without it, yet if I'm not in life as I want, the hole shows in the work. The work can't answer the life because the life can't lie to the work. But the lie is true two ways. The truth is necessary to the life, though the truth is not necessarily what you mean. There are things you can't say because they will be understood, and trying to say them feels like lying. Saying them in secret, though, to find them, feels like inventing the life, so lying.

Montano: Has anything happened in the last seven years that made you aware of death?

Templeton: Five years ago my father died. I stayed with his body. He had had a stroke, so one side looked dead. The side that faced the wall

had an open eye and an expression, so I climbed over the body to look in. I couldn't believe that he wasn't still there. I couldn't think where he could have gone. After the body left, I was alone there, thinking I must write of his death if my writing had anything of life. I had to go into my old bedroom, where he had lain, to think of what I couldn't think of, not with a thinking that was like touching, not even an absence like elsewhere. I was afraid to go in, with fear of a presence, of a demand that I could not meet, to know and to go with. After hours against myself I opened the door and found nothing. He wasn't there, he was in me, and that is where people go when they die.

Montano: You are concerned, then, with the idea of death, since it is the most important act in your life?

Templeton: I don't think of death itself much. Mortality is not death; it's a condition of life. I'm glad to be mortal. Perfection would be an end. Art is not divine. Death is not the most important act in your life, it's its necessary opposite event; even killing yourself or making yourself sick, as most of us do, is your response to life.

Montano: Coming from a more traditional society—England—do you feel the helping role of ritual in situations such as death?

Templeton: Ritual has been automatic and gave answers that seemed to have no questions, or I still asked. Automatic form distracts from what it holds. But that's what it's for. Americans are jealous to create rituals, so think about them more, make symbolism a task until ritual only symbolizes the need for tradition.

Montano: Do you feel that you will have to deal with death in your future work?

Templeton: One's mortality is not the death of many. The telephone horoscope promises romantic meltdown. The threat of no more humanity can't be thought. It must be more of a metaphor than death: not, not me—simply, not. Nothing, like everything, without its opposite can't be thought. The threat is a lie I circle under.

MIERLE LADERMAN UKELES

Montano: I saw you for the first time in 1980 at Charlotte Moorman's Avant-Garde Festival, so let's start there.

Ukeles: In 1980 I had just finished shaking hands for eleven months with eighty-five hundred sanitation workers. It involved facing each one bodily and saying, "Thank you for keeping New York City alive." It was a ritual and a discipline for myself because I intended to mean exactly that as I faced and spoke to thousands and thousands of people. That was my own private goal: to watch myself very closely so that I wouldn't turn it into a mechanical thing. And I didn't. I proved to myself that I had ritual strength. It was not even hard because there was so much response from those people that I met, and that carried me. It was a very positive energy field that I was in.

But it was also difficult because I heard a lot of bad things from sanitation workers. They told me that people thought of them as animals, cockroaches, mules. They said that their families would never tell anyone where they worked because of the stigma attached to their jobs. I also found that their work was demanding in other ways, because they are exposed to all kinds of weather, and that is a discipline in itself. The other difficulty for me was the strain of seeing different human beings all the time, and I was frightened by having to come into new situations. But mostly it was hard having to listen to people who were feeling so bad. As a result, I went through a depressed, sad stage until I reached a point where I said to myself, "This is ridiculous," and I started getting pissed. It was then that I told the sanitation workers, whenever I went to a new group, "You are getting a very raw deal."

Part of the hand-shaking performance was called *Follow in Your Footsteps*. I followed along in back of the garbage trucks and simply copied the motions of loading garbage, putting myself in the same mode of experience, of correspondence with them. It allowed people to see me,

and if they had any negative feelings about sanitation workers, then I wanted to mirror that and become as stigmatized as the workers.

When you saw me in 1980 doing that performance, I was completely unbalanced because I felt that I had absorbed eighty-five hundred volts of electricity through my right hand from shaking that many hands and that energy was residing inside of me. I needed to pass it along. I needed to send the energy back out to the people because it was always for them. I was the medium, the battery that had to get rid of some of that energy or I would explode, so I did this transference of energy out of my other side. And because the festival was on the water, I felt that I could turn my body into this wave-making mechanism.

Montano: What were your rituals as a child?

Ukeles: I grew up in a very ritualistic culture. My father is an Orthodox rabbi, my brother is an Orthodox rabbi, my uncle is an Orthodox rabbi. A lot of rabbis. An enormous amount of learning. Unending learning that never ceases. But also discipline and ritual. That was natural to me. I grew up that way; I liked it. On the other hand, I had a very free childhood. I played a lot. My mother let me do that. I was always outside playing with my friends, and my parents used to drag me in. My mother appreciated it; she felt that I was doing something by playing. I've never talked to her about this, but I feel an enormous gratitude to her for allowing me to play.

She didn't start school until she was twelve, so she had a free childhood herself. This was because when she was two, she ran away from Russia with her mother, baby sister, and grandparents. In Cuba they tried to send my mother to school, but it interfered with her play, so she ran away from school, and her mother didn't force her to go back. Of course, that affected me.

My own play was very ritualistic—a combination of mother and father, I guess. We would put on dramas and plays about slaves getting freed, which I'm sure was related to the fact that I am Jewish. That part

of my life was very simple. But it wasn't simple being a rabbi's daughter, because I always felt that I was being watched. As I say that, I see some connection to that and being a performance artist. People in the community kept an eye on me, and I was supposed to be an expert Jew and an example, even though my parents never said that.

Montano: When did ritual first appear in your work?

Ukeles: My art then was very private and expressionistic. I discovered that the act of painting was a true ritual action. Then I started making environments by wrapping cheesecloth, tying, knotting, and stuffing the resulting forms so full, to the point of bursting; then I would pour paint over them, in them, through them. This work got me in a lot of trouble because the dean—I was in graduate art school then—said that I was obviously oversexed and that the art was pornographic. I knew it was a new kind of art that rose deeply from within me, that unleashed a ritualistic form-making power in me, and they were rejecting it. So I left school.

I guess that it was too early historically for me to get a lot of help from anybody else or to fight back very long, so I withdrew, knowing that I had locked into a ritual mode. It was more than art that I was doing—it had to do with ancient and primary energy. It opened up secret doors. In Judaism there are prayer shawls to wrap into and lots of ritual knotting, although that imagery has been for men, and that's a whole other story. But I can't deny that Judaism gave me a good background in ritual, in rhythm making. Also Jewish ritual has an amazing capacity to mediate time. It can swell the present moment, suffuse it with multiple meanings, and it also opens the present to the past. Ritual makes the moment very conscious and yet knocks out the boundaries of the moment. I relish doing an action—waving a *lulav,* a palm branch, knowing someone did this two thousand years ago at the same moment in the year to celebrate the same historical passage.

Jewish ritual taught me, although this is a great time of gender ferment, to not feel wiped out when inside a larger group. Group con-

sciousness is social consciousness. To aim for community and the act of being in community is spiritual. These theories have deeply marked my work, but this is totally misunderstood. Of course my investigations of ritual were feminine, more open-ended, nonformal. And I discovered, with other Jewish women, a new aspect beyond the patriarchal themes of this religion, since women have a deep bodily knowledge of cycle because of our lunar correspondences. We have a lot to offer, an enormous amount to offer, but the traditional Jewish religion doesn't know how to deal with it all and is having a hard time.

There is a developmental immaturity in Judaism that verges on idolatry because they are not moving beyond the idea of seeing God as male. I guess that Christians and Muslims are in the same mess. What is interesting to me in the traditional forms, and the reason not to dump them altogether and take a walk, is that there are ancient truths in some of the Jewish rituals for women, which have been isolated, encapsulated, and repressed in that structure. *Mikvah*—a ritual immersion bath—is one of them. Many women abhor it, thinking it so primitive, but I know that it is phenomenal and keeps ancient matriarchal religions alive. It's interesting that Judaism didn't get rid of it. I've recently been called a licentious idolater by a group of great rabbis, along with some other women like me, so I guess that we are in a heavy situation.

Montano: When did you come to think of sanitation as an image, and why?

Ukeles: First of all, it's a ritual image, going from dirty to clean. It's a power image, but also it came out of a long development with maintenance imagery, that is, it came out of having a baby and feeling split into two people: the artist and the mother. I felt as if I was doing two different things, two conflicting things. The artist always has to make something new, and the mother always has to keep doing the same things. I didn't like being separate people, so I said, "I'm calling necessity art. I am now a maintenance worker, and since I'm the artist, I'm

also the boss, and I get to call whatever I do art. Therefore, maintenance is art."

What's nice about art is that everyone is their own boss. We have to give that information to others. In 1969 I decided to call it maintenance art, and eventually I did pieces about larger and larger systems, going from personal maintenance to city maintenance to earth maintenance. The questions I was asking were: "Does this take away our creativity to have to do this repetitive work, which is loathsome and boring and makes your head go dead? And how does this kind of repetition link up with ritual actions, which are also repetitive but don't freak me out?"

What I found was that there was a way to link the two ideas, and I did that by asking questions: "Am I doing this with no mind? What am I supposed to do with my mind? Is this why I am here on earth? Is this to be done by humans when there is a machine that can do it better? If someone else is doing it, are they worse than me? How can you have a democratic society when some people are lower? What do you owe people who do this?" I have a great ambivalence about maintenance. I am not a priestess of cleanliness; in fact, cleanliness makes me very nervous.

In the concentration camps, the first words that people read were "Wash Room," and they were told, "You will come here and you will be cleaned." And when they walked in the room, they read another sign, "Work Makes Freedom." That was the goal of the twentieth century, and, of course, the biggest lie of all. So cleaning up makes me nervous and is often a mask for not talking about what is really going on.

I feel that it is essential to preserve freedom so that you are always asking, "Should I do this? Is this necessary? Why is it necessary? Maybe it shouldn't be done at all. Is it to keep the city alive?" I found that to be the reason, and it gives my action validity. And, therefore, if I am a sanitation worker keeping the city alive and you have a life in the city, then you owe me if I am doing that for you. Now we already have a

relationship, even if we haven't spoken, and if you call me garbage man, as if I am the garbage that you threw out, then you've gotten it wrong. It's just a wrong understanding. So by asking these questions, I have been able to find a way to correspond ritual and mundane life actions, and that's as far as I have gotten. But still I reserve the right to say that maybe no one should be doing this work.

Montano: Have other images emerged? You have an office in the sanitation department. Will you continue there, and does it affect images?

Ukeles: I didn't come here because of a primary interest in garbage. I came because it is the biggest maintenance system in the city, although I have gotten interested in garbage since I've come here. If there was another public system that was maintenance-oriented, I would do that. But it has to be public, because that means everyone owns it and has a right to deal with it.

There is another aspect to my work: *The Machine Dances.* Often people like them much better than the heavy-duty work. I've done three so far: a *Ballet Mécanique* with six mechanical sweepers, a *Barge Ballet* on the Hudson with fully laden barges and tugs making a spiral pattern clear across the Hudson tides, engaging the great power of the water. The third piece I just completed in Rotterdam. I choreographed six garbage trucks and four tiny sweepers. The Futurists made paintings about this kind of stuff. I'm really doing it with the sanitation people, because I know this great secret, and that is that they are such experts and do this all day long, only I move away the rest of the action so that you can focus on it.

I need to finish several more works. They are about open land in the city—by that I mean nature in the city. The land has been poisoned and needs healing. Rivers serve as a support system for garbage flow. To maintain a city, there must be flow, in and out, up and down, around and around. That's where ritual comes in. To reimagine the common ground. Then I can leave for the subways.

WILLIAM WEGMAN

Montano: Did you have any early childhood death experiences?

Wegman: The first experience that was framed was when I dug my grandmother a grave behind my parents' house in the blackberry patch and filled it with broken glass. She died about ten years later when I was fourteen, and I had a lot of recurrent dreams about that.

Montano: What was it like with your father being a POW?

Wegman: He came back, and I was told that.

Montano: What motivates you to do your work?

Wegman: I was drawing and painting as a child. I was good at it and rewarded with praise. Then I gave it up during my early teens.

Montano: You made up stories during your youth?

Wegman: I was very, very shy, and also I had trouble getting waited on in restaurants and bars. I never got any good attention. So I made up stories, even told true ones and elaborated on them, and my friends would say, "What was that?" and in that way I got attention.

After I started making videos, I thought of that story about the prow-headed family in Maine. All of the children had heads shaped like the prow of a boat. They were very weird-looking and lived in the backwoods of Maine. Many years later I found out that they were studied by Harvard Medical School; that they had extremely high intelligence; that the parents were art historians who would play tricks on people; that they owned antique shops and would put one of the kids in an antique coffin, and they would pop out, "Boing!" when people came into the store. Scary.

Montano: What was your relationship with your dog like?

Wegman: I had two dogs as a child, and then I got one with Gayle [my wife] at the time that I was doing photography and video in California in 1970. He would get in the way in the studio, and so I started using him, but I didn't know how great he was until many years later. He was actually a professional and got to be that way just by working.

Montano: How did you work with his death?

Wegman: I heard about it on the telephone. I was in New York. He was in Angell Memorial Hospital, going for an operation at seven in the morning. I walked into another room after I heard it and didn't feel anything at all. Then I had a dream about plastic bags, et cetera. He was eleven years old. I cried for a week. I've had other dreams where he comes back to life and helps me with my art world problems as a deus ex machina. He appears as Mexicans or women. He comes back for me. When I started to paint, he said, "What are you doing that stuff for? Let's make photographs."

Montano: What is your direction now?

Wegman: The emphasis is on painting. But I am also making photos, tapes, and films. Too much.

Montano: How do you feel about death now?

Wegman: Being in my forties, I am more concerned with getting things done. Also, I'm more particular about my time than when I was younger.

PAUL ZALOOM

Montano: Do you remember any childhood rituals?

Zaloom: The main one was eating breakfast in the morning, getting dressed, having to wake up, eating toast, brushing some hair, and then schlepping to school—walking a mile to the school bus unless we could con my father into driving us. That was the ritual. Plus doing the homework on the bus.

My father was Catholic, my mom an Anglican, so those were two different schools on ritual. The Anglican was low church and the Catholic was high church. My mother was British and spoke the King's English, but the harder English edges have gotten whacked out of it; she still she speaks an Americanized King's English, or I guess you

could call it Queen's English. My dad is Syrian, and the Syrians got whacked by some Crusaders a long time ago so that they got turned on to Jesus way back when. Supposedly there is this Zaloom family tree in the Shouf Mountains, which dates back to the thirteenth century and was painted by some Zaloom monk a couple hundred years ago. That's what my friend Joe Zaloom, a distant cousin, tells me. He's in showbiz, too; he's an actor. But, anyway, my dad dragged us to the Catholic church for God knows how many years, and I went to catechism and all of that. The Palm Sunday thing was neat, when they gave you the free palms as you came in, but the drag of it was that it was an extra ten or fifteen minutes on the service, and we were always itching to get out of there. But the thing that was great about it was that they waved around this burning pot of frankincense and it filled up the whole church with the smell.

The church was designed so that it had the worst acoustics in the world, and you would get guys up there who would give a sermon that was incredibly bad, because they were cantankerous and had no idea what was going on, and they'd get up, act pompous. The bishop was the worst, because the higher you get, the more arrogant they get. Finally we came of age and could tell my father basically to stuff it, and so we didn't go, and my father, who also found the whole thing pretty irritating and hypocritical, stopped going. I think that has prejudiced me pretty strongly against that type of ritual, because I associate ritual with religion, which right now I don't feel that close to and am actually intolerant of it. I really don't like organized religion.

Montano: Is your work ritualistic in any way, and if so, when did it become that way?

Zaloom: I don't know that it is ritualistic to view—well, it is because there are certain elements that repeat, and that frames it. There is a dance that happens. If you frame it in a certain way, in a certain con-

text, then it might appear ritualistic, but I'm more aware of the ritual that I go through preparing for the show, performing the show, and after the show. The ritual is that I do the setup myself, working from a list. If I am doing a run at one place for a long time, then I go in at the same time, lay out the stuff, check out the prop list, make sure that the several hundred objects are all put in a certain way and at a certain place so that I can have them in my hand in a second without looking at them. That is really something that other people can't help me with; that's my little ritual. I like doing it because it puts me in touch with the physicality of stuff—I've never understood actors who have people set up for them, a prep person putting the gun here and the hankie there. Why? The performers use the gun and the hankie, so they should know where it is; they should put it there because that's their reality, that's their thing, that should be their job.

I'm also, to varying degrees, superstitious, and I associate that with ritual, maybe because it's on the same plane. I'll get into these things where I'll invent a superstition and go along with it for the moment, stick to it for a while, or maybe I'll get bored with it and just take my chances and break it. The theater has a lot of superstitions, but I find the baseball ones even more interesting. I don't buy a lot of the theater ones, like you can't look at the audience before a show! That's a lot of hooey—I look all the time. Then again, I've had lousy luck, but—who knows! Baseball is the greatest ritual there is. For example, somebody from Boston, a guy named Boggs, is having a great year and hitting well—all he eats is chicken and has been eating chicken for seven years. You know, that's really great, and I think that the guy has written a frigging cookbook because he won't eat anything else and he's an expert on it. Other guys won't step on lines in the field. There are hundreds and hundreds of things like this. There are guys who have worn the same shirt for years. And the sport itself and the ritual of them warming up and running around and playing a hundred sixty games in

the season allows them to have this constant repetition. Talk about a ritual in that respect!! In the routine life aspect, theirs is incredible.

Montano: What do you think is the purpose of that routine? What does it do to the mind?

Zaloom: The purpose of it is to get ready; it focuses the mind. I would think that a professional ball player would have the same attitude that I have when I'm going to perform. I want to be in top physical and mental condition for the performance, which means going to the theater with enough time in advance to be able to lay out the props, check the lights; doing whatever little bullshit; going into the dressing room, putting on makeup; doing warm-up exercises; going into the wings and hyping yourself up; and going out there. I hype myself up by taking a couple of deep breaths, or I'll clench my fists, or I'll say, "I'm going to kick their ass." Something ridiculous, a Rocky type of thing. It's sort of gross, but I really want to pump myself up. My work actually is very fast and requires a lot of attention. I can't be asleep at the wheel. I have to keep really on the ball.

Montano: Where did you learn your concentration?

Zaloom: Just through doing. Also through Bread and Puppet Theatre, where I worked. Talk about ritual! Christ, that's very ritualistic, and of course draws on Christian myths and other Western stories. We had setup rituals, and everyone knew what they did before the show. We didn't do warm-ups there; I've added that to my work.

Montano: What does your work do for you?

Zaloom: The concentration serves the performance, hopefully, and makes it sharp and not drowsy. But concentration is something that you can't concentrate on having; it either is there or it isn't. I can't seem to push it. I try to set up the ritual so that it helps to guide me in the direction of concentration, but I can do parts of the show and be thinking about something else, and that is not right; I'm not happy with that. But there is no way to control concentration. You can't say,

"Go away, little nasty thoughts." I realized through experience that if I wasn't concentrating, I was going to blow it, or it was going to suck, or something would not work well. It's much better to be right there and try to get up above it so, let's say, if something goes wrong, I don't have to think in order to get a big laugh. It's like the guys who surf with surfboards—they get ahead of the wave. That's the way that I want to be with performing, just in front of the wave so that I've hit that plane where you are flying. Do you know what I mean? You are out there. And there is no thought involved. Just a very pure kind of thing.

Montano: What is your training?

Zaloom: Fifteen years on and off with the Bread and Puppet Theatre and then working a couple of comedy groups, solo work, national tours, and ten European tours. From doing all of that, I found all of this out; I was never trained. When I was twenty-one, I started this process, stuck with it, and that's it. It happened over a period of time.

Montano: Your mother's elocution helped you, no doubt.

Zaloom: Yeah, either that or I talk this way because I'm high on my nicotine gum. It's supposed to keep me from going bananas. Ritual! There's another ritual—cigarettes. I smoke Camels, straight, and I have this lovely little blue case to carry them in. I mean, I smoked, until today. And I love that ritual—buying the pack, tapping it down on my hands, sliding them out, smoking. That's one that is going to go by the wayside.

Montano: What do you think that the churches and institutions did wrong so that ritual became less attractive to us and made us have to be artists and make up our own? Or another way of saying it, what do artists do right?

Zaloom: I don't think that the bishops have the ritual wrong. They could make the services more entertaining, I suppose, and they tried that with Vatican II when they brought in the guitars and tambourines,

but they probably made it ten times more boring. What do artists do right? I don't know. Bread and Puppet does an annual event, and images repeat themselves. About ten thousand people come for two days to this twenty-acre outdoor stage, walk around, and see different spectacles all day and night. There are certain things that they know are going to happen every year. At the end of the pageant they know that a half mile away, those little white birds are going to appear over the hill and fly across this whole landscape and disappear up the road. That one thing unifies it. [Peter] Schumann's work is about death and resurrection. He repeats those themes. And at the end of the shows he hands out bread to the audience. That's as ritualistic as you can get. It's a real Catholic deal—it's like communion, but instead of those little wafers it's this sourdough bread.

Montano: What are your daily life rituals?

Zaloom: I really don't have them because of the nature of my work. I don't have rituals. I don't have a regular bedtime or wake-up time and actually never have since I've left school. I guess that shows how enamored I was of those rituals. I hated the routine of that time. Now, I get the mail. In a way I yearn for it and like the dependability of that kind of regularity and the nine-to-five scheduled life. Walking down the street and seeing the same people going to work every day is comforting. But I also have a tremendous love of going to weird places and being stuck in somebody's couch in somebody's living room—and going through that whole adventure. And having to not get lost. Day or night. The task is to keep my bearings, stay on the ball, work all day, do the show, pack it up, and go to the next place without fucking up, without leaving one of the couple of hundred props behind, or forgetting to put it in the right place. That becomes life as ritual. I'm dedicated to trying to get it right because I don't like leaving things or forgetting things. It disrupts the ritual of doing my job, which is to do a perfect performance every time, which is impossible. In fact, it's impossible to do that even once, but I'm always trying to do that.

Recently I did a run at the Dance Theater Workshop. Every night I was disappointed with the performance because we still hadn't hit the perfect performance—this was in a group piece. And yet I looked at a tape of what I thought was one of the lousier performances and actually found it quite delightful, and I liked watching the show quite a bit more than I did being in it. So I think that it's a phony guilt that makes me dissatisfied, never being satisfied with anything, self-flagellation, that whole routine. At one point, I celebrated and said, "Yes, this is good." Before I did this analysis, I used to have more bad performances, and now they are generally good, and it's quite unusual if there is a lousy one. Now there is more discipline and attention and more caring because I really don't like doing lousy performances. It pisses me off. But I don't do this for spiritual reasons. The Catholic church really turned me off to trying to find out that kind of truth. I had friends who were into Buddhism, and I asked them to tell me what the truth was when they found it out. But this is my way.

ELLEN ZWEIG

Montano: How did you feel about death as a child?

Zweig: I used to have a recurring dream that I was dead, and that all of the things that I wanted, my father was giving to my sister. While I was looking at a photograph of a dead person, I realized that it was me who was dead. Other than that, I didn't know anyone who had died, and I didn't have feelings about it, although my grandmother died recently at the age of one hundred three.

Montano: Is that what got you interested in Alexandra David Neel, the French mystic who became a Tibetan nun? Wasn't she very old when she died?

Zweig: I'm interested in Victorian lady travelers and was reading about Alexandra, and yes, that was actually at the time that my grandmother

died. Alexandra lived to be old also, about one hundred one. My grandmother traveled from Russia to this country and never traveled again and was, in fact, the exact opposite of the traveling ladies. She hardly ever went out of the house and lived in a very small world. Alexandra was quite a traveler. The piece that I do about Alexandra, *We Must All Be Explorers,* is, in a lot of ways, about death. Parts of it are based on *The Tibetan Book of the Dead.* In the piece I don't act; rather, I bring Alexandra alive. I don't like acting. I don't like the idea of pretending to be somebody else. The only way that I could dress up as Alexandra or as a Victorian lady was to think that she had come alive in me for the time of the performance. She inhabits me, but I'm myself too, so it's a complex merger and relationship.

Alexandra was about my height and we don't look very different, so for her to inhabit me was simple. There wasn't that much change. I found her to be wonderful—she's feisty and strong. She's a writer and so am I. At the beginning of the performance, I'm sitting at a desk writing. I don't say anything. There are slides and music. At the end of that section I say, "I am not able to write anymore," which is what Alexandra said just before she died. I reverse it and say it at the beginning. Then I take her through some of the stages of *The Tibetan Book of the Dead* to be reborn in me. When I'm writing at the beginning of the performance, it is wonderful because it's a way of having the time to let her come and be part of me. The last line of the performance is "I have been alive again a few moments, beyond that, my friends, we must all be explorers." The piece was not only about exploring physical places but also about exploring the country of death. Alexandra talks about this in the speech that she gives at the end, which is composed partly from her writings. Some of her books that I used in researching and writing *We Must All Be Explorers* were books by her, titled *My Journey to Lhasa* and *Magic and Mystery in Tibet.*

Montano: Is this work preparation for death?

Zweig: I don't know. I'm afraid of pain and suffering more than I am afraid of death itself. I'd be afraid if I thought that someone was going to attack me and kill me, but the idea of death itself is more mysterious than frightening. I have no idea what it would be like. I'm not sure if the work is preparing me for something or if it's about history, the past, and about other people who are dead—about how I can make them alive. In some sense it's not about my own death but about others' deaths, about bringing the past into the present. My technique has become a way of bringing these ladies into the public, not by pretending to be them—but by actually being them. On the other hand, I don't lose myself. It's almost like I'm a double person. When I put on the Victorian costume, which I wear for all of the performances in my *Ex(Centric) Lady Travelers* series, I find that I say things that a Victorian lady might say rather than what I would say. I'm now writing a piece about a Dutch lady traveler, Alexine Tinne, who was violently killed. This piece is about colonialism and is more critical of the lady travelers. It is not only about the death of this woman, but it reveals how she and other travelers caused the death of different cultures by invading them with their values.

Montano: Are you afraid of evil?

Zweig: Oh yes, evil frightens me. I think that I have had a couple of experiences where I have actually encountered evil. It's not so much something that someone did, but a feeling that I have had, and I had to get away from that person. The experience was extremely powerful.

I also developed ways of protecting myself—like imagining a safe circle of light around me—and a way of holding my hands so that I could center myself. I just remembered that once I went to the Witchcraft Museum in San Francisco, and I felt something there very strongly. It was as if there was some evil lurking in the building. Maybe this is superstitious, but I think there's something real too. People who are evil have a charisma, although not all charismatic people are evil,

but you feel this power, and you feel as if it's gone the wrong way. Somehow in that misdirected power, that's where the evil lies.

For example, these Victorian ladies were pretty powerful, traveled around, and brought a kind of destruction in their wake because of the way that they invaded other cultures. Someone like Alexandra I don't see that way, because she tried to understand Tibetan culture in a deep way and didn't misuse the information. She, in some ways, became Tibetan, but not in a false way. She learned from the culture and didn't damage it as she went along. But the women I am researching now were cultural murderers.

Montano: Can you talk about the metaphor of travel in your work?

Zweig: It's a metaphor for being and living. A lot of it is about being alone and being lonely and the difference between those two. It has something to do with facing death, because essentially we travel through life alone. How do you do that without being lonely? How can you be alone in that essential way, because only you can experience your death? How do you reconcile that with a life lived with other people and a life that is not lonely? My fascination with the lady travelers is that they essentially chose to live alone and surrounded themselves with people from other cultures, which was another way of being very alone. For them it was a way of getting rid of their culture, even though they brought it with them. Traveling is about looking, taking the stance of the observer, and being an outsider. That stance can be intrusive and damaging to the culture that you are observing and to yourself, although it's fascinating at the same time.

I travel a lot to work and I dislike traveling alone, although I do it quite often. I also think of traveling as a metaphor for my life, whether or not I want to live it alone. I'm learning to not be alone, not to be a loner. In some ways the ladies are teaching me the opposite of what they did. They tended to run away from relationships, which is something that I don't want to do. It's ironic I'm attracted to them as sub-

jects. Like the ladies, I feel that I can take care of myself probably better than anyone else can, but now I'm beginning to know that I can travel with someone else.

Montano: Are you attracted by the techniques in *The Tibetan Book of the Dead,* or do you feel that as an artist you have your own techniques?

Zweig: The latter, although I've always been fascinated by the Tibetan way. I like categories and order, but I feel that the techniques from *The Tibetan Book of the Dead* belong to a different culture. I can't use them. The idea of the levels of dying, the bardo and the path, is very interesting to me. Death is not digital, it is slow; Tibetans treat dying as a process. In Alexandra's speech she says, "The Tibetans have the road map for dying."

Also it interested me the way that Gregory Bateson died. He explored different ways to heal himself and different ways to die and chose to die at a Zen center with everyone meditating around the bed.

afterword

QUICKSILVER AND
REVELATIONS

Performance Art
at the End of the
Twentieth Century

KRISTINE STILES

In his visionary examination of alienation in everyday life, Henri
Lefebvre summoned Baudelaire's counsel to artists "to confront the ev-
eryday—and even if necessary to tear through it to reveal the living
spirit enshrouded within, not above, or beyond, but within." But
Baudelaire, according to Lefebvre, failed to live up to his own charge.
Longing to discover the marvelous in the quotidian, the French poet
(along with Rimbaud, the Symbolists, and later the Surrealists) ulti-
mately discredited the ordinary, launching "a sustained attack on ev-
eryday life which has continued unabated up to the present day." For
Lefebvre, the search to discover the extraordinary within the ordinary
merely produced a "lining" to everyday life that abandoned daily exis-
tence, and the everyday required sustained and continuous attention.
"Even at this very moment," he wrote in 1947, "action, work, love,
thought, the search for truth and beauty are creating certain realities
which transcend the transitory nature of the individual. And the fact
that this assertion has become trivial, that it has been put to use too
often—sometimes to the worst kind of ends—does not mean that it has
stopped being true."[1]

Such a tenacious belief in the insistent truth of ordinary life de-
clared that what is lived has dignity and must be honored. Action in

art commenced with this affirmation of life. When performance artists made their bodies and lives the primary medium and means of visual expression, they irrepressibly brought into visual discourse the truth, beauty, and pain of the *actual lived circumstances* of everyday life. They confronted viewers with the *real* corporeal, conceptual, and psychological conditions of *actual* lives—lived and communicated through bodily actions. What was so unsettling about performance art was how simultaneously startling and banal visual confrontation with real action could be. For in performance art, viewers encountered a person who was actually doing something in the here and now, recontextualizing and reviewing the everyday by means of bodily action in and on the changing processes of life. Performance artists were putting into life-action conditions of work, love, thought, and the search for truth and beauty, as well as sex, food, ritual, money, fame, and all the other subjects explored in this book.

From this perspective, the most accurate theoretical context within which to consider performance art as a medium of visual production is the dialogue it vivifies between art and the real world. When Linda Montano invited me to respond briefly to her book, I was honored to write an afterword. I thought it best to lay out the broadest cultural framework for the impact of everyday life on performance art in the last two decades of the twentieth century. I propose four categories of experience that I believe largely shaped the context within which performance artists responded with their bodies to their time. First, the early 1980s ushered in the initial cases of AIDS, causing a global health crisis. Second, by the end of the 1980s, Mikhail Gorbachev's policy of perestroika resulted in a series of unprecedented international power shifts that permanently altered geographic boundaries and social relations. Third, the new electronic and biogenetic technologies that exploded globally in the 1990s radically affected the public domain, transforming the very structure and relation of information to knowledge,

providing a model for the reconstruction of the body. And, fourth, the planetary threat of continuous ethnic strife and warfare combined with impending ecological disaster imbued all these acts with an ever-present urgency. Because of the exigencies of a brief summary, I will only touch on these subjects in the hope that such provisional assumptions will inspire further exploration. I offer these comprehensive hypotheses in the spirit of both concluding remarks and an introductory preface to future research.

In 1993 Tim Dean conjectured that by the year 2000 some forty million people would be infected with HIV worldwide, a figure that achieved "the philosophical status of Kant's mathematical sublime [in being] so extensive as to be unthinkable."[2] Considering the global threat to public health posed by HIV, Leo Bersani's suggestion seems to be true. A fundamental "aversion . . . to sex" accounted, in large measure, for the tragic failure of people to respond appropriately to the AIDS crisis.[3] One group that did not ignore this crisis was the Coalition to Unleash Power, better known as ACT UP. This small group of gay activists formed in 1987 to perform strident media-staged events. Their direct actions enabled ACT UP members to cope with HIV individually and collectively to confront public fear and neglect of the deadly ramifications of the spreading AIDS epidemic. At the same time, the hysterical response by the Christian right to Andres Serrano's 1987 photograph *Piss Christ* dovetailed with the outcry over a proposed retrospective exhibition of Robert Mapplethorpe's photographs at the Corcoran Gallery of Art in Washington, D.C. The storm of protest against Mapplethorpe's photographs, especially the images of gay men in sadomasochistic sexual contact, exaggerated the alarm, dread, and panic already surrounding AIDS. It is not coincidental that the growing public awareness of AIDS, in part facilitated by ACT UP, made the visual confrontation with homosexuality and/or body fluids all the more loathsome and frightful.[4] While neither Serrano nor Mapplethorpe

practiced performance as his primary mode of visual expression, each artist used his body or body fluids as the subject-image of his photographs. Such practices aligned both artists squarely with performance art in a clash with both the state and organized religion over control of bodies.

One direct and aggressive response to the public condemnation of art that employed the body came from a small number of performance artists in the United States. Karen Finley, Holly Hughes, Annie Sprinkle, David Wojnarowicz, Tim Miller, Robert Fleck, and others set the tone and conditions for the broad public reception of performance art that took place in the 1990s. They were, however, culturally vilified for drawing attention to various aspects of suffering and debasement that paralleled the public discussion of bodies diseased with AIDS. Overlapping and continuous with this discussion, an underground, alternative performance culture emerged (especially in California) in which body piercing, tattooing, and sadomasochism joined the sacrificial to the sacred in the work of such artists as Bob Flanagan, Fakir Mussafar, and Ron Athey. Together with the reconsideration of sexuality fueled by the AIDS crisis, such performances encouraged and provided the material example for the rise in a score of theories of gender and sexuality, ranging from the emergence of "queer theory" to discussions of trauma and abjection. I doubt whether these wider cultural theories would have become so prominent without the broad-based cultural discussion of sexuality brought about by the AIDS crisis or without performance artists' attention to the everyday exigencies of the body. Similarly, artists not only in the United States but around the globe created explosive actions and environments for the consideration of difficult and probing questions about the relationship between public morals and state control of bodies. Elke Krystofek (Austria), Xu Bing and Zhang Huan (China), Orlan (France), Mary Duffy and Andre Stitt (Ireland), Lorena Wolffer (Mexico), Oleg Kulik and Afrika (Russia), and Kendell

Geers and Minette Vari (South Africa) all made performances in the last two decades of the twentieth century that examined such subjects as physical brutality and repression, abuse, masturbation, incest and rape, psychical and physical disabilities, and the human results of ordinary social, ethnic, and religious intolerance and racial violence.

While the antecedents for such actions in the United States remained the civil rights movement, feminism, and multiculturalism, AIDS galvanized attention to the body, becoming a catalyst for discourses on every repressed, suppressed, and disenfranchised condition and situation of the body. The positive effect of such a broad-based political discussion of the individual and social body was that formerly taboo subjects such as lesbianism found a space where open debate might take place. In Canada, for example, the lesbian collective Kiss and Tell presented *True Inversions* (1992), a performance with lesbian themes and simulated lesbian sex that sparked a yearlong controversy on arts spending in the province of Alberta.[5] The negative side of this broader forum, however, was that subjects like lesbianism would be disputed primarily in a context of abjection, disease, and marginality. Moreover, any lateral polemic on sexuality and the body moved the discussion farther away from HIV and the AIDS crisis.

The Soviet Union was dissolved in the very midst of this health emergency and broad-based social discussion of gender and sexuality. National and ethnic spaces across the world shattered when the Eastern bloc was liberated from Soviet hegemony. The seemingly sudden end of the cold war forever altered the East-West ideological divisions of the globe, causing a massive shift in the geographic organization of space.[6] Of the many events involving global relations of power that followed the fall of the Berlin Wall on November 9, 1989, two are of particular note: one anticipatory, the other repercussive, bringing the philosophical and human implications of these circumstances into sharp emotional and intellectual focus. The first occurred when a Chinese

student selflessly stood before the tanks in Tiananmen Square, momentarily stopping their advance during the suppression of the pro-democracy protests there on June 3–4, 1989. This student's heroic act required anonymity to protect him from further political repercussions, retaliation by the authorities that could have resulted in prison and brutal punishment. The second event was the thrilling vision of Nelson Mandela walking free on February 11, 1990, leaving the South African prison where he had been incarcerated for twenty-seven years and soon becoming president of his nation, then struggling to free itself from vicious apartheid, and, three years later, winning the Nobel Peace Prize.

These weighty world events liberated artists to act who formerly had been confined behind the Iron Curtain, had endured apartheid in South Africa, or had remained within the repressive clamp of Communism around the world. In countries where totalitarianism made it virtually impossible to do so before 1989, artists seized on the presentational medium of performance to express long-repressed, pent-up energies. This is not to say that Happenings, Fluxus, body art, and various kinds of ceremonies and demonstrations presented in the context of installations, land art, and Arte Povera had not taken place in Eastern Europe, for indeed they had, especially in the former Czechoslovakia. There, in the late 1980s and 1990s, performances by Tomas Ruller, in particular, were painful reminders of life in the former Eastern bloc. In Ruller's most visually compelling performance, *8.8.1988,* the artist set fire to the clothing on his back while performing outdoors in an abandoned, brutal industrial site. This action was executed nearly a year after the artist's passport was inexplicably revoked in 1987, the day before he was to depart from Prague to participate in Documenta 8. The revocation of his passport denied Ruller the ability not only to travel but also to perform at Documenta. His *8.8.1988* was a response to these events; it also took place on and commemorated the twentieth anniversary of the suicide of Jan Palach, a student who killed himself one

year after the 1967 Soviet occupation of Czechoslovakia. Such memo-
ries of the pre-1989 conditions of the Eastern bloc also came into vivid
focus in Hungary, where the pioneering conceptual and performance
work of György Galánti had been thoroughly repressed since the mid-
1970s. But after 1989, Galánti—who together with his partner Julia
Kalaniczay had founded Art Pool, the most important international
center for mail art—was able to open his comprehensive archive to the
world. In Poland, where Happenings and body art had been actively
created since the early 1960s, thanks to the pioneering efforts of
Tadeusz Kantor, performance continued to thrive.[7] Indeed, young
artists from all over the former Eastern bloc turned to performance.[8] In
Romania alone, even a short list of artists working in performance in
the late 1980s and 1990s is impressive.[9] In Moldova, especially under
the organizational brilliance of artist-organizer Octavian Esanu, perfor-
mance art became one of the primary mediums for the first generation
of experimental artists to appear in that country.[10] The situation was
much the same in Russia, where after 1989 younger artists began to
learn about the activities of the Collective Action Group (active in the
late 1970s and early 1980s). Performance art also appeared in Cuba and
the Caribbean in the 1990s, and Chinese performance artists like Zhang
Huan, who had been performing underground since the late 1980s,
began to travel in the West and show their work to an international au-
dience.

In these contexts performance art became a critical new voice with
a social force similar to that found in Western Europe, the United
States, and South America in the 1960s and early 1970s. It should be
emphasized that the eruption of performance art in the 1990s in East-
ern Europe, China, South Africa, Cuba, and elsewhere should never
be considered either secondary to or imitative of the West. Rather,
the great exuberance for the use of the body in art in places around the
world where radical change was taking place signified that the political

dimension of performance art remained a cultural force for change in everyday life. Performance art proved repeatedly to be the medium of expression in which the belief and investment in the social power of art held fast and could be rejuvenated, even in a period of deep cynicism (associated with postmodernism) regarding the efficacy of art in life.

A third area in which performance art developed was in relation to the new electronic technologies, which burst into the public domain on a global scale in the 1990s. In the words of French political and cultural theorist Paul Virilio, such technologies altered both "the nature of the human environment, our *territorial body,*" as well as "the nature of individual[s], and their *animal body.*"[11] For, along with electronic technologies, biogenetic technologies extended the promise—given in the guise of a sheep named Lucy, cloned in 1997—to replicate and perhaps even replace humankind. If the thesis of Hans Moravec, a senior research scientist at Carnegie Mellon, was to be believed, robotic cyborgs would gain the capacity to implant surgically the slower brains of humans with computer chips in order to bring us mere "meat machines" up to the speed of our own technological inventions.[12] In a similar vein, Donna Haraway's essay "A Cyborg Manifesto" was highly influential in laying the groundwork for acceptance of cybernetically and technologically altered bodies that would—in her utopian formulation—contribute to improved gender and sexual relations.[13] These kinds of theories coincided with discussion of and research on HIV. Matthew Barney's performances in New York and Uri Katzenstein's performances in Tel Aviv in the late 1980s and 1990s operated in the interstices of this hybridity. Cosmetically altering their bodies, Barney and Katzenstein individually created androgynous, human-animal-shaped body types and visualized the very real possibilities of surgically augmenting the body in previously unimaginable ways. Artists like Victoria Vesna, working almost exclusively on the Internet, designed interfaces that enabled the public to combine a variety of images, morph-

ing and thus performing new representations of the self that more closely resembled their own conceptual and psychological self-images. Fragmentation and multiplication of identity, as well as the adaptation of alternate personae, had long been anticipated in performance art by Linda Montano, Eleanor Antin, Martha Wilson, Jacki Apple, Adrian Piper, Lynn Hershman, Tom Marioni, Jürgen Klauke, Urs Lüthi, and a host of other artists internationally. They paved the way for the marketing of Cindy Sherman's photographs, which translated Sherman's performative multiple personae into salable objects and thus distanced the viewer from the real act of self-transformation being explored. Among the most dramatic and troubling performances in the 1990s were Orlan's numerous cosmetic surgeries. These operations, which increasingly threatened the artist's health and well-being, initially were attempts to reconstruct and transform her face and body into a composite of the ideal Western art-historical notion of beauty, and later became pure physical disfigurations.

Never was "the body" a more contested or beleaguered site than at the end of the twentieth century. The very prevalence of a nomenclature of "the body" signaled a dramatic shift away from the consideration of human beings as complex, sensate, psychophysical, soul-embodied beings with consciousness to figuring us simply as "bodies." This was especially true of writing in cultural studies and art history, where hundreds of new books on and theories of "the body" and "performativity" appeared in the last two decades of the century. For Paul Virilio, the body had become synonymous with the electronic and technological revolution, as well as the computer terminal: The "staking out of [geographical] territory with heavy material infrastructure (roads, railroads) is now giving way to control of the immaterial, or practically immaterial, environment (satellites, fibre-optic cables), ending in the *body terminal* of man, of that interactive being who is both transmitter and receiver."[14] In this context, in a 1997 performance entitled

Time Capsule, the Brazilian artist Eduardo Kac even demonstrated how the body might literally become a terminal for surveillance. During this action, Kac "implanted in his ankle an identification microchip with nine digits and registered himself with a databank in the United States via the Internet."[15] This action was staged against an installation of photograph mementos of his grandmother, who was killed as a Polish Jew in the Holocaust. A different kind of radical submission of the body to public and state control was systematically undertaken by the Cyprus-born artist Stelarc. He aimed to "extend the concept of the body and its relationship with technology through human/machine interfaces incorporating the Internet and Web, sound, music, video and computers . . . [to enhance] an interplay between physiological control and electronic modulation of human functions and machine enhancement."[16] In his performance *Amplified Body* (1996), for example, Stelarc was connected to the Internet and electrical discharges were sent to his body by remote users. His responses were measured through a variety of monitoring devices, including EEG, ECG, and EMG machines, a nasal thermistor, a plethysmogram, position sensors, and ultrasound transducers.

The growing acceptance of a disembodied notion of "the body" also had a curious new dimension in the 1990s, which might be likened to the fin de siècle dread so common at the end of the nineteenth century. This foreboding and yet increasing accommodation of a dematerialized, prosthetically augmented body resulted, I think, in the widespread fascination with the idea of extraterrestrial life and abduction by aliens, which was especially exploited by television and Hollywood during the last two decades of the twentieth century. Parapsychology as a discipline had not received so much attention from intellectuals and the public at large since the end of the nineteenth century, and representations and embodiments of angels (in art and on television and in Hollywood) both drew aesthetic interest and became a commercial

success. While the connection between so-called New Age phenomena, electronic technologies, biogenetic engineering, and A-life (artificial life) may not at first be apparent, the disembodiment of human relations made possible by the Internet and e-mail increased consideration of new modes of consciousness that had been anticipated by such philosophers as Teilhard de Chardin.[17] Such mind-expanding possibilities were particularly welcomed by performance artists like Linda Montano, John Duncan, Lynn Hershman, and Ken Rinaldo (United States), Ulricke Rosenbach (Germany), Kathy Rogers (England), Aya and Gal (Israel), and many others throughout the world.

The HIV threat, the reshuffling of geopolitical borders, and the explosion of new technologies in the last two decades of the twentieth century took place under the global umbrella of political and ethnic strife, as well as impending environmental disaster. One has only to think of the multiple sites of ethnic conflict to recognize just how unstable existential conditions on the planet were at the end of the twentieth century: the massacre of millions of people in Rwanda; continuous warfare in Northern Ireland and between North and South Korea, Egypt and Eritrea, and Israel and its neighbors; ethnic cleansing in Bosnia and Kosovo by the Serbs; as well as the world-threatening demonstrations of aggression in 1998 when India and Pakistan tested nuclear weapons, ostensibly to be used against each other. In addition, massive relocation and the status of refugees became an enormous issue in the 1980s and 1990s—consider, for example, that the second-largest city in Pakistan and the third-largest city in Malawi were both refugee camps.[18] Ecologically, the planet demanded serious consideration of sustainable development and an altered relationship between human beings and the earth. A short list of potentially dangerous environmental conditions included depletion of the ozone layer shielding the earth, the pollution of the seas and clean water, deforestation and decimation of the tropical rain forests, the disappearance of species, and the effects

of nuclear fallout (either from testing or from the malfunction of the
world's aging nuclear energy plants). These fragile ecological condi-
tions were exacerbated by such global conflicts as the Gulf War in
1992, which left massive oil fires, and the destruction of sea and animal
life, as well as the further pollution of the planet's air. Given the rapid
and unprecedented advances in technology that reconstituted bodies as
progressively more like cyborg-robotic beings, the collusion between
humans and nature appeared ever more pressing.

Unity between animals, nature, and humans was exhibited in the
growing attention to animal rights and the protection of nature (as, for
example, in the two-decade-long fight—in the 1980s and 1990s—to
preserve the ancient giant redwoods in Northern California). In this re-
gard, the public actions of Greenpeace (founded in the 1970s) were
analogous to certain concerns expressed in performance art. I am think-
ing particularly of the Vietnamese artist Dinh Q. Lé, who performed
his public action *Damaged Gene* in the central market of Ho Chi Minh
City, in August 1998. There, Lé sold small hand-painted plastic figures
of Siamese-twin babies; he also sold T-shirts printed on the front with
the same image of the two-headed child and on the back with the fol-
lowing message:

> Five million acres of land in Vietnam were soaked with twenty million
> gallons of Agent Orange during the Vietnam War. Half a million Viet-
> namese children may have been born with dioxin-related deformities
> since 1965. Since 1994, there have been five pairs of Siamese twins born
> in Vietnam. This is 10 times or 1,000% more than the expected number
> based on Vietnam's population. Agent Orange was produced by Dow
> Chemical, Monsanto, Diamond Shamrock Corp., Hercules, Uniroyal,
> TH Agricultural & Nutrition and Thompson Chemicals.

In this regard, the local and global politics practiced by such perfor-
mance artist–intellectuals as Martha Rosler, Suzanne Lacy, and Anto-
nio Muntadas, but especially by Linda Frye Burnham and Steven Dur-

land, former editors of *High Performance,* are equally important. Burnham and Durland moved from Los Angeles in the early 1990s to a small North Carolina town, where they dissolved the magazine and began a sustained involvement in and commitment to the kind of grassroots community action in which they had long been involved.[19]

Throughout the twentieth century performance art evaded attempts by art historians to define or categorize it fully, and after a century of its multifarious forms and styles, no comprehensive history of this international medium exists. But if the complexities of defining performance art and identifying its key historical moments and presentations have eluded art historians, it has remained vulnerable to ideologically driven theories of it. Performance art has proved particularly susceptible to psychoanalytic theory for explicating its psychological conditions of production and reception, and to Marxism, used to theorize its embedded discourse in everyday life. Although both these methods have been crucial analytic tools for examining this unusual and unparalleled twentieth-century art, not enough attention has been given to how performance art visualized the urgency of *real* human experience in *actual* everyday life. A celebrated case in point is the work of Rudolf Schwarzkogler. Even though his horrific photographic tableaux of 1965–66 led to the false tale of his self-castration (a notorious myth that has fueled the often hysterical public and intellectual response to performance art in general), Schwarzkogler did work with a real body, that of Heinz Cibulka. To simulate castration for Schwarzkogler's photographs, Cibulka actually submitted his genitals to be wrapped in gauze and dripped with blood and then let a double-edged razor blade be placed on his swathed penis.[20] This example makes vividly clear how astounding the real acts of performance artists are in terms of what they actually do *to* bodies, usually their own. That the castration was simulated as a visual representation does not diminish the facticity of the performance as an image and the way in which that presentation of

an action aroused the imagination of actual viewers to their own psychosexual anxieties and myths. No wonder that performance art often had such a volatile reception and that it was the only art medium seemingly able to evade the voracious commodification of late capitalism.[21]

The immediacy of presentational art—and its contingency to an artist's actual life—differentiated action in art from its parallel aspects in the performing arts. This is not to claim that elements belonging to dance (such as expressive bodily movement) or theater (such as mimetic or scripted narrative representations) did not also occur in performance art. They often did. But the ability of visual artists' actions to stir the public's emotions may have accounted for some critics' longing to appropriate it to the performing arts (which generally failed to engender the direct kind of political and social results that performance art obtained in the twentieth century).[22] For example, the immediacy with which the concept of the Happening transformed popular culture in the 1960s was testimony to how live art captured the attention of the public. Moreover, the appropriation of the Happening as a medium for political agitation by the Yippies in the United States, the PROVOS in Holland, and performance artist–activists in Japan provided further evidence. Perhaps the best register of the political impact of action in art was the wide imitation and adaptation by academics (cultural theorists and art historians alike) of the writings of the Situationist Internationnale. In particular, the theories of Guy Debord were plundered (especially in the 1980s and 1990s) and used to support every imaginable ideological position. Given that his work intended to discredit the academy, the great success of the fatuous imitation of his principles no doubt contributed to Debord's tragic suicide in 1994. Six years earlier, he had made the recriminating observation that the obliteration of historical knowledge and memory only enabled "all usurpers" to fulfill their aim: "to make us forget that *they have only just arrived.*"[23] Perhaps, in the end, Debord's reminder to

remember—like Nietzsche's earlier exhortation that nihilism begins in forgetting—preempted the usurpers.

The public efficacy of performance art was also demonstrated in other arenas. For example, to understand how eroticized or violated bodies threaten those moralizing imperatives throughout the world that seek to hold bodies in check, one need only recall the public reaction to *Wiener Aktionism* from the early 1960s to the late 1990s. I am thinking here particularly of the irony of summoning the police to protect Hermann Nitsch's Six-Day Festival of the Orgies Mystery Theater from animal rights protesters in the summer of 1998 at his château in Prinzendorf, Austria. It may well have been that some of the very same police had been summoned in the 1960s, 1970s, and 1980s to arrest the artist for his work. In another context, the cultural potency of performance art was demonstrated in Germany when Joseph Beuys's visual art actions made him a charismatic popular leader and eventually an actual political figure. Karen Finley incurred the public's wrath, its defensive response to being actually confronted with her performed self-abuse, when she offered visual demonstrations of the effects on women of normative female objectification and physical and psychic abuse. Finally, such artists as Rasheed Araeen, Coco Fusco, Sherman Fleming, Guillermo Gómez-Peña, Lorraine O'Grady, William Pope L, James Luna, Yasumasa Morimura, and many others provoked genuine public responses to questions of ethnicity and race. In these ways performance art extended the Duchampian principle of the readymade, insofar as a performance artist chose an action, performed it in an altered context, and thereby imbued that act with a new signification. This new signification, however, was not fundamentally about surpassing the everyday but instead intervened in the plain conditions of life. Interference in the quotidian is precisely what gave performance art its robust public presence. For in their visual actions, these artists attended to the pressing necessities of the ordinary, about which Lefebvre spoke so passionately.

I have suggested that the artist's body, in its mutual contingency with the viewer's body, is precisely what sustains the direct connection between viewing subjects (the public) and acting subjects (artists).[24] For their *actual effect* in the public domain, artists making actions have been slandered, envied, imitated, and appropriated by other artists, academics, politicians, and even Hollywood. In large measure, the success of performance art in undermining the traditional aesthetic principles, aims, and practices of art may account for these extremes in admiration and detraction. If one thinks of the central role of mimesis in Western history, for example, it is possible to understand that when performance artists brought sculptural and painterly figural representation into the presentational mode, they brought to life Pygmalion's dream in bold bodily actions. Action augmented the situationalism inherent in the phenomenology of sculptural objects; and it extended the process of making, taking gestural abstract painting into real time and space. In other words, action in art extended painting and sculpture into the real, where mimesis always hungered to be. Moreover, such procedures challenged deeply embedded values of behavioral propriety; they also drew the public into an unprecedented dispute over the social, cultural, and political ethics of the body. I have long suggested that the *actual* appearance of the body in action recuperated human representation from the prurient denigration of much late-nineteenth-century academic figurative art. Moreover, embodied actions restored the integrity further stripped from figurative representation by fascist, communist, and capitalist versions of Social Realism, laying the ground for a neoexpressionist revitalization of figurative painting and sculpture in the 1980s.[25] Performance artists questioned, mocked, and rejected representations of the ideal body and notions of its perfection, long linked in the aesthetic theories of absolute freedom.[26] In this way they could be seen to have deserted the production of bodily images as abstract models for moral principles, plunging viewers into actual considerations of actual

corporeal conditions. They attacked, parodied, and abandoned the stock and trade in perfect bodies upon which the master narratives and the highest values of conventional Western art and its histories were based. Performance artists insisted that the exigencies of the body exceeded mere representation and, moreover, that Enlightenment notions of aesthetic distance, indifference, and autonomy were dangerous fictions that had little to do with the actual conditions upon and in which real human beings live and artists produce art. Finally, performance art at the end, just as at the beginning, of the twentieth century was like quicksilver, slipping through the fingers of historians and theorists alike to provide revelations about everyday life.

Notes

1. Henri Lefebvre, *Critique of Everyday Life,* vol. 1, translated by John Moore with a preface by Michel Trebitsch (London: Verso, 1991), 107, 105, 126; originally published as *Critique de la vie quotidienne I: Introduction* (Paris: Grasset, 1947).

2. Tim Dean, "The Psychoanalysis of AIDS," *October* 63 (winter 1993): 83.

3. Leo Bersani, "Is the Rectum a Grave?" in *AIDS: Cultural Analysis, Cultural Activism,* edited by Douglas Crimp (Cambridge, Mass.: MIT Press, 1989), 197–98.

4. The special issue of *RE/Search* magazine devoted to bodily fluids is of particular interest in this regard. See Paul Spinrad, ed., "The RE/Search Guide to Bodily Fluids," *RE/Search* 16 (1994).

5. See, for example, Laura Cottingham's *How Many "Bad" Feminists Does It Take to Change a Light Bulb?* (New York: Afterwords, 1994). Cottingham offers an insightful, humorous critique of the ways in which curators inappropriately appropriated lesbian artists to the context of "Bad Girls" for the numerous shows on this theme that took place in the early 1990s in the United States and England.

6. See Mikhail Gorbachev's *The Coming Century of Peace* (New York: Richardson and Steirman, 1986).

7. Younger artists like Jerzy Truszkowski and Katarzyna Kozyra emerged, and Polish performance artists inaugurated many international events.

8. Jusuf Hadzifejzovic (Bosnia and Herzegovina), Ventsislav Zankov (Bulgaria), Nenad Dancuo (Croatia), Tanja Ostojic (Yugoslavia), Robertas Antinis (Lithuania), and Micha Brendel, Else Gabriel, and Ulf Wrede (former East Germany). For an excellent source on Eastern European performance art, see Zdenka Badovinac, ed., *Body and the East: From the 1960s to the Present* (Ljubljana: Museum of Modern Art, 1998).

9. Felix Aftene, Matei Bejenaru, Rudolf Bone, Theodor Graur, Uto Gusztav, Vlad Horodinca, Iosif Kiraly, Dan Mihaltianu, Cosmin Paulescu, Amalia Perjovschi, Dan Perjovschi, and Sorin Vreme. After 1989 these artists finally had the opportunity to learn about and reconnect to an earlier generation that had made performances, often in secret. Among the influential artists of the older generation were Alexandru Antik, Geta Brateşcu, Constantin Flondor, Ion Grigorescu, Ana Lupaş, Wanda Mihuleac, Paul Nageau, Mihai Oloş, Eugenia Pop, and Decebal Scriba. An especially useful catalog, reviewing experimental art in Romania, came out in 1997. See Alexandra Titu, ed., *Experiment in Romanian Art since 1960* (Bucharest: Soros Center for Contemporary Art, 1997).

10. Especially remarkable in this context were the street events staged by Mark Verlan; performances by Pavel (Pasha) Braila, Alexander Tinei, Vasile Rata, and Igor Scerbina; and the collaborative sound works of Lilia Dragnev and Lucia Macari.

11. Paul Virilio, *Open Sky,* translated by Julie Rose (London: Verso, 1997), 67; originally published as *La vitess de libération* (Paris: Éditions Galilée, 1995).

12. Hans P. Moravec, *Mind Children: The Future of Robot and Human Intelligence* (Cambridge, Mass.: Harvard University Press, 1988). During the annual symposium at Ars Electronica in Linz, Austria, in 1991, Moravec described humans as "meat machines" in a debate with me regarding art, technology, and survival.

13. See Donna Haraway, "A Cyborg Manifesto: Science, Technology, and Socialist Feminism in the Late Twentieth Century," *Socialist Review* 80 (1985): 65–108.

14. Virilio, *Open Sky.*

15. Arlindo Machado, "Expanded Bodies and Minds," in *Eduardo Kac: Teleporting an Unknown State,* edited by Peter Tomaž Dobrila and Aleksandra Kostiá (Slovenija: Kulturno izobraževalno društvo KIBLA, 1998), 49.

16. See Stelarc's official Web site: www.stelarc.va.com.au/index.html.

17. See, for example, Edward Shanken's extended abstract of "Technology and Intuition: A Love Story? Roy Ascott's Telematic Embrace," *Leonardo* 30, no.1 (1997): 66. (This text appears in full at Leonardo's online site: www.

mitpress.mit.edu/Leonardo/home.html.) See also Shanken's "Life as We Know It and/or Life as It Could Be: Epistemology and the Ontology/Ontogeny of Artificial Life," in the special issue "Sixth Annual New York Digital Salon," *Leonardo* 31, no. 5 (1998): 383–88.

18. See Diane Weathers, "Impact of Refugee Camps," in *WFP and the Environment* (Rome: World Food Programme), 9–10.

19. See, for example, Linda Frye Burnham and Steven Durland, eds., *The Citizen Artist: An Anthology from* High Performance *Magazine 1978–1998, Twenty Years of Art in the Public Arena* (Gardiner, N.Y.: Critical Press, 1998).

20. For the origins of the myth, see Robert Hughes, "The Decline and Fall of the Avant-Garde," *Time,* December 18, 1972, 111. This irresponsible myth has been repeated so often since 1972 that references are too numerous to mention. For a discussion of the myth, see my "Notes on Rudolf Schwarzkogler's Images of Healing," *White Walls: A Magazine of Writings by Artists* 25 (spring 1990): 13–26; reprinted in *Rudolf Schwarzkogler* (Vancouver: University of British Columbia Press, 1993), 29–39.

21. Even a massive international exhibition of objects used in performance—such as Paul Schimmel's "Out of Actions: Between Performance and the Object, 1949–1979," at the Museum of Contemporary Art in Los Angeles in 1998—was unable to institutionalize actions themselves.

22. There are, of course, some notable exceptions to such a visual/performing arts dichotomy, including Richard Schechner, George Coates, Ruth Maleczech, Meredith Monk, Simone Forti, and John Cage. Also see, for example, how Bonnie Marranca, the editor of *PAJ,* laments the resistance of many art historians, myself included, to consider developments in theater as directly related to the histories of performance art: Bonnie Marranca, "Bodies of Action, Bodies of Thought: Performance and Its Critics," *PAJ: A Journal of Performance and Art,* no. 61 (January 1999): 11–23. For a pictoral history of performance art, see RoseLee Goldberg, *Performance: Live Art since 1960,* foreword by Laurie Anderson (New York: Harry N. Abrams, 1998).

23. Guy Debord, *Comments on the Society of the Spectacle,* trans. Malcolm Imrie (New York: Verso Books, 1990), originally published as *Commentaires sur la société du spectacle* (Paris: Éditions Gérard Lebovici, 1988).

24. See, for example, my "Synopsis of the Destruction in Art Symposium (DIAS) and Its Theoretical Significance," *The Act* 1 (spring 1987): 22–31; and my "Uncorrupted Joy: International Art Actions," in *Out of Actions: Between Performance and the Object, 1949–1979,* edited by Paul Schimmel (Los Angeles: Museum of Contemporary Art, 1998), 226–328.

25. See my "Survival Ethos and Destruction Art," *Discourse: Journal for Theoretical Studies in Media and Culture* 14, no. 2 (spring 1992): 74–102.

26. For an excellent discussion of the representation of the body in art history and its connection to ideals of freedom, see Alex Potts, *Flesh and the Ideal: Winckelmann and the Origins of Art History* (New Haven: Yale University Press, 1994).

biographies

Marina Abramovič was born in Belgrade, Yugoslavia, in 1946. She attended the Academy of Fine Arts, Belgrade, from 1965 to 1970 and also studied at the Academy of Fine Arts, Zagreb. She has been creating performances since the early seventies and collaborated extensively with Ulay. She has taught at the Academy of Fine Arts, Nova Scotia; has been a visiting professor at the Hochschule der Kunst, Berlin, and the Académie des Beaux-Arts, Paris; and has been a professor at the Hochschule für Bildende Kunste, Hamburg, and the Hochschule für Bildende Kunste, Braunschweig.

Vito Acconci, born in 1940, has conceptually investigated autobiography, identity, and the nature of consciousness, gender, and perception in videos and live performances since 1969 in works such as *Seedbed, Centers, Sir Time,* and *The Red Tapes.* More recently, he has created furniture-like sculpture that questions notions of play, fantasy, and limitation. His objects, such as *Garden Chairs* and *Bud Dream House,* have been shown nationally and internationally.

Jerri Allyn is a West Coast–trained activist and artist who has produced interactive art/life feminist events and installations aimed at breaking free of gallery and museum walls to build social connections with people

in arenas other than the art world. Alternating for years between being an artist, adjunct faculty member, and events producer, Allyn was in November 1994 appointed the director of education and public programs at the Bronx Museum of the Arts, where she combines her skills to create innovative, interactive, hands-on arts programs in a multicultural milieu.

Eleanor Antin, an artist and filmmaker, has worked for many years in installation, performance, writing, drawing, photography, video, and film. She has had one-woman exhibitions at the Museum of Modern Art, the Whitney Museum of American Art, and the Wadsworth Athenaeum, as well as major installations at the Hirshhorn Museum, the Philadelphia Museum of Art, and the Jewish Museum in New York. Her retrospective opened at the Los Angeles County Museum of Art in February 1999. Antin is represented in major collections, has written two books (*Being Antinova* and *Eleanora Antinova Plays*), and has written, directed, and produced numerous narrative films, including *The Hunger Artist* (in collaboration with David Antin). In 1997 she received a Guggenheim Fellowship. Antin is professor of visual arts at the University of California, San Diego.

Robert Ashley completed the opera *Atlantic (Acts of God)* (twelve hours of music for voices and orchestra in three acts) and *Now Eleanor's Idea* (four operas of ninety minutes each), all in television format. *Atlanta Strategy,* a thirty-minute pilot program for *Atlanta (Acts of God),* was produced in 1986. French Television INA produced *Improvement (Don Leaves Linda),* one of the operas of *Now Eleanor's Idea,* in 1997. Other projects include *Balseros,* an opera about the Cuban raft people commissioned by the Florida grand opera, which premiered in May 1997, and *The Immortality Songs,* a series of forty-nine short operas for television. One of these operas, *Yes, But Is It Edible?,* was produced for South German Radio in 1997.

Helene Aylon, born in 1931, has used the metaphor of the sac since 1978, when she began utilizing the image in her process paintings.

Since that time, her ceremonial earth events have invited participants to practice peace artfully, via community involvement. This work has led her to once-warring sites throughout the world, using art as a transforming healer. Aylon, formerly a rabbi's wife, has traveled full circle from her Orthodox upbringing. Her ecofeminist approach has led to *The Liberation of G-d* from fundamentalist projections.

Nancy Barber documented food on video, interviewing people cooking in their homes. These videos were shown on Channel C, Cable TV, New York City. Other food performances have included authoring a child's book, using food photos for alphabet letters, and working as a professional chef and restaurateur.

Bob and Bob began their collaboration in 1975 as students at the Art Center of Design. Called Light Bob and Dark Bob, they worked together until 1982. Their shows featured live onstage painting; installations of themselves on their magic studio chairs at a zoo, crosswalk, store aisle; themselves posing as statues on buildings in New York City; and humorous events that collaged sound, images, storytelling, and actions. More about this art team can be found in their book *Bob and Bob: The First Five Years* (1980), with a text by Linda Frye Burnham.

Eric Bogosian is the author of two plays, *Talk Radio* and *subUrbia,* as well as three Obie award–winning solos: *Drinking in America; Sex, Drugs, Rock 'n' Roll;* and *Pounding Nails in the Floor with My Forehead.* He starred in Oliver Stone's film version of his own *Talk Radio* and adapted for the screen his play *subUrbia,* directed by Richard Linklater. He is on the World Wide Web at www.interport.net/~ararat.

Nancy Buchanan, born in 1946, received her M.F.A. at the University of California, Irvine. Her work is in the collections of the Museum of Modern Art, New York; the Museum of Contemporary Art, La Jolla; the Long Beach Museum of Art; and the Allen Memorial Art Museum, Oberlin. Buchanan has exhibited at the Modern Art Center, Portugal; American Film Institute; National Video Festival, Los Angeles; New

Television (WHET, KCEH, KGBH); and various PBS stations (New York, California, Chicago). She taught video production at the University of Wisconsin, Madison, from 1982 to 1984, and at Cal Arts, Valencia, from 1985 to 1992. In 1997 Buchanan received a Rockefeller grant.

Chris Burden, born in 1946, performed his first event, *Five Day Locker Piece* (1971), as a graduate student in Southern California. Since that time he has performed actions that address issues of danger, achievement, and physicality. *Bed Piece, Art and Technology, The Big Wrench, The Citadel, Coals to Newcastle, The Curse of Big Job, Garcon, Garden Icarus, Shadow, Shoot, Transfixed 101,* and *You'll Never See My Face in Kansas City* are the titles of some of his performances. Since 1975 Burden's sculptural environments, sardonic in nature, have prophetically forecast our future, as in *A Tale of Two Cities* and *The Reason for the Neutron Bomb.*

Linda Frye Burnham is a writer who lives in North Carolina. She founded *High Performance* magazine, the Eighteenth Street Arts Complex (with Susanna Dakin), Highways Performance Space (with Tim Miller), and *Art in the Public Interest* (with Steve Durland). She has been a staff writer for *Artforum* and a contributing editor for the *Drama Review,* and is now contributing editor for the *Independent Weekly* of North Carolina.

John Cage, born in 1912, was class valedictorian in 1928. He studied architecture and piano in Paris, counterpoint with Schoenberg, composition with Cowell, and philosophy of India and Indian music with G. Sarabhai; he also attended lectures on Zen by D. T. Suzuki. In 1930 Cage began composing chromatic music, becoming more interested in percussion and rhythmic structure. In 1936 he met the choreographer Merce Cunningham, and they began their lifelong collaboration. In 1950 he was introduced to the *I Ching,* which became the foundation of his subsequent Chance Operations. Cage's art strove to imitate nature in its complexity and naturalness, and he often asked his audience

to listen to all sounds as music; for example, in $4'3''$, the performer sits at a piano, playing nothing. He died in 1992, just short of his eightieth birthday. John Cage's influence on the music of the second half of the twentieth century is legendary.

Ping Chong was born in Toronto, Canada, on October 2, 1946, and was raised in New York's Chinatown. He has created over thirty works for the stage, three videos, and six visual arts installations and is the recipient of an Obie award, a Bessie award, and numerous prizes and fellowships. His work has been seen at major museums, theaters, and festivals throughout the world.

George Coates is a director and producer, born in Philadelphia in 1952. He was a member of the performing ensemble the Blake Street Hawkeyes from 1975 to 1977. He organized a nonprofit multimedia theater company in 1980. Coates continues to make large-scale mixed-media performances, which have been presented internationally as well as in the United States at the Brooklyn Academy of Music, the Kennedy Center Opera House, the Walker Art Center, Spoletto Center, the SUNY Purchase Summerfare, and the American Conservatory Theater. Productions include *The Way of How, SeeHear, Actual Sho, Rare Area, Invisible Site, The Architecture of Catastrophic Change, Nowhere Now Here,* and *Box Conspiracy.*

Papo Colo is the cofounder (with Jeannette Ingermann) of Exit Art/The First World and has been an artist in New York City for more than twenty years. Colo's perspective reaches across art movements, cultures, and backgrounds. He explores differences and the possibilities they generate in his performances, installations, photography, and traditional painting. In 1992 Colo established the Trickster Experimental Theater, which produced *Stolen Kisses, Zygmunt,* and *Resonances.* Colo received a Guggenheim Fellowship in 1991 and has received grants from the New York Foundation for the Arts, the National Endowment for the Arts, and the New York State Foundation for the Arts.

Philip Corner, a teacher, poet, and composer, was born in the Bronx in 1933. He was educated as a composer, although his musical scores have evolved into pure graphics and poetry. Corner has been a member of Fluxus, and his lifelong interest in both spirit and body has led to meditative improvisations with dancers, including most recently Phoebe Neville, his wife. He has published in numerous poetry magazines and has performed extensively the works of contemporary composers on piano and trombone. He has lived in Reggio Emilia, Italy, since 1992.

Laura Cottingham is an art critic who lives in New York. Her writings on feminism and art are featured in many recent anthologies and museum catalogues from Europe and the United States, including *Claude Cahun* (Munich, 1997), *Sunshine and Noir* (Copenhagen, 1997), *Inside the Visible* (Boston, 1996), *L'Art au corps* (Marseille,1996), *Sexual Politics* (Los Angeles, 1996), *The Power of Feminist Art* (New York, 1994), *Bad Girls* (London, 1994), and *New Feminist Criticisms* (New York, 1993). She was one of four guest curators chosen for the exhibit *NowHere* at the Louisiana Museum of Modern Art, Denmark, in 1996; and curated *Vraiment féminisme et art* at Le Magasin Centre National d'Art Contemporain, Grenoble, France, in 1997. She has organized other projects on art, aesthetics, and politics, including "Amazing: Lesbian Video USA," an all-video exhibition that opened in Copenhagen and traveled to Paris. She is the director of the ninety-minute video essay *Not for Sale: Feminism and Art in the USA during the 1970s* (1998) and author of *How Many "Bad" Feminists Does It Take to Change a Lightbulb?* (1994) and *Lesbians Are So Chic . . .* (1996).

Paul Cotton, a sculptor and poet, was born in 1939. He creates spaces in parks, fairs, and museums, where the public can experience the living nude (*Model Citi-Zen*) as a chosen expression of lifestyle and spiritual belief. Cotton lives and works in California.

Betsy Damon, born in 1940, began a performance in 1975 based on a female myth, *The 7,000 Year Old Woman*. This tribute to female energy

was ritualized on the streets while Damon wore a sixty-pound garment of colored flour bags. In a later event, *Blind Beggar Woman,* Damon collected stories to be retold. Damon's intention is community building through ecological and social awareness. Recently, she completed a large project in China.

Lowell Darling ran for governor of California in 1978. His Fat City School of Find Arts (1971) granted master's degrees to thousands. Other actions included performing acupuncture on Los Angeles to relieve pressure and sewing up the San Andreas Fault. He lives and works in California.

Steven Durland is an artist, writer, editor, and arts administrator. He has been the editor of *High Performance* magazine since 1986 and is codirector of *Art in the Public Interest,* founded in 1995. His sculpture, installations, and conceptual performance works have been exhibited at venues throughout the United States and Ireland.

Angelika Festa was born just after World War II in southern Germany. She moved to North America as a teenager and has lived in Canada and the United States since 1961. Interested in literature, philosophy, and the arts, she received formal education in those areas from Canadian and American universities. As a practicing artist and performer she has taught art and writing courses. She is currently working on a book on performance and identity.

Karen Finley, an artist, author, and performer, attended the Chicago Art Institute and the San Francisco Art Institute. She collaborated with Brian Routh, a.k.a. Harry Kipper, in the 1970s. Her performance events *Theater of Total Blame, We Keep Our Victims Ready, Constant State of Desire,* and *American Chestnut* address issues of the dysfunctional family and government, victimizing social conditions, and eroticism stripped of taboo. Finley was one of the NEA Four (which also included John Fleck, Holly Hughes, and Tim Miller). She appeared as a doctor in the movie *Philadelphia* and also appears on *Politically Incorrect* with TV host Bill Maher. Finley currently lives in New York.

Simone Forti was born in Florence, Italy, in 1935 and emigrated to the United States with her family in 1939. She began working with dance improvisation and the workshop process in the fifties with Anna Halprin. From her early minimalist dance-constructions through her animal studies and news animations, she has followed an inner voice, keeping an eye on the natural world. Over the past ten years Forti has been exploring the place where the moving body and verbal mind come together. In 1995 she received a Bessie New York Dance and Performance Award for sustained achievement. She lives at Mad Brook Farm in northeastern Vermont.

Terry Fox, born in 1943, studied at the Cornish School while working for Boeing Aircraft. He also studied at Academic de Belle Arti, Rome. His action of physical presence, trance induction, and visual poetry questions life's fragility. Some works are *Air Pivot, Breath, Cell, Children's Tapes, Corner Push, Hospital, Incision, Isolation Unit, The Labyrinth of Charities, Liquid Smoke, Ruin, Sweat, Washing,* and *What Do Blind Men Dream.* Fox lives and works in Europe.

Howard Fried, in 1970, began a series of performance actions addressing issues of arbitration, confrontation, decision making, control, intentionality, group behavior, and predictability in works titled *Allmydirtyblueclothes, The Burgers of Fort Worth,* and *The Cheshire Cat.* In 1972 he participated in Documenta 5, in Germany, and received a National Endowment for the Arts grant in 1975. Fried lives and works in California.

Cheri Gaulke worked primarily in performance art from 1974 to 1992, as well as in video, installation, artist's books, and public art. At the Woman's Building in Los Angeles, she embraced the function of feminist art to raise consciousness, invite dialogue, and transform culture. Her work has addressed the themes of religion, sexual identity, and the environment. She cofounded two collaborative performance groups, the Feminist Art Workers (1976–81) and Sisters of Survival (1981–85) and has also worked in collaboration with teens. Her work has been

shown at the Museum of Modern Art, New York; at the Museum of Contemporary Art, Los Angeles; in a Smithsonian touring exhibition; and in alternative settings, including buses, churches, and prehistoric temples. She has received grants from the National Endowment for the Arts, the California Arts Council, and the Los Angeles Department of Cultural Affairs. Currently, she is designing art for a Metro-Rail station in Los Angeles.

Vanalyne Green worked with Judy Chicago and Shelia Levrant de Bretteville and was an active member of the West Coast feminist art movement at the Woman's Building. From 1980 to 1990 she directed and produced *Trick or Drink* and *A Spy in the House That Ruth Built,* in New York. Now based in Chicago and making videotapes (*What Happens to You*), Green chairs the Video Department at the School of the Art Institute of Chicago. Grants include a Rockefeller Foundation Production Grant, a National Endowment for the Arts grant, and support from the New York State Arts Council. In 1993 she taught at L'Ecole des Beaux-Arts, Paris.

Alex Grey, born in 1953, studied at the Columbus College of Art and Design, and the Boston Museum School. His work is in the collections of the Museum of Contemporary Art, La Jolla; the Brooklyn Museum of Fine Arts; and the Krannert Art Museum, among others. Grey has also exhibited in numerous venues, including the University of California Museum of Art, Santa Barbara; the New Museum of Contemporary Art; and the University of Colorado Museum. A teacher of the anatomy of art in New York City, Grey is also a professional medical anatomist. He, his wife Allyson, and daughter Zena do performative rites involving elaborate installations that include the audience. A recent event at a Florida hospital, *Mending the Heart Net,* included the ill in a healing ritual. Grey's paintings are featured in his book *Sacred Mirrors, Inner Traditions* (1990), and his collaborations with Allyson are documented in *The Art and Life of Alex and Allyson Grey* (1992).

Deborah Hay has lived in New York, Vermont, and Austin, Texas. Her performance and choreography explore the nature of experience, perception, and attention. Her work applies resourcefulness to all aspects of movement and performance—nothing is wasted attentionally. She tours extensively as a solo performer and teacher. Her book *Lamb at the Altar: The Story of Dance* was published in 1994 and has had its second printing. Her new publication is titled *My Body, the Buddhist*.

Mel Henderson, born in 1922, has been using the public event format to express concerns over social issues and the repressive climate of the times since 1969. To do this, he left the gallery system and brought his work into the streets and freeways, hillsides and waters of the San Francisco Bay. Large groups of people with searchlights, yellow cabs, and cutout Holstein cows participated in this work. His performance *Search Light Project* (1988) examined the prison systems of California and the entire United States. Currently, he is finalizing plans for a three-day event using fifty searchlights on and around Alcatraz Island.

Geoffrey Hendricks, born 1931 of Norwegian ancestry, is often referred to as a "cloudsmith." In 1965 he began painting "sky on everything." In 1980 he began keeping "sky journals," with the idea of painting "every sky." He has been active with Fluxus since the mid-sixties. A solo exhibition, organized by the Deutscher Akademischer Austauschdienst (DAAD), Berlin Artist Program, toured Germany and Scandinavia in 1983 and 1984, and another solo exhibition toured Scandinavia and Poland in 1993 and 1994. His performance works, sometimes private acts such as *Between Two Points* and *Headstands for Santa Barbara,* are introspective outlooks on the world, the self, ancestral roots, and cycles of nature. Other times they are public acts dealing with rites of passage and life's rituals, such as his marriage to Sur Rodney on September 30, 1995. Hendricks is professor of art at Rutgers University, where he has taught since 1956. He is a member of the board of directors of Visual AIDS.

Donna Henes is an urban shaman, contemporary ceremonialist, and cele-
bration artist who has produced countless public participatory events in
museums, universities, parks, plazas, and institutes in more than fifty
cities in nine countries since 1972. The title of her book *Celestially Aus-
picious Occasions* is also the name of a syndicated column appearing in
Free Spirit magazine (circulation 500,000). This work was awarded a fel-
lowship in nonfiction by the New York Foundation for the Arts in
1991. The author of two other books, *Dressing Our Wounds in Warm
Clothes* and *Noting the Process of Noting the Process,* she is presently collab-
orating with Dominique Mazeaud on *Peace: Piece by Piece.* Henes is a
founding member of the International Center for Celebration and
served as a children's book award judge for the United Nations Jane Ad-
dams Peace Association from 1980 to 1988. She originated the first satel-
lite peace message in space, *chants for peace*chance for peace,* in 1982, and
designed the New York City Olympic ticker tape parade in 1984. In ad-
dition to teaching and lecturing worldwide, she maintains a ritual prac-
tice and consultancy in exotic Brooklyn, New York, *Mama Donna's Tea
Garden and Healing Haven,* where she works with individuals and groups
to create personally relevant rituals for all of life's transitions.

Lynn Hershman, born in 1941, is a conceptual artist who founded the
Floating Museum (1977). In 1978 she created an alternate persona,
Roberta Breitmore, a composite fictional/real, archetypical character
who fully participated in the world. Aided by makeup, Roberta had a
life, including a checkbook, driver's license, therapist, and a room in a
boardinghouse. Hershman also wrote a cartoon book titled *Roberta
Breitmore.* Other performances include *The Dante Hotel* (1973), *The
Chelsea Hotel* (1974), *Windows, Bonwit Teller* (1976), and an interactive
video disc titled *Lorna,* made in the eighties. Currently Hershman lives
in San Francisco, where she is making a movie.

Julia Heyward is a multimedia artist whose work continues to center
around music, image, and language. She creates music videos, tours

with music groups, and has written a cartoon opera, which includes characters made from light and interactive slide animation. Heyward's work has received numerous National Endowment for the Arts grants, a Fullbright, a Bessie, a New York Foundation for the Arts grant, and others. Since 1983 Heyward has worked commercially as a music video director for Sony/CBS, Warner Brothers, MCA, Capitol IRS, and Electra. In 1990 she designed and directed the "Host" segments for a series on MTV called *Buzz*.

Dick Higgins was born in 1938 to American parents living in England. He studied musical composition with John Cage and Henry Cowell. A cofounder of Happenings (1959) and Fluxus (1961–62), he developed the concept of intermedia in 1964. In more recent years he mostly painted. Higgins died in Canada of a heart attack in October 1998.

Mikhail Horowitz, a performance poet, performs throughout the Hudson Valley. The author of *Big League Poets* and *The Opus of Everything in Nothing Flat,* he appears in clubs, coffeehouses, colleges, and correctional facilities across the country, including recently at the Bumbershoot Festival in Seattle and the Lord Buckley Memorial Birthday Bash at the Westbeth Theater in New York City. For twelve years Horowitz was "cultural czar" of the *Woodstock Times.* Some of his performance poetry, satire, and parody can be heard on the CDs *The Blues of the Berth* and *Live, Jive and Over 45.*

Joan Jonas was born in New York City in 1936. She attended Mount Holyoke and Columbia University Graduate School. In 1968 Jonas showed her first performance piece, and in 1970 she began to work in video in relation to performance and sculpture. Her work *Organic Honey's Visual Telepathy* began a career that was supported by the Guggenheim Foundation, the Rockefeller Foundation, and the National Endowment for the Arts. Jonas continues to work in installation and performance, which includes drawing, photography, and video/ob-

jects. She lives and works in New York City and is a professor at the Academy of Art, Stuttgart.

Kim Jones, born in 1944, transforms himself into a sculpture that is both aggressive and adaptive. With his body covered with mud, he wears an irregular lattice composed of locally found sticks, cord, tape, and foam rubber. He has appeared in this structure at galleries and museums, on the streets, and in subways in Europe and the United States.

Allan Kaprow helped to develop the theory and phenomena of Environments and Happenings in the late fifties and sixties. His Happenings—some two hundred of them—evolved over the years; in their present form they are nearly indistinguishable from ordinary life. He has published extensively and is professor emeritus of the University of California, San Diego.

Laurel Klick, in the early seventies, was involved in the feminist art movement at Fresno State University, the California Institute of the Arts, and the Woman's Building in Los Angeles. In 1977, along with Cheri Gaulke, Nancy Angelo, and Candace Compton, she formed Feminist Art Workers, a collaborative performance and educational group. Throughout the seventies and mid-eighties she performed at numerous galleries, museums, and nontraditional locations. For the past twenty years she has worked on over fifty major effects films and commercials. After beginning her career in film opticals while working on *Star Wars,* she expanded into digital video. Presently, she is the digital supervisor at Available Light Ltd. in Burbank, California.

Alison Knowles, born in 1933, is a visual artist, sound artist, book artist, and founding member of Fluxus. Performing and teaching nationally and internationally, Knowles has also worked with a human-scale book/walk in installations titled *The Big Book* and *The House of Dust*—books that break down traditional categories of painting, sculpture, and music. She often uses food in her work.

Steven Kolpan, born in 1949, created videos based in personal perfor-
mance, from 1970 to 1992. His art, which he calls "video minimalism,"
is often created in real time, without technical manipulation or editing.
This approach allows for true intimacy between intention and activity,
and between the impression of the activity and the response of the au-
dience. Currently he teaches at the Culinary Institute of America; he
has coauthored a book about wine, *The Culinary Institute of America's
Complete Guide to Wines of the World,* which received the "Best Wine
Book of 1996" from the James Beard Foundation. Two more books are
forthcoming: another about wine and one about Francis Ford Cop-
pola's vineyard in California.

Jill Kroesen wrote and produced musical theater events from 1974 to
1986, including *Fay Shism Began in the Home* (Hitler as a femme fatale);
Who Is the Real Marlon Brando (the poetry scene of the early seventies);
Stanley Oil and His Mother (a history of the Western world in two
hours); and *Lou's Dream* (a symbolic microcosm of society, love, and
power). She made two recordings: an LP, *Stop Vicious Cycles* (1982),
and a 45, *I Really Want to Bomb You* (1979). She currently works as a
special effects editor and maintains the archives of ballerina Gelsey
Kirkland.

Robert Kushner studied at the University of California, San Diego, where
he participated in performances by Pauline Oliveros. His own work
centers around costumes—presented as fashion shows, masques, pag-
eants, stripteases, and variety shows. He began making costumes in
1970, presenting them as performances from 1971 to 1982 in museums
and galleries in both America and Europe. Even while dealing with se-
rious subject matter, such as gender stereotyping, spirituality, and grief,
Kushner is interested in lightening the atmosphere with liberal doses of
humor, because, after all, "life is actually pretty funny most of the time."

Leslie Labowitz, born in 1946, began her performance career in 1971 with
public art that addressed violence against women. She ended her public

career and does private work that addresses life, death, and rebirth. *Sproutime* became a real-life business and has been so for seventeen years.

Suzanne Lacy is an internationally known conceptual/performance artist whose large-scale activist actions have addressed issues of aging (*The Crystal Quilt,* an event including 340 women elders), domestic violence (*On the Edge of Time*), and numerous other social and urban themes. Lacy believes that activism, audience engagement, and creativity can shape the public agenda. Her articles on social theory can be found in *Performing Art Journal, Art Journal, High Performance, Ms.,* and *Public Art Review,* and in her book on new genre public art, *Mapping the Terrain.* Lacy teaches new genre art at the California College of Arts and Crafts, where she was also dean of the School of Fine Art.

Minnette Lehmann, a San Francisco artist, National Endowment for the Arts award recipient, and professor of photography at San Francisco State University for twenty years, works with metaphoric possibilities embedded in cartoons, comic books, and science fiction. She uses appropriated material to expose and clarify fears and desires around disease and death. Her primary work, *Gory Allegories,* was exhibited at LACE in 1989 in the form of large-scale photos, and in 1991 as wallpaper at New York University's Grey Gallery. Her *Christ Mocked Again,* a performance narrative, is a psychological, anthropological, theoretical, and anatomical reseeing of the Crucifixion. Lehmann's recent digital collage work will appear in the book *Art of the X-Files.* She is active on the curatorial board at the Lab in San Francisco.

Les Levine, a "media sculptor," was born in Ireland in 1935. He is the founder and director of *Levine's Restaurant* (1968), the publisher and editor of *Culture Hero* (1969), and the founder of the *Museum of Mott Art Inc.* (1970). Since 1964 Levine has been molding media to interpret existing social systems in works titled *Sound Receive, Lose Your Life, Brand New, I Am Not Blind, We ARE NOT Afraid, Forgive Yourself, Media Mass, Billboard Cartoons,* and many others.

Lucy R. Lippard, born in 1937, a writer-activist living in Galisteo, New Mexico, is the author of nineteen books, including *The Pink Glass Swan: Selected Essays on Feminist Art, Overlay: Contemporary Art and the Art of Prehistory, Mixed Blessings: New Art in a Multicultural America,* and *The Lure of the Local: Senses of Place in a Multicultural Society.*

Lydia Lunch, born in 1959, is a confrontationist who seeks to destroy the taboos that surround sexual politics. She uses spoken and written words, music, film, photography, and sculpture to express her anger and astonishment at the global apathy and corporate greed that are responsible for the spiral toward the apocalypse.

Linda Mac was born in 1952 and raised in Philadelphia. In the early seventies she became interested in the spiritual/women's liberation movement and moved to Berkeley, California, to work in this field. After a short adventure in the business world, she teamed up with artist Frank Moore, and the two have been doing art together for over twenty years. A jack-of-all-trades, she is a cameraperson, singer, actor, and manager.

Alistair MacLennan made durational performances in Britain and America of up to 144 hours nonstop, usually neither eating nor sleeping, during the seventies and eighties. His subject matter deals with political, social, and cultural malfunctions. Since 1975 he has been based in Belfast, Northern Ireland, where he is a founding member of the Art and Research Exchange. Since 1975 he has taught at the University of Ulster. Presently, he is a research professor in fine art and travels extensively in Europe and America, presenting actuations—performances/installations. MacLennan is a member of the European performance group called Black Market International.

Jackson Mac Low, a poet and composer, is Ann Tardos's husband and lives in New York.

Ann Magnuson is an actress, singer, writer, and part-time performance artist. She was cofounder and manager of the now-legendary neo-Dada

Club 57 in New York City, which she ran from 1979 to 1981. Throughout the eighties she developed and performed in solo pieces, in duets (with Eric Bogosian, Joey Arias, and Kestutis Nakas), and with bands in nightclubs, art spaces, and theaters across the United States, as well as in Canada, Europe, and Japan. She released five albums with the cult rock band Bongwater, as well as a solo album, *The Luv Show,* presently out on Geffen Records. Her one-woman show *You Could Be Home Now* played at Lincoln Center's Serious Fun Festival and sold-out runs at the New York Shakespeare Festival's Joseph Papp Public Theater, the Theater Pass Murielle in Toronto, and the Coast Playhouse in Los Angeles. Her many TV and film appearances include *Vandemonium, Anything but Love, Making Mr. Right, Clear and Present Danger,* and the beloved classic *Cabin Boy.* Curious parties are invited to visit her Web site at www.annmagnuson.com.

Ruth Maleczech, born in 1939, is a founding co–artistic director of Mabou Mines and has collaborated on almost every work in the company's twenty-seven-year history. She has received three Obie awards for her performances in *Hajj, Through the Leaves,* and *Lear.* As a director, she won an Obie for *Vanishing Pictures* and a Villager Award for *Wrong Guys.* Outside of Mabou Mines, she has performed in productions directed by Joann Akalitis, Peter Sellars, Fred Wiseman, and Robert Woodruff, and has appeared across the country at the Joseph Papp Public Theater, the Guthrie Theater, and the La Jolla Playhouse. She has been the recipient of numerous grants and fellowships for her artistic achievement.

Tom Marioni, born in 1937, studied at the Cincinnati Art Academy. He is a sculptor and conceptual artist and was editor of *Vision* magazine from 1975 to 1982. Marioni has taught at the University of California, Berkeley, and UCLA, and has received numerous National Endowment for the Arts grants and a Guggenheim Fellowship in 1981. He founded the Museum of Conceptual Art (1970–84) and the MOCA

Ensemble, a free jazz group (1973–74), and is the founder and composer of Art Orchestra (1996). *Drinking Beer with My Friends, Wednesdays,* is his long-term San Francisco performance.

Paul McCarthy's actions, which have included investigations of ketchup, mayonnaise, and masks, are trancelike, ritualistic journeys to excessive behavior often stopped by the authorities. Some of his performances and videos are *Meat Cake* (1972), *Press* (1973), *Heinz Ketchup* (1974), *Class Fool* (1976), *Experimental Dancer* (1976), *Halloween* (1978), and *Political Disturbance* (1976). Born in 1945, he currently exhibits his sculptures/installations nationally and internationally and is an art professor at the University of California, Los Angeles.

Paul McMahon is an Interfaith minister, Renaissance person, teacher, and healer whose creativity manifests in any and all media. At the time of this interview he was coproducing (with Nancy Chunn) the *Party Club,* a multimedia performance extravaganza at the Franklin Furnace. It was a make-believe nightclub in which many musicians and artists, including the author, performed. He currently resides in Woodstock, New York, and is known as the King of the Universe, the Rock 'n' Roll Therapist, and the inventor of Mock Mouse, a cat toy.

Ana Mendieta was born in Havana, Cuba, in 1948. After moving to the United States in 1961, she lived in Iowa and New York and frequently visited Mexico. Her seminal works in the seventies are known as the *Silueta* series, a group of earth and body works in the landscape involving performances, physical materials, and references to spiritual rites that she documented with photographs and super-8 films. In the mideighties she began to make sculpture, drawings, and objects, as a result of receiving a Prix de Rome fellowship in 1983. Ana Mendieta died in New York in 1985. Since her death, her work has been honored with retrospectives organized by the New Museum of Contemporary Art, New York (1987), the Helsinki City Art Museum (1996), and the Centro Galego Arte Contemporaraneo, Spain (1996).

Tim Miller is a solo performer whose full-evening theater works have been presented all over the world. He is artistic director of Highways Performance Space in Santa Monica and teaches in the graduate theater program at the University of California, Los Angeles.

Antoni Miraldi was born in Barcelona in 1942 and moved to Paris in 1962, where he worked as a fashion photographer and started to create objects and edible art pieces. This work evolved into ceremonial events involving food, ritual, and color. In 1971 he moved to New York, and since then he has lived and worked in both the United States and Europe, creating public art and participatory events and installations.

Susan Mogul, photographer, performer, and filmmaker, was born and raised in New York. The oldest of six children, she moved to Los Angeles in 1973 to participate in the feminist art movement and video and performance scene. Her autobiographical work views the everyday as performance, often with an eye for the ironic and the absurd. In 1987 she was an artist in residence at a treatment center for abused children, an experience that became an emotional and artistic turning point in her work. Currently Mogul is making diaristic documentary films *Everyday Echo Street, I Stare at You,* and *Dreams.* Her personal fictions have received numerous grants and fellowships and are included in permanent collections.

Meredith Monk is a composer, singer, filmmaker, and choreographer/ director who pioneered what is now called extended vocal technique and interdisciplinary performance. She has created over one hundred works since 1964. Her awards include a MacArthur Foundation Fellowship, two Guggenheim Fellowships, three Obies, a Bessie, and a National Music Theater Award. In 1968 she formed the House, a company dedicated to interdisciplinary performances, and in 1978 she founded the Meredith Monk Vocal Ensemble to perform her unique vocal compositions. She has made more than a dozen recordings, most of which are available on the ECM New Series label. An exhibition

entitled *Meredith Monk: Archaeology of an Artist* was presented in 1995 at the Library of Performing Arts at Lincoln Center.

Linda M. Montano, born in 1942, studied sculpture in Florence, Italy, and at the University of Wisconsin, Madison. For two years she was a Catholic novice. Since 1970, when she met her guru, Dr. R. S. Mishra, Montano has been merging her spiritual interests with her art. Endurance, persona changes, attention states, singing, living life as art, trance inductions, using art as therapy, and humor have been performative themes for Montano, who considers life to be her studio. In 1983–84 she joined Tehching Hsieh in his *Art/Life: One Year Performance,* in which they were tied together with a rope. From 1984 to 1998 she performed *Fourteen Years of Living Art,* wearing different one-color clothes each year in honor of the seven chakras. *Chakraphonics,* a durational sounding of each chakra, is one of Montano's performances of this experience. Video Data Bank lists her numerous videotapes. *Art in Everyday Life* (1981) and forthcoming books document her performances. Montano is currently practicing *Family Art.* Web sites to visit are www.rubylamb.com, www.vdb.org, and www.bobsart.com.

Frank Moore, born in 1945, has been presenting his paintings, live performances, videos, and lectures in the United States and Canada since 1963. His books, essays, criticism, and poetry have been published internationally. Moore directed the popular seventies cabaret show *The Outrageous Beauty Revue.* In the 1990s he was targeted by Senator Jesse Helms when the *New York Tribune* included him in a listing of "scandalous" performance artists. Moore publishes and edits the acclaimed underground zine the *Cherotic Revolutionary.*

Vernita Nemec is a painter, writer, performance artist, and activist feminist. She founded the Floating Performance, a one-woman presenting organization, in New York City.

Hermann Nitsch, born in 1938, became interested in religious art while studying graphic illustration. He copied from Rembrandt's *100 Gulden*

Blatt and *Christ Crucified,* and from other religious themes by artists such as Tintoretto and El Greco. At this time he was also strongly influenced by Cézanne, Klimt, and Munch, among others. About 1957 the depiction of Dionysian revelry and ceremonies entered Nitsch's drawings. Nitsch then conceived his idea for a radical theater, Orgies Mystery Theater, which incorporates themes of Aristotelian catharsis, Freudian psychology, conventional theater, and Dionysian orgy. It is an attempt to create a *Gesamtkunstwerk,* a total art, and a mystical experience that involves all senses. Nitsch has been jailed for his art.

Lorraine O'Grady lives and works in New York. After studying economics and literature, she began work as a visual artist in 1980 with the performances *Mlle Bourgeoise Noire* and *Nefertiti/Devonia Evangeline.* Since 1992 she has created photo-based installations. Recent exhibitions include *Miscegenated Family Album,* a spatial narrative in "nowhere," Louisiana Museum of Modern Art, Denmark; and studies for the work in progress, *Flowers of Evil and Good,* in the exhibit *New Histories* at the Institute for Contemporary Art, Boston. In 1995–96 she held the Bunting Fellowship in Visual Art at Harvard University.

Morgan O'Hara, born in 1941, received her M.A. from California State University in Los Angeles and has been active nationally and internationally in group exhibitions. Her performances and installations have occurred at the Experimental Intermedia Foundation, at the Knitting Factory, in numerous music festivals in Hungary and Germany, and in many other venues throughout the United States and Europe. O'Hara has received research and production grants from the National Endowment for the Arts, Harvestworks, the Irish Film Center, and Cologne, Germany. She maintains a studio in Bergamo, Italy.

Pat Oleszko's work in the popular art forums of the street, party, restaurant, burlesque house, beauty contest, sporting event, and parade has led to the more prescribed forms of the one-person show, films, conventions, installations, and special events. She has appeared in magazines

from *Penthouse* to *Ms., Artforum* to *Sesame Street.* Having made about thirty short films, she has also received numerous prestigious awards and continues to seek fun.

Pauline Oliveros is known worldwide as a composer, accordionist, and teacher. Her work in electronic technique, teaching methods, classical improvisation, myth, ritual, and consciousness has changed the course of contemporary music. Since leaving the University of California, San Diego, in 1981 as full professor, she has established the Pauline Oliveros Foundation to encourage other artists' creative efforts, especially those that emphasize interartistic collaboration. For twenty-five years she has worked with dance, literary, theater, and performance artists. Her work emphasizes attentional strategies, musicianship, and improvisational skills. Oliveros's compositions have been performed worldwide, and in 1985 she was honored by a retrospective of her work at the John F. Kennedy Center for the Performing Arts in Washington, D.C. Her written work was anthologized in 1984 in *Software for People,* and her recorded work is available on numerous labels. Oliveros founded the Deep Listening Space in Kingston, New York.

Adrian Piper is a conceptual artist whose work in a variety of media has focused on racism, racial stereotyping, and xenophobia for nearly three decades. She exhibits her work internationally and at the John Weber Gallery and the Paula Cooper Gallery in New York City, and is the recipient of many awards: a Guggenheim Fellowship, Award for Visual Arts, numerous National Endowment for the Arts fellowships, and the Skowhegan Medal for Sculptural Installation. She is the author of the two-volume *Out of Order, Out of Sight: Selected Writings in Meta-Art and Art Criticism, 1967–1992.* She is also professor of philosophy at Wellesley College.

Jim Pomeroy was a sculptor, performance artist, photographer, video/ sound artist, and computer guru. His work mixed puns with politics, gadgetry with science fiction, and Brecht with Mr. Wizard. He held

undergraduate and graduate fine arts degrees from the University of Texas at Austin and the University of California, Berkeley, and served as chairman of the sculpture department at the San Francisco Art Institute and as associate professor of video art at the University of Texas at Arlington. Pomeroy died of a cerebral hematoma after suffering a fall at the age of forty-seven. His archive is being organized at the Center for Creative Photography in Tucson, Arizona.

Faith Ringgold, born in 1930, is a painter and sculptor. She has completed commissions for Williams College, the Museum of Modern Art, the Studio Museum of Harlem, and Women's House. She has had retrospectives of her work at Rutgers and the Studio Museum of Harlem, and one-person shows at Wooster College, the Bernice Steinbaum Gallery, the Baltimore Museum of Art, and the Deland Museum of Art. She is the founder of Coast to Coast, a women of color national artists book program, and has been a professor of art at the University of California, San Diego, since 1984. Her work has won numerous awards, including the La Napoule Foundation Award (1990), the Corretta Scott King Award (1992), and the Colescott Honor (1992).

Rachel Rosenthal has performed since she was three. In 1956–66 and 1976–77 she created, directed, and performed in *Instant Theater,* an avant-garde, underground theater piece in Los Angeles. In the seventies she was a leader of the women's art movement. In 1975 she began her career as a performance soloist, creating and performing over thirty full-length pieces in twenty years, teaching the form in workshops, classes, and residencies, and lecturing throughout the United States and internationally. She is the recipient of many awards, including several National Endowment for the Arts grants, an Obie award, a Getty fellowship, a Rockefeller grant, a Women's Caucus of the Arts award, several California Arts Council and LA Cultural Affairs grants, the College Art Association Distinguished Body of Work Award, the Genesis Award for Performance, and the Robert Rauschenberg Tribute 21

award. She is now performing and touring with an ensemble of ten artists in the Rachel Rosenthal Company, a nonprofit group begun in 1989. Her book *Tatti Wattles, a Love Story* was published in 1997.

Martha Rosler, conceptual feminist and activist, has created videos, performances, and books that address consumption habits, food as necessity and commodity, and cooking as metaphor, internalized value, and colonizing strategy. Her videos include *Budding Gourmet: Semiotics of the Kitchen, Losing: A Conversation with the Parents,* and *Vital Statistics of a Citizen Simply Obtained.* An artist's book titled *Service: A Trilogy of Colonization* was printed in 1977.

Moira Roth is a feminist art historian, critic, activist, and curator. Born in London in 1933, she was educated in England and the United States, receiving a Ph.D. from the University of California, Berkeley, and for many years taught at the University of California, San Diego. In 1985 she began to teach at Mills College, Oakland, as the Trefethen Professor of Art History. In addition to many articles and catalogue texts, Roth has edited four books: *The Amazing Decade: Women and Performance Art in America, 1970–1980; Connecting Conversations: Interviews with Twenty-five Bay Area Women Artists; We Flew Over the Bridge: The Memoirs of Faith Ringgold;* and *Rachel Rosenthal.* In 1998–99 two volumes of her writings, together with critical commentaries, appeared in the series Critical Voices in Art, Theory, and Culture: volume 1, with Jonathan Katz, *Difference/Indifference: Musings on Postmodernism, Marcel Duchamp and John Cage*; and volume 2, with Sutapa Biswas, *Musings on Feminism and Cultural Diversity.* Among Roth's recent awards and honors are the Mid-career Art History Award (1989), the Lifetime Achievement Award from the Women's Caucus for Art (1997), and an honorary Ph.D., San Francisco Art Institute (1994).

Jerome Rothenberg is the author of over fifty books of poetry and seven major assemblages of traditional and contemporary poetry, from *Technicians of the Sacred* in 1968 to *Poems for the Millennium* in the nineties. A

foundational figure for a renewed ethnopoetics, he has also been involved with various aspects of poetry/performance, including a theatrical version of his book *Poland/1931* by the Living Theater in 1988 and a musical version of the poem cycle *Khurbn* with composer Charlie Morrow and Japanese novelist Makoto Oda, produced for the Bread and Puppet Theater in 1995.

Brian Routh, born in 1948, lived in England until the age of twenty-one. He then met Martin Von Haselberg, with whom he formed the Kipper Kids and toured Europe and North Africa. David Ross invited them to the Long Beach Museum and they arrived in the United States in 1974 and stayed. They continue to work together today. Routh lives in Sonoma, California, with his wife, Jeana.

Richard Schechner is a professor at the Department of Performance Studies, Tisch School of the Arts, New York University, a theater director, and author/editor of the *Drama Review* (*TDR*). He began eating long before he did art in any formal way. He continues to mix the two, as in his *Faust/Gastronome* (1993), a recasting of the German alchemist as a chef.

Carolee Schneemann, born in 1939, studied art at Bard, the University of Illinois, Columbia University School of Painting and Sculpture, the New School for Social Research, and the University de Puebla, Mexico. Her work is included in the collections of the Museum of Contemporary Art (Los Angeles), the Museum of Modern Art (New York), the Philadelphia Museum of Art, the Institute for Contemporary Arts (London), and the San Francisco Museum of Modern Art. Schneemann has had numerous solo exhibitions in Europe, and a retrospective was held at the New Museum of Contemporary Art in 1996. Her body art examines Western aesthetics by research into archaic visual traditions. The founder of Kinetic Theater, Schneemann uses film, video installations, and projection systems to present the body as a source of knowledge and the sacred erotic. She has received grants and awards

from the Gottlieb Foundation, the Guggenheim, and the Pollock-Krasner Foundation. Her books *More Than Meat Joy* (1978) and *Documentex: Imaging Erotics* (1997) clarify her development of genres now defined as body art, performance, and installation.

Robert Schuler was trained as an engineer before studying art. He taught in the art department at the State Univerity of New York in New Paltz and has devoted his time to sandblasting images on granite cubes that are then dropped into the ocean, like a necklace strung around the world. Schuler lives in a foam dome he built in upstate New York.

Willoughby Sharp, born January 23, 1936, is "still alive and working to enhance the value of advanced art in our culture."

Bonnie Sherk began performing her social artwork in 1970, when she sat in a chair in a flooded city dump, in San Francisco, wearing a formal gown (*Sitting Still #1*). In 1971 she performed lunch in the San Francisco Zoo's lion house, eating an elegant meal next to the lions in the next cage (*Public Lunch*). She waitressed as art in *Cleaning the Griddle* (1972–73) and later created a life-scale sculpture, *The Farm* (1974–80), a real, functional, sociological working model of interaction, relationship, difference, and codependence among species. Her current work, *A Living Library,* philosophically functions as a dream for a magical and harmonious new world order.

Stuart Sherman (born in Providence, Rhode Island, in 1945) is a performance artist, visual artist, and film and video maker. He has performed and shown extensively since 1976 in the United States, Europe, and Japan. He has received numerous awards, including a Guggenheim Fellowship, the Prix de Rome, and an Obie award. He has taught performance and intermedia at the San Francisco Art Institute, the Art Institute of Chicago, Massachusetts Institute of Technology, and many other national and international venues. Sherman actively practices Zen.

Theodora Skipitares is a multimedia artist and director who has been creating her works in New York for the past twenty years. Her autobio-

graphical solo performance eventually grew to include hundreds of puppet figures, ranging in size from a few inches to twelve feet, in productions that have investigated subjects such as medicine, genetics, and women's prisons. Her visual works and theater productions have been exhibited and presented throughout the United States and Europe.

Barbara Smith's work was initially based in painting and sculpture, aligned with minimalism and the conceptual art movement of the late sixties and early seventies, and then with feminism. Since the mid-seventies, when she began studying Zen meditation, Smith's work has explored personal and spiritual issues, penetrating the darkest levels of human experience. Many of her performances have been "ritualistic" and have involved food. Other performances have explored issues of sexuality, confronting male and female cultural roles, and personal interactions.

Michael Smith received his B.A. from Colorado College and attended the Whitney Museum Independent Study Program. He has performed at the New Museum of Contemporary Art, the Kitchen, Franklin Furnace, Caroline Comedy Club, and Dixon Place in New York. His large-scale installations have been exhibited at the Whitney Museum of American Art, Castelli Graphics, and the New Museum of Contemporary Art. His videos have been shown on PBS, European Television, and Cinemax. He is the recipient of numerous awards, including a Guggenheim Fellowship, National Endowment for the Arts fellowships, and two New York Foundation for the Arts fellowships.

Annie Sprinkle spent eighteen years as a porn star, stripper, prostitute, and pioneer of the kinky sex scene. With the outbreak of the AIDS crisis, she became interested in healing modalities and spirituality. She evolved into a high priestess of sacred sex magic rituals, a Tantrica, an internationally acclaimed avant-garde artist, a facilitator of sex workshops, a safe sex innovator, and a feminist "pleasure activist." One of her latest creations is *XXXOOO—Post Porn Post Card Books,* published by Gates O'Heck. Please visit her Web site at www.heck.com.

Stelarc, born in 1946, has been obsessed with the obsolescence of the body and the necessity for its redesign. He has explored the body not as a site for the psyche but as an evolutionary structure. He has internally probed the body with video endoscopy and has extended it with attached prosthetic devices. Between 1976 and 1988 he did twenty-five body suspensions with hooks in the skin in varying positions, situations, and locations. He has performed with a third hand, a virtual arm, and a sculpture inserted into his body. Recently he has developed a touch-screen interface for a muscle stimulation system to remotely choreograph the body's movements.

Kristine Stiles, an artist and associate professor of art and art history at Duke University, is internationally recognized for her research and numerous publications on performance and experimental art; destruction, violence, and trauma in art; and recent work on consciousness. She coedited with Peter Selz *Theories and Documents of Contemporary Art.* Her forthcoming books include *Correspondence Course: The Selected Letters of Carolee Schneemann, an Epistolary History of Art and Culture* and *Uncorrupted Joy: Art Actions, Art History, and Social Value.* She is also completing an anthology of her writings and public lectures entitled *Concerning Consequences, Essays on Trauma, Survival, and Action in Art.* She received a Guggenheim Fellowship and a National Endowment for the Humanities Summer Travel Grant in 2000 to work on her manuscript "Remembering Invisibility: Documentary Photography of the Nuclear Age." Stiles is the recipient of numerous grants and was given the Richard K. Lublin Distinguished Award for Teaching Excellence at Duke University in 1994.

Elaine Summers is a performer, lecturer, teacher, healer, writer, filmmaker, dancer, and choreographer. She received her degree from the Massachusetts College of Art and New York University. Summers danced with Merce Cunningham and Martha Graham and is the founder of the Experimental Intermedia Foundation, which she di-

rected from 1968 to 1986. She received a Fulbright and numerous National Endowment for the Arts grants (1971–86). Her films include *Crowsnest, Desert Mirage, Illuminated Working Man,* and *Interchange.* She is the founding director of the Kinetic Awareness Center.

Christine Tamblyn was born in 1951. As part of an ongoing project to integrate theory and practice, she made multimedia art and wrote criticism beginning in 1974. She published more than one hundred articles and reviews in a variety of periodicals and anthologies. Her performative lectures have been presented at numerous professional conferences. Her two CD-ROMs, *She Loves It, She Loves It Not: Women and Technology* and *Mistaken Identities,* have been shown internationally in England, Germany, Australia, the Netherlands, Spain, Argentina, Canada, and Finland, as well as featured at many museums and galleries in the United States. She was an assistant professor of studio art at the University of California, Irvine. She died in 1998 of breast cancer.

Anne Tardos, an artist, composer, and poet, is Jackson Mac Low's wife and lives in New York.

Fiona Templeton is a Scottish poet, director, performer, and the founding member of the Theater of Mistakes, London (1974–79). Her book projects include *Cells of Release, You—The City, Delirium of Interpretations,* and *Elements of Performance Art,* which was written with Anthony Howell. Templeton has received fellowships from the National Endowment for the Arts, New York Foundation for the Arts, and Cambridge University.

Mierle Laderman Ukeles is a conceptual artist who has been active in a form she terms "maintenance art." Ukeles keeps an office in the New York City Department of Sanitation. Recently, she completed a work titled *Urban Freedom Hall* at the Museum of Contemporary Art, Los Angeles, with the participation of hundreds of firefighters, street maintenance workers, sanitation workers, children, and teachers. This event featured over one million pounds of crushed glass mounds surrounding

a cobalt blue glass table that is used for real peace talks. She is represented by Ronald Feldman and has received grants from the National Endowment for the Arts, the Guggenheim Foundation, and the Joan Mitchell Foundation.

Ulay (Uwe Laysiepen) was born on November 30, 1943, exactly three years before Marina Abramović, in a bomb shelter in what is now Germany, and is best known for his performance work with Abramović from 1975 to 1988. Ulay's independent focus has been photography. In the late 1960s he experimented with the collusion of the Polaroid camera and the self-portrait. In the 1990s his photographic interests have broadened to include film. One of his most recent endeavors is an hour-long piece produced and distributed by the Humanist Broadcasting Foundation in the Netherlands entitled *Ulay—In Photography,* a tribute to Australian aboriginal ceremonies and Ulay's mentor Watuma Taruru Tjungurrayi.

Veronica Vera began exploring and researching sexuality in 1980. She wrote hundreds of articles, lectured and performed at universities and galleries worldwide, and testified for freedom of expression in Washington, D.C. In 1992 she founded Miss Vera's Finishing School for Boys Who Want to Be Girls, in New York City, the world's first cross-dressing academy. Her book of the same name is the subject of a major motion picture.

Martin Von Haselberg, a Kipper Kid (known as Harry Kipper), performed with Brian Routh, the other Kipper Kid (known as Harry Kipper). Together they created actions around seemingly harmless, gentle events—the tea party, the birthday party, the dinner—except their reversed rituals became a Rube Goldbergian occasion for nightmarish, comedic, and spectacular food fights, boxing matches, and primitive sound making, all designed to question the niceties of social behavior. The Kipper Kids performed at the Whiskey-a-Go-Go in Hollywood and in many venues in Europe.

William Wegman, born in 1942, received his B.F.A. at the Massachusetts College of Art and his M.F.A. at the University of Illinois. He has taught at the University of Wisconsin and at California State University, Long Beach, among other universities. He is a Guggenheim and National Endowment for the Arts recipient, and his work is in numerous collections, including the Whitney Museum of American Art, the Museum of Modern Art, the Ed Ruscha collection, and the International Museum of Photography. He is best known for his large-format Polaroids of his dogs, especially his weimaraner Man Ray.

Hannah Wilke (1940–93) invented a female iconography based on organic forms related to bodily and vaginal imagery in the late fifties. She was one of the first artists to deal directly with feminist issues. Initially she modeled small terra-cotta objects made precious by their boxlike enclosures. These gradually evolved during the sixties into gestural folded shapes with names like *Venus Basin* and *Teasel Cushion.* During the early seventies, Wilke began to work with latex and other malleable materials such as lead, kneaded erasers, lint, and chewing gum. Concurrently, she became involved with video performance, body art, photography, and film, using herself and her life in a series of works, dating from the seventies into the nineties. These works aggressively parody sexual stereotypes, playfully question human and societal relations, and bridge the time and space between life and death. Wilke's last greater-than-life-size watercolor and photo self-portraits, her floor sculptures and ready-made medical objects, and her everyday videos and drawings made with her own hair carry her exploration to a new level of revelation. She died of lymphoma in June 1993.

Martha Wilson was born and raised a Quaker outside of Philadelphia. She moved to New York by way of Canada in 1974 and founded Franklin Furnace two years later. During the next twenty years, her work turned inside out, from introspective, autobiographical performance

to political satire. She has performed in the personae of Alexander Haig, Nancy Reagan, Barbara Bush, and lately Tipper Gore.

Paul Zaloom has written, designed, and performed nine full-length solo performances, including *Fruit of Zaloom, My Civilization,* and recently, *Sick but True*. U.S. venues Zaloom has played include Lincoln Center, Spoleto, the American Repertory Theater, the Pennsylvania Academy of the Fine Arts, the Washington Project for the Arts, King Tut's Wah-Wah Hut, and several hundred others. Foreign venues include the Edinburgh Festival, Les Semaines de la Marionette (Paris), Casa Nova (Rotterdam), and other venues during eight European tours. Zaloom has received four grants from the National Endowment for the Arts and has also been given an Obie, a Bessie, an LA Weekly Critic's Award, three Citations of Excellence in the Art of Puppetry, and a Guggenheim Fellowship. He appears as the scientist Beakman on CBS TV's *Beakman's World*.

Ellen Zweig is an artist who works with text, audio, video, performance, and installation. For twenty years she created performances that explored unrequited love and fantasies of travel, culminating in the series *Ex(centric) Lady Travelers*. In her installations, she uses optics to create camera obscuras, video projection devices, and miniature projected illusions. She has presented work in Europe, Australia, and the United States and has received two grants from the National Endowment for the Arts. Her recent work includes *Hubert's Lure,* an installation in a storefront on Forty-second Street in New York City, and the radio play *Mendicant Erotics (Sydney),* commissioned by ABC Radio, Australia. Among other projects are a permanent installation of a camera obscura for the Exploratorium in San Francisco and the novel *Surveillance*.

index

525

Text 10.5/15.5 Bembo
Display Syntax and Bembo
Design Nola Burger
Composition Impressions Book and Journal Services
Printing and binding Edwards Brothers
Index Ruth Elwell